Digital Drawing:

PRINT & WEB GRAPHICS USING FREEHAND

Digital Drawing:

Print & Web Graphics using FreeHand
A New Method of Instruction
By David Bergsland

Delmar
Thomson Learning™

Africa • Australia • Canada • Denmark • Japan • Mexico
New Zealand • Philippines • Puerto Rico • Singapore
Spain • United Kingdom • United States

Delmar Staff:

Business Unit Director: Alar Elken
Acquisitions Editor: Tom Schin
Editorial Assistant: Fionnuala McAvey
Executive Marketing Manager: Maura Theriault
Channel Manager: Mona Caron
Production Manager: Larry Main
Art/Design Coordinator: Nicole Reamer
Cover Design: Steele Graphics

Asia
Thomson Learning
60 Albert Street, #15-01
Albert Complex
Singapore 189969
Japan:
Thomson Learning
Palaceside Building 5F
1-1-1 Hitotsubashi, Chiyoda-ku
Tokyo 100 0003 Japan

UK/Europe/Middle East
Thomson Learning
Berkshire House
168-173 High Holborn
London
WC1V 7AA United Kingdom
Thomas Nelson & Sons LTD
Nelson House
Mayfield Road
Walton-on-Thames
KT 12 5PL United Kingdom

Australia/New Zealand:
Nelson/Thomson Learning
102 Dodds Street
South Melbourne, Victoria 3205
Australia
Latin America:
Thomson Learning
Seneca, 53
Colonia Polanco
11560 Mexico D.F. Mexico

Canada:
Nelson/Thomson Learning
1120 Birchmount Road
Scarborough, Ontario
Canada M1K 5G4
Spain:
Thomson Learning
Calle Magallanes, 25
28015-MADRID
ESPANA
International Headquarters:
Thomson Learning
International Division
290 Harbor Drive, 2nd Floor
Stamford, CT 06902-7477

Library of Congress Cataloging-in-Publication Data
Bergsland, David

Digital Drawing: Print & Web Graphics Using FreeHand: A new method of instruction by David Bergsland.

p. cm.

ISBN 0-7688-1839-7 (alk. paper)

1. Computer graphics 2. FreeHand (computer file) I. Title

T385.B4654 1999

006.6'869--dc21

*I dedicate this book
to my lovely wife,
The Rev. Patricia H. Bergsland.
She is the reason
I keep pushing for excellence.
Her love is the best thing in my life*

DIGITAL
DRAWING:
PRINT & WEB
GRAPHICS
USING
FREEHAND

Contents

Chapter 7 139

Color

Chapter 11 253

Designing for the Web

Chapter 12 273

Production Tips

Forward

It's been a wonderful ride. About six years ago, a sales rep from Delmar called me on the phone in my lab where I taught Commercial Printing at Albuquerque TVI. She wanted to know if I was using any of her books. I explained that I couldn't because they were all application-specific and I taught all the major software at the same time in the same lab. As a result, I was forced to write all of my own materials. I had to create everything from scratch because nothing existed that taught the basic principles of the paradigm shift our industry was undergoing. She said, "You interested in writing a book?" Like an idiot, I said, "Sure!"

About a month later I received a call from an editor from Delmar, in Albany, N.Y.. He asked me if I was serious about that book. Again, in blissful ignorance, I said, "Sure!" I explained that I was a nobody who just liked to write. I told him that I needed a conversational book, in the style of my lectures, or the students would refuse to read it. Actually, we talked for about forty-five minutes. The result was that he told me they were receiving proposals on a book like this and he'd like to see one from me.

That time around

That first book was a revelation. What I discovered was a paradigm shift. All of the rules that worked when I was in industry were changing faster than anyone could write them — except for in the magazines. One of the advantages of a paradigm shift is that the new persons start on the same footing as the old hands. Everyone has new rules. Often, in fact, the new people are not hindered by the habitual reactions from the old paradigm.

My sources were MacWorld, MacUser, Publish, Step by Step (both), NADTP, GATF, NAPL, Graphic Arts Monthly, American Printer, Southwest Graphics, Aldus (now Adobe), and several others. The best was and is Before & After by John McWade. Here I found a man after my own heart ... and look at what he is doing!

There were no textbooks on this new trail. I used Roger Black's Desktop Design Power and Robin Williams's books. These two authors are probably my biggest influences. They had a conversational tone that I liked — clear, concise, and entertaining PLUS my students would actually read it. The old printing

textbooks were never used at all. I needed a retail book, but none of the well-written computer books covered printing problems adequately or even accurately. (Since then, many have come out for various portions of the industry, but there's still no overview.)

The advantage of being forced to start from scratch became obvious. Not being hampered by traditional ways of doing things, I developed an entirely new method of instruction (see Appendix C). Based on my twenty-plus years in the industry, I knew what employers needed. I discovered that students also thrive when they are taught real-world solutions to real-world problems.

This time around

This textbook is written as an entertaining read. It is meant to be conversational, entertaining, and a little controversial. My primary concern is the higher learning skills — we need graduates who can think and solve problems. This means asking difficult questions.

This book is quite different from the first book in that it actually teaches software. All of my other classes can assume a basic knowledge of the software from the required entry-level tutorial courses. FreeHand (as part of my PostScript Illustration course) has no preliminary tutorial course. PostScript illustration is so far outside the normal experience of community colleges that I have to teach the software as well as the industry knowledge and techniques.

Going online

In 1996, it became obvious that most industry communications were going to be over the Net. As a result of that, I converted all of my coursework to online instruction. At present, all of my students have the option to do all or part of their work online. This is a real boon for students who are convinced that they can survive professionally on a PC (my lab is all Mac). More than that, it has enabled employed personnel to upgrade their skills while working. What I saw in 1996 has become fact. For this book, all communication with the publisher has

been via email, the final digital documents will be PDFs FTPed to the printer in Canada, and everything is moved around attached to emails.

My goal is extremely practical. What do you need to succeed in this industry? I am relentless about that. I call it reality orientation. That's what this book is all about.

 July 1, 1999

PS: For those of you compulsive about these things, except for a little Dover clip art and a cartoon from my former student Robert, I created everything. I wrote all the copy, shot or own all the photos, and drew all the drawings on my Performa 5215, 32/1GB, plus a SyQuest 88, ZIP, JAZ, APS 4x4x20 CD-RW, and an old UMax 840 scanner. My word processor is PageMaker 6.5. My illustrations were done in FreeHand 8. The bitmaps were done in Photoshop 5. Finally, I designed all my own fonts for this book.

MY EMAIL ADDRESS IS:
graphics@swcp.com

MY HOME PAGE IS:
http://kumo.swcp.com/graphics

**DIGITAL
DRAWING:
PRINT & WEB
GRAPHICS
USING
FREEHAND**

Acknowledgments

Over the years, many people have helped me along the way. Personally, I have to thank my friends Jack and Karol Davie, Bruce Watson, Betty Hoisington, Shauna Barnes, Kay Melgaard, Jerry Debevc, Kevin and Kate Megill, Ken and Don Jackson, June, Chris, and Vinnie Scott, Larry and Kathy Pennington, and John Thurman for their immense help in bringing me kicking and screaming into humanity. Their love and support have been essential to my growth as a person, as a teacher, and as a writer. This wouldn't have happened without their prayers and support.

At school, I have to thank my Dean, Lois Carlson; my friend and Associate Dean (recently retired), Chuck Edelman; and my Program Directors, Marcella Green and Susan Cutler. They have given me leeway to pursue this new pedagogy and a great deal of support and kindness. We creative types can be very hard to live with, but they have hung in there with me even though I am severely bureaucratically challenged. I am grateful.

Many thanks have to go to my students in my Business Graphics and Communication degree program and in my commercial mentoring venture, Pneumatika Online Publishing School. It is horribly unfair to name names, but recently several stood out not only as students, but also as critics and "cohorts in crime." We've had a great deal of fun. They are the ones who let me know what works and what does not. I thank them as a group, and especially Richard, Bry, Kathy, Kyle, Shane, Will, Mati, Bill, John (3 of them), Roy, Lynda, Louie, Jason, Mary, and Dominic. There are many more from previous terms and years. They didn't volunteer as guinea pigs. In fact, most of them think I know what I am doing.

There are two students who have gone far above the call of duty. They have been the primary proofers of this book and have been a major encouragement to me. Darrylin O'Dea on the North Island of New Zealand has been a wonderful help. She heads the word processing department in a small private school there. The difference of her culture and language has been a huge help in making my work more understandable. Her

enthusiasm to learn has been a real joy. Locally, Marcia Best has helped, encouraged, proofed, and supplied PC graphics as needed. The original PowerPoint pie chart in chapter one is hers, for example. Her joy in life and creation is the reason why we all teach. Both of these women have worked their mousing finger to the bone trying to figure out what the heck I am doing.

At Delmar, all of the original people I knew are gone except for Larry Main, their production manager. His experience, stability, and encouragement have been a huge help in the practical matter of allowing an author to do all of the production work as well. He had the answer to every question of mine. Wendy McCully was a real help at WebCom, cheerfully answering all of my questions. Brooke Graves generates a masterful index. Her copyediting is essential to the readability of this work, and her comments are a delight. My new editor, Tom Schin, has been a real joy to work with. His marketing background has kept me on track, and his ability to cut through the red tape has been a real help. His assistant, Fionnuala, has been very helpful and readily available.

My major gratitude is reserved for my incredible wife, the Rev. Patricia H. Bergsland. Her ability to put up with my foibles is staggering. Without her love and support, I would have quit a long time ago. In addition to being my wife, she is also my pastor which, as you can imagine, is a fantastic help. Serving as one of her elders has given me a glimpse into true leadership and a teaching ability that has been the core of my inspiration as a teacher and mentor. Her friendship has been my stability. Our love is my reason for going on …

DIGITAL DRAWING: PRINT & WEB GRAPHICS USING FREEHAND

A greeting to the students:

Welcome!

As you begin this book, I want to give you both a word of welcome and a word of encouragement. This book is the result of eight years of study, research, trial, and experience. It has been field-tested with hundreds of students. I welcome you to their number. I think I can promise you a fun ride.

However, this will be training like you have never had before — unless you have used my materials in another class. Please do not expect the normal, "All right now, kiddies, let's open our books to page ..." There are no lockstep tutorials contained herein.

Adult education (even for teenagers)

For most of you, this will be your first experience with truly adult education. I realize that some of you are still in high school, but it's high time you were treated like an adult anyway. So what do I mean by "adult education"?

Adult education assumes that you are in this class because you choose to be here. It assumes that you are genuinely interested in learning to draw digitally, and that you have a genuine interest in becoming an artist or a designer. It assumes that if you get confused or feel like you are in over your head, you will ask questions and seek help.

Adult education is not a baby-sitting service. When you get hired or start producing jobs for real clients, they will not hold your hand. They will hand you a job ticket, ask if there are any questions, and tell you it's due tomorrow morning.

Your instructor and staff will be glad to help you get to the point where you can work freely and unsupervised. There are no stupid questions, only stupid students who do not ask questions. This is your chance to learn how to work.

The nature of graphic design

The first thing you will notice, as we go through the theory, miniskills, and skill exams found in this book, is that there are usually no right or wrong answers. The best we can do as designers is to find better or worse solutions to the problems presented by the designs we need to create. For the essence of graphic design is problem solving.

We will talk a lot about this throughout this book. You will discover that there are essential problems like, "Who is the desired reader for this piece and what are they looking for?" Plus there are hundreds of little problems like, "Does this yellow triangle help the readers make the connection to this important point they need to understand?"

In fact, I have argued for years that graphic design is probably the most difficult job in existence. This is problem solving as a way of life: dealing with subconscious motivations of the readers; meeting the needs of demanding clients; reading everyone's mind trying to figure out what they are really saying; analyzing your content and message to see where they touch the reader with a genuine need; and doing it all incredibly fast under tight deadlines.

You will discover shortly that graphic design is very much a service industry where you have to serve and satisfy many different people with different, and often conflicting, needs. The readers need to be shown why they genuinely need this product or service. The client needs to survive. Your boss needs you to stay well within budget so the profit keeps you employed. And the production staff needs a design that prints or downloads quickly, easily, with no snags or difficulties.

These are the normal tasks of the graphic designer. As you can clearly see, there is little room for the person who "just likes to draw." This will take dedication to a career that either fits you like a glove or you won't last. You have to really like this line of work. If you do not, the pressures will be too great and you will quit.

How to tell if you belong

It is not hard to determine if you are cut out for graphic design. There are common characteristics in most, if not all, commercial artists. There is usually a real joy in the experience of visual beauty. Most find that visual stimuli are extremely enjoyable. Many of us use elegance of design, richness of packaging, and a high level of craftsmanship to help determine which products to purchase.

There is usually a compulsiveness to our art. We draw or at least doodle all the time. Often we cannot really look at something without trying to figure out how to make it better, prettier, or more useful. Often we are highly critical. When we go to an art exhibit, we are either blown away by the beauty or almost disgusted by what we consider mistakes – often in the same piece of art. Usually we really think we can do it better, and often that is true. Somehow, for us art, designs, and graphics really matter – more than they do for most.

These things are not grounds for arrogance. They are simply indicators that we have been given a creative personality. Often there will be an insatiable curiosity, an intellectual quickness, an emotional sensitivity that makes us different from most of our peers. Again, this is nothing wrong, it is merely who we are.

This book and this career give you an opportunity to make a living using these attributes of your character. Some of you will discover that you really cannot work within these restrictions. Just learn the techniques then, and go on into fine art, where your personal vision is all that matters.

You are part of what my wife and I were once called – exotic people – those strange creatives: artists, writers, musicians, and the like. The world at large may never understand, but we are a neat group of people. One thing for certain, life will never be boring or dull!

So relax and enjoy the ride.

DIGITAL
DRAWING:
PRINT & WEB
GRAPHICS
USING
FREEHAND

With my first book, I provided a service to my readers that proved to be helpful. Because this is a long journey to a strange land, you really need a steady landmark to maintain your bearings and help you on the path.

Here's yours!

CONCEPTS:

1. Lineart

2. Continuous tone

3. PostScript

4. Resolution independence

Definitions are found in the Glossary on your CD.

Chapter One

Drawing as Opposed to Painting

Placing PostScript illustration into the context of the publishing industry

Chapter Objectives:

By giving students a clear understanding of the position of PostScript illustration in the publishing industry, this chapter will enable students to:

1. define the difference between lineart and continuous tone
2. list the advantages of graphics done in FreeHand
3. list the advantages of graphics done in Photoshop
4. discuss why speed and efficiency are such virtues in the publishing industry – both print and Web
5. list unique capabilities of digital drawing or PostScript illustration, in general, and FreeHand, in specific.

Lab Work for Chapter:

- Install FreeHand and set up aliases or shortcuts to enable it to be accessed easily.
- Learn the file management procedures for your lab or set up folders for you to use on your own computer.
- Open the Website for this class (or the version found on your CD) and explore the links offered.

If you are taking this class in a classroom setting, this is the time to learn the procedures set up by your school. You will not have time later, and many problems will be avoided by learning these things now.

PRINT & WEB
GRAPHICS
USING FREEHAND

Drawing as Opposed to Painting

A different
type of drawing

In this book we cover one of the most misunderstood tools in our arsenal. Digital drawing, more commonly known as PostScript illustration, is one of those indispensable tools of digital publishing. However, it has been lost in the hype of Photoshop and the PageMaker-versus-Quark brouhaha. Back in those bad old days (before computers), when we {GASP} had to do everything by hand, things were clearer. There was camerawork, inkwork, typesetting, and pasteup. These areas have been replaced by image manipulation, digital drawing, word processing, and page layout software.

So, this book is about inkwork instead of camerawork – digital drawing instead of image manipulation. What does that mean? It means that our focus is on an entirely different type of artwork. This artwork is not focused on soft transitions and subtle effects. The purpose of this type of art is fundamentally different. These are images that are crisp, precise, and direct. This is where we basically leave the natural world and enter an environment with no dirt, no scratches, no broken parts, no garbage. This is not to say that you cannot have these things – if you want them. However, you will have to specifically decide to draw them.

As you see on the opposite page, the drawing is very different from the painting. It's not to say that one is better than the other – they are simply different. The painting is soft, subtle, more "realistic." The drawing is clean, crisp, easily resizable, with a much smaller file size. It is also extremely easy to add professional-quality, easily resizable type (with complete typographic control) to the drawing. Any type added to the painting is limited to large point sizes and fuzzy edges. Painted illustrations simply cannot handle quantities of type.

As you can see on this page, the Free-Hand EPS from the opposite page can easily be resized and have type added to it. There is no fuzziness or pixelation. The type is crisp and sharp, even though this is printed out at 133% of the original size of the drawing. If this were a Photoshop TIFF, it would be pixelated even at this slight enlargement.

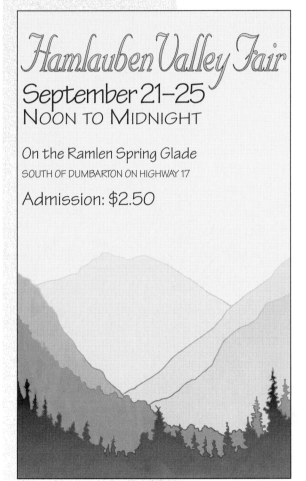

Hamlauben Valley Fair
September 21–25
NOON TO MIDNIGHT

On the Ramlen Spring Glade
SOUTH OF DUMBARTON ON HIGHWAY 17

Admission: $2.50

3

By pixelated, we mean that you can see the jagged edges of the individual picture elements. In addition, it would have been extremely clumsy to add the type. Finally, the Photoshop type would be very crude at 200 to 300 dots per inch, whereas the FreeHand EPS has type at the typographic standard — 1,200 dpi to 2,400 dpi.

Type manipulation

However, digital drawing goes far beyond the simple penwork seen so far. Its main power is found in type manipulation. It is helpful to remember that FreeHand was written by the same software engineers at Altsys that wrote Fontographer, which is the most popular font creation software. These are the same people who originally developed the EPS format used by our entire industry. In fact, in my opinion, this is the only program out of the "Big Five" (PageMaker, Quark, FreeHand, Illustrator, and Photoshop) that truly understands type — handling it freely, powerfully, and beautifully. InDesign is upping the ante, but FreeHand still offers more freedom.

One of the interesting phenomena that controls the reality of digital publishing is the fact that most customers do not want to pay for the graphics we think they need. One of FreeHand's major assets is its ability to rapidly convert a word or two into a powerful graphic within the time constraints of modern digital deadlines.

As mentioned in the first paragraph, this type of artwork used to be called inkwork or lineart. This outdated name still has a useful function when designing in FreeHand. This type of drawing is always built on a strong structure of lines that are filled in. To think of digital drawing as technical pen illustration is not far off the mark.

Of course, there are some major differences in FreeHand. Formerly, we could specify a color line, black line, white line, or no line. However, we had to hand-draw the line to the proper width. We could specify any basic fill, but we had to spray custom airbrushed gradients for graduated or radial fills. FreeHand is a dream come true — virtually infinite flexibility, with a precision that was incomprehensible before the late 1980s.

For logos there is nothing better. Logos have to be the most flexible graphics imaginable. They will be used very small, very large,

CHAPTER ONE:
DRAWING
AS OPPOSED
TO PAINTING

4

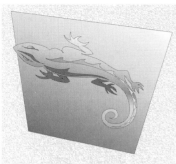

THE UNICORN DRAWING WAS DONE WITH A BRUSH AND INDIA INK — then it was scanned, traced into paths, cleaned up, and filled as desired. One advantage of this procedure is that it can be converted to color very easily. The final EPS can be resized as needed; the scan could not.

and everything in between. There must be black-and-white versions, spot color versions, process color versions, and in addition, low-resolution RGB Web versions. All of this is usually specified in a logo usage sheet. We will talk about this at length in chapter eight.

Digital drawing is almost specifically designed for this purpose. FreeHand enables very tiny file sizes that are resolution independent. In other words, they will print at the highest resolution allowed by the imagesetter, platesetter, printer, or monitor.

The CONVERT TO PATHS command makes even those incredibly troublesome TrueType fonts disappear into a collection of editable shapes. With fonts converted to paths, you can use any font and not have to worry about sending it with the logo. Logo slicks become a thing of the past when you have a graphic that can be easily resized to any dimension needed. The logos can even be rotated in 3D for use in perspective illustrations or Web animations.

Here's an example, using the logo I created for my design firm. I started with a scan and trace of my signature using a large blocky marker. Because this process converts the artwork to a FreeHand path, it was easy to stylize it and add the word "DESIGN" in a favorite font.

I quickly made a small version for those tiny little dingbats I would need. In a few more minutes I had made a spot color version, a process color version, and had begun designing my letterhead, business card, envelope, and invoice.

This is not to say that all design decisions are made this quickly. However, once the design concept is clear in your mind, the production of it can go very fast.

In your daily work, it becomes extremely easy to quickly create a functional logostyle for events and organizations that either cannot afford a logo or whose name makes a traditional logo untenable. Many times the client likes a modified headline, like the one on the poster on

page 2, and makes it the logo. As you can clearly see below, these quick solutions are rarely award winners. (However, even this is possible given the unpredictable nature of creative inspiration.) The main

Hamlauben Valley Fair

thing is to please your client and make things easy and clear for the customers of your client. Custom dingbats can be easily generated from logos or project pieces to use as bullets for bulleted lists in brochures. There is a great deal of excellent stock art sold in EPS format that can easily be modified for use. Often this is virtually a lifesaver, because of the deadlines that have to be met. Visually attractive bursts to explode "FREE" across the front of your ad, flyer, or brochure are quick and easy. The list is virtually endless.

Another large area of graphics in common usage includes charts and graphs. All of the common chart- and graph-producing software, like spreadsheets and presentation software, produce horrible-looking work that is designed for a monitor. To translate, that means they are in the wrong color space and far too low in resolution. Basically, every chart or graph you receive will have to be tossed completely or scanned and used as a rough template in the background while you recreate the graphic to professional standards so you can use it. FreeHand does have a chart and graph creation tool.

FREE!

As you can see from the sample below, showing usage of watercolor board, even the best I can do with the received graphic is terrible. I received the image as a 72 dpi, RGB TIFF generated from a PowerPoint slide. Even for this example, I have done a lot of work in Photoshop: cropping tightly; resizing the image to half size, thereby increasing the resolution to 144 dpi; and converting the image to grayscale. The result is still hardly inspiring. The font choice is clumsy, at best -- not to mention that it does not fit my Style Palette

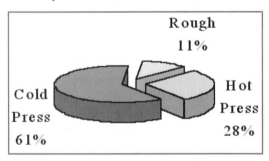

choices. The type alignment, leading, tracking, etc. are very amateurish. Worst of all, there is no explanation to help the reader determine if this knowledge is helpful, useful, or even relevant. In all ways, this graphic is useless unless it is used as part of a well-spoken, entertainingly written, enthusiastically presented oral explanation.

We have to remember, as graphic designers, that our explanations are found in the professional presentation of our copy. Poor font choices cannot be covered with glib jokes or even pithy verbal commentary. Our readers are going to make choices based on the attractiveness and usefulness of our designs. First of all, they will decide whether they are even going to read our work. If it is not clear in concept and easy to comprehend, you have lost them. With printed materials, you rarely get a second chance. So, with that in mind, let us redesign this awful pie chart.

First of all, we need to know what it represents. We discover that it refers to the use of watercolor board by the art department of an architectural design firm for the past year. They are in the process of making a presentation package that they can use to show their changing focus and capabilities to prospective investors as the firm expands.

As we learn this, we also find another bar chart showing, paradoxically, that sales resulting from the use of the board give a very different view. The rough board is used for hand-painted gouache illustrations, for which this firm is developing a real reputation. The cold press sheets are used as mounting board for client presentations to use as they seek to fill the spaces of the various projects with targeted tenants. The hot press is used for quick visualizations, models, and as a mounting board for general signage around the firm's offices – a utility board.

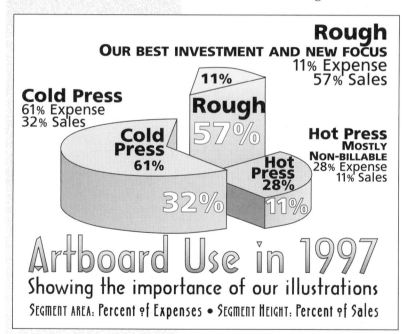

It turns out that the expensive d'Arches 300# rough watercolor board is used for illustrations that generate 57% of all income. The cold press board used for client presentations and to present proofs to the clients for printed materials in support of their buildings represents 32% of the income. The hot press board is second as far as expense is concerned, but it only accounts for 11% of the income. The hot press board calls for conservation measures.

With that in mind, I quickly traced the ugly PowerPoint slide (by hand, using the Pen tool); extended the height of the various slices (adjusting by eye); added stylish type giving both sets of figures; added a title line; and colored in the shapes. It took about a half hour to fix up the graph. However, there is a much greater likelihood that it will

actually be read now. More than that, the data now makes an important point that can clearly and easily be seen by capitalists as they decide whether to invest in the firm.

Spot color

In addition, there is an entire area of graphic design that cannot be touched by paint programs – spot color. Until Photoshop 5, there was no option for spot color illustrations except software like FreeHand. Both PageMaker and Quark are too clumsy to use as illustration software (even though they are usually necessary for document assembly and page layout). The best guesses for spot color usage at present are from 25% to 45% of all printing jobs, depending on the area of the world where you are having your printing done. If you want graphics for those jobs, PostScript illustration is the only option.

AUTHOR'S OPINION TO START DISCUSSION:

(This is meant merely to start you thinking.)

I believe that spot color printing is a passing fancy. This is certainly a minority opinion, but I think spot color will virtually disappear relatively quickly. This is not because it isn't economically helpful (a two-color job typically costs less than half as much to print as a four-color job). It is because spot color requires presses that are able to use ink (custom-mixed ink). Digital presses must have different toner and color heads for every spot color. The only digital press that can do that, at present, is the Riso-Graph digital mimeograph and even they have fewer than two dozen colors available.

Traditional presses will last mechanically for another 30–50 years minimum. So why do I think they will disappear? No press operators will be available. If the current trends continue, the emergency shortage of competent press operators that presently exists will increase exponentially until it forces an almost total shutdown of that industry except for isolated niches. I suspect this will begin happening very soon. In magazines like *American Printer* (and the rest of the trade rags), I saw estimated operator shortages of 35,000 or more in the mid-1990s. I know that trade schools in my area are only able to supply 5% of the annual need. Students are simply no longer willing to get their hands dirty. It's the same reason why there are no repairmen available now. All we have is parts swappers. The idea of a press operator who can keep a million-dollar press operational is a concept that has been lost in history on a practical basis. This type of uneducated

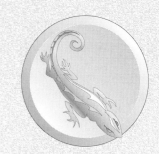

CHAPTER ONE: DRAWING AS OPPOSED TO PAINTING

HERE IS AN OPPORTUNITY FOR A GOOD CLASSROOM DISCUSSION.

With these opinions in mind, go to class with ideas about how the printed materials we see every day will change in the new millennium. The author may be wrong.

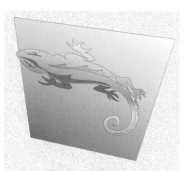

skilled laborer is very rare, and educated laborers cannot stand the boredom of simply watching a machine produce thousands of identical copies per hour.

Digital presses can economically handle four to eight colors. I suppose they could be spot colors, but why? They all have tight enough registration to enable process color or even hi-fi color. These processes produce millions to billions of colors. Their printing costs are rapidly reaching the spot color level. Why go with spot color when full color costs the same?

Discussion aside, for the short term, you will design many spot color jobs. As long as the equipment is running and there are people to run it, spot color will solve the budgetary problems for many clients. It is certainly possible that new digital options will become available. No matter how it plays out, your best tool is FreeHand plus your page layout software.

Web graphic solutions

It might seem as if the low-resolution (72 dpi) monitor graphics of the Web are a clear place for bitmap graphics. However, even here the creative freedom and flexibility of FreeHand give you a decided speed and efficiency advantage over people who are limited to Photoshop or less when it comes to graphic creation for online use.

Bitmap painting programs are extremely clumsy for quick, clear graphic production. FreeHand graphics can be exported as GIFs or JPEGs. By exporting as RGB EPSs that can quickly be rasterized to the exact size needed, you obtain a design freedom and image control that are very difficult to accomplish in Photoshop. The first time you try to make type fit a certain size, transform, or simply scale type in Photoshop, you will long for the freedom of FreeHand. Even Photoshop 5's much vaunted type layers are very limited when compared to FreeHand. Modified type from a FreeHand EPS rasterizes clearly and sharply when compared to transformed type done in Photoshop (which cannot be transformed unless bitmapped).

Determining graphic needs

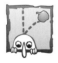 **A BASIC CONCEPT:**

Dropping in random graphics "just because they are pretty" is much worse than a waste of time (bad as that is). Especially on the Web, but equally true in printed materials, graphics should be added only for a good reason – to aid comprehension and help the reader implement the message of the project. If you cannot think of a good reason, do not use it.

 To put digital drawing into its proper perspective, you need to consciously add its capabilities into your planning procedures. One of the first things you need to determine when bidding on a job or setting up to produce that job is what graphics are needed for your project. This should be done very early in the process to enable effective workflow. I suggest that you make a list dividing the graphic needs between lineart and continuous tone. All photos, paintings, and pencil drawings go in the continuous tone column, to be scanned and executed in Photoshop. The rest go to FreeHand. Charts, graphs, logos, manipulated headlines, header and footer graphics, dingbats, technical drawings, maps, and more are far easier to produce and much clearer to read as Freehand EPSs than anything possible with Photoshop. As you become accustomed to the different capabilities available, you will wonder how you ever managed without this marvelously powerful drawing software.

Knowledge Retention:

1. What function does PostScript illustration fulfill in our industry?

2. What are the advantages of digital drawings?

3. Why is FreeHand far superior to programs like PageMaker or Quark for quick illustrations?

4. Why should logos be done in FreeHand instead of Photoshop?

5. List three advantages of FreeHand over Photoshop for illustration.

6. List three advantages of Photoshop over FreeHand for illustration.

7. Why is the speed of FreeHand so important in the workplace?

8. Why will spot color probably fade in importance?

9. What is resolution independence?

10. What is the problem with most charts and graphs?

PRINT & WEB GRAPHICS USING FREEHAND

CONCEPTS:

1. Bézier curves

2. Points

3. Segments

4. Handles

5. Stroke & fill

Definitions are found in the Glossary on your CD.

Chapter Two

PostScript Illustration

Explaining the new paradigm of PostScript illustration

Chapter Objectives:

To give students a firm conceptual basis before they start drawing in ignorance, this chapter will enable students to:

1. explain the difference between the different point types
2. explain stroke and fill
3. explain how a PostScript path differs from a fine art line
4. define point, segment, path, handle, and tangent.

Lab Work for Chapter:

• Finish setting up.
• Explore FreeHand help.
• Create a two-point circle (optional).

PostScript Illustration

This little cartoon is an excellent example of a quick illustration that is best done in FreeHand. The original sketch was drawn by one of my students, Robert K. Brown. He drew me several versions of this little character (whom we called Overbyte) to use in my first book, *Printing in a Digital World*. This one was used to illustrate the concept of sneakernet. The actual artwork was a full-page sketch, lineart only, done with a large, bullet-tipped black felt-tip marker.

© ROBERT K. BROWN

The process of scanning, tracing, opening in FreeHand to colorize, and saving as an EPS took less than 15 minutes. Because it is a FreeHand graphic, it can be resized, rotated, flipped, or edited in any way. This version is simply flipped and enlarged.

12

Drawing in PostScript

In FreeHand, digital drawing is a specific type of vector drawing called PostScript illustration. No matter what type of drawing you want to create, PostScript illustration must be approached as a combination of objects belonging to two simple categories: lines and shapes.

When discussing PostScript illustration, it is helpful to consider the fine art technique of collage. This is where you glue separate pieces on top of each other to produce the final image. It is not like a montage, where you assemble photos into a larger photo. In a collage you can use any type of object and arrange it anyway you wish – piling pieces on top of pieces. Here is a task for your imagination: you are about to create a collage with an inexhaustible supply of lines and shapes. Each line and shape can be stretched, bent, and otherwise reshaped however you choose. Virtually any color can be applied (even blends of color, from one to another). You can then paste these manipulated lines and shapes on your collage in the locations and order that you decide are best. Because it exists only in digital code, this collage is infinitely flexible; you can pick up any line or shape and put it down in a new position, slip it between two other objects, or discard it altogether. Any element can be exactly duplicated, manipulated in a new way, or left as is. It is almost as if each shape is on a separate sheet of perfectly transparent, infinitely thin Mylar and you can shuffle these sheets at will.

This scenario is actually a reasonably accurate description of the PostScript illustration process. We have been given a totally fluid, incredibly malleable drawing medium. It has taken "inkwork," or line art, to new heights, adding color, type, patterns, shading, and much more. It's a wonderful tool.

The nature of PostScript

Although it is true that we can add almost anything, that usually is not advisable, for reasons we will cover in chapter ten on Printing Problems. We can bring in bitmaps from Photoshop, for example. But that really defeats the purpose of PostScript illustration. The basic idea of digital drawing is that it

LEARNING TO THINK IN POINTS, SEGMENTS, PATHS, AND LAYERS

Here are the 12 shapes used to draw this lizard.

They were simply piled on top of each other.

13

produces graphics that are very small, very portable, and extremely flexible, and that can be resized at will.

It does this through a uniquely digital solution. It takes all of the pieces and describes them through the use of mathematical equations. These equations are used to generate outlines (curved and straight) that are called Bézier curves (named after the Frenchman who defined the equations). It is extremely important that you understand this concept of mathematically generated outlines of shapes. Because all these shapes are mathematical, they are much smaller than bitmaps.

To understand the difference, let us talk about a simple drawing: a white page with a black circle in the middle of it. As you can see in the drawing, this image could not be much simpler. Let's make it ten inches wide, eight inches tall with a three-inch circle centered in the image. (The rectangle outline is just to show you the edges.)

Let us assume that we have drawn it in Photoshop, at a resolution high enough to avoid the jaggies around the edges (let's say 300 dpi). If this Photoshop drawing is 10 inches wide by 8 inches tall, at 300 dpi it contains millions of pixels. (10 x 300) (8 x 300) = 7,200,000 pixels. So if this is a black-and-white image (1-bit color), this file has to be at least 900K in size. If it is in grayscale mode (8-bit color), it would be 7.2 MB of data. If it is in RGB mode (24-bit color), it would be 21.6 MB. If it is in CMYK mode (32-bit color), it would be 28.8 MB.

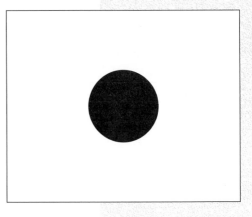

These figures are true no matter what type of image is in that ten-inch by eight-inch area. Bitmaps do not care what the pixels are. All they do is describe them individually. Yes, we know that there are compression schemes that ameliorate this problem. However, the concept is accurate. Every pixel has to be described. This is why so many of you have been surprised when you place a TIFF from Photoshop and the background is opaque white. How can you get rid of that opaque background? Only by using PostScript.

How would PostScript describe this same simple illustration?

I will not even attempt an accurate rendition of the PostScript language. This is what we are dealing with here: a programming language — actually a specialized form of that type of torture device for creatives known as a page description language. PostScript has its own dictionary of terms used to express itself. You do not need to know it. In fact, if you are an artist, you will probably not be able to stand dealing with it. The good news is that you don't have to.

However, you have to understand conceptually what is going on. So, this is basically what PostScript does. It describes shapes by

their starting and ending points, locating them on a bitmap grid that is included in the page size description. So, for this example, we have something like this: Page size: 3000 wide, 2400 tall; draw circle, start 350,250; end 650,550, fill 100 black. As you can see, the start and end locations are measured in pixels from the upper left corner.

The arrows on the drawing below point to the corners of the bounding box of the circle. A bounding box is defined by the horizontal and vertical lines that touch the far left, far right, top, and bottom extremes of a shape. Points placed at those locations are called *extrema*. The shape locations are described by using the upper left corner to start and the lower right corner to end.

The invisible square box that contains the circle starts 350 pixels from the left and 250 pixels from the top.

The invisible square box that contains the circle ends 650 pixels from the left and 550 pixels from the top.

The important thing to understand is the simplicity of this approach. Assuming that each character in that description just written is a byte of data, we used 86 bytes of data to accurately and completely describe this simple drawing. That is 86 bytes — not 86K (or 86,000 bytes), or 86 MB (86 million bytes of data) — but 86 bytes. So, on a floppy disk, where the minimum recording segment is 256 bytes, this would show up as a 1K file in your window. It is so small that Finder or Program Manager cannot even list it correctly.

Now, of course, there are complications. The saved document would have to have a path location, a document creator descriptor, a creation time and date, a modified time and date, and so forth. The additional descriptions would probably actually bring the document up to the 500-byte mark. However, this is still remarkably small when compared to the 900K to 28.8 MB necessary in Photoshop.

All shapes and lines in FreeHand are described in this manner. Even bitmaps brought into FreeHand are placed into a box (usually invisible except for the handles) that is described using this language. All of these shapes are simply described and piled on top of each other, the last one on top of the first ones. Because each of these shapes is independently described as a specific object, it is very easy to reshape by rewriting the description. As you can see to the left, it is just as easy to reorder the layering and shuffle shapes up and down in the stack. In addition, as we will see later, groups of these shapes can be assigned to a uniquely named layer to give control over the group.

15

The assembling of independent shapes

Almost any drawing can be expressed as an interacting collection of lines and shapes. What we need to discuss is the peculiar nature of PostScript lines and shapes.

The line

A line connects points. If you remember your geometry, a straight line is the shortest distance between two points. Any line starts at one point and ends at another. Lines may be any length. Lines can be very short (millionths of an inch) or stretch for light years. They can be straight, curved, or any combination of straight and curved sections.

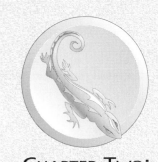

In PostScript, lines are called paths and are defined by points.

Segments are drawn between points to connect them. A segment can be straight or curved. Segments can connect two points in the shortest distance or indirectly in a curve, bending along the way. PostScript segments are linked together so that neighboring segments share a common point. In this way, you can think of a line as a connect-the-dot puzzle. Each point is a dot. You draw one segment from dot A to dot B, a second segment from dot B to dot C, a third segment from dot C to dot D, and so on. The completed image is called a *path*. A path may consist of only one segment, a thousand, or much more.

Obviously, the form of each straight and curved segment in a path determines an image's overall appearance. The appearance of a path is equally affected by the manner in which one segment meets another segment at a point. Segments can meet at a point in two ways. First, the two segments can curve on either side of a point, meeting on the common tangent to the curves passing through the point. This kind of point is

□ Corner Point:	Independent handles.	
○ Curve Point:	Two handles locked together as a tangent to the curve.	
△ Connector Point:	One tangent handle that remains aligned with incoming segment.	

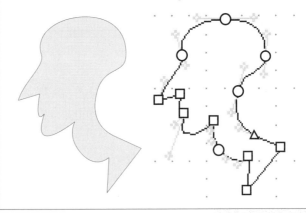

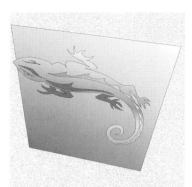

LEARNING TO THINK IN POINTS, SEGMENTS, PATHS, AND LAYERS

called a smooth point or a curve point. Second, two segments (straight or curved) may meet to form a corner. If two curves meet at a corner, each of those curves will have a different tangent. The point where they meet is called a corner point. FreeHand has a third choice, called a connector point, where a straight segment is the tangent of the other curving segment.

 Key definition: Tangent – a straight line touching a curve at a single point. There can be only one tangent to any curve at any given point.

In PostScript, assembling segments is much like drawing curving lines using French curves in drafting. If you match the tangents, you get a smooth curve. If the tangents do not match, there is a bump or corner in the resulting curve. PostScript curve points have a single tangent for both curved segments meeting at that point. As a result, the curve flows smoothly through the point with no bump. Corner points have separate tangents for each curve, or one of the segments is a straight line that is at a different angle than the tangent of the curved segment.

Direction

All paths, the segments going from one point to another, have direction. In PostScript this is important information. The direction is determined by the order in which you place the points. Later it can be changed with menu commands, but that will be discussed when it matters in later chapters. What you need to know now is simple. All points (except the first and last) have an incoming segment and an outgoing segment, which is determined by the direction. I know this seems so obvious that you might think I am treating you like an idiot. However, this will become important as we go on.

Handles

As you can see in this illustration, one of the apparent differences between point types is those thin lines with the crude cross at the end that appear when you select a point. These are called *handles*. All points have two handles: an incoming handle describing the tangent of the segment attached to the previous point; and an outgoing handle which will determine the curve of the next segment generated when you click to produce the following point. Point handles are a unique part of PostScript illustration.

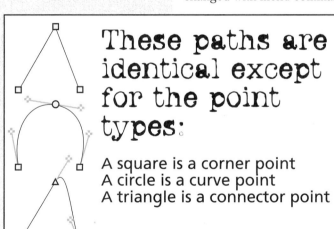

These paths are identical except for the point types:

A square is a corner point
A circle is a curve point
A triangle is a connector point

17

Handles are the WYSIWYG tools we use to manipulate the curves of segments. They have two basic attributes. First of all, they indicate the tangent of the curve of the segment they are attached to. Every segment has a handle at each end. When you click on a point, four handles appear – the outgoing and incoming handles for each segment attached to the point. Secondly, the length of the handle determines the amount of curve of the segment.

To rephrase, let's consider simple corner points. Often you cannot see one or both handles. If you simply click to produce corner points, you get straight lines connecting the dots. A corner point with straight segments coming into and out from the point will appear to have no handles. In fact, both handles have zero length in this case. In other words, when the handles have zero length the segment is as short as possible. Remember from high school geometry, the shortest distance between two points is a straight line.

When the handles have length, that length is added to the segment. As a result, the segment has to bend, and the shape of those

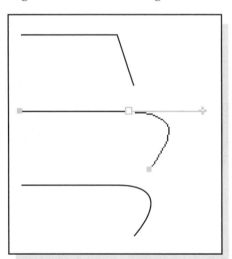

bends is determined by the tangent shown by the angle of the handles. The easiest way to show you is to draw a little two segment path with corner points, and then draw out the handle of the middle point. You can draw out the handles by clicking on the point with the Selection Tool, then hold down the Option key (PC: Alt) and drag out the handle. The first time you do this you get the outgoing handle. The second time, you get the incoming handle. That is all I did in the little illustration here. As you can see, the length of the handle is added to the segment. This is obviously not a one-to-one relationship, but conceptually this is what happens.

All of this sounds very complex. However, once you start practicing with the point creation tools, it becomes second nature. You do not even think of it any longer. You find yourself simply creating and manipulating infinitely malleable lines into shape. It is very elegant and free.

There is a major attribute of PostScript lines that we have not covered yet. It is the same situation formerly found with technical pen lines. One of the main advantages of a tech pen is that all its lines have a common thickness. A half-point pen produces a half-point line and nothing else. This is also its main disadvantage and the major reason

18

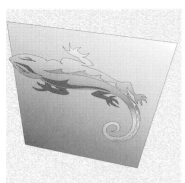

why tech pen drawings tend to look too perfect and somewhat sterile. PostScript has the same problem. FreeHand drawings often look unreal, too clean, like computer drawings.

In nature, almost all lines vary in thickness. Only man-made lines are a constant width. Consider, for example, the difference between a vine strung between branches and a phone line hung on poles. The only ways to use a constant line to depict organic forms are crosshatching, stippling, or filled shapes. PostScript uses primarily the latter approach, but stippling is very difficult to do on a computer.

The shape

If you recall, a line is called a *path* in PostScript. Like a geometric line, a path is a purely one-dimensional shape. It has length but no width or height. More appropriately stated, in PostScript, a path can have any width at your whim (including none). It is merely a description of a line no matter what form it takes.

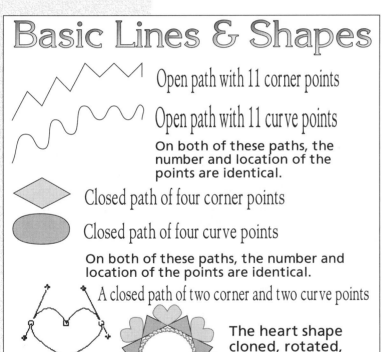

Basic Lines & Shapes

Open path with 11 corner points

Open path with 11 curve points

On both of these paths, the number and location of the points are identical.

Closed path of four corner points

Closed path of four curve points

On both of these paths, the number and location of the points are identical.

A closed path of two corner and two curve points

The heart shape cloned, rotated, and duplicated into a star.

When a path goes back to the originating point and connects the last point with the first point, it becomes a closed path — a shape. The area enclosed by the closed path is the shape. In PostScript the attributes of the area are called the *fill*. The attributes of the path are called the *stroke*. All shapes have stroke and fill. Open paths can also have both *stroke and fill* (since version 8 only). The only difference is that the fill, on an open path, is contained by an unstroked straight segment between the beginning and ending points.

Properties of stroke and fill

Unlike a line drawn with a pen on paper, any path must be consistent in thickness, or weight. Certainly, a line drawn with a bamboo pen will be heavier than a line drawn with a steel pen point. In addition, because a pen is a flexible tool, the weight of the line will fluctuate, depending on how hard you press the tip to the page. This is not the case in PostScript. Different

19

lines can have different weights, but the weight of each line must be constant throughout its length.

The illusion of variable-width lines in FreeHand is created by drawing very long skinny shapes that vary in width. These long thin shapes have both stroke and fill. They are generated by a graphic pen and a graphic tablet, or they are traced from scanned inkwork done with traditional tools. "Natural lines" such as a vine or a crack must be done in this manner in PostScript. Because it is impossible to create a line

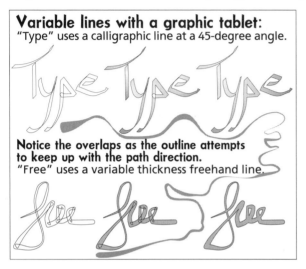

Variable lines with a graphic tablet:
"Type" uses a calligraphic line at a 45-degree angle.

Notice the overlaps as the outline attempts to keep up with the path direction.
"Free" uses a variable thickness freehand line.

that varies in thickness, the only option is to trace around the outside of a varying line to produce a long narrow shape and then fill the shape with the same color as the stroke, or use fill only. It is easy for a computer to create a shape that is only a few thousandths of an inch (or point) wide, so any line that can be printed can be drawn.

 A graphic tablet creates variable-width lines automatically. However, this is a tool, like a fine sable watercolor brush, that takes a great deal of practice to use well.

Also, drawing a path is like having millions of different colored inks at your disposal. A line can be black, as if drawn with India ink, or it can be light gray or dark gray. It can also be red, or green, or blue, or any one of millions of colors. A line can even be white or nothing (a stroke of None). Line weight and color combine to determine the stroke of a line or the outline of a shape.

You can manipulate the area inside a path separately from the outline itself. This inner area is called the fill. Just like a line, the fill of a shape may be black or white, none or colored. It can even combine many colors fading into one another in linear or radial gradients.

 Be very careful of lines called hairlines. There is no standard definition of hairline thickness.

Some say a hairline stroke is a quarter of a point (which is now FreeHand's default), some say a third of a point, some say one dot or pixel. Regardless, a hairline printed at 300 dpi is a very different thing

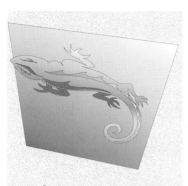

from a hairline at high resolution. Many imagesetters set hairlines at a single pixel. Often high-res hairlines disappear entirely. They are so thin that film cannot hold them. Even if you get them on film, plates may drop them out. (This is the first thing to check when a shape seems to have disappeared on a proof.)

For printed materials, make sure that you are at one-quarter point minimum; a half-point stroke is prudent unless your printing establishment is top-notch. A slightly heavier line that prints is far better than a thinner line that disappears. You should contact your printer for their standards. I use three-tenths of a point in this book for my hairlines. I made it my default in PREFERENCES.

For the Web, the best a hairline can be is one point (because that is the size of a single pixel on the monitor). In fact, because of anti-aliasing, where edge pixels are made in various grays or pastels to soften the edges, the minimum line in a Web graphic must be almost three points wide to have predictable color.

Line Weights & Colors

ANALYZING SHAPES

Determining a path

Before creating a path, you must evaluate the point structure and the segments involved. Every time the path changes direction you will need another point: corner, curve, or connector.

Corner points are placed at corners of the path and smooth points are inserted at the tangents of the curves, often where the curve of the path changes direction. In PostScript, economy is everything. It is possible to create paths with so many points that they take forever to print — if they print at all. If you analyze the shape you plan to create before starting, you can keep it simple and elegant. For example, a circle needs a maximum of four points (it can be done with two). If you have an illustration with hundreds or thousands of shapes, simplicity becomes a cardinal virtue. It is very easy to create a drawing the complexity of which will choke virtually any imagesetter (not to mention the problems involved in keeping control of these huge monuments to the designer's ego).

It makes no difference what tool you use. Most consider the Pen tool the most elegant way to place points, but the most efficient and the fastest is probably the Bezigon tool. No matter which tool you use, the procedure is the same. After you practice a while, you will discover which tools are most comfortable for you to use in which circumstances. As with most publishing programs, there are always at least two ways of doing everything, and usually half a dozen.

However, the basic procedure is always the same. Quickly place the fewest points necessary to generally describe the line or shape you need. Modify the position of the points and their handles until the shape is finished. Apply the appropriate stroke and fill. Make sure the shape is in the proper layer. Move on to the next shape and so on.

Graphic assembly

Once you grasp the basic concepts involving path and shape construction, building an image is like building the collage mentioned earlier. Sometimes it helps to build layer by layer from the shadows, laying lighter and lighter shapes, finishing with the spot of white in the highlights. Other illustrations require layering like stage props; for example, sky, distant mountain, foothills, forest, field, house, garden, and children playing. FreeHand gives you more than enough freedom to work in whatever manner you conceptualize. More than that, it allows you to "turn off" areas that might get in the way, so you can focus on certain shapes and objects.

The terrific thing about PostScript is that the shape collage is fluid. You can change anything at any time. You can rearrange the layers at will; change shapes; change colors; add anything; delete anything. The major change is conceptual. No longer can you think about shading as just blending in a little more color. (PostScript blending can mimic that, but we cover that later in chapter five.) Shading becomes a layering of shapes.

A deceptively simple project
Using either the Bezigon or the Pen tool, click to place a point. Move the cursor down a couple of inches, hold down the Shift key, and click a second time. Then click a third time back on top of the first point. Select both points. Then using the Object Inspector (the left tab on the Inspector Panel), change both points to curve points and turn on the Automatic checkbox. Then, holding down the Shift key (to constrain the handles to horizontal), drag out the handles until the shape looks like a circle.

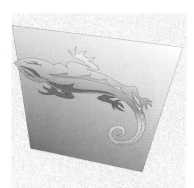

It might help you to think of it like applying shadow shapes or spotlight shapes to an object. It requires solid color knowledge. For example, you must know that all outdoor shadows are quite blue, whereas interior shadows tend toward brown (because of incandescent lighting). Before going on to the actual creation of graphics, you need to open your copy of FreeHand so we can explore its interface. Once you understand how FreeHand works, then we will go on to drawing.

Knowledge Retention:

1. What is the only difference between a corner point and a curve point?

2. What are the two main pieces of information shown by a handle?

3. How would you create the effect of a connector point using a curve point following a corner point?

4. How big is a single point?

5. How does a PostScript path differ from a line drawn with a traditional fine art tool?

6. Where are the handles if you select a point and you cannot see them?

7. How do you access handles that you cannot see?

8. Why do you think path direction is important?

9. How do you close a path?

10. How would you draw an "S" curve, and how many points of what kinds would you use?

Where should you be
by this time?

You should have FreeHand installed and have aliases or shortcuts created to enable you to launch FreeHand conveniently.

You should have launched FreeHand to make sure it works.

You should have looked through the FreeHand User Manual that came with your software and/or checked out FreeHand Help, under the Help menu, once you open FreeHand.

You should have decided on your file management procedures (or learned the classroom procedures). You need your own folder on a hard drive or removable cartridge to keep the pieces you generate for this class. Do not use a floppy or ZIP cartridge except as backup. Floppy drives (and that is all a ZIP is) are far too slow to work in. You will need a primary folder on a hard drive, SyQuest, or JAZ cartridge to enable proper work procedures. At the end of every class, you should back up your work onto a removable cartridge of some kind.

The two-point circle is fun but optional at this point. If your instructor is giving you a grade for this, make sure you show him or her a copy for grading.

This would be a great time for a general class-room discussion on how to create specific shapes and simple objects. For example, how would you draw a three-dimensional cube? How would you draw a pyramid? How would you draw a STOP sign on a pole with a square cross-section, using two slotted bolts to hold the sign on the pole?

Talk amongst yourselves ...

CONCEPTS:

1. Preferences

2. Defaults

3. Interface

Definitions are found in the Glossary on your CD.

Chapter Three

FreeHand's Interface

Discovering where everything is and setting up for efficient production

Chapter Objectives:

By teaching students the options and capabilities of FreeHand, this chapter will enable students to:

1. set up preferences
2. create an functional default page
3. adjust the interface to fit their working style
4. begin dealing with the realities of a publishing career.

Lab Work for Chapter:

- Set Preferences.
- Create a personal FreeHand Defaults document that can be taken to whatever computer the student is working on (even into other labs).

FreeHand's Interface

SETTING UP FOR EFFICIENT PRODUCTION

27

FreeHand has a unique way of interacting with you. Maybe it was not designed with this in mind, but it is virtually the perfect program for the graphic designer needing quick, effective graphics for publishing products. It has incredible power that is easily accessible — IF you get things set up well.

Illustrator went another way entirely. Almost everything that Illustrator can do is done with a specialized tool. At first glance, Illustrator seems clean, open, easy to access. However, that is an illusion. Hidden behind Illustrator's cleanliness is a bewildering array of tools. Every tool has two to six alternate tools hidden on a popup menu off the toolbar. Now it is true that all of these tools can be accessed with keyboard shortcuts — and, if you work in the program eight hours a day, it can seem like an extension of your hand. However, the fact of the matter is that you must work eight hours a day at pure illustration to get the benefit of the software.

Freehand uses panels instead of tools

Most of the capabilities of FreeHand are found on easily understood, logically arranged panels of options. This has many advantages and two specific disadvantages. Let's deal with the disadvantages first and get them out of the way. Both of them are related to FreeHand's interface style. For most of us, these are not major problems, just minor inconveniences while learning the software.

The first is that you have to explore all of the panels and learn what capabilities are found where in the interface. It will take a little work on your part (although nothing like being forced from day one to remember which alternate tool does what, as in Illustrator). That is the purpose and focus of this chapter.

The second is that all of the panels can fill your monitor screen worse than Windows ever managed. There is no way to get any work done with all of the panels open. Even on a high-resolution screen, you can be left feeling like you are working on a huge desktop that is completely littered with books, letters, folders, files, tools, and reminders. You feel like you have to push everything aside with your forearms to clear enough space to get any work done. You will find a solid solution to this problem in this chapter.

Organization is not optional

Fortunately, the solution to both of these disadvantages is in arranging your workspace — cleaning up your mess, as it were. So, what we are going to do is go through a step-by-step procedure to set up FreeHand's interface. This is surely one of the greatest advantages of FreeHand: you can completely customize the interface so that it works best for you. I will not even attempt to give you all of the options. You will be briefly introduced to them and then you will be given my solution, based on eight years of using FreeHand daily.

So, let's start with a general disclaimer. I do not expect that you will use my setup for the rest of your career. However, it is functional and will give a place to start as you make FreeHand your own. Especially if you are in a classroom setting, you will have to set things up in a consistent manner for the rest of the students who will be using the same computer. Your instructor will almost certainly have some specific changes for you to make for this setup. Remember, there is no right or wrong. Your task is to learn what options you use the most and make them easy to access. FreeHand gives you a great deal of help.

Preferences

Before we can go on to actually setting up the window and toolbars, we must set up the preferences that enable us to work effectively. This is even more important if you are using an older version of FreeHand. FreeHand 8 (and 7 to a certain extent) allow a great deal of customization of the toolbars. In general, I resent the space allotted for toolbars. If you are using the window-within-a-window paradigm of Windows on a PC, this becomes even more important. With those multiple menu bars, plus the task bar on the bottom, a full set of toolbars can eliminate working space quickly.

So, I am going to show you how to set up without the need for toolbars. At the end of the chapter, I will show you my toolbar solution that takes up a minimum of space. However, you cannot set up a toolbar until you know what the buttons mean and why you might need that particular function in the first place.

So, let us go through the extensive preferences options, page by page. Throughout this book, I will refer to each different option in a dialog box as another page. I will be using the FreeHand 8 dialog boxes, with references to the older versions as they apply. As you can see to the right, PREFERENCES has eleven pages. Many of these are very simple with only a couple of choices, and most of the rest are clearly just personal preference. However, there are two preferences that really matter on this first "General" page: Undo's and Cursor Distance. I've typed in the changes that I recommend and use in my classroom.

UNDO'S: FreeHand can do up to 100 Undo's. However, they all have to be held in RAM (FreeHand works entirely in RAM), so I have found that 25 work well. If you tend to work more experimentally, you might find that you need more – but 25 is a good starting

IN WINDOWS the different pages are accessed with tabs arranged across the top of the PREFERENCES dialog box. The names are the same.

Preferences
Category

General
Object
Text
Document
Import
Export
Spelling
Colors
Panels
Redraw
Sounds

Undo's: 25
Pick distance: 3
Cursor distance: 0p.25
Snap distance: 3

☒ Smoother editing
 ☐ Highlight selected paths
☐ Smaller handles
☒ Smart cursors
☒ Enable transform handles
☒ Dynamic scrollbar
☒ Remember layer info
☒ Dragging a guide scrolls the window
☐ Enable Java™ scripts (relaunch to apply)

Cancel OK

SETTING UP FOR EFFICIENT PRODUCTION

point. If you have an older machine with very restricted RAM, you may need to cut back to ten undoes or less.

CURSOR DISTANCE: Here again is a number that is different from the factory defaults. Notice that I have typed in 0p.25. Because I am working in inches, I want to enter my distance in points. This is because most of my work is with type, and points are unavoidably the system used when measuring type. Plus, all stroke widths are in points. Regardless, the factory default for cursor distance is far too large.

Cursor distance affects the distance a selected object, point, or points move when you strike the arrow keys. You will soon discover that accurately moving objects into alignment requires minute adjustments. A quarter point works well. It is not so small that it requires multitudinous arrow strokes, yet it is small enough to easily allow tight alignment manipulations.

As for the rest of this page, the factory defaults work fine. You can see from the illustration which ones I use. PICK DISTANCE and SNAP DISTANCE refer to how close the hot point of your cursor has to be (in number of pixels) to select an item or to snap to grid, guide, or point.

SMOOTHER EDITING is obviously good (if you have the RAM). HIGHLIGHT SELECTED PATHS can be visually irritating. SMALLER HANDLES might work later. For now, though, you need to be able to see the handles clearly as you begin to learn to think in points, segments, and handles. SMART CURSORS sounds good and they're not documented in the User Manual.

ENABLE TRANSFORM HANDLES will be mentioned later. This is a new capability of FreeHand 8 which is only irritating to me. This enables you to scale and rotate any object or group without changing tools. You should try them to see if you use them. They are not available in older versions. DYNAMIC SCROLLBAR – sure, why not (if you have the RAM)?

REMEMBER LAYER INFO is new to FreeHand 7 and 8 and it is a real help. GROUPING or JOINING moves all of those objects into one layer. In older versions, ungrouping or splitting causes a jumbled mess.

MEASURING SYSTEMS

In FreeHand (as in most professional graphics programs) you can always type in a measurement in a different system and the software will automatically convert it. When you are working with type, as you are so often in FreeHand, you need to get in the habit of using the point system. Picas are no longer needed, but all type is measured in points. So, you might as well get used to thinking in these terms.

I am assuming that you have had enough typography to know about points. For those that have not, a point is a seventy-second of an inch, and is the basic measurement system of all type. So it doesn't matter whether you are working in inches or millimeters. You can always add measurements in points by typing a p in front of the number. In my example, I used 0p.25 — which would be said as zero picas and a quarter point.

Other systems are: 5i = five inches; 5m = 5 millimeters; 5p = 5 picas

29

DRAGGING A GUIDE SCROLLS THE WINDOW is a real help. In older, slow computers this can be irritatingly slow. However, with G3s and Pentium IIs or better, this is no longer a problem. ENABLE JAVA™ SCRIPTS is for those of you using FreeHand to design Web pages. We will discuss this in chapter eleven.

OBJECT PAGE

The OBJECT page of PREFERENCES needs a few adjustments. CHANGING OBJECT CHANGES DEFAULTS and GROUPS TRANS-FORM AS UNIT BY DEFAULT are self-explanatory. The first one is a personal preference. What it does is change the default stroke and fill every time you change an object. This is usually very handy. If you find it bothers you, turn it off.

JOIN NON-TOUCHING PATHS is essential. We will cover joining in chapter five. However, for now let's just say that this enables you to make a word or phrase one composite path with a common fill.

PATH OPERATIONS CONSUME ORIGINAL PATHS applies when you use the path combination filters, which are also discussed in chapter five. This is one you will want to keep track of. Sometimes you want the original consumed and sometimes you want the newly combined paths on top of the old paths. You will find yourself switching back and forth here.

OPTION-DRAG COPIES PATHS is an Illustrator user help. It means that holding down the Option key (PC: Alt), after you click to select the path, will copy it when you drag that path. This is necessary for Illustrator because they do not have the CLONE command (or any easy equivalent).

SHOW FILL FOR NEW OPEN PATHS is another Illustrator ability. The problem in Illustrator is that it is not an option. It applies a file to all paths (open or closed). With an open path, the end points are connected with an unstroked straight segment. It is extremely irritating visually. However, there are times when you need this function. Take a look at this ugly little plane sketch, for example, which shows a place where you might want an open path to fill, in the front wings and the tail fin.

WARN BEFORE LAUNCH AND EDIT refers to the External Editors found on the next few lines of the page. This allows you to hold

Preferences

Category
General
Object
Text
Document
Import
Export
Spelling
Colors
Panels
Redraw
Sounds

☒ **Changing object changes defaults**
☒ **Groups transform as unit by default**
☒ **Join non-touching paths**
☒ **Path operations consume original paths**
☐ **Option-drag copies paths**
☐ **Show fill for new open paths**
☒ **Warn before launch and edit**

External Editors:
Object: PNG Image
Editor: <none> [...]

Default line weights (relaunch to apply):
0.25 0.5 1 1.5 2 4 6 8 12

New graphic styles:
☒ **Auto-apply to selection**
☒ **Define style based on selection**

[Cancel] [OK]

OLDER VERSIONS of FreeHand have the Preference pages rearranged, and the options are more limited, but most comments still apply or they are noted in the copy.

SETTING UP FOR EFFICIENT PRODUCTION

down the Option key (PC: Alt) and double-click to open an application to edit imported images. Because importing images is usually a bad idea anyway (see chapter ten), I have never used this. However, you might find it handy. It could be very handy if you use FreeHand to generate Web pages, for example.

DEFAULT LINE WEIGHTS allows you to specify which line weights you want to appear in the Stroke Inspector. I used to change this to .5, 1, 1.5, 3, 5, 7, 9, 11, 13 because I never used the two-point line and the four-point line seemed too wide. Recently, I have added .3 (three-tenths) stroke to use for hairlines. It really makes no difference except for fitting into your personal preferences.

NEW GRAPHIC STYLES are two options concerning your use of the style panel (for versions 7 and 8). DEFINE STYLE BASED ON SELECTION is very handy. The Auto-apply option seems clumsy.

TEXT PAGE

The TEXT page has several options that matter. The first one, ALWAYS USE TEXT EDITOR, should be turned off. This goes back to Free-Hand 3 or earlier, when you could only edit text in a separate dialog box (like Photoshop still uses). It remains very clumsy and irritating. Its presence here merely shows that you can get used to anything, even if it is bad design and counterproductive.

TRACK TAB MOVEMENT WITH VERTICAL LINE is very handy. This option provides a vertical line in the text box to show you where the tab will line up when it is placed on the ruler. It is especially handy if you are adding tabs to type already set.

SHOW TEXT HANDLES WHEN RULER IS OFF is essential for text editing using the text box handles. You will be doing this a lot, and you need to be able to see these handles.

NEW TEXT CONTAINERS AUTO-EXPAND is also very important. One of the most common questions from new students is "Why can't I change the size of the text box?" The answer is always "You have auto-expand turned off."

DISPLAY FONT PREVIEW is a very limited option that shows you what a font looks like in a small preview window in the Text Inspector. You are far better off getting a separate utility for this purpose – however, they are becoming harder to find all the time. The best were always MenuFonts or WYSIWYG menus from Now Utilities. However, Now Utilities seems to have bailed from System 8 and I have no idea what is

available on the PC side. This type of utility can greatly help, however, especially if you have hundreds of fonts or more to remember.

"SMART QUOTES" is one of those options that sounds very good, especially to new (lazy) students who do not want to learn the keystrokes necessary for typographic quotes [ı ıı " " ' ']. It causes two problems. First, if you are using both quotes and inches/feet, smart quotes will cause typos for inches and feet. Second, and most important, the characters used on a Mac have different keystrokes than those used on a PC. So, if you are working cross-platform (and most of us are now), smart quotes can add many typos that have to be corrected. There is nothing wrong with turning this option on, as long as you turn it off when necessary and correct any typos that occur. It should be a conscious decision, though.

You want to BUILD PARAGRAPH STYLES BASED ON: First selected paragraph. And you want only a single paragraph to change when DRAGGING A PARAGRAPH STYLE, unless you do a lot of paragraph formatting in FreeHand and multi-page documents. Most of us do that in Quark, InDesign, or PageMaker.

DOCUMENT PAGE

The DOCUMENT page has only minor personal preferences to deal with. They all have to do with how to handle the document you are working on. The first two determine the size, location, and magnification of a document when it is reopened. The FreeHand 4 placement affects you only if you will have to open the document in FreeHand 4. The pasteboard grew from about three feet square to twenty-five feet square with FreeHand 5. It became possible to save a document on the pasteboard in a location that could not be retrieved in FreeHand 4.

The next two, which concern setting the active page, apply only if you are working with multiple pages in a document. Even then they don't matter much. ALWAYS REVIEW UNSAVED DOCUMENTS UPON QUIT can be irritating, but it is always wise. SEARCH FOR MISSING LINKS is a Mac-only option (and a bad one to rely on). If you have missing links, you have used bad file management technique.

IMPORT AND EXPORT PAGES

The IMPORT and EXPORT pages have a couple of important options. You do want to CONVERT EDITABLE EPSs UPON IMPORT (but then, as we'll discuss in chapter ten, you do not want to import them anyway – you should copy and paste). You definitely do not want to EMBED IMAGES AND EPS UPON IMPORT – which will also be covered thoroughly in chapter ten.

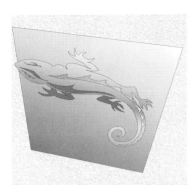

You do want to CONVERT PICT PATTERNS TO GRAYS. As we will discuss later, you almost never ever want to use patterns. The DXF import options should be set as needed, if you use that format.

The EXPORT options are almost entirely dependent on the software and hardware used for final output (usually by your service bureau or printing firm). The thumbnail and preview options have little

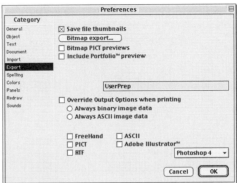

to do with you unless you use graphic management software as a library for all of your images. In that case, set this up the way that software asks you to work. The UserPrep files are used to change output for specific high-end imagesetters, platesetters, and the like. I would always set this option to NONE unless you are given specific instructions by your service bureau, printing firm, or instructor. These options have gotten more complicated with every new version, yet I have never had occasion to use them. I suspect that this will be true of you also. However, it might well vary for every supplier you use.

SPELLING PAGE

The SPELLING page gives you four obvious options that are your choice. I set them up as shown at left. However, the adding words to dictionary options should be available in the Spell Checker dialog box. In FreeHand, the only option is to check ALL LOWER-CASE, and then make sure that you watch your capitalization very carefully for errors.

COLOR PAGE

The COLORS page has a couple of relatively important options. The guide color and grid color are your option. The only time you will want to change them is if you are working in the same colors and the guides or grid disappear into the color you are using.

The COLOR LIST should definitely show the text color. For those rare occasions when you want to color the text box or container, you could change this preference. However, it is much easier to simply draw a rectangle in back of the text and apply color there.

You definitely want the colors to auto-rename. This refers to when you drag a color from the MIXER or TINTS panel onto an old

patch in the Color List. It provides you with a way to easily get rid of poorly specified colors or make simple global changes (when you discover that your laser printer drops out 5% tints, for example). Auto-renaming also allows you to easily adjust your basic palette.

COLOR MIXER/TINTS PANEL USES SPLIT COLOR WELL is a very handy option, so it should be turned on. This gives you side-by-side comparisons of the original color and the new changes. Dithering is almost always a poor idea. Plus this only dithers the monitor.

COLOR MANAGEMENT will depend entirely upon the setup you are using with your specific computer. If your instructor has a system in place, follow his or her instructions. Once you are on your own, or are employed, you will find many color management solutions. Use the one that fits with your workflow. At this point, it looks like ColorSync will win out and be the standard, but there are still many different types of implementation – both in hardware and in software. Until that time you are better off learning how to manage color yourself. We will discuss this in chapter seven on color.

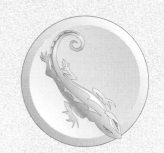
PANELS PAGE

The Panels page of Preferences looks very simple. However, it contains one of the most important settings that has to be changed.

 REMEMBER LOCATION OF ZIPPED PANELS is the key factor in being able to control the clutter of all the panels used in FreeHand. It gives you the ability to set your panels in useful places.

When you close or minimize a panel you store the title bar where it is out of the way, yet comfortable to access. When you open it again, it pops back up where you have already decided you want it to be. This ability is enhanced even more powerfully with version 8. Now we can set our panels up where we want and tuck them away by closing. In addition, we can place opening buttons on the toolbar to pop them back into place. In versions 5.5 and 7 you still had this litter of title bars to deal with. Even that is taken care of in version 8. We'll show how that is done by the end of the chapter with our suggested default layout and page setup.

SHOW TOOL TIPS is always a good idea when you are starting out. FreeHand's implementation doesn't get in the way, so I leave it on.

REDRAW PAGE

The Redraw page has several items that you need to take into account. These will vary according to your hardware. Mainly they have to do with the quality of the image on your screen while you are working with your images. I have never had a problem with BETTER

REMEMBER LOCATION OF ZIPPED PANELS is on different pages in versions 5.5 and 7, but it is even more important for the older versions.

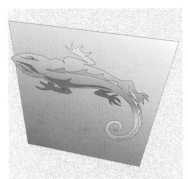

SETTING UP FOR EFFICIENT PRODUCTION

(BUT SLOWER) DISPLAY. However, this is completely dependent on the speed of your CPU and video card. I suggest leaving it on unless the slowness bothers you.

DISPLAY TEXT EFFECTS is one of those nonsensical selections. It refers to the type effects available on the Type Inspector like HIGHLIGHT, INLINE, SHADOW, STRIKETHROUGH, UNDERLINE, and ZOOM. The default was formerly to have these turned off. The Zoom effect, especially, caused very slow screen redraws. That is not nearly as large a problem as it was with 386s and 68K machines. However, for many reasons (some of which we will cover later in chapter six) you should never use any of the effects.

 Think of type effects as being on the same level as using the free clip art from Word or Word-Perfect. The effects look crude, ugly, and (worst of all) they brand you as a beginner or amateur. No one else would use these effects – just as no professional would ever use Word clip art.

REDRAW WHILE SCROLLING is a personal thing. Turning it on causes the screen to redraw as you scroll instead of waiting to redraw the screen after you have scrolled. It is one of those things that sounds good on paper, but is visually disconcerting in reality. The screen appears to flash the image at you while it continuously redraws. With a slow machine or a slow video card, it can slow your production to a halt.

HIGH-RESOLUTION IMAGE DISPLAY can be very helpful. Again this requires a G3 or Pentium and a fast video card. However, it is the only way to make imported bitmaps visually accurate enough to make design decisions. Of course, as we will thoroughly discuss in chapter ten on printing problems, the whole concept of importing bitmap images defeats the purpose of PostScript illustration and often causes severe printing problems with the older versions of FreeHand.

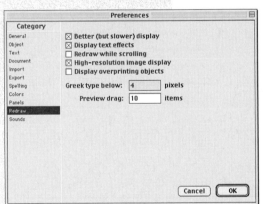

DISPLAY OVERPRINTING OBJECTS should be used only for those situations when you can't keep track and it really matters. What this option does is cover any overprinting stroke or fill with a pattern of little Os. This is visually very ugly. Plus, it can cause you to make design decisions based on erroneous visual data, because it can make strokes look dashed and lighten the apparent value of fills.

GREEK TYPE BELOW should be set at three or four pixels. This controls when the computer replaces type with gray bars (if it gets too small). Originally this was yet another necessity for slower machines. Now that slowness is usually no longer a problem, even type rendered at four pixels or less can still be clear enough to make design deci-

sions. You just need to remember that those gray bars are really type and that they will be a different color when they print.

PREVIEW DRAG can be very helpful on faster machines. This refers to the way the screen image is handled when you click and drag a selected object or objects. As with most professional graphics programs, clicking and immediately dragging objects merely shows you the outline of the bounding box (the corners of which are represented by the handles of a selected object). If you click and hold down the mouse button for a moment, the cursor changes to a four-sided arrow. This means that when you drag, you will see either a keyline or a preview version of the objects as they are dragged. By checking this item you can set how many objects can be selected and previewed at the same time as you drag them. As you can see, I have mine set at ten, but this is determined by the speed of your computer and the amount of RAM you have available to FreeHand. For old, slow machines, you should set this at one or two.

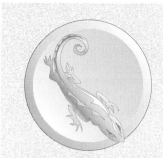

SOUNDS PAGE

The final page, SOUNDS, is a page I have never implemented personally. This is almost entirely due to the fact that I virtually never use the "Snap to" capabilities of FreeHand. It just doesn't fit my personal working style. However, sound, in general, is very helpful from a production point of view. I have sounds that tell me when I have new email, when I eject a disk, when I insert a bad disk (or a good one), and so forth. I thought this was merely cute until I upgraded to Mac OS8 and my sound implementation software was no longer compatible. I was so disconcerted that I had production speed problems until I found a compat-

ible solution. These sounds will help you in the same way if you use the "Snap to" options a lot. If you don't like them, turn them off. Like many of these preferences, your personal working style determines what really matters for you.

Preferences come first

It is important to note that you should make all of these Preference adjustments **before** you create your first document. Equally important: you need to watch your work habits as you proceed through your career and make adjustments to these preferences as needed to improve your performance. This attitude should be cultivated in every aspect of your career. Graphic design and digital publishing are parts of a fast-paced, deadline-driven industry. You must make every effort to streamline your personal production habits. This is not just to satisfy some boss or client, but to free you from some of the drudgery of busy work so you can have fun doing what you do.

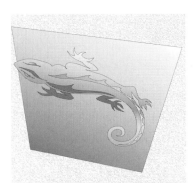

 We are continuing our examination of FreeHand's interface by giving you a model that has worked as a starting point for hundreds of students. It is not sacred – it is a starting point. It is hoped that you will make changes to this setup that fit your working style. It is my hope that this will cause you to ask the questions necessary to set up a default page that will save you a great deal of time and allow you to work efficiently and effectively. The goal is a basic setup that encourages your creativity by placing your tools conveniently within your reach. Eventually you should be able to access any tool or option you need virtually without conscious thought – focusing entirely upon the creative process and the image you need for the project you are working on.

Creating a default page

FreeHand is a mess when you first open it up. Here you can see approximately what FreeHand 8 on a Mac looks like when you first open it, with all four toolbars open. It is not a pretty sight! It does not

matter what your own computer looks like, for we are going to change it a great deal. The way it comes from the factory is almost unusable. On version 5.5, you will not have any toolbars and the toolbox will be a double row of tools. FreeHand 7 is similar to version 8 but is not nearly as customizable.

The first thing to note is that the basic window is merely a standard Mac or Windows window with a few additions at the lower left corner. It has the same close, zoom, windowshade or minimize, maximize, close buttons as you would expect in your operating system. In Windows, you have an even more severe problem because of the real estate taken up by Windows' standard "window within an window" setup. With all of the toolbars, menu bars, panels, and rulers open there is virtually no room left to work. In addition, Windows has the task bar at the bottom of the screen.

Before we go on to clean up this mess, we need to discuss some of the parts of this scenario that are unfamiliar to you. First of all, the

parts of a panel must be understood. Basically they are mini-windows with prescribed content. The title bars have changed a little on the Mac. The left button is still the CLOSE button, but the right button is called the ZIP button and its function is to close the panel to its title bar and then open it again. The Windows panels have the three normal buttons of all Windows windows and a mini-application icon on the left corner.

One of the nice aspects of panels is that many of them are

designed as tabbed pages under the title bar, as in common Windows practice and current Adobe style. In the example to the left, I have taken the MIXER and the TINTS panels and combined them by click-dragging the tab of TINTS into the open space under the title bar of MIXER. The result is the combined panel you can see here at left.

A list of the panels

The INSPECTOR panel is the functional core of FreeHand's panel capabilities. It controls and modifies selected objects, their stroke and fill, most aspects of typography, and the ability to add, subtract, size, and determine the basic resolution of pages in the document. There is really no way to work without the INSPECTOR panel open. Many of the Inspector capabilities are found nowhere else in the interface. It has five standard tabs.

 OBJECT INSPECTOR: Displays the position and dimensions of a selected object, plus point types, blend data, and other information, depending on what is selected.

 STROKE INSPECTOR: Controls the stroke color, stroke width, special dashes, joins and miters, and arrowheads.

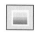 FILL INSPECTOR: Sets fill color and type, direction of gradient fills, and the center of radial fills.

 TEXT INSPECTOR: Controls most aspects of type: font; leading; kerning; tracking; baseline shifts; paragraph controls; columns, rows, and tables; scaling; word spacing and letterspacing; vertical column justification; copyfitting; and more.

 DOCUMENT INSPECTOR: Sets the page size, location, bleed, and resolution of each page; used for all gradient and blend calculations.

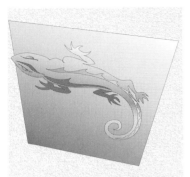

Next in importance after the INSPECTOR panel are the panels that control color. There are three of them: COLOR LIST; COLOR MIXER; and TINTS. We do not want all of these docked together. With the amazing drag'n'drop color application capabilities of FreeHand, we need the MIXER and TINTS next to the COLOR LIST for easy additions and modifications.

To manage the document, we need the LAYERS and STYLES panels constantly available also. As a result, we group the tabs of COLOR LIST, LAYERS, and STYLES into one panel and COLOR MIXER and TINTS into another panel. When we set up our default page, we will have the MIXER/TINTS panel open up directly next to the COLOR LIST for easy control of the colors used in any given document.

The only other tabbed panel is HALFTONES and you will rarely use that. It is used to control the halftone screen, dot shape, and screen angle of your illustrations. It usually do not want to do that. It is far better to leave that to programs designed for that purpose, like PageMaker, InDesign, and Quark-XPress. Even when printing from FreeHand, that is usually set with the options for the printer driver found on the SETUP page of the PRINT dialog box.

There are two other panels that we will set up when we get to the default page: TRANSFORM and ALIGN; plus the two uncontrollable renegades of this interface, XTRA TOOLS and OPERATIONS. These four panels are used regularly and we need to set them up also, but they do not work as tabs (write Macromedia and complain).

The final thing we need to take care of before we begin constructing our default page is a quick discussion of the popup menus in the lower left corner of the window. These controls are also available (in Windows only) as the status bar (another space waster).

50%	▼	◄	►	1	▼	Preview	▼	Inches	▼

These four popup menus were new in version 7, so in 5.5 you will have to use the menu bar at the top of your monitor to access these controls (except the MEASUREMENTS popup, which is in the Document Inspector in version 5.5). The left popup lets you quickly select the magnification you want, or you can double-click and type in a custom enlargement. This is used a lot, but it is a waste of time!

 This is simply because you cannot control what magnifies or where it will be located on the

screen after you are done with the popup. No matter what, it is far slower than simply using the keyboard shortcut – ⌘ Spacebar (PC: Control Spacebar) – and marqueeing what you wish enlarged. Whatever area you marquee will be enlarged as large as possible and centered in the document window. In addition, the MAGNIFICATION TOOL shortcuts are standard in the industry (except of course for Quark).

Here we come to the first keyboard shortcuts you will need to learn (although you can change them to anything that works for you in version 8). You need to memorize the FIT IN WINDOW, FIT SELECTION IN WINDOW, and MAGNIFICATION TOOL shortcuts. These shortcuts are only one of many ways to control your movement around the image as you work. However, they are not optional. Everything else takes too much time.

 The basic procedure is simple. Whenever you want to see something clearly to work on it, hit the FIT IN WINDOW shortcut. Then hold down the MAGNIFICATION TOOL shortcut and marquee the area you want to view. Virtually instantly (depending on the speed of your equipment), what you need to see will be enlarged as large as possible and centered in your window. Because we can enlarge up to 25,600%, all of the reducing options simply take forever. By adding the Option (PC: Alt) key and clicking, you can back out your view a little at a time. The new view will center on your click location. If you miss the view you need, just FIT IN WINDOW and remagnify – quick and simple! You truly need to memorize this procedure.

Fit in window:	Mac: ⌘⇧W	PC: Control Shift W
Fit Selection:	Mac: ⌘0 (zero)	PC: Control 0 (zero)
Enlarge tool:	Mac: ⌘ Spacebar	PC: Control spacebar
Reduce:	Mac: Add Option	PC: Add Alt
Preview toggle:	Mac: ⌘K	PC: Alt K

The second popup is for page navigation. It tells you what page(s) are being viewed in the window and enables you to switch from one to the other. Most of the time you will not use this. There are compelling reasons to make each graphic a separate document, unless you are doing everything in FreeHand. There are occasions when you do multi-page documents in FreeHand (like building Flash animations) and this is the navigation tool for those.

The next popup enables you to switch from keyline to preview views. You will do that a lot. However, as usual, mousing is far too slow. So most of you will simply learn the keyboard toggle to switch back and forth – ⌘K (PC: Alt K).

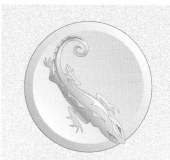

OLDER VERSIONS:

The FIT IN WINDOW, FIT IN SELECTION shortcuts are different in every version of FreeHand. You will have to look in your VIEW menu to determine what they are for 5.5 or 7.

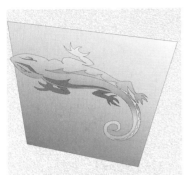

IMPORTANT NOTE!

The fourth (far right) popup is important, however. Since version 7, this is the only way to switch measurement units from inches to points to millimeters. You will not do this very often (in fact, it will normally just be your default), but you need to remember where the menu is. It is found nowhere else.

Toolbars

Here we have the major difference between the versions. Version 5.5 has no toolbars. Version 7 has limited customization options. Version 8 allows almost complete control (although you still cannot access the XTRA TOOLS or OPERATIONS panels through the toolbars). The first thing you need to understand is that toolbars are not necessary. In fact, they are usually a hindrance. There is no way that clicking on a toolbar can ever approach the speed or the efficiency of keyboard shortcuts. In fact, they are barely faster than menus. When setting up our default page, the first option will be with no toolbars.

There are three basic toolbars:

the Main toolbar:

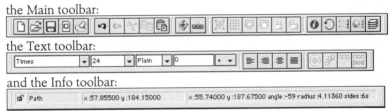

the Text toolbar:

and the Info toolbar:

The Info toolbar is one of those options that sounds very good to a programmer, but is never used by a real human. It gives fascinating data. However, the only use it might have is for people trying to use FreeHand when they should really be using AutoCad. So we will close that one.

The Main toolbar sounds even better and it's certainly more obvious. However, let's think about this for a minute — remembering that keyboard shortcuts are approximately 400% faster than mousing (even to a toolbar). When was the last time you forgot the keyboard shortcut to SAVE, PRINT, OPEN, NEW, CUT, COPY, PASTE, SELECT ALL? The GROUP, UNGROUP, UNDO, REDO, LOCK, UNLOCK commands are probably already in your memory banks if you use PageMaker, Illustrator, or Photoshop (if your software experience is different, you can always change the shortcuts to meet what you have memorized in version 8). You basically already have a faster way to implement almost all the buttons in the Main toolbar, so let's close that one also. We have now saved at least an inch (even at high resolution) at the top of our monitor.

The Text toolbar is different, because you have to mouse for these commands no matter what. You can change fonts on the Text toolbar, in

the Text inspector, or in the Text menu. All the options require a mouse and the toolbar is a little faster here than either the INSPECTOR panel or the TEXT menu. So we can leave this one open.

At the end of this chapter I will give a suggested scenario for modifying the toolbars for the most efficiency in version 8. For now let's just assume that we have the default Text toolbar open and the rest of the toolbars closed.

The default page

FreeHand has given us a very easy method for generating default setups. In fact, we can have multiple default pages and switch back and forth by using the DOCUMENT page of the Preferences dialog box. The basic default page is simply a FreeHand document, set up the way you like to work, saved with a specific name (FreeHand Defaults – case-sensitive) into the FreeHand application folder (wherever you store that on your hard drive).

You do not want to do this until you have thought out what your defaults should be. The first choice you need to make is your measurement system. The factory defaults are points. This is one of the things inflicted upon us by the software programmers. Someone told them that all of *us designers* are strange and work in points. This is certainly not true in my experience. All of my students inside the United States work in inches. Outside the States, they seem to work in millimeters. Those are your three choices. Pick the one you think in.

Page size

This will obviously be determined by your measurement system. However, beyond that it is determined by your normal working methods and your typical job.

The main thing to consider is what your normal graphic size will be. I have found that when I am working normally, the largest my graphics ever get is seven inches wide – and those are much bigger than normal). When I am working on a book this size, my largest graphic is five inches wide. In general, I have found that making a page square enables it to fit in the window best and still give me room on either side to have my panels open. So, my default page size is five inches square. You need to pick one that fits your working requirements.

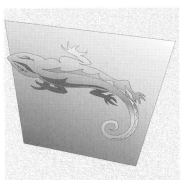

 Beyond that, I have learned through painful experience that all FreeHand documents need to have a bleed. This is due to a peculiarity of PostScript illustration in general. When you export an EPS from any creating software that uses pages (PageMaker, Quark, InDesign, and FreeHand), the graphics on the originating page are cut off exactly at the trim. If a bleed is set up, they are cut off there. Often I have received EPS graphics that have the edge cut off. Having a bleed solves a great many of those problems.

Panel arrangement

Here we come to the crux of the matter. The key to working with panels comes down to having a plan. First of all, you need to find out what panels you use regularly. I find that everyone needs the INSPECTOR, COLOR LIST, and COLOR MIXER/TINTS panels (you'll recall that we have already combined MIXER and TINTS into a single tabbed panel) on a virtually constant basis. You will also need easy access to the TRANSFORM and ALIGN panels.

As you will learn in the next chapter, the TRANSFORM panel is easily accessed by double-clicking on any of the transformation tools in the toolbox. The ALIGN panel can be accessed through the WINDOW menu far to the top of your monitor, a toolbar button, or through a keyboard shortcut. Personally, I do not use FreeHand's alignment capabilities often enough to remember the keyboard shortcut.

 MAJOR TIP: No one can memorize all the keyboard shortcuts. You must be wise in picking the shortcuts you will memorize. They are an amazing aid to production speed – but only if you can remember them.

This is one of the main advantages of FreeHand over Illustrator. You can set up the program so that you do not need to waste precious wetware storage space on shortcuts you rarely use. In Illustrator, you are virtually dependent upon keyboard shortcuts. The management of the panel interface is the method used to control this area in Free-Hand. Only you can determine which panels you use and how often.

The key to panel management was mentioned on page 34. The REMEMBER LOCATION OF ZIPPED PANELS option gives us the ability to set up panels where they will work the best and then tuck them away for easy access. All we have to do is click the ZIP button (MINIMIZE/MAXIMIZE in Windows) to open or close the panel. We can also open a panel by clicking on the appropriate tab when we have several panels tabbed together.

So, where shall we put those panels? First of all, we have to talk about the value of consistency. Those of you who have never done

production work will have no idea how valuable it is to have your tools located where you can pick them up without thinking consciously. The goal is to be able to use your tools without having to decide (or having to remember) where they are located.

 The key to this is to always place your tools in the same location. If that is done, tool access time will be shortened noticeably.

Of course, it is important to have your tools located in a logical position to start with. Let's deal with that first.

First of all, let me say again, these are my solutions. They work very well for me, and I work extremely fast and efficiently. However, you need to modify my suggestions to make them your own. When you come to a functional setup for your working style, I would suggest that you save a copy of FreeHand Defaults and the Preferences file onto a floppy or ZIP disk so that you can quickly set up whatever machine you are working on. I have three computers that I have to keep consistent – school, office, and church. You might be working as a temp with a different computer every day (or be forced to use computers on a first-come, first-served basis).

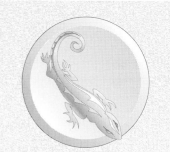

On page 42 you can see the zipped location of the panels that I use. If you are using version 5.5 or 7, you will need a setup like this because either you will not have toolbars or the toolbars cannot be fully customized. In a little bit, we will look at a customized toolbar setup for those who have version 8. However, in any version the panels should be set up something like what is shown above. The different versions merely have different capabilities to reopen the panels.

 Notice that you basically cannot work with all of the panels open. Zipping panels is not really an option. It is a necessity. You may modify the locations of the zipped title bars, toolbar buttons, or opened panels. However, the basic zipping concept is a requirement.

When you are working, you will probably need the INSPECTORS and the COLOR LIST open at all times. If you have a small monitor, you may even need to HIDE them (Mac: ⌘⇧H; PC: Control Shift H) to

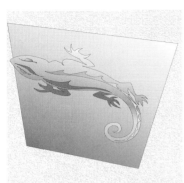

SETTING UP FOR EFFICIENT PRODUCTION

work in enlarged views. By using the square page setup, there is room to tuck these two panels on opposite sides of the page. Put them on opposite sides or you will find that they often overlap, which takes extra mouse clicks and slows you down considerably. You can use either side, but most people seem to like the INSPECTORS on the right and the COLOR LIST on the left.

When you need to add colors or tints to the list, it is very important that those two panels be tucked directly next to the COLOR LIST to enable quick and easy drag'n'drop color management. We'll talk about this at length in chapter seven. For now, let's just say that this is a critical capability.

Both the TRANSFORM and ALIGN panels are opened for specific uses and then zipped immediately to open up working space. Because of that, it is most convenient to have them open up in the center of the window. You can mouse there the quickest and see the panel choices most clearly in that location.

Because the COLOR LIST also has tabs for LAYERS and STYLES, everything you need is now readily available at a convenient location. After using a setup like this (modified for your needs) for only a few weeks, you will be almost unable to go back to the chaos of the factory defaults. In fact, you will find yourself going through similar routines for PageMaker, Quark, InDesign, and Photoshop. You can truly expect your production times to be twice as fast (or more) than people using the same computer or hardware/software configuration if they are not set up. This is not advanced stuff, but a necessary, practical approach to survival in employment.

A toolbar setup (FILE>>CUSTOMIZE>>TOOLBARS)

There is, however, another option for those of you (like me) who use version 8. For a long time, I thought toolbars were a complete waste of time and space. Now, I can certainly state that although a custom toolbar might not speed you up a great deal, it is at least as fast as the setup we have already discussed. It has the additional advantage of freeing up even more space in your window. Remember, to work in FreeHand effectively, you must open up space to work. Controlling toolbar clutter is a good method of doing that.

Before we get into that, however, let's talk a little about the general concept of toolbars. I have never used them much, for some very simple reasons. First of all, they are cluttered with buttons I have no need for, like Clipboard operations. I memorized the shortcuts for the Clipboard operations (CUT, COPY, PASTE) plus NEW, OPEN, SAVE, and SELECT ALL the first week I got on a computer so many years ago. They have never changed. They are the same in all programs. Sometimes I have to think to remember what they are because I apply them without thought. I am certain most of you are in that position also. *If not, you are wasting your precious time.*

Also included on most toolbars are functions that are better done with keyboard shortcuts. You need to be clear in your mind about the relative speed of these procedures. Here is the key to efficient production.

 If mousing menu commands takes about two seconds and a keyboard shortcut takes about two-tenths of a second, mousing a toolbar button takes about one second. These times are approximate but proportionally accurate.

So, for commands like EXPORT, which is used many times a day, the keyboard shortcut will save a great deal of time. When I am doing a series of Web graphics, for example, I might create two dozen in a morning. This can easily mean exporting (in various formats) nearly a hundred times. If I save nearly two seconds every time I use a keyboard shortcut (and I do), then I have saved more than three minutes on this operation alone (when compared to someone doing it with a mouse and a menu command). I've even beaten a toolbar user by a minute and a half. It's one of the reasons why I can finish projects in about half the time most people require.

Because IMPORT just drops the Shift key, a button for that is not necessary either. GROUP, UNGROUP, JOIN, SPLIT, LOCK, and UNLOCK are used so often that you will have the keyboard shortcuts for them down very soon (plus grouping and locking use the same shortcut in almost every application).

You can see that eliminating these buttons wipes out almost the entire Main toolbar. The Text toolbar is cluttered with buttons that should also be eliminated. BIND TO PATH and REMOVE FROM PATH are rarely used more than a few times per day (if they are, there's a shortcut). The CONVERT TO PATHS option for type will be used so much that you will soon learn the keyboard shortcut for that. So we have eliminated another sub-bar.

Now the only buttons left are the text popups for font name, size, style, and leading, plus the alignment buttons. All that is left on the Main toolbar are the buttons that open panels, plus the FIND

SHORTCUT LIST
There is a complete list of shortcuts in Appendix D at the back of the book.

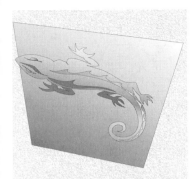

button, which is the same keyboard shortcut as Find is anywhere else (so we can eliminate it also). We can simply drag'n'drop those buttons to the right side of the Text toolbar. Now everything we need is on one simple, clean toolbar that can easily be remembered.

It is just as fast to click on a button as it is to unzip a panel by clicking on the ZIP button on the title bar. The only thing that is marginally slower is that we will only have one button for each panel, necessitating a click on a tab of the opened panel. This seems to take about as much time as a keyboard shortcut. Regardless, when working it feels marginally faster than the older zipped panel option already discussed. You still have to have the same preferences checked and you still have to locate the panels as described. But it is even more elegant and a little faster. You will find that customizing your toolbars will not save you huge amounts of time, but it will give you that warm fuzzy of being in control. (It will also help you convince people that you really know what you are doing.)

Now you are ready to work!

In the next chapter, let's go on to a discussion of FreeHand's capabilities. This is a very complicated piece of software, but the organization we have placed on the program will help you learn them much quicker and enable you to find the tools you need.

47

Knowledge Retention:

1. Why is defaults control so important?

2. What is the practical difference between PREFERENCES and FreeHand Defaults?

3. What are the advantages of panels?

4. What are the disadvantages of panels?

5. What are the relative access times for menus, toolbars, and keyboard shortcuts?

6. Why should you care about saving a few seconds by using a keyboard shortcut?

7. What is the proper way to set up a defaults page?

8. What is the problem with mousing commands?

9. How would you bring your defaults to another computer?

10. What is the importance of the INSPECTOR panel?

Where should you be by this time?

You should have your preferences and defaults set up so that you are ready to get to work. Your instructor may well have a different setup that he or she thinks will work better for you. Regardless, while you are working in FreeHand – for the next several years – be watching your work habits. The more you can set up FreeHand to work with you, the more you can grab a tool to use without conscious thought, the faster you will work and the more fun you will have doing it. *Try it, you'll like it.*

DISCUSSION:

You should be discussing the importance of learning production methods as a creative person. How would they give you more time to create and allow more freedom to use all the capabilities of FreeHand? How has this discussion changed your views of digital publishing as a career? Why is production speed so critical?

Talk amongst yourselves ...

Chapter Four

FreeHand's Abilities

Learning the abilities and options of the tools and menu commands

CONCEPTS:

1. Tools

2. Panels

3. Menu commands

Definitions are found in the Glossary on your CD.

Chapter Objectives:

By teaching students the options and capabilities of FreeHand, this chapter will enable students to:

1. describe the function and use of all tools in the toolbox
2. describe the options available in the panels
3. describe all of the options in the top menus
4. analyze which tools, options, and commands they need easy access to, and which are only occasionally used.

Lab Work for Chapter:

- Practice with each tool – doodling.
- Practice exercises for transformations – doodling.
- Create a simple grid using CLONE and DUPLICATE.

FreeHand's Abilities

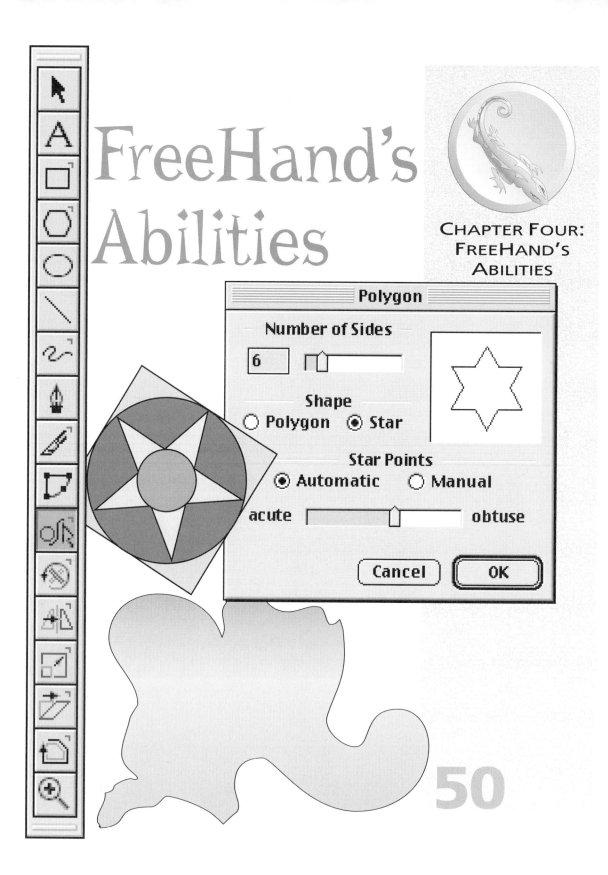

Polygon

Number of Sides

6

Shape

○ Polygon ● Star

Star Points

● Automatic ○ Manual

acute obtuse

(Cancel) (OK)

50

WITH VERSION 8,
your first project is to reorder the tools so they are in numerical selection order from top to bottom, as you see to the right. Just go to FILE>>CUSTOM-IZE>>TOOLBARS and drag'n'drop the tools into position.

SHORTCUTS:
All of the tools can be accessed with keyboard shortcuts (on the Mac only). See Appendix D.

51

The toolbox

The obvious place to start a discussion of FreeHand's abilities is with the tools available in the toolbox. Clicking a tool gives your little cursor supernatural powers to draw, transform, select, move, and so forth. But you already know that. What we need to do here is describe how FreeHand's tools differ from your normal experience.

First of all, they will have many more capabilities than most programs offer, but they will often be very different capabilities from PageMaker, Quark, or Photoshop. It is important that you know what the options are. For example (if you skip the Text tool), the top ten tools can be selected by typing the numbers 0 through 9. In the example to the left, I have reordered the tools so they are in numerical order going down. The only difference between the versions is that version 5.5 cannot select the Selection tool by typing 0.

Selection tool (0)

This pointer tool is fairly normal. You click on an object and it is selected. This means you can see the handles if grouped or joined; you will see the points for a path; or you will see the text box if it is type. Generally, you click on something to move it – either its location or up or down through the layers by using ELEMENT>>ARRANGE.

The Selection tool can always be accessed, no matter what tool you are using, by holding down the Command (PC: Control) key. This is very important to remember.

You will use the modifier keys so often that you will develop the habit of using your dominant hand for the mouse and your other hand for the modifier keys. To rephrase, while I am working in FreeHand my left hand draws with the mouse and my right hand lightly rests on the Command and Option keys. This will switch if you are right-handed (though many more creative people are left-handed than the norm). If you are using a PC, the keys your "other" hand rests on will be the Control and Alt keys.

Rectangle tool (1)

This tool works like any other rectangle tool you have ever used, with a few additions. Normally, you click at the upper left corner

and drag to the lower right corner. When you release, the rectangle appears with your current default stroke and fill. In most cases, this will be the same stroke and fill as the last object you drew. This is controlled by your Preferences settings.

 FreeHand does add some bells and whistles to its tool, however. If you hold down the Shift (⇧) key, you will draw a square. If you hold down the Option (⌥) key (PC: Alt key), you will draw from the center out. If you hold down ⌥⇧ (PC: Alt Shift), you will draw a square from the center out. Drawing from the center out is very handy when you need to add a square to an object that has a center point.

 Above and beyond that, however, is the Rectangle Tool option dialog box. In FreeHand, any tool that has the tiny rotated L like you see circled to the left can be double-clicked to show an option box for that tool. The Rectangle tool doesn't have much. As you can see, all it does is give you an option to draw a round-cornered rectangle of any radius you desire. The only irritating part of this is that round corners often become the default, so you have to go back and double-click again to set the radius to 0 to eliminate the round corners.

 A round-cornered rectangle already drawn can only be changed back to square corners by going to the Object Inspector and typing in 0 in the field for the corner radius. The final thing to be noted about the Rectangle tool is that it draws grouped shapes. This is often important when we deal with combining paths in chapter five.

 Polygon/Star tool (2)
Again this tool is fairly obvious. In most cases you will want to double-click the tool to get the option box seen at left. However, once you have set the tool it remains that way until you set it again. It will even be added to your Preferences and be that way when you open FreeHand the next time. Holding down the ⌥ (Alt) key will allow you to draw from the center out, as usual. The polygon/star drawn will be ungrouped. So, if

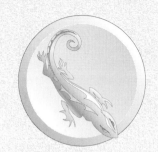
THE POLYGON TOOL is the quickest way to create a burst. Simply draw a multi-pointed star and then click-drag the points to randomized, useful, and pretty locations. Then add your splash word: FREE!; Buy Now!; or whatever you need.

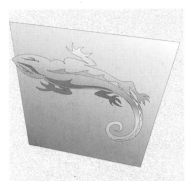

HERE'S A PRACTICE EXERCISE. Draw out two guides and hold down ⇧Option (PC: Shift Alt) while click-dragging over the intersection of the guides with the various tools. Obviously, the square is drawn first, the circle second, and the star third. The fills are irrelevant (unnecessary to the concept).

you want to resize the object without ruining the regularity you will have to GROUP it first (⌘G; PC: Control G). This is one of those tools that is not used much – but when you need it, you need it.

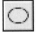

Ellipse tool (3)

This tool is even more straightforward. It works exactly like the Rectangle tool. The Shift key constrains it to a circle, and the Option (Alt) key makes it draw from the center out. As you can see, there is no tool option mark in the icon for this tool.

Line tool (4)

This last of the "basic tools" also has no options or unusual functions. You click and drag, then release to produce a straight line (two corner points). Holding down the Shift key constrains the line to 45° angles. Other than that, it works the way you expect. The main use of this tool is to add arrows and pointers when making callouts on an illustration – but we will cover that when we get to the options on the Stroke Inspector.

These four basic tools are really nothing special, as you have seen. AppleWorks and Microsoft Publisher can handle these options. But "you ain't seen nuttin' yet!" The next five will knock your socks off. They are not only unique to PostScript illustration, two of them are unique to FreeHand, and a third has extra powerful capabilities. These are the tools that allow you to draw – create those shapes that make your designs personal. They allow you to "break out of the box."

Freehand tool (5)

This drawing tool is the most obvious in use and the first drawing tool selected by the beginner. It is also almost useless in its default setting. The basic freehand tool simply draws a line as you mouse around holding the button down.

It sounds very good in theory. In practice it gives you bumpy, unpredictable lines. This is due to the fact that you cannot control what type of points will be placed or where in the path. The TIGHT FIT option only gives you more uncontrollable points to deal with. This tool always produces lines that take a great deal of time to edit.

Lines made using the freehand tool are rarely useful unless you need a random, rough look to your drawing. It is also useful for small shapes dropped on top of other objects, like eyebrows, pebbles, scratches, and so forth. If you get into the habit of using it as a last resort, you will find it useful when needed.

53

 Variable stroke tool (5)

This variant of the Freehand tool is used quite a bit more, but only if you have a pressure-sensitive graphic tablet. There are many of these on the market and they would seem to give you the freedom to draw in PostScript. In the author's opinion, Wacom's seem to be the best. However, as usual, several words of caution must be said.

First of all, this is an extremely sensitive tool. Graphic tablets are commonly seen as the be-all and end-all of drawing input hardware. How-

ever, they require a great deal of practice. For those of you with fine art experience, the difficulty level is about the same as a very large W/N Series 7 round sable watercolor brush. They are undoubtedly the most sensitive, incredibly versatile brushes in the world. The same skill level is required for pressure-sensitive pens. For those who have never used a Series 7, let's just say that it can take several years to get competent and fluent with a pressure-sensitive pen.

However, this is really not the basic problem with these digital pens. The real problem is that they do not solve the problem of excessively smooth "computerized" drawings. Most people use graphic tablets to get "realistic lines" that look like they were drawn by traditional tools. Pressure-sensitive pens cannot do that. They are still overly smooth (no dirt, no breaks), computer-generated lines.

However, many of you will be using this tool. There is nothing wrong with that once you realize several things:

1. To get "realistic lines," it is usually simpler and faster to draw with traditional ink tools or markers and then scan and autotrace to get the skeleton of an illustration that you can complete in FreeHand.

2. Graphic tablets can be greatly helped by placing a thin sheet of smooth drawing vellum over the tablet. However, even smooth vellum is very abrasive, so you need to make sure that the pressure-sensitive pen you buy has replaceable tips. You can draw on the vellum and trace with the pen also.

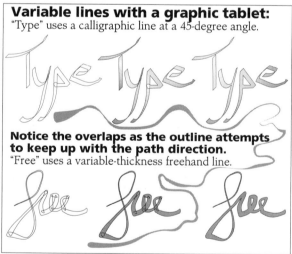

Variable lines with a graphic tablet:
"Type" uses a calligraphic line at a 45-degree angle.

Notice the overlaps as the outline attempts to keep up with the path direction.
"Free" uses a variable-thickness freehand line.

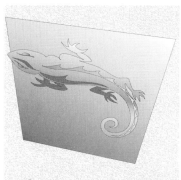

The Pen tool is the core of PostScript illustration!

55

3. There are several pens on the market that are pressure-sensitive ballpoint pens. That is, you place paper over the tablet and draw on it. The digital lines follow the same shapes as you have drawn. Of course, the variable thicknesses will be very different for the ballpoint line.

The real problem with all of these options remains the same. You have no control over point type or placement. As you can see on the other page, these shapes to appear to be variable thickness lines. But they are certainly bumpy and clunky. Beautiful lines can be drawn with this tool, but it will take a while and a lot of practice. But then, drawing takes a lot of practice anyway.

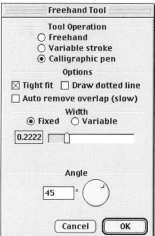

 Calligraphic tool (5)

This final option for the Freehand tool is finally useful. It is designed to produce the effect of a chisel-tip ink pen. It does that job very well. As you can see in the options box, we have a variable option here also. However, even in the traditional tools, the change in line width was caused by a change in direction as opposed to a change in the width of the tool. The standard calligraphic pen uses a flat tip that comes in different widths. At the standard 45° angle (designed for right-handed people), the pen produces a very narrow line when moving at 45° and the widest possible line when moving at 135°. You can see that on the opposite page with the word "Type." Here is another example, to the left. No comments, please, on the gracefulness of the line (or lack thereof). As you can see, when the pen is running parallel to the axis the line is thin. When it is running perpendicular, it is the thickest. This calligraphic pen works well with either the mouse or a graphic tablet and produces beautiful calligraphy. For those with calligraphy skills, this gives you the option of editable shapes. You will no longer have to toss out a sheet because it has one mistake on it.

Pen tool (6)

This tool is the core of PostScript illustration. It was invented by the folks at Adobe for Illustrator, but I find that FreeHand's pen works better. This is also the exact same tool Photoshop and InDesign use for drawing paths. What I am trying to say is simple: "You must become fluent with the Pen tool!" This is not an option.

How do you add that skill?

This is a very strange tool that does not seem intuitive at all. There is nothing like it anywhere else except in PostScript drawing programs. So let's talk a little about how you gain skill. When I went to the orientation session of my first drawing class at college, the final thing the professor said as we left (planning on coming back on Monday morning to have him "teach" us to draw) was, "Oh, by the way – when you come Monday, bring sixty drawings that you have done over the weekend. I don't care what you draw, but you must bring sixty new drawings done in the next three days."

During that first nine-week course, we all drew nearly 600 drawings in pencil, conté crayon, charcoal, crowquill, and heavy bamboo dip pen. The first ones were horrible and I threw them away. I wish I had them to show my students now. I didn't produce my first "keepers" until my second year, after four drawing courses, two painting courses, three courses on color theory, and so forth. By that time I had produced thousands of drawings, hundreds of stupid exercises, and more than twenty large paintings. They were starting to get fairly good – surprise, surprise!

You will have to do the same thing with the Pen tool. You just need to draw. I will do something I rarely do, here in the next few pages, and lead you through a simple drawing step by step. Let's call it your first official skill exam. But your real assignment, for the next few weeks, is to draw at least a dozen drawings a week with the Pen tool. In reality, I hope you will do many more than that. By the time you finish, you will be getting pretty good with the Pen tool.

So, with that intro, how does the tool work? When you simply click with the Pen, you produce corner points. The star at the right could be produced this way, although making it this regular normally drives us to the Polygon tool. The key to the tool is the click-drag. When you click and then immediately drag, while still holding down the button, a curve point is produced. With these two options you can draw anything your little heart desires – easy, huh?

Actually it is. That is the reason for the Unofficial Homework assignment in the sidebar. Once you get accustomed to the tool, you will be amazed with its precision, dazzled by its fluidity, and addicted to its editable flexibility. As you are drawing, if you do not like the way the handles are arranged, or the shape of a segment, simply press down the ⌘ key (PC: Control) to access the Selection tool. Click on a point to select it and the handles will appear for that point (the outgoing handle of the preceding point, both handles of the selected point, and the incoming handle of the following point). Adjust the point location and the handles as you decide they need to be set, then click on the end point to select it and continue with the line.

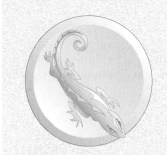

CHAPTER FOUR: FREEHAND'S ABILITIES

UNOFFICIAL HOMEWORK:

You are to draw at least forty-eight simple line drawings with the Pen tool over the next four weeks. They are not to be turned in for a grade. You do not even have to save them. (You might want to save a few, however, to remind yourself how bad you were when you started.)

 VERY IMPORTANT TIP! Every shape must be drawn in one continuous path. If you need a closed path, you have to draw in one continuous path the entire way around the shape. If you find you have two or more parts to your path, delete all except the first one, click on the end point to select it, and redraw it as one continuous path. This is the most common mistake of beginning PostScript illustrators.

LEARNING THE CAPABILITIES OF THE SOFTWARE

Skill exam #1

This little exam is unusual for two reasons. First of all, it is located in the book. Most of the exams will be found on your Website (a copy of the Website is also on the CD). For this first one, however, let's lay out the rules:

Skill exam rules

1. There is no time limit, unless it is specifically stated in the rules. Regardless, you can practice as much as you like.

2. You can ask as many questions as you need to ask. Skill exams are designed to teach you a needed skill. We are not interested in your methodology. The steps of the skill exam are all there for a reason. You can invent your own shortcuts later, on your own time.

3. If you cannot figure out how to do any part of the skill exam, the instructor or one of the staff will demonstrate it for you.

4. You will finish with a specific product (usually a PDF) that you attach to an email, which you then mail to your instructor for grading and comments.

5. If there is a problem with your final product, the instructor will annotate your PDF and send it back for corrections. There is no penalty for the second try (or third or fourth).

As mentioned above, there is no way you can cheat on these tests. You have to be able to acquire the skills. At any time, if there is any doubt in the instructor's mind, all he or she has to do is ask you to do the skill while they are watching. Once you have done a skill exam, you should be able to do it again in just a few minutes.

Instructions for skill #1

This is merely a simple tutorial exercise. You will begin by setting up guides, then draw a simple shape, and finally you will decorate the center of that shape with the FreeHand tool plus some duplicating transformations.

STEP #1 (assuming a default 5" x 5" page)

Before we can start, we have to develop a center point on the page. You may want to add this feature to your FreeHand defaults page. You begin by double-clicking on the little box with the off-center crossed lines in the upper left corner of your document window where the rulers meet. This will reset the rulers so they line up with the sides of the page with the zero point of the side ruler at the bottom corner of the left side, and the zero point of the top ruler at the left corner of the top.

After the double-click, you then click on that same box and drag out the zero points. You will see a crossed, dotted guide that moves with the cursor. Watch the little dotted lines as they move along the ruler until they line up with the 2.5-inch mark. When they are perfectly lined up, the mark on the ruler will disappear (re-placed by the dotted lines). Carefully release the mouse. If you have done this right, the zero points of your rulers will now be exactly centered on the page. I know this seems very elementary for many of you. However, this is the number one problem of my students with most of my skill exams. To do many things in FreeHand, you want the zero points and the center of your illustration to be 0,0. It makes it much easier to work with multiple transformations, for example.

STEP #2

Draw two circles, from the center out, begin-ning exactly at the 0,0 point. Choose the Ellipse tool by clicking on the toolbox, or type the number 4. Click on the intersection of the zero points of the rulers and draw a circle that is approximately 1.5 inches in diameter. Then, with the circle still selected, type the num-bers you see at the left in the appropriate boxes of the Object Inspec-tor. This will give you a circle that is exactly centered on the page, 1.5

inches in diameter. Do the same thing with a second circle 4 inches in diameter, typing in -2, -2, 4, 4. Then Shift-Select both circles and click on the GUIDES layer. Then lock the GUIDES layer by clicking on the little Lock icon. The final page should look like the example shown on the opposite page, with two concentric circle guides centered on the page. You should also be getting a good example of how boring lockstep tutorials are. This will be the last one. From now on you will be given much more freedom.

STEP #3

Now you need to select the Pen tool (type 6). Then click on the inner circle guide. Next click on the outer circle guide and drag out the handle horizontally to the right. This will be made much easier if you hold down the Shift key as you drag (which will constrain the handle to a perfect horizontal). When you release the mouse button the result should look as it does in the top left sidebar picture.

STEP #4

Then click symmetrically back down on the inner circle guide. The result should look like you see in the second sidebar image. Now you continue by click-dragging again (without the Shift key this time) on the outer circle. Then back on the inner circle, continuing around the circles until you can close the path. Do not worry about making every petal perfectly symmetrical.

The final closed path should look like the outline of a simple daisy shape (as you see above right). At this point, I would use a fill of None. Any fill will simply get in the way as we draw the center of the flower.

STEP #5

Using the Freehand tool (type 5), draw a continuous, irregular wavy line around the center of the flower (like seen to the left). It is important that you draw one continuous line so you can close the path.

STEP #6

With the new center you have just drawn still selected, clone it by using the CLONE command toward the bottom of the EDIT menu. This will give you an exact duplicate of your selected shape, exactly on top of the original shape.

STEP #7

Then you have to be careful. Do not touch your cloned shape with the mouse! You need to generate some duplicated transformations. You can do this with one mouse-generated transformation or one of every type generated with the TRANSFORMATION panel. So, the procedure is to double-click on the Rotation tool (or open the TRANSFORMATION panel from the toolbar). Then, with the daisy center still selected (and untouched), type a small rotational angle into the dialog box. At the bottom of this panel, you can see two fields that locate the center of the rotation. Type in 0,0 in these fields (thereby learning the importance of accurately centering the rulers before drawing). Click Apply.

STEP #8

Then, with the shape still selected, click on the SCALE button of the panel to select that tool. Type 85 in the Scale %: field, check the UNIFORM box, and type 0,0 into the Center: x and y fields. Click Apply.

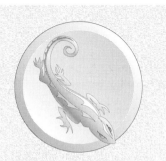

STEP #9

Enter the DUPLICATE command four times by using the keyboard shortcut: ⌘D (PC: Control D). This will give you four smaller rotated centers that are concentric. Usually I would also add a third transformation by flipping the cloned shape around the 0,0 center, using that button of the panel. This gives a slight irregularity that looks a little more realistic. As you can see to the left, not flipping tends to give you a spiral. However, for the purposes of this skill exam, this does not matter at all.

The final step is to color the flower. *Have fun!* It makes no difference whether you use color or grayscale tints. Just enjoy the completion of your first skill exam. You can see the final result, with an arbitrary grayscale color fill in the sidebar.

Back to the tool descriptions!

Hopefully that was a helpful digression. But we have not even covered the drawing tools, let alone the transformation tools (that you have already used on a simple basis). We have to cover all the rest.

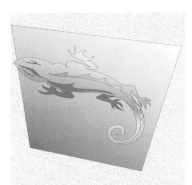

Knife tool (7)

Knife Tool

Tool Operation
◉ Freehand ○ Straight

Width

`0` [slider]

Options
☐ Close cut paths
☒ Tight fit

[Cancel] [OK]

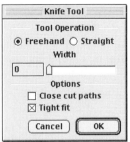

This is a very handy tool when you need it. Its basic function is to cut a path into two or more separate paths. We have already emphasized the importance of making a path one continuous shape. Why would we want to cut it into pieces? In fact, you will not do this too often. However, as you can see to the left, the Knife options dialog box gives us hints of a much more common use for this powerful tool. These options make the tool much more useful. In fact, you will actually use it quite regularly. Let's look at a little demonstration with the CLOSE CUT PATHS option checked. To use the Knife tool you have to select the path first. The easiest way to do this is to select the Knife tool (type 7). Then hold down the Command key (PC: Control) to access the Selection tool to select the path. Then draw the cut you want to implement. The example here uses the STRAIGHT CUT option with the width set at .125 (an eighth of an inch). As you can see, the tool gives you a black line the width of the cut to help you visualize where the cut will take place. Because the CLOSE CUT PATHS option was clicked, the heart was cut into two closed paths – but notice the fill was not cut. It is now the same for both halves. The bottom heart in our sidebar example shows the same tool with the Freehand option checked.

There are a couple of things to note about this tool. First, it is obvious that fills have to be planned and adjusted carefully. Flat tints are the easiest. But if you are like most of us crazy artists, this will be too boring for your design. Second, look carefully at the bottom cut. I was attempting to do a jagged broken heart image. However, because the freehand option never allows us to control the point type or placement, I was given a result that looks soft and clumsy.

However, by quickly selecting all of the interior points, converting them to corner points (using the Object Inspector), and retracting all of the handles, we can get a much more jagged break. All it takes then is the addition of a few more corner points with the next tool on our list. This is obviously just a quick demo, but you should get the idea. On the right, please notice that I inverted the bottom fill for continuity.

61

 Bezigon tool (8)

This is the tool that I used to quickly add the extra points for the broken heart we just finished with on the previous page. This tool is unique to FreeHand. You should use it a lot. Its basic function is simple to describe. If you click with the tool you get a corner point. If you hold down the Option key and click (PC: Alt) you get a curve point. If you hold down the Control key you get a connector point.

YOU'RE RIGHT! IT IS A VERY CLUMSY WAY TO DRAW. YOU HAVE NO CONTROL OF THE HANDLES.

However, there is a very powerful use of this tool that you should use constantly: path adjustments. Once a path is drawn, you almost always will want to make minor adjustments to get the shape just right. Just hold down the Command key (PC: Control) to quickly access the Selection tool to select the path – then type 8. If you click-drag on a segment of a selected path, you will add a sharp corner that you can move to the position needed. If you Option-click-drag (using the Alt key on a PC), you can curve the segment into the position you need. You will find this to be an extremely intuitive method of path adjustment and control.

 Push/pull tool (9)

VERSION 8 ONLY

We finally arrive at the final drawing tool. This is one of those "Oh wow!" tools that you may never use much. It performs the same function as the Bezigon tool, but it "feels" very clumsy in operation.

As you can see from the dialog box to the right, the tool is full of non-intuitive, overly complicated options. This tool probably comes into its own

with a graphic tablet because the size of the tool can vary with pressure. You can see its basic capabilities in my little sarcastic slam in the sidebar to the right.

This is yet another of those options that some will love and some (like me) will rarely use. It is also something that you will have to use quite a bit to make it second nature. As long as you are consciously aware of a tool, you cannot draw a shape with freedom.

The real problem is that it adds points according to its rules and not according to your needs. All points added are curve points at the extrema. The *extrema* are those points where the handles are perfectly

62

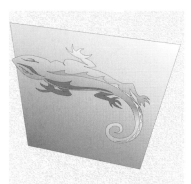

horizontal or vertical. PostScript likes extrema points, but they are rarely very elegant. You end up with soft, round, almost puffy shapes. So in most cases, you are going to need to go back with the Bezigon tool to add some "edge" to your design.

 ### Reshape tool (9)

VERSION 8 ONLY

The Reshape tool seems clearer in its operation, but actually it is far worse. Once you choose this tool, the predictability of the push/pull tool looks like a real virtue. The Reshape tool pushes and tugs at the sides of the shape in a completely uncontrolled manner. It adds points of various types in seemingly random locations, raggedly distorting the portion of the shape to which it is applied. It only works from the outside of a selected shape. It serves basically the same function as most distortion filters.

 DISTORT: the dictionary defines this as "to twist out of its true meaning; to twist or alter the natural to the unnatural." Computer artists take great delight in these capabilities. The thing to remember is that most readers do not. In general, people are attracted to harmony, grace, and beauty – and are repelled by twisted, distorted graphics. Our job as graphic communicators is to attract our readers, viewers, or surfers to our client's product and to give them a positive experience that will tend to help them say, "Yes!" when it comes time to purchase that product or service. 'Nuf said for now.

Here's what the Reshape tool did with a couple of quick push/tugs at the sides of the push/pull distorted heart. Obviously, this is not a serious attempt at using this tool. Seriously, the tool appears to be a simple way to avoid having to deal with points. Once you understand how points work, you will use the Selection tool and the Bezigon tool for your alterations. They can be controlled.

Now our survey of drawing tools in FreeHand is complete. Before we can move on to the capabilities found on the panels, we have to discuss the remaining six tools in the toolbox. We start with the four transformation tools. These will become as much a part of your drawing technique as any of the tools we have already discussed. They give you the ability to modify shapes to meet your needs.

The transformation tools

There are four of these tools in the toolbox, as we mentioned, with a fifth that is found only in the TRANSFORM panel. These are Rotate, Flip, Scale, and Skew, with Move being found only in the panel. As you can see, they all have option marks in the upper right, but rather than separate dialog boxes all of these options are found in the TRANSFORM panel.

 There are several procedures that you need to understand about the transformation tools.

1. When you click-drag with a tool, the transformation is centered (or moves around) the clicking point.

2. When you click with the Rotate or Flip tools, a line appears that indicates the angle of the transformation. As you hold down the mouse button, move out along that line from the clicked center to get more control. If you try to rotate or flip with the tool right next to the clicking point, the shape transforms so fast that you lose any possibility of control.

3. The Shift key constrains the transformation.

4. Go slow and easy.

These are very powerful tools that can quickly transform a shape beyond recognition until you get used to them. Let's go through them one by one using the option panel for the tool as a guide.

Rotation tool (F13) (PC: F2)

This one is relatively straightforward. You can click and drag, pulling the horizontal line that appears around the click point until the shape is in the location that you need. Or you can select a shape and rotate it to any degree (or thousandth of a degree) around any specified center by simply typing in the numbers and hitting the Enter key.

 IMPORTANT TIP! You should get in the habit of always using the Enter key at the lower right corner of the numerical keypad when using FreeHand. The Return/Enter key on the QWERTY keyboard often has a different function than enter or apply.

Unchecking the Contents or Fills checkbox lets you rotate the path without rotating what is inside the path. This would obviously be important if you have a photo clipped by a path, or if you need all of your graduated or tiled fills to have the same angle.

Reflection tool (F9)

This is one of those tools that is too powerful for its own good. The more advanced the version, the better you can control it. However, there is still a very strong tendency to lose control as the selected shape flips wildly around the screen. (With versions 5.5 and 7, I did all

Transform

Rotation angle:

0 °

Center:

x: -0.05019

y: 0.05286

⊠ Contents
⊠ Fills

Apply

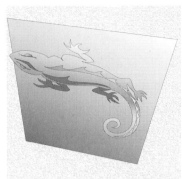

of my flipping with the TRANSFORM panel to keep control.)

The problem is that you can flip on any axis. The second problem is remembering what those degrees mean. Basically, you only want to flip on a vertical or a horizontal axis. The buttons in PageMaker and Quark are almost always sufficient. As is usual with PostScript illustration programs, you get an unbelievably wide choice of actions with every tool. In this case you can adjust the angle flipped in the panel to a thousandth of a degree.

 Degree measurements in panels are something you have to deal with on a regular basis. All degrees are measured from the center of the selected shape – whether clicked or specified in the panel fields. 0˚ is the horizontal to the right; 90˚ is vertical up; 180˚ is horizontal to the left; and 270˚ is vertical down. To rephrase, the degree angle circle begins at the right horizontal with 0˚ and proceeds counterclockwise.

So a 0° flip is on the horizontal axis – the bottom exchanges with the top. A 90° flip causes the left side to exchange with the right side. Version 8's tool is much more controllable.

Scaling tool (F10)

Again this tool is so powerful that you must be careful. You will use the SCALING page of the TRANSFORM panel a lot. The problem is that the Scaling tool moves around the clicked center and scales selected objects very fast and in nonintuitive ways. Moving the tool the wrong way can scale an object until it is upside down and stretching down until it is hard to remember what shape you started with. A far better option is to temporarily group the selected shape(s). This is a keyboard shortcut you probably have memorized already anyway (⌘G; PC: Control G). Then you simply use the Selection tool to grab a handle and resize the group. You don't even have to change tools. Simply hold down the Command key (PC: Control) and you have the Selection tool no matter what tool you are in.

The SCALING panel, sidebar left, will be used a lot because it has several useful options that cannot be accessed in any other way. As you can see, you can scale up or down with virtually no limits from any specified center. Remember that 100% is same size, 200% is twice

size, and 50% is half size. By unchecking the UNIFORM option, you get both a horizontal and a vertical field for nonproportional scaling (although you will usually do that with the Selection tool on groups).

REMEMBER TO UNGROUP AFTER YOU ARE DONE.

The problem that this panel solves is one that you really need to be aware of. Unchecking the Contents and Fills boxes prevents the resizing of tiled fills and clipped graphics (PASTE INSIDE). Hopefully, you will not have to use this option too often, as both of those options are normally unwise from a printability standpoint.

 The one you must keep track of, however, is the resizing of lines when scaling up or down.

Most of us have an innate sense of what width stroke looks good to us. Probably most common is the half-point stroke or finer. If you scale up 400%, that half-point stroke is now 2 points. Worse yet, if you scale down 25%, that half-point stroke is now an eighth of a point. For most purposes, an eighth-point stroke is not reproducible. The smallest line that can normally be reproduced is a quarter of a point or about .003 of an inch. Even that is far too fine to be reproduced by quickprinters, screen printers, flexographic printers, inkjets, 600 dpi laser printers, or the Web.

The result of this is that you should often rescale with the Lines box unchecked. Or, you should readjust the strokes of all the scaled objects after you scale them.

Skewing tool (F11)

This one is by far the most difficult to control. Just practice and be careful. You will use this one a lot. This tool seems to simply give you the option to reshape from a rectangle to a parallelogram. Right?

Wrong! You can skew any shape in any direction on any axis. If you keep dragging the tool up to the right at a 45° angle, the selection will appear to twist 180° in three dimensions. If you skew down and to the left at a 45° angle, the selection will appear to flip three-dimensionally through space until you can see the back side of this paper-thin shape. However, if you skew several shapes like that, the layering does not change and the items that were in front remain in front.

There are two very common uses of skew. You can see one in the sidebar on page 67. Just hold down the Shift key and skew up. This will constrain your skew to vertical. In fact, this type of transformation is common enough that we need to do a miniskill. This one is quite a bit more open-ended. It is simple enough so that it should be worth half the points, but it is fun and useful.

Miniskill #1

We start with a word — any word. The only thing important is that there be no descenders for this first try (descenders will make the

Transform

Skew angles:

h: 0 °

v: 0 °

Center:

x: -0.05019

y: 0.05286

☒ Contents
☒ Fills

Apply

LEARNING THE CAPABILITIES OF THE SOFTWARE

ONE OF THE MOST COMMON USES of skew is to take some words and skew them vertically. This gives a strongly accented appearance that looks normal and natural.

type appear to float in midair). I used the word "HAPPY!" set in one of my fonts called Swell. It is a little easier if you CONVERT TO PATHS, but that is not necessary. Then take the Skew tool, click at the left end of the baseline of the type, and skew up (holding down the Shift key) until you like how it looks.

Then clone the word, color the clone a medium to light gray, and stretch it up by clicking on one of the top handles. If you have not converted to paths, you will have to hold down the Option key (PC: Alt) after you click on the corner handle to stretch the type. It really does not matter how far up (or down) you stretch the word. All it will change is the apparent angle of the light source.

Now you have to use the Skew tool again. Click on the same location of the stretched clone as you did with the original word. Now skew it down, holding the Shift key again, until the baselines of both words line up to the same angle.

Finally, we use the Flip tool clicked on the same point (hold it down a second to see the outlines of the type as it moves). Move the tool, holding down the mouse button, until the axis of the flip matches the baseline of the type. The final result should look something like what you see to the left. For this example, I sent the clone to the back of the original and recolored it with a graduated fill from 50% to 10% at a perpendicular angle to the baseline. No real reason except I thought it made the word HAPPY! a little more dramatic. Of course, adding the graduated fill to the clone requires that it be converted to paths.

Now it can be argued that this type of illustration can be done much more impressively in a 3D rendering program — with multiple light sources, extruded type, and many other embellishments This is certainly true. However, I will ask the questions, "How much more impact will that give the word you have chosen?", "How much more likely are those bits of decorative computerese going to help your client's reader decide to buy the product or service?", and finally (and most importantly), "Could you do those fancy 3D renderings in three minutes?" That's what it took to do this in FreeHand.

 ## Autotrace tool

The final two tools require a little explanation. The first one (covered here) has changed a lot with the versions. However, it is at the core of one of your most common tasks in digital publishing. Basically the tracing tool does not work in version 5.5. It works reasonably well in version 7, and it works very well in version 8. In fact, until version 8 of FreeHand, it was necessary to buy a dedicated autotrace program called Streamline by Adobe. This ability is so important that you will find two required autotracing skill exams on your CD or Website. The reason for this emphasis is that you will have to scan and trace existing logos on an almost daily basis if you are in a production setting. If you are in a mainly creative scenario, you will still find yourself scanning and tracing drawings as a foundation for many of your graphics.

As you can see from the Trace options to the right, the options are daunting in their complexity. In reality, you only have to worry about a few things. You will find that it works much better if you start with a high resolution TIFF — either black-and-white or grayscale. For autotrace to work well, you should be using two colors in the Color mode. You can trace more complicated images in up to 256 colors. However, if you have to do that, be prepared to spend a lot of time cleaning and adjusting the resulting collection of paths produced by how FreeHand thinks the colors separate.

It is important that you come to understand how autotracing works. It basically reads outlines of shapes from the top down. In a two-color trace, the first shape it traces will be filled black (no stroke), the second shape traced inside the black shape will be on top of the first filled with white, and so forth. As you can see in the sidebar on the right, all of the black is one large shape. I have colored the interior white shapes a light gray so you can see them better. The final graphic is shown directly below (I made it into a composite path to make the white areas transparent — see chapter five).

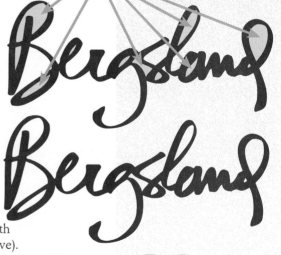

All the light gray areas are interior shapes traced on top of the outer black shape.

As far as type of trace is concerned, you really only want to do "Outline" traces. Centerline traces sometimes look all right, but they are al-

68

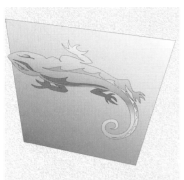

most impossible to edit or fix. Just remember that to trace an outline of a rectangle, you will get two shapes: a large black rectangle and on top of that a slightly smaller white rectangle that just reveals enough so that the image looks like a thin outline.

You'll get the hang of it very quickly if you practice. And you do need to practice. As I mentioned (I do so again as emphasis so you'll actually remember how important this is), scanning and tracing are two of the major skills you will use on a daily basis in PostScript illustration using FreeHand.

 Magnification tool
⌘ SPACEBAR; PC: CONTROL SPACE

As mentioned earlier, this is a tool that you should almost never use by clicking on the toolbox. That is because you will use it so much that the keyboard shortcut can become automatic very quickly. It also helps that it is the same keyboard shortcut used by PageMaker, Illustrator, and Photoshop. The Command (Control) Spacebar shortcut should become your normal tool to navigate through your document, because it is so quick and accurate.

The popup menu at the bottom of the window does not control what is centered in the window. The magnification commands in the VIEW menu are clumsy (and very slow) to access. However, you cannot effectively use the magnification shortcuts without remembering the FIT IN WINDOW and FIT SELECTION IN WINDOW commands. These are ⌘⇧W and ⌘0 (zero) for Mac and Control Shift W and Control 0 (zero) for PC.

The basic procedure is this. Hit FIT IN WINDOW to see the entire document. Then hold down the ⌘ Spacebar combination and marquee the area you want enlarged and centered in the window. Release and it's done! If you are too close, just add the Option key (PC: Alt) to the Magnify shortcut and the cursor switches from + to - and you can demagnify a skosh. I suggest that the next time you are in FreeHand, you practice a half-dozen times (right now would be good). This is certainly a procedure to quickly add to your repertoire. It will save you many minutes each day (especially if you add the same procedure to the rest of your software).

Stroke and fill options

We have finally finished all of the tools. Obviously they will need a little practice, but I'll assume that you did the practice exercise, Skill Exam #1, and Miniskill #1 as you went along. Before we can go on to other things, we need to talk about some rather esoteric options

as far as stroke is concerned, plus we need to cover all of the options for fill. You have a huge amount of control with many options.

Stroke Inspector

The first choices are simple. As you can see, there are only five. Of those five you will only use two, and of those two the first is None. Custom and Pattern strokes are ugly, always 72 dpi, and used by cartographers for maps. We will cover Custom, Pattern, and PostScript strokes when we get to the Fill Inspector. For now, let's just leave it simple – you do not want to use them.

The Basic stroke has several options of which you need to be aware. Of course, the stroke can be any color – Crayola, Pantone, Process, Focoltone, TruColour, or any of the other libraries of color that come with FreeHand. Plus the stroke can be spot, RGB, or CMYK color (but that will be covered in chapter seven). In fact, as we'll discuss then, FreeHand has more color options and control than any other illustration software. It equals or betters page layout abilities.

We will skip Overprint until chapter ten. It is used only for poor-registration printers and to generate traps for high-resolution printing. Width can be almost anything from 0 to much wider than you will ever use. Remember that you can set the default widths in PREFERENCES. The line width measurements are in the same system you have chosen at the lower left of your window. Just remember that you can always add stroke width in any measurement: 7i = 7 inches; 7m = 7 millimeters; 7p = 7 picas; and p7 = 7 points. Like most people, you will probably get used to speccing stroke width in points.

Cap and Join

Many times, controlling these options will be the only way to create the effect you need. The cap and join options seem very esoteric, but they actually provide a solution to the problem of how to end a line. There are three types of caps (line endings) and three types of joins (corner point renderings in the middle of a stroke). This gives us nine combinations, but let's just look at three for now: the left sample has Butt Caps and Mitered Joins; the center sample has Round Caps and Joins; the right has Square Caps and Beveled Joins. The caps are easy to understand. Butt Caps cut off directly at the end point at a 90° angle. Round Caps end the stroke with a half circle centered on the point with a radius of half the stroke. Square Caps extend the 90° cutoff a distance of one-half the stroke width beyond the end point.

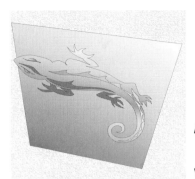
Miters are a little more complicated because we have to define a miter as far as PostScript is concerned. A *miter* is the corner defined by two intersecting lines of the same width where the extra line length on both sides is trimmed off even with the outer edges of the corner. This rather complicated definition can be seen easily in the example below. The black shape is the miter that results from a stroke as wide

as the two light gray intersecting boxes. The miter limit box limits how long the point can be by cutting off the miter at a predetermined length beyond the corner point. This is to solve the supposed problem of miters extending several inches beyond the point. In practical experience, however, this is never a real problem – other than the fact that the miter limit can cut off the points when you do not want that to happen. It really only matters when you are using wide stroke widths.

So, there are three types of joins at a corner point. First is the miter, which we have already defined. The Round Join connects the outer edges of the corner with a circular arc whose radius is half the stroke width. Finally, there is the Beveled Join, which works just like a miter limit except that it cuts off the miter at the corner point. By the way, the angle of the bevel cut is a 90° cut to the bisector of the angle produced by the handles of that corner point.

The most common form of this cap and join control is seen in the infamous "Neon" effect. This is achieved by blending a thin light line to a thick dark line while using Round Caps and Joins. We'll let you figure this one out in the next chapter after we describe blends. It is a simple effect, yet relatively powerful. Like all of these tricks, however, they tend to flag you as one of those digital designers who uses software like a video game. As usual, discretion and good taste must govern your design choices.

Dashed and dotted lines

You don't often need dashed or dotted lines, and when you do it is often better to use multiple transformations or blends along a path. However, FreeHand does have more than you need, as usual. The ten standard dashes offered in the Stroke Inspector are applied to a stroke exactly the way you think they would be. However, there are a few twists that you may not have thought about. These twists usually involve wide lines and selected end caps.

71

Let's look at a few:

24 points wide — 30% gray

8 points wide — Round Caps

12 points wide — Round Caps under a white hairline (Round Caps) — blended 25 steps

30 points wide — Butt Caps 10% Black under a Black hairline blended, 35 steps

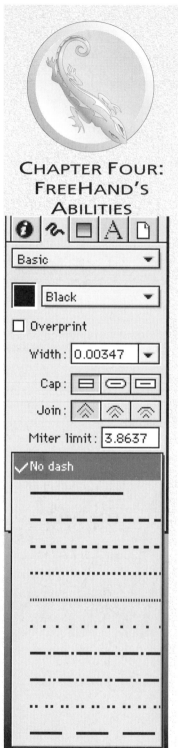

I agree. They are no big deal. This is merely a visual trigger to get you thinking about possibilities. The only places things like dotted and dashed lines are usually used are maps, borders, and so forth.

Arrows and callouts

As opposed to dashed lines, which are rarely used, arrows are used regularly. This is another place where FreeHand shines over its competition. There are two popup menus at the bottom of the Stroke Inspector. Both are exactly the same except the left one puts arrow heads or tails at the beginning of a stroke and the right puts them at the end. To be honest, the standard options are sufficient most of the time. However, by selecting the NEW command you have the option to make any specialized, extraordinary arrowhead or

tail that you might think you really need. As you can see, the Arrowhead Editor has all of the basic drawing tools you might need: Selection, Pen, Rotate, Flip, Scale, and Skew. However, all you can do is draw a new shape. You make a outline line ending (stroked only), but you cannot do a specialized fill (like adding a gradient to your arrowhead). In general, the supplied arrowheads are all you will ever need.

Fill Inspectors

Fills have even more options than strokes. However, in your daily work you will probably only really use three: None, Basic, and Gradient. Lens and Tiled fills are used (you need to be careful about printing problems), but Custom, Pattern, Textured, and PostScript fills have the same troubles as in strokes.

It seems silly to cover a fill of None. However, I regularly see students frustrated by trying to select a shape with a fill of None. You have to click directly on the path to select such a shape. You cannot click inside the shape *for there is nothing there.*

The Basic fill is as uncomplicated as it sounds. You get a popup menu with all of the colors on the COLOR LIST panel. It is important to note, however, that you must use the colors on the color panel (or you must run the XTRAS>>COLORS>>NAME ALL COLORS filter). If you ever see a blank next to the color swatch, a red flag

should pop up in your brain. Colors that are not named can cause serious printability problems. The Overprint checkbox is very important to keep track of, but we will cover that in chapter ten also (along with the unnamed colors problem). The main problem you will run into in the beginning is remembering to make your shape with one continu-

73

ous path, and closing it by clicking back on the starting point. Otherwise your gorgeous fill will not print. Yes, you can fill an unclosed path, as we mentioned. However, this is something you will want to add on a case-by-case basis.

Gradient (Linear and Radial) fills are used constantly. They can cause printing problems with banding, but that will also be covered in chapter ten. This is also an area that has changed with the versions. Version 5.5 could only do spot color to white or any process to any process. Version 7 allows anything but is not as easy (in "feel"). Version 8 allows you to gradually change any color to any other color. This can cause some serious problems if you mix spot and process colors. But we'll cover that in chapters six and ten.

For now, you can see that you have the same popup menu for color choices we first saw in BASIC. There is one at each end of the gradient. We still have the Overprint checkbox and it still covers the entire fill.

There are two new options that must be described. TAPER refers to the two ways that the gradient can change from one end to the other. LINEAR means that 25% of the way from Black to White you will find a 75% gray. LOGARITHMIC starts with narrow bands of color and progresses to wide bands. So, with LOGARITHMIC selected, 75% of the way from Black to White the color might still be 60%. LINEAR is what you will normally want.

Below the TAPER popup is a circle with a tiny circular knob. Below that is a field with a degree symbol after it. You can either click-drag the knob or type in a degree to change the angle of the gradient. Remember that in FreeHand 0° is always to the horizontal right. The degree number describes the location of the knob in the circle, which represents the location of the bottom color. To rephrase, at 0° with a Black to White gradient, the Black will be on the left and the white on the right. However, it is so clearly interactive that you will almost immediately do what you need without thought.

Below the fill type popup under GRADIENT are two buttons. The left is for the linear fill that we just described. The right button changes the gradient to a radial fill. As you can see at the top of the next page, the color popups and the Overprint options are identical. However, this fill starts at the farthest edge or corner of a shape, with

GRADIENT FILLS — same colors, gradient on top, radial on the bottom.

GRADIENT FILLS —
Multicolor (approximately what you see in the screen capture above right); same colors, gradient on top, radial on bottom.

the gradient changing in concentric circles to the center. This center represents the bottom color and is indicated by the little ball at the crosshairs in the square at the bottom of the panel. The top color is the outside, or the point that is farthest from the center of the radial gradient. Again, this becomes very obvious as you use it. Radial gradients are by far the quickest and easiest method of making a ball with the illusion of three-dimensional shading.

Just to the left of the color bar of the RADIAL GRADIENT panel you can see a multicolor version of that bar. Multicolor gradients are created by simply dragging a color swatch into the color bar. You can drag any color and place it in any location. If you click, hold down the Option (PC: Alt) key, and then drag, you can move copies of the color swatch around the bar. There are no practical limits other than the fact that you sometimes cannot get two colors close enough to achieve the effect you desire. Here again, you need to make sure that you drag your color swatches from the COLOR LIST and not from the COLOR MIXER or TINTS panels. If you cannot

remember, there is no visual reminder in the multicolor bar. So you will have to run the NAME ALL COLORS filter.

The LENS panel is only available in Version 8. The media usually considers this the major place where FreeHand blows away Illustrator. Primarily, this has to do with the whole concept of PostScript transparency.

PostScript can NOT do transparency. All it can provide is the illusion of transparency -- so there!

Now that I have gotten that off my chest, let's talk a little about how this amazing, fantastic transparency lens is less than useful. This mainly has to do with one major flaw in the procedure. As it is written (inconspicuously) in the documentation, "Spot colors under a lens are converted to process colors for output." If you remember, one of the major reasons we use FreeHand is to generate spot color graphics. This certainly ruins that scenario. It basically means that you cannot use the lens effects at all when you are working in spot color, unless you do all of your lens effects over grayscale images.

The result of all of this is simple. Your transparent effects in FreeHand should rarely be used unless you are doing them in process color or in RGB for the Web. You should do them in Photoshop. However, this is the one place where Illustrator has us beat (I assume that this will be solved in FreeHand 9). Photoshop cannot read FreeHand's layers. Presently you will have to save each layer as a separate EPS and then rasterize each layer in Photoshop separately and then composite them transparently there.

There are several other lens effects that sound very interesting. They all have the flaw of converting colors to process. The MAGNIFY lens lets you enlarge an area of the graphic for callouts and the like. As long as you solve the obvious process color problem this can be extremely handy. INVERT, LIGHTEN, DARKEN, and MONOCHROME lenseshave obvious functions. But again, you can only use them in process illustrations, or in grayscale. I know that process color work is growing exponentially, but it is still less than 20% of the industry. Actually, at the time of this writing it is still less than 10%. This conversion-to-process limitation can mean problems with the Web palette and RGB color.

The main thing to remember with these lens fills is that they are very powerful. They work very well, and print well (if you really want process color). The only additional problem is the file size issue. LENS fills can greatly add to the file size, and make printing unlikely — simply because your printer's RIP does not have enough RAM. Again, we will talk about these problems with printing in chapter ten. For now, all I can do is urge caution. If your complicated images refuse to print, all you can do is simplify them by eliminating some of the lens fills, objects, pasted inside, and overly complicated joins and blends. In general, FreeHand and Illustrator can both easily be too powerful for their own good, creating images that look fantastic but are too complicated to print.

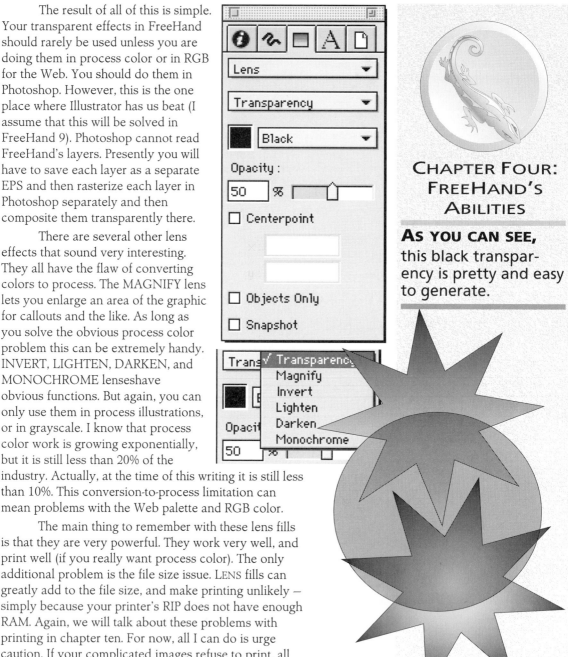

AS YOU CAN SEE, this black transparency is pretty and easy to generate.

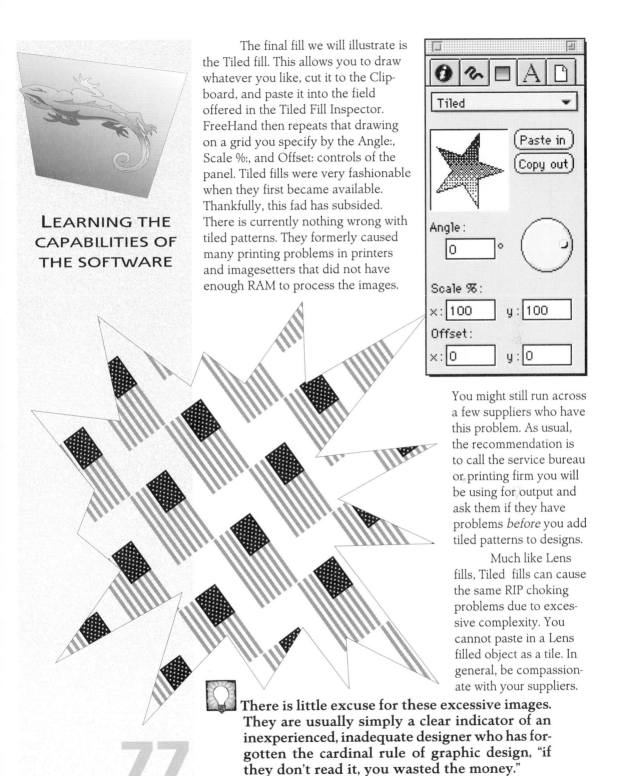

The final fill we will illustrate is the Tiled fill. This allows you to draw whatever you like, cut it to the Clipboard, and paste it into the field offered in the Tiled Fill Inspector. FreeHand then repeats that drawing on a grid you specify by the Angle:, Scale %:, and Offset: controls of the panel. Tiled fills were very fashionable when they first became available. Thankfully, this fad has subsided. There is currently nothing wrong with tiled patterns. They formerly caused many printing problems in printers and imagesetters that did not have enough RAM to process the images.

Tiled

Paste in
Copy out

Angle :

0 °

Scale % :

x : 100 y : 100

Offset :

x : 0 y : 0

You might still run across a few suppliers who have this problem. As usual, the recommendation is to call the service bureau or printing firm you will be using for output and ask them if they have problems *before* you add tiled patterns to designs.

Much like Lens fills, Tiled fills can cause the same RIP choking problems due to excessive complexity. You cannot paste in a Lens filled object as a tile. In general, be compassionate with your suppliers.

There is little excuse for these excessive images. They are usually simply a clear indicator of an inexperienced, inadequate designer who has forgotten the cardinal rule of graphic design, "if they don't read it, you wasted the money."

The final fills we need to at least mention have very little normal use. The Textured, Pattern, and Custom fills will only print to Post-Script printers (which is only a small limitation). Mainly, they do not show up on your monitor, so you have very little control over them. Finally, they are designed for low-resolution printers. They do not usually transform with the shapes containing these fills. In almost all ways they are a low-quality, nonprofessional solution to your design needs. Even though Patterns seem to offer solutions for those of use who have to make maps, they do not output properly from high-resolution printers, imagesetters, and platesetters. You will do better with a custom tile saved to your graphic styles panel.

The PostScript Fill requires that you be able to write in Post-Script code (and we know how many creatives are fluent in programming [virtually none – with the exception of Olav Kvern]). It is unlikely that you will ever use this fill option even if you find a snippet of code that will work. On the screen, the fill just appears as a pattern of PS's although it prints correctly.

Normally, the only place where these fills – especially the PostScript options – are useful is in "FreeHand WOW!" books. They are fun, titillating toys for designers who can afford to play. They do have a certain usefulness when trying to reach other FreeHand users.

This finishes our coverage of FreeHand's abilities for the moment. The typographic features are covered in chapter six. The color capabilities are covered in chapter seven. The Web capabilities are covered in chapter eleven.

Filters (see Appendix A)

Finally, however, we need to briefly mention a category of tools that I consider trouble. We will go through these completely in Appendix A. I am referring to the Xtra tools and the Operations toolboxes. The first reason that they are trouble is that these palettes cannot be set to a usable location by default. They always pop up in the middle of your screen the first time you open them and they have to be put out of the way. Secondly, you really do not use them enough to justify wasting your memory on keyboard shortcuts – however, some of you will do that. Mainly they have been used as bragging rights by FreeHand and Illustrator. FreeHand wins, of course, because it can run all of the FreeHand Xtras plus all of Illustrator's filters.

 In general, the best way to use Xtras is by using the XTRAS menu, which you can customize so that it holds only those tools you use. You can also add custom keyboard shortcuts to those you use a lot (like the shape combination tools of Union, Punch, Intersect, and so forth). The two palettes must be used the old-fashioned way by

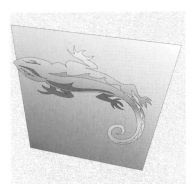

LEARNING THE
CAPABILITIES OF
THE SOFTWARE

setting up a location that is useful and then zipping them back into storage locations. **You will have to set this up every time you open a new file, if you are going to use this option.**

The biggest problem, however, has to do with taste. Several of these tools (for that is what they are) merely distort images in ways that tend to make students verge on ecstatic experiences. "Wow, you can do that!" They really have little practical use in helping your clients communicate with their readers, viewers, or surfers. I call them:

TOOLS FOR NOUVEAU RICHE DESIGN

Much like a set of gilded longhorns on the hood of a gold-encrusted Cadillac, all they do is clearly demonstrate the designer's conspicuous consumption of program bells and whistles, along with a decided lack of taste. The basic attitude seems to be, "Well, I can't figure out how to fix this. So let me play with this tool to cover up my lack of skill." In Appendix A, I will note which tools are clearly nouveaux riche. You may certainly disagree with me. In fact, I hope you do exactly that and try all of them to find out if they fit your style. But I am almost certain (or should I say, I certainly hope) that experience will teach you that nouveaux riche tools have little real use other than to distort shapes and make them ugly.

Now, we need to proceed to the tools and commands that allow us to combine paths into useful shapes. Here is where the real power of PostScript illustration is found. Chapter five will finish covering the drawing capabilities of FreeHand.

Knowledge Retention:

1. What is the problem with Lens fills?

2. What are some major advantages of the Bezigon tool?

3. What is the major problem with the FreeHand tool?

4. Why do we not use Patterned strokes and fills?

5. How do you create a curve point with the Pen tool?

6. What is the fifth transformation tool in the TRANSFORM panel?

7. What does the EDIT>>CLONE command produce?

8. How does transparency work in FreeHand?

9. Why will you almost never click on the Magnification tool?

10. Why is the Knife tool so useful?

Where should you be by this time?

You should have absorbed the general concepts of the tools and their options. Plus, you should have practiced with each tool; completed the practice exercise, the first skill exam, and the first miniskill. You should also have drawn several dozen simple shapes with the Pen tool. By now it should be an almost comfortable addition to your drawing arsenal.

DISCUSSION:

You should be discussing how you would construct various images, how the Pen tool works, which tools fit your drawing style, where you find drawing references, how you create a fashionable look (and just what is that look today, anyway?), plus what modifications to the basic defaults described in this book you are making to help you work better.

Talk amongst yourselves ...

PRINT & WEB
GRAPHICS
USING FREEHAND

Definitions are found
in the Glossary on
your CD.

Chapter Five

Combining Paths

*Learning how to create complex shapes
and objects by combining paths*

Chapter Objectives:

By teaching students the options and capabilities of
FreeHand, this chapter will enable students to:

1. describe the difference between a group of shapes and
 those same shapes joined into a composite path

2. generate a blend and modify each originating shape

3. use the combining paths tools to create the illusion of
 transparency

4. describe the limitations of the Paste Inside function and
 how it works in the PostScript environment.

Lab Work for Chapter:

* Two practice exercises.
* Miniskills #2 and #3.
* Skill Exams #2 and #3.

81

Combining Paths

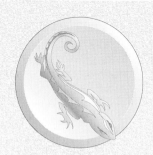

Join	⌘J
Split	⇧⌘J
Combine	▶
Alter Path	▶
Rasterize...	⇧⌥⌘Z
Lock	⌘L
Unlock	⇧⌘L
Group	⌘G
Ungroup	⌘U

Combining

Blend	⇧⌘B
Join Blend To Path	⇧⌥⌘B
Union	⇧⌥⌘U
Divide	⇧⌥⌘D
Intersect	⇧⌥⌘I
Punch	⇧⌥⌘P
Crop	⇧⌥⌘C
Transparency...	⇧⌥⌘T

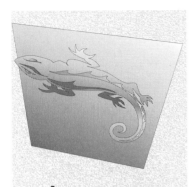

GENERAL CAUTION:
As we get into grouping, blending, paste inside, joining, merging, and so forth, you will have entered an area where it is very easy to make a file that is too complicated to print or rasterize. There is nothing wrong with these abilities — they simply require wisdom and discretion.

Combining paths

Now that we understand points, segments, handles, and paths, we need to discuss methods of using multiple paths to produce discrete objects. This is often done best with the Layers Palette. On a regular basis, graphic production is greatly enhanced by having the separate objects of our illustrations on separate layers that can be turned on and off as needed.

 TIP: Don't add a layer unless you have a good reason. It should help you organize, not add unnecessary complexity. Many of my students quickly get lost in a morass of layers that are not only unnecessary, but serve only to confuse the designer. If you need a layer, create one. Simply refuse to add a layer unless you have a specific need and a logical reason for that additional (and separated) layer of information.

However, this chapter covers those groups of paths that you need to keep in a permanent relationship for various reasons. Sometimes layers will help you sort things out, but that is not what we are talking about here — at all. Now we are talking about capabilities that put FreeHand far above all other graphic software. Although Illustrator and CorelDraw can do almost everything mentioned in the pages to come, with them it is more of a struggle.

There are basically four ways to combine paths: grouping, joining, blending, and (for now, let's call it) merging. They all have their uses, and it is important to understand their differences in concept. Almost everyone understands and uses grouping. It is probably the most overused capability of digital publishing software. The most common question I am asked by my students is, "Why won't this work?" (Usually with a whining twist.) The first thing I usually have to do is UNGROUP several times to get to a place where I can show them how to fix what they were trying to do.

This has become less of a problem with version 8. Now we can, at least occasionally, use groups in other path combination techniques. With versions 5.5 and 7, this cannot be done at all. Like many things in the digital publishing environment, grouping is overused.

Grouping {⌘G or Control G}

 DEFINITION: Grouping is the establishment of a permanent relationship between multiple objects, without changing any of those objects.

If I group a man's hat with his head, whenever I move his head, his hat moves also. There are a couple of things to remember about grouping. As simple as it is, many think that grouping is the best way

to protect yourself from accidental changes. There are some problems with that. They primarily involve changes that make normal workflow more difficult. If you get into the habit of always ungrouping as soon as you are done transforming the group, it will help you in the long run as you work with your graphic.

Primarily, grouping messes up your layers, unless you are careful. Grouping moves everything to the current drawing layer. Ungrouping can cause real problems, however. Often it is done long after the original grouping command. Under PREFERENCES>>GENERAL is a Remember Layer Info checkbox. If that box is checked, everything in the group returns to its original layer when it is ungrouped (assuming that you can remember where that was). In actual practice, ungrouping seems to mess up your layers no matter what you do. My suggestion is to be careful when you ungroup and assign all of the newly ungrouped objects to the layer of your choice, as an ungrouped set of selections, before you try to select any of the parts of the group. If you do this as a conscious choice, many problems will be avoided.

Please notice that any transformation of the group transforms every piece of the group while maintaining the original relationships. All of the fills remain the same. None of the paths are altered in any way. However, the strokes will vary their thickness as you scale up or down. As a result, there is very little use for grouping other than to gather various paths into a temporary unit to enable transformation as a single piece. Even here you need to be careful. Having GROUP TRANSFORMS AS UNIT BY DEFAULT checked under PREFERENCES>>OBJECT will help, but often you have to transform with the TRANSFORM panel with LINES unchecked to maintain control of your strokes.

 TIP: Grouping adds memory requirements when printing. So, in general, you should always remember to ungroup after grouping for a temporary purpose. It will solve some printing problems. As usual, be conscious of your actions.

Our other methods of combining paths actually change the paths in some manner. Let us look at the method that changes the fills.

Composite paths (Joining) {⌘J or Control J}

FreeHand's name for composite paths is good, for in a real way the paths used are joined into one path. However, it is a very special type of joining. First of all, it has several rules, which we will cover

This group works as a unit

This group works as a unit

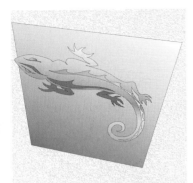

**ASSEMBLING
SHAPES
INTO DESIGNS**

next. Second, it fundamentally changes the appearance of the paths by giving them a single overall fill.

THE RULES OF JOINING

1. All paths to be joined must be ungrouped in versions 5.5 and 7. Version 8 can join grouped shapes, which makes rule #1 obsolete. However, you need to remember which parts are groups and which are not (it's still better to work ungrouped). This is a larger problem than you think because (as you so clearly remember from the previous chapter) all rectangles and ellipses are drawn as grouped shapes, so that they will remain rectangles or ellipses when you grab a corner handle. However, these aren't even the most common groups that you have to ungroup before you can join paths. When type is converted to paths, the entire text block becomes a group. When ungrouped, each line remains a group. When each line is ungrouped, you finally have access to the individual paths (except for characters that are already composite shapes).

2. All paths must have the same type of stroke. They can all have a stroke of None, or they can all have a Basic stroke, or they can all have a Pattern stroke, etc.

3. All paths must have the same type of fill: None, Basic, Gradient, PostScript, etc.

4. All paths must be closed paths.

When the four rules are satisfied, all the paths to be joined are selected and then joined. When paths are joined, some very special effects appear. First of all, the new composite path has a single stroke and fill, based on the path farthest back in the layering of the paths. This is very helpful when you want to generate a word that has a graduated fill starting in the first letter and ending in the last letter (or whenever you need a fill to cross through several different shapes). You will use this a lot.

Miniskill #2

These two words are part of the beginning of the Miniskill Exam found in the sidebar on the next page. You should go there, read the instructions, and do this miniskill.

IDEA
Establishment

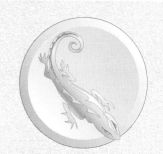
Also, notice how easy it was to embellish the dot over the i by simply holding down the Option key (PC: Alt) to subselect the dot and delete it. Then you can simply replace it with a drawing.

The second, and probably most important, attribute of composite paths is that they have even/odd fill. This is where the single fill appears and disappears as it passes through the various sections of the composite path. Here again it is probably easier to show you with type characters, because the most common composite paths are letters.

The most useful part of this even/odd fill is that the unfilled portions are not white – they are transparent, empty, open areas within the composite path. When you think about this, these transparent areas are essential for almost every graphic design. How would we deal with letters like O, P, R, a, b, d, etc. if the counters were not transparent? Every time we placed type over a colored background, we would have to manually select the paths of the counters and color them the color of the background. This can be done. But what happens when you want to place type over a photograph or a gradient fill? It is impossible to match portions taken from the middle of a gradient. Type is filled with composite paths to solve this problem.

Of course this even/odd fill attribute of joined paths can get a bit out of hand. Below, you can see that the word *FAST* is fairly chewed up. I had to try several fonts for that word before it was legible. As you can see, it is important to look at these joined paths carefully to make sure that readability has not been compromised.

Advanced Exercise

For this project we have three pieces: two words, *Getting*, and *FAST*; plus a simple box with a jagged edge drawn with the Pen tool. For the exercise, just work on the word *FAST!* The word *Getting* is a bit advanced at this point, but let me describe what was done for those of you who want to experiment. The word was set in a fifties-style script and carefully kerned until the letters lined up in one continuous flow.

MINISKILL #2 IDEA ESTABLISHMENT

1. Use Text tool to create a text box and type the words you desire.

2. Using the Selection tool, click on the lower right handle. Holding down the Option key (PC: Alt key), resize the type until it fits your idea or concept.

3. Kern type and resize until it seems perfect for your purposes, then CONVERT TO PATHS (⌘⇧P; PC: Control Shift P).

4. UNGROUP and UNGROUP until you have the individual letters, then JOIN PATHS (⌘J or Control J). In versions 5.5 and 7, UNGROUP and SPLIT PATHS until you have the individual paths.

5. FILL and STROKE as desired. Subselect one of the paths. Delete and redraw as desired for your need.

ASSEMBLING SHAPES INTO DESIGNS

OPTIONAL EXERCISE FAST...

1. Use Text tool to create a text box and type the word *FAST!* in a bold sans serif face.

2. Using the Selection tool, click on the lower right handle. Holding down the Option key (PC: Alt key), resize the type until you like it.

3. Kern type (Option/Alt & the arrow keys) until it seems perfect, then CONVERT TO PATHS (⌘⇧P; PC: Control-Shift P). Then UNGROUP.

4. Draw the jagged box. You can use guides or draw a rectangle, UNGROUP, and add points with the Bezigon tool. Fill the box with a gradient and move it behind the word.

5. SELECT ALL and JOIN.

The sample I am showing is obviously a different font. I cannot even remember the font I used for the original word. It doesn't matter. I would not use that same font if I redid it today, regardless.

So we have the word *Getting* kerned together carefully and skewed up to an angle that works for the design. It looks pretty good, doesn't it? However, the problem was that I wanted to fill the word with a graduated fill that went from the upper left to the lower right with a half-point stroke.

You can see the problem when I put the word into outline (after converting it to paths). Notice how all of the letter shapes overlap. If I simply JOIN them, all of those little overlaps become transparent holes (as you can see in the third example). So, the solution was more complicated than usual.

I ungrouped until the individual letters were selected. I still had two composite paths – the lowercase *e* and the lowercase *g*. Those two were selected and then SPLIT PATHS (⌘⇧J; PC: Control Shift J) was commanded. Then, by holding down the Shift key, all of the paths were selected except for the interior path of the *e*, the dot over the *i*, and the two interior paths of the *g*. With the exterior paths of the letter shapes selected, XTRAS>>PATH OPERATIONS>>UNION was commanded. This eliminated all of the interior overlaps. Then all of the paths were selected and joined, filled with the gradient, and stroked.

The instructions to build the word *FAST!* are found in the sidebar. This is what the two pieces look like before moving the jagged box behind the word and joining. You can see that this relatively simple logo was a reasonably complex process.

However, as the front cover of my first PDF book (*Getting Fast! Graphic Design in the Real World*), in full color, the logo was striking and effective. The interlocking even/odd fills were stronger than a motion blur, and the clean, graphic appearance of the logo was very appropriate for the content of the book.

 DEFINITION: Winding – the direction of a path: clockwise or counterclockwise.

FreeHand does composite paths better than its competition. For example, all composites in Illustrator are based on winding. If the paths wind in the same direction, there is no even/odd fill. If the paths wind in opposite directions, even/odd fill occurs. In FreeHand, you can simply click the EVEN/ODD fill button on the Object Inspector. If your composite paths occasionally misbehave, you can correct them with MODIFY>>ALTER PATH>>CORRECT DIRECTION.

Blending {⌘⇧B or Control ⇧B}

Now we enter a method of combining paths that generates many other intermediate paths. This is the object-oriented version of morphing in the bitmaps of video and animation. Blending changes one shape to another shape with a specified number of intermediate steps. This is one of the areas where FreeHand has always stood far above its competition, primarily because FreeHand's blends remain completely editable. In other words, FreeHand's blends automatically regenerate after modification. Of course, like joining, there are rules.

THE RULES OF BLENDING

1. All paths to be blended must be ungrouped. Composite paths or tiled fills cannot be blended, nor can bitmap images.
2. All paths have to have the same type of stroke. They can all have a stroke of None, or they can all have a Basic stroke, or they can all have a Gradient stroke, and so forth.
3. All paths must have the same type of fill: None, Basic, Gradient, Pattern, and so forth.
4. Paths are blended from bottom to top of the stacking order.

To keep it editable, you need to make sure that you do not ungroup the blend. Ungrouping the blend breaks the blend into the original shapes plus a group for the added blended shapes. In like manner, if you subselect one of the added shapes and modify it, the blend will also lose the ability to regenerate.

This is one of the areas where FreeHand has gradually gotten more powerful. Now, in FreeHand 8, you can blend almost anything – any quantity of shapes – and attach the finished blend to a path just like you can attach type to a path. In earlier versions (depending on how early), you will find yourself restricted to blending two paths, and you will not be able to attach to a path.

The same is true of color. In FreeHand 8, you can do anything you can conceive of attempting. Spot color to spot color, spot to process, process to process, and (of course) anything to RGB. We will discuss why this is probably a bad idea in chapter seven. In earlier versions, you can only blend process to process, and from one tint to

ASSEMBLING SHAPES INTO DESIGNS

another tint of a spot color (or white). In very early versions, you can only blend Basic fills.

HERE WE SEE A TYPICAL BLEND:

There are many ways we can work with this. First of all, we have complete control of the number of steps in a blend. However, changing the number of steps is as easy a typing in a new number on the Object Inspector. (The only differences between these two screen captures are that the

number of steps has been changed from 100 to 9 and the stroke has been eliminated from the blend below. This is as simple as selecting the blend and dragging the None color patch to the STROKE box of the COLOR LIST.)

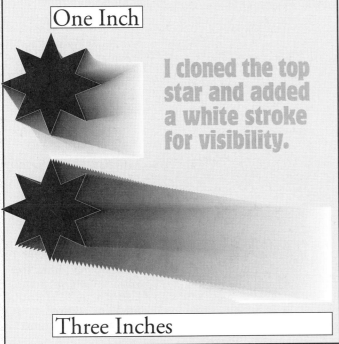

Second, huge numbers of steps are usually unnecessary and merely add memory requirements to the RIP that has to print your blends. It is actually a simple mathematical calculation. If you need a smooth blend (to give the illusion of shading), you need to make sure that no step is farther than a seventy-second of an inch from the previous or next step. In other words, make sure that the steps are no farther apart than one point. However, they also do not need to be any closer than one point. When the overlap is that small, the human eye cannot see it and the transition looks smooth.

For example, a seventy-step blend over one inch will appear to be absolutely smooth (assuming that you have high enough printer resolution to avoid banding, which will be covered in chapter ten). That same seventy-step blend over three inches will clearly reveal the steps. In fact, this is always the solution to banding: increase the steps and/or the resolution.

89

To the right, I have played a little with the word *Type*, blending the initial *T* to a rectangle. I am not pretending that it is wonderful art. What I want you to notice is that the blend gives us a simple field to lay the words upon for impact. Again, this type of illustration is wonderfully fast when you cannot think of a drawing to fit your need and your deadline looms over your head like a guillotine. To make it work better, I started with the blend you see in the screen captures on the previous page and changed the number of steps to 200 to give a smooth background. Then I lightened the two blended shapes until it worked.

We can blend from point to point, by selecting a reference point in each shape. This can give us blends that appear to twist through space. Here you will have to experiment until you get the effect you desire. The shapes of the intermediate steps are completely out of your control.

Any blend created can be modified by changing any of the original shapes. You can change color, add–subtract–convert–move points, or move any of the point handles. Color changes can be as simple as dropping a swatch on one of the originating shapes. You don't even have to be super accurate – just get the color swatch close to the shape (although occasionally you change the stroke color by mistake).

Basically, you do not want to be too radical with blends. Shapes that have deep dips in the sides, blends that twist though space, and blends done for the sheer joy of power rarely have any beneficial impact on your client's readership or sales.

Type *provides the impact to lead your customer to read…*

Type provides…
Miniskill #3

1. Use Text tool to create a text box and type the word *Type*.

2. Using Selection tool, click on the lower right handle. Holding down the Option key (PC: ALT), resize *Type* until you like it.

3. Kern type, then TEXT>> CONVERT TO PATHS (⌘⇧P; PC: Control ⇧P).

4. Ungroup and hit Tab to deselect.

5. Draw rectangle below *Type* and ungroup.

6. Multiple-select the rectangle and the letter *T*. Blend (⌘⇧B; PC: Control Shift B). Change the number of steps to 200.

7. Subselect the letter *T* and CLONE. JOIN the four letters and FILL. Using the Text tool, add the words that overprint the blend.

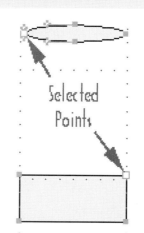

Selected
Points

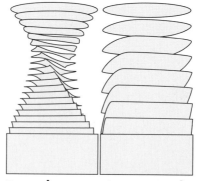

Points
Selected No Points
Selected

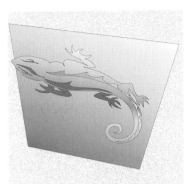

ASSEMBLING
SHAPES
INTO DESIGNS

You need to look carefully at the blends to the right. The left one has a blend from a dark gray rectangle to a light star to a tree shape. Why anyone would want to do that is beyond me, but don't let that distract you from looking closely at the intermediate shapes. Notice that several of them have twisted into overlaps. It is certainly remarkable that you can morph like this. However, the question is always, "Why?"

The rock below gives a hint at the major use of blends: creating the illusion of three-dimensional space. Yet it is obvious that this rock needs a

great deal more work before you can tell it is a rock without someone telling you. It could take hours adding little blends here and there — drawing nicks, scratches, and dirt, to make this rock look "real." In most cases you are better off to go to Painter (or even Photoshop) and work with a bitmap version.

Occasionally, you will find a use for the newest wrinkle to the blend scenario in FreeHand: attaching a blend to a path. This, again, is one of those capabilities that sounds wonderful until you actually think about it. On the next page you will find a sample of a multi-shape blend attached to a path. It was fascinating to watch that tubular worm as it formed in response to my command. It was a genuine "WOW, look at that" type of experience. The true questions are, "Do I really want to do that?", "How does that help me communicate with my readership?", and "Is it distracting?"

There are a couple of points to be made — and these apply to many of the newer, fancier capabilities of FreeHand. Although (for those of us who have used PostScript illustration for years) these capabilities are close to amazing, we really have to pay a price for

them. As I write this I am still working on an old PowerMac with a 603 chip. In general, it is relatively fast and certainly meets my needs. However, as soon as I generated the ATTACH BLEND TO PATH graphic, I was forced to sit and watch the video show as it slowly generated on my screen. Not only does it slow my drawing times to a crawl, it also makes me very insecure about my printing times.

The second point has been mentioned already. What real need do I have for these capabilities? This is a serious question that should be asked regularly as I design graphics to help me communicate to the customers of my client. Many of the graphic capabilities of our incredibly powerful software only appeal to those of us who use that software. Do not be caught in the trap of drawing a graphic (that you find exciting) that merely causes your reader to yawn and turn the

CHAPTER FIVE: COMBINING PATHS

Blend to path... Step by Step

1. Draw the three ellipses and UNGROUP each one. Fill with gradient fills.

2. SELECT ALL (⌘A; PC: Control A) and BLEND (⌘⇧B; PC: Control⇧B).

3. Draw a simple open path. SELECT the path and the blend, and MODIFY>>COMBINE>> ATTACH BLEND TO PATH.

4. SUBSELECT the right ellipse. EDIT>>CLONE. Stroke the clone and modify the fill until it looks like the tube is hollow. (I reversed the gradient direction, but that was not real enough, so I changed to a radial fill and dragged the center point up and left.)

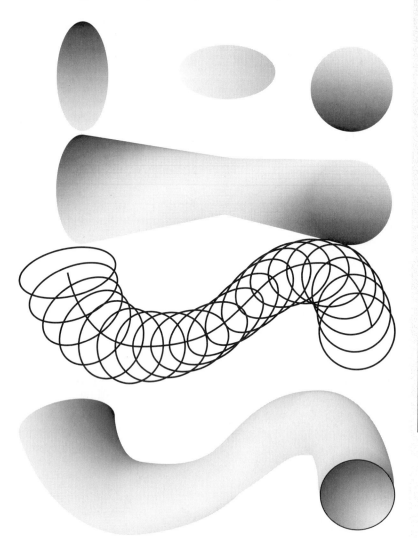

92

ASSEMBLING SHAPES INTO DESIGNS

THE PROBLEM WITH BLENDS ON A PATH

Since adding the blend attached to a path on the other page, I have developed a major problem. If even a corner of that graphic appears on my screen (even a handle), every operation ceases until the graphic redraws, and that takes 28 seconds. Yes, you read me right — a full half a minute! Basically I cannot work on that page now. Thankfully, I knew it was coming. So I finished the layout over there before I dropped the graphic into place. But it is certainly something to be aware of. Even on my G3 at school, the redraw on a graphic like this is nearly 10 seconds, and that's an eternity when you are trying to work.

page to something more interesting. Only computer geeks will stop to look just because it is an amazing thing done on a computer.

 TIP: The goal of any graphic is to communicate something specific to the reader of your project.

That being said, any blend can now be attached to a path. Any of the changes we have discussed can be made before or after the blend is attached to a path. This makes it relatively easy to create a shape like a tube moving through space. Who knows, maybe you are selling heating ducts!

 TIP: Strokes are almost always a problem with blends. Obviously, this is not true if you are blending one line to another. But if you are blending shapes, a stroke will normally cover up the changes made within the fills.

The major thing to consider as you gleefully contemplate the power of blends is WHY? The primary use of blends is to give the illusion of three-dimensional space. They are really the only method of adding irregular highlights to irregular shapes. The question you need to ask before getting involved too heavily in this is, "Should I really be working in Photoshop or a 3D illustration program?"

Remember the general area of graphic design we are dealing with in Freehand: lineart, inkwork, typographic manipulations. I am not saying that you cannot do extremely impressive, fully shaded illustrations in FreeHand. In fact, there are certainly times where the clean shading of FreeHand is exactly what is needed. What I am saying is, "Why would you want to do that?" There are a number of reasons, but "Wow, that really looks cool" is not one of them.

It is possible to draw a realistic image in FreeHand — just remember that every speck of dirt, every scratch, all litter must be specifically drawn by YOU. There are occasions when you really need the cleanness of FreeHand's images. Just remember to keep the complexity under control. If the number of paths rises above two or three thousand, you've probably merely made a mess.

Duplicating transformations

This is yet another of the areas where FreeHand has amazing capabilities. The basic idea is simple. If I EDIT>>CLONE (⌘=; PC: Control Shift C) a shape, group, or composite (giving me an identical copy exactly on top of the original), I can then apply up to one of every kind of transformation to that clone (MOVE, ROTATE, SKEW, FLIP, and/or SCALE) with the TRANSFORM panel. Then, by using the EDIT>> DUPLICATE (⌘D; PC: Control D) command, I can repeat those transformations for as long as necessary.

Of course, this is yet another capability that has to be kept under tight rein. Immature designers like to run wild with this type of thing. Remember, please! These capabilities only amaze PostScript

illustrators. So, if your client's readers are not illustrators, they will tend to see this merely as bad design and visual clutter. Duplicating transformations can make beautiful patterns, as you can see. I've done some wonderful snowflakes, for example.

TIP: The basic design rule always remains the same: "If you do not have a good reason to make a mark on the page – DON'T DO IT!"

Your primary use of duplicating transformations will be to generate grids, checkerboards, borders, and so forth. It is important that you remember the capability. There are times when this ability is almost a lifesaver (though that is probably a little strong).

Yes, I started with this shape: cloned, moved, rotated, flipped, and then duplicated 22 times.

OPERATIONS Panel {⌘⇧I or Control Alt O}

Although the entire list of operations is found in Appendix A, there are several path-combining filters that you will use regularly. These path-combining capabilities, found on the OPERATIONS panel, enable you to combine paths in ways that will greatly enhance your drawing production speed. They are the source of the power found in the Lens fills (found only in FreeHand 8).

In the older versions, everything done by the Lens fills must be done by hand; often using the path-combining power of the OPERATIONS we are covering here. In fact, if you need to work in spot color, this will be your only option no matter what version you have. In fact, as we will discuss in chapter seven, transparency in spot color is almost impossible.

The six operations we will cover now are simple in concept yet profound in application. They are the best method available to PostScript illustration to give the illusion of transparency. They also enable complex shape construction from basic geometric shapes. In fact, you will find yourself using them constantly. For example, it is almost impossible to generate realistic shadows that cross other shapes without using these path combination techniques.

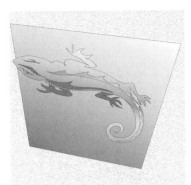

BASIC CONCEPT:

Many times it is much easier and faster to stack simple geometric shapes and combine them to get the more complicated shape you need for your drawing. You need to keep these capabilities in the back of your mind at all times.

Path combination options

We started with these three shapes. As we go through these operations, it is important to observe the layering of the shapes and the fills applied to each. Normally the attribute of the bottom shape selected will apply to the results. Also note that the PATH OPERA-TIONS CONSUME ORIGINAL PATHS preference is checked. If you need to retain the original paths, either work with clones or change the PREFERENCE. Obviously, this is part of the strangeness of working with a collage of shapes — the uniqueness of PostScript illustration.

• Union

Here you can see that all the paths became one path that is a combination of all of the shapes. The attributes of the bottom shape are applied to the newly combined shape. We have already discussed this operation in the "Getting Fast" exercise. It will almost always be necessary when trying to add a single overall fill to typefaces like script where the characters overlap. It is the fastest way to build a cross, a dunce hat, a silhouette, and many other shapes you will need.

- **Divide**

Here, in all of the places where the shapes overlap, separate shapes are generated so there is no longer any overlap. Please note carefully that the gradient fills get chewed up pretty badly. You will have to carefully fix your look after applying this filter.

- **Intersect**

Here all that is left is the tiny shape where all three shapes intersected. This is the key to transparency, because this intersection must be made of a combination of the colors of the original shapes to look transparent.

- **Punch**

Here the top shape punched a slot into the two lower shapes.

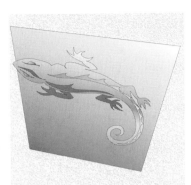

- ## Crop

Here the top shape cropped the two lower shapes. Note that the fill and stroke attributes of the top shape are completely gone. Also observe that the gradient of the middle shape still goes from side to side of the new shape. In other words, the colors were not cropped to reveal only the gray portions in the middle of the original gradient. This is the tool to use for RIPs where PASTE INSIDE does not work. This is yet another operation or command that has worked much better with each new version of FreeHand.

- ## Transparency

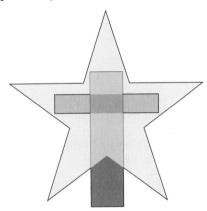

Here the top shape has been given the appearance of transparency by averaging the colors of it and the shape beneath according to the percentage chosen with the tool slider bar. Three additional shapes were generated. **NOTE: All fills were converted to Basic. In older versions, the tool simply won't work if there are any Gradient fills in any of the shapes.** Also, all of the intermediate colors will be process (FreeHand cannot mix spot colors except in blends).

As you can see from the examples above, these are handy tools. In older versions, you may be missing one or more of these operations. Some of them are so handy that you will almost certainly be adding keyboard shortcuts to them in FreeHand 8 (I used the Command-Option-Shift combination, plus the first letter, for mine).

Skill exam #2

Building a grid

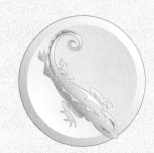

We start by creating a little tile. This is very easy to make. It is such a simple procedure that you will use it, or something like it, a great deal. Let's run through it step by step:

1. Draw a square with a quarter-point stroke and a graduated fill from light to dark, top left to bottom right.

2. Clone the square and, using the TRANSFORM panel, scale it down 85% to 95% (using the default centers). Change the stroke to white. Switch the two colors in the fill so the gradient goes from upper left dark to lower right light. This gives the illusion of delicately scooped tile with the light source to the upper left.

3. Multiple-select the two squares and CLONE.

4. Click on the selected squares and drag straight sideways (after the drag begins, hold down the Shift key) until there is a nice looking gap between the two tiles.

5. DUPLICATE (⌘D; PC: Control D) five times.

6. SELECT ALL, CLONE, click on one of the selected tiles, and drag straight down (holding down the Shift key) until the gaps around the tiles are even.

7. DUPLICATE (⌘D; PC: Control D) five times.

... and you are done!

Obviously a technique like this works for checkerboards, Italian tablecloths, floors, walls, and an infinite number of similar uses. You can SELECT ALL and use the 3D Rotation tool or the Envelope tool to move the tiles into position. You can play with the colors. Whatever you decide to do with the procedure, it has now become a part of your PostScript illustration arsenal of techniques.

What Fun!

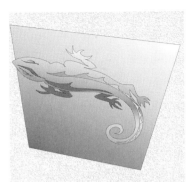

Paste Inside (Clipping path)

Although this is one of the most powerful features of FreeHand, it is another that has to be used with care. First of all, it adds a great deal of complexity. Second, there are RIPs (like the original RIP used for Agfa's Chromapress) that cannot handle this function. So, before you use it extensively, check with your printer to see if it works with the RIP you will be using.

 DEFINITION: RIP (Raster Image Processor) – is the computer in your PostScript printer, imagesetter, platesetter, or digital press that generates (rasterizes) the custom bitmap (raster image) for your output. This custom-generated raster image is designed to fit the resolution of your output device. Its abilities are controlled by the capabilities written into your PPD (PostScript Printer Driver) which works with your RIP. All RIPs have different capabilities depending on their PostScript level (1, 2, or 3) and whether they use a true Adobe PostScript or one of the many clones. As usual, be very careful of PostScript clones. There is a real reason why they are cheaper (they don't work as well).

 TIP: All RIPs are different. Often you will end up picking your service provider because of its RIP. For example, in my shop at school, we have a TrueImage RIP (Microsoft clone) that will not print either Quark or Illustrator files.

One of the reasons PASTE INSIDE is used so often is that it is so easy to understand. It seems to be a simple – and very powerful – cropping tool. In fact, it does not crop at all. It provides a boundary where the images pasted inside are revealed inside the path and not seen outside the path. However (like all clipping paths), the portions of the images that seem to be cropped are merely hidden. As far as the memory of your computer or your RIP are concerned, all you did was add data telling the printer not to print those areas outside the clipping path. To translate, this means you have added RAM requirements to your RIP and a lot of file size. As usual, there are rules to be obeyed.

Paste Inside Rules

1. You can only paste inside one path at a time.
2. That path must be closed.
3. That path can be a composite path, but the composite must be generated first. For example, if you want to use type to crop or mask an image using PASTE INSIDE, you must first convert the type to paths, ungroup down to the separate letters, (in the older versions you will also have to split paths until you are down to the

basic shapes and then select all the paths) and then join them all into a composite path.

The basic procedure is simple: Select the objects to be clipped and CUT (⌘/Control X) them to the Clipboard; select the clipping path desired; choose EDIT>>PASTE INSIDE. To edit the contents, you must first select the clipping path and then subselect the contents (Option key–Mac; Alt key–Windows), then edit as usual. You can use paths, shapes, text, TIFFS, and EPSs. To remove the contents, you must choose EDIT>>CUT CONTENTS. You can add additional contents by following the same procedure with the same path. They will appear in front of existing contents.

Here's a sample of the type of thing that can be done. In a postcard reminder of this little church outside a ghost town south of Santa Fe, this image may actually work. The procedure was simple. Type the word *Lonely* and adjust it to size. After carefully kerning, CONVERT TO PATHS; select each of the outside lettershapes and click the UNION button on the OPERATIONS panel; SPLIT PATHS until you can select all of the paths on the word (you'll have to turn off PREVIEW); then JOIN the entire word. Place the TIFF of the church over the word and CUT it to the Clipboard; then EDIT>>PASTE INSIDE. Use the small center handle to move the TIFF into position and add the rest of the type. It is fancy looking, but is it effective? That is for you to determine. I guess I'm old-fashioned, but I still like the straight photo better.

These path combination tools are simply part of your arsenal. You will find most of them invaluable as you run into the deadlines of real-world employment. It's a real shock to many graduates to discover that most graphics are not budgeted — meaning they have to be done very fast. It is not at all unusual to be forced to generate a competent graphic in twenty minutes or less. The power of FreeHand, with its ability to freely combine, edit, and manipulate paths, enables this to be a realistic and very common requirement.

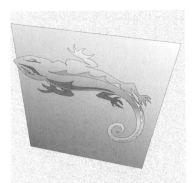

Knowledge Retention:

1. What is the most common use for a blend?

2. Why are composite paths necessary for type?

3. What are the primary differences between a group of shapes and joined shapes?

4. Describe how you would add a Gradient fill to a phrase of words so there is only one fill starting in the upper left of the phrase and finishing in the lower right.

5. Why would you need to use the transparency filter for shadows?

6. Describe a situation where the use of UNION, DIVIDE, PUNCH, INTERSECT, and/or TRANSPARENCY would help you produce an illustration or logo much more quickly and effectively.

7. What do you think are the main problems with pasting photos inside letter shapes?

8. What are the major problems with attaching gradient blends to a path, from a production point of view?

9. Describe a situation where attaching a blend to a path would help you communicate more clearly with your client's readers.

10. Why are strokes a problem when trying to create 3D shading through the use of a blend?

Skill Exam #3

This skill exam requires generating a blend, cloning and regenerating a cross blend, then adding type which is converted to a Graduated fill, Radial fill, and two graduated composite paths. The exam is found on your CD or the Website of this class.

Where should you be by this time?

You should have become relatively comfortable with the tools, panels, and interface of FreeHand. You should have practiced with every tool (at least a little). You need to have completed the skill exams and the miniskills. Those who are serious about this career will have done all of the optional exercises and drawn at least a few dozen drawings with the Pen tool to gain skill there.

At this point we have covered all of the tools except for the Xtras and Operations that are found in Appendix A. It is recommended that you go there and familiarize yourself with those capabilities also. From now on the gloves are off, as far as drawing is concerned. It will be assumed that you know the tools, panels, and keyboard shortcuts. At the very least you must know where to look to find them.

DISCUSSION:

You should be discussing uses for the path combination options. It should be clear by now that you will be using grouping constantly, and that this might not be advisable. It should also be clear that composite paths are a regular and normal part of PostScript illustration. The proper place of blends should be an interesting topic, plus the entire concept of the illusion of transparency.

Talk amongst yourselves ...

Chapter Six

Typographic Controls

Discovering the amazingly complex typographic capability of FreeHand

Chapter Objectives:

By teaching students the options and capabilities of FreeHand, this chapter will enable students to:

1. describe and list the reason for basic typographic practice
2. describe the different classes of type styles with their "normal" usage, advantages, and disadvantages
3. find any typographic capability of FreeHand
4. set complex tabular copy
5. generate simple graphics using type attached to a path.

Lab Work for Chapter:

* Practice with the various options.
* Miniskills #4 and #5.
* Skill Exams #4 and #5.

Typographic
Matters

Fact

Graphic design is rated as one of the top ten careers for the new millennium, in terms of growth and demand, by the U.S. government.

Type is not typed!

One of the major concepts of graphic design (often lost in the shuffle) is the centrality of the copy. Our entire idea is to communicate the client's product as the solution to the reader's need. More than 95% of this communication will take place through the words you place on the document. (If you don't understand this, you need to read books on advertising and design. We are not even going to attempt more than a bare-bones review of the field. Those written by David Olgilvy, among many others, are highly recommended.) This is why this book emphasizes type so strongly.

The standard proverb is that a picture is worth a thousand words. This is true, but it takes an exceptional picture to express exactly the thousand words necessary to produce the desired action on the part of the reader. These pictures can be created. However, they will take you lots of time and money plus the services of an exceptional illustrator or photographer. Even exceptional designers can rarely pull it off without needing additional explanatory verbiage.

In reality, writers are much more common than illustrators. The level of competence available in wordsmiths greatly exceeds the accessibility of visual accuracy among illustrators when it comes to communicating ideas. So, in the real world, you will be dealing with words, but we are talking about typeset, not typewritten, words. I will briefly go over the differences in a little bit.

Typography in general

It would be nice if I could assume that you have already had six credits in typography. However, it is common that you have never had any formal instruction in the basics. Although we do not have the time or the space to teach typography here, we do need to review the essentials. This is yet another place where you need to study (if you have not already done so). I am not talking about some of the overkill found in many schools, but a good solid basic knowledge of type. Probably the most fun to read is *Stop Stealing Sheep* by Erik Spiekermann and E. M. Ginger (Adobe Press, 1993).

You will probably find that the longer you work in graphic design, the more you will fall in love with type. As mentioned above, it is our major avenue of communication. Often, it comprises all of the graphic design of a piece. Yes, Toto, there are many printed projects that have no graphics. For the next few pages, we are simply going to review terminology and basic typesetting knowledge. This is by no means intended to be comprehensive, but it covers what you will need for this book.

Letterpress terminology

To begin with, most typographic terminology comes from letterpress. This is changing somewhat, for some unimportant words, but most of the present terms will remain. Before you can set type, you must be able to speak the language and understand the concepts.

A typical example is *leading* (pronounced like the metal). It would be better (or at least more accurate) to change the term to line spacing. For a number of reasons, that probably won't happen. Leading came from the letterpress practice of increasing the space between lines of type by adding strips of lead between the rows. These strips came in standard thicknesses: 1/2-point, 1-point, and so on. In letterpress usage, you could only increase leading and could never have line spacing that was less than the type size. That is no longer true with digital type, but the term remains.

We have gotten ahead of ourselves, however. Before we can continue, you need to know how letterpress type was sized and assembled. The visual aid to the right should help straighten this out. The major fact to remember is that letterpress type was cast metal. The letters were cut into dies and cast into blocks of metal. They all had to be the same height, thickness, hardness, and so on. You had to be able to fit them together into blocks that could be locked into place in the chase. If any letter was a lower height, it wouldn't ink up as you rolled the brayer across the surface of the type. If the rectangles didn't fit together snugly, pieces would fall out during printing. Much of our present type usage comes from factors that were determined by the physical nature of letterpress.

Pica Scale

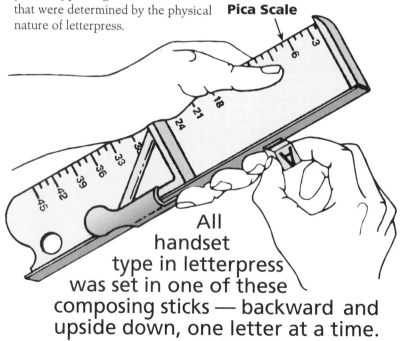

All handset type in letterpress was set in one of these composing sticks — backward and upside down, one letter at a time.

106

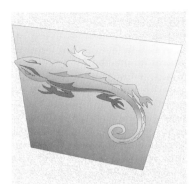

A slug of type was always .918 inches high and left enough room for the highest ascender and the lowest descender. This was because all type had to fit into evenly sized rectangles to line up properly on the composing stick. Some specialized terms no longer mean the same things. *Face*, for example, used to mean the actual printing surface of the letter. Now, in common usage, face often means a type style such as Helvetica or Times. The same is true of the word *counter*. A counter was the recessed area around the letter above which the face of the character protruded. Now it is usually used (if at all) as a term for the open areas inside a *P* or *e* or *g*, for example.

Composing type

We need to remember how type was set. All the slugs had to be placed in rows on the composing stick, one letter at a time. This is where the rectangles were built, and they had to be precise. If anything was out of size, the slugs would move or fall out as they were printed. There are hundreds of specialized terms used for all this equipment. If you are curious, read almost any book written on printing up to the present. An excellent one is *The Lithographers Manual* by GATF. Most of those terms are of mere historical significance now.

Nevertheless, many terms in your software are from letterpress. For example, the sizing of type remains the same — from top of ascender to bottom of descender, with the capital letters being slightly shorter than the ascenders. This was determined by the necessities of the composing stick.

AaBbGgQ

Everything has to fit in the same height!

Type height measurements are all measured from the baseline, as you can see on the next page. The baseline is the imaginary line that all the letters and numbers sit on. The x-height is the height of the lowercase x (the x is the only lowercase letter that is normally flat both top and bottom). Ascenders are the portions of lowercase letters that rise above the x-height, as in b, d, f, h, k, and l. Descenders are the portions that sink below the baseline, as in g, j, p, q, and y. The cap height is the height of the uppercase letters.

The reason that x is specified is that curves have to extend over the lines to look the proper height. Yes, it is an optical illusion. The same is true of letters such as A or V that have points. If the point does not protrude past the guidelines, the letter looks obviously too short. Even your readers, who normally know nothing about type, will know that something is wrong. Type design has many of these understandings that have become rules. We'll cover many of them as we continue. They are very important because most readers react to type subconsciously. You do not want to upset the reader.

Often different typefaces look very different in size, even though they are the same size. This is primarily due to variations in x–height and built-in leading. This x-height variation is one of the most important factors in picking a type style for your designs. The largest

dphyTx

Ascender

Cap Height

X–Height

Baseline

Descender

x-heights came from the 1930s and the 1970s. As the new millennium begins, the retro styles are dictating smaller x-heights again. For example, examine this graphic carefully. As you can see, font measure-

dpdpdpdpdp

All five of these very different typefaces are the same point size. They simply have widely varying x-heights and differing built-in leading.

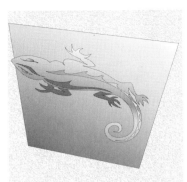

ments can and do vary widely. It is a waste of time to try to make sense of it. Type design is a completely unregulated industry. All you can do is be aware of the differences, and use them for your purposes, consciously picking type styles that communicate to your readers.

Dealing with points

By now almost all of you know that a point is a seventy-second of an inch. Again the point is an old letterpress term and measurement. Until the mid-1800s, all type foundries had their own sizes. These sizes were given common names, but there was no universal standard. Some of the names will still be familiar to you. Agate, for example, was a small size used for classified ads (5.5 point). Other common type sizes were diamond, minion, brenier, long primer, great primer, and canon.

Around 1875, a type salesman named Nelson Hawkes decided to rectify the problem. He came up with a measurement system based on one of the more common sizes, the pica. It happened to be 12 points high. In the early 1700s, King Louis XV had established the point as the standard type measurement for printers in France. By the time Nelson made his plans, there were two points: the European point, which was .0148 inches; and the American point, which was .0138 inches. Hawkes decided that 12 points should be called a pica and built an entire type sizing system upon picas and points. It was an immediate hit, and became the standard within a couple of decades.

Points are an excellent sizing tool. At approximately 72 points per inch, the smaller sizes of body copy can be clearly differentiated. Type that is one point larger or smaller is almost the smallest increment of size that can be distinguished with the naked eye. Today all type is sized in points.

One of the most recent developments in type sizing was brought about by the Mac. When Apple came out with the Mac and its GUI, they set the screen resolution at 72 pixels per inch. In the years since 1984, the 72-point-per-inch standard has become universal on desktop computers. The letterpress systems did not match inches at all. This caused amazing havoc for traditional pasteup artists and designers, whose art never fit the way they designed it. For years, many artists drew all their boards in inches, set all their type in picas, and tried to force things to fit (they often didn't). At this time the pica is disappearing, but points will probably stay.

Typographic measurements

Type size: Type size is measured from top of ascender to bottom of descender in points. Capital letters are usually approximately two-thirds of the point size, but a little shorter than the ascender. The x–height is normally around one-third. The most important factor in visual or comparative size is the x–height. Sans serif faces, in general, have larger x–heights.

Leading: Sometimes called line spacing, leading was tradition-
ally measured from baseline to baseline. In other words, leading was
the distance advanced to leave room for the next line, measured from
the baseline of the original line to the baseline of the following line. To
use typewriter imagery: when you hit the carriage return, the roller
advanced the distance necessary to allow the next row of type to be
typed without overlap. It was simple to calculate leading in traditional
typesetting by using a pica gauge.

Here software developers have messed us up. At present, every
application has different definitions for leading. FreeHand has bailed
out of the traditional entirely. We will cover the options when we go
through the Type Inspector, but thankfully it can all be adjusted
visually by moving the top or bottom handle of the text box.

This is not Typing 101!

I hope that, by this time, you have realized that "type" has
nothing to do with typing. It is obvious that the terminology is differ-
ent. However, we have hardly begun. Much more significant than the
new language are the actual mechanics of typesetting. The rules have
changed! In fact, one of the difficulties in publishing classes today
involves a paradox. 1. To get a job, desktop publishers have to be able
to type well. 2. Learning to type in a typing class teaches students so
many bad habits that you wonder if it is worth it. In fact, the standard-
ized keyboarding classes require many of these typographic errors to
receive a passing grade.

At this point, we're going to talk about a group of major differ-
ences. By then, we hope, you will be into the new paradigm enough to
notice the rest as we finish this section. It is very important to realize
that these differences are not minor quibbles. They have a major effect
on your ability to communicate with type. They are absolutely neces-
sary for professional document construction and career advancement.

If this is all brand new to you, read
The Mac (or PC) Is Not a Typewriter
by Robin Williams

1. No double spacing

Typing classes teach that one should always double-space after
punctuation. This was required by typewriter character design. All
characters on a typewriter are the same width, or monospaced. The
result is that sentence construction becomes hard to see. A double
space emphasizes punctuation and makes it visible.

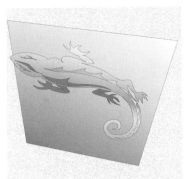

Typesetting, in contrast, is done with proportional type. This means that every character has its own width that is designed to fit with the other characters. Typeset words form units characterized by even spacing between every letter. In fact, professional typesetting is judged by this characteristic. What is called the *color* of the type is created by the even fit, which is called *letterspacing*. Professional type should have an even color (no blotchiness) when seen from far enough away that the paragraphs become gray rectangles. Double spacing after punctuation puts little white holes in the type color. Double spacing is no longer needed because the better-fitting words make punctuation a major break. In addition, there is extra white space built into the typeset punctuation characters themselves.

2. Fixed spaces

Spaces cause many other problems for people trained in typewriting. On a typewriter, the spacebar is a known quantity. This is because every character in monospaced type is the same width — even the space. This is definitely not true for type. In fact, in type, the space band is almost never the same width as it was the last time you hit the key. Worse, it cannot be predicted.

This is caused by several factors. The space changes with point size, of course. This is not a problem with typewriters, because they only have one size. More than that, word spacing is one of the defaults that should be set to your standards. Page layout programs give you very precise control over word spacing. Not commonly known is the fact that every font has its own spacebar width — there is no standard. Finally, word spacing varies with every line when setting justified copy. Here's how this works:

When you are setting a line of justified type, you determine a justification zone. When the last word that fits in a line ends in this justification zone, any remaining space in the column width is evenly divided and added to the word spaces in the line. If the last word does not reach the zone, the length of the zone is divided and added to the spaces in the line (any additional space is divided and added as letterspacing between every letter in the line).

What this means is that the spaces on every line are a different width in justified copy. More than that, they are different from paragraph to paragraph whenever size or defaults change. As a result, you never really know how wide a spacebar character will be.

This has been solved by using some more letterpress solutions. When type was composed, it was brought out to a rectangle no matter what the alignment was — right, left, centered, or justified. The characters used to do this were blank slugs, called quads, that were a little lower so they would not print accidentally. These quads came in three widths: em, en, and el. The el space is long gone; it is now called a thin space (if it is even available). Because FreeHand was marketed by

Aldus for so long, it uses the same special characters as PageMaker. In general, it also uses the same keyboard shortcuts, although many of them are not available.

Originally these characters were blanks the width of an M, N, and l, respectively. Of course, they were standardized. This is something you should memorize. These spaces are now defined as follows: an em space is the square of the point size; an en space is the same height, of course, but half as wide; a thin space varies (and you thought you had this one pegged). In FreeHand, the thin space is extremely narrow and can therefore be used for very subtle adjustments. It appears to be a fifth of an en or a tenth of an em. This extra-small thin space is the most useful I have seen.

These fixed spaces are used a lot. For example, they should always be used for custom spacing, because the spacebar can vary proportionally if you change the point size. Another fact to bear in mind is that numbers are normally an en space wide. This means that an en should be used as a blank when lining up numbers (an em for two numbers).

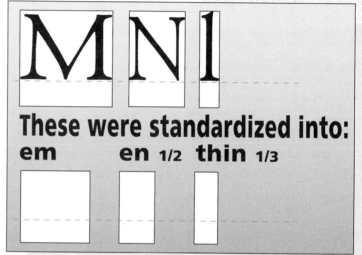

3. Tabs

Actually, custom spacing should normally be done with tabs. Typesetting tabs are much more powerful than typewriting tabs. They come in five kinds in Free-Hand: left, right, centered, decimal, and auto-wrapping tabs. All tabs can be set up with leaders. These leaders can be lines, dotted lines, or any repeating character you need. We'll thoroughly discuss tabs before the end of this chapter.

In general, get used to the idea that the spacebar should only be hit once. In fact, you need to be a little careful. On a Mac, any key that is held down will automatically repeat, including the spacebar. My students fight this, but in typesetting there is no legitimate use of the double space. Clients can, and will, bounce them as typos.

There is no legitimate use of the double space.

4. En and em dashes

The next major change we need to discuss is dashes. Typewriters only have one: the hyphen. Type has three: the hyphen, the en dash, and the em dash. All three have very specific usage rules.

Hyphen ‑ En Dash ━ Em Dash ━━

Hyphen: This is the character used to hyphenate words at the end of a line and to create compound words. A hyphen is used in no other places.

Em dash: This dash is an em long. It is a punctuation mark. Grammatically it is stronger than a comma but weaker than a period. Other than that there is no standard any more. American English is a living language in constant flux. These changes have accelerated in recent years. In many cases, there are no rules any more. Em dashes are used more every year. In many ways they are very helpful, but traditionalists tend to hate them. In general, all you can do is flag any doubtful use and go with your customer's opinion, right or wrong.

Typewriters use a double hyphen for the em dash. This is an embarrassing error to professionals. In fact, it is one of the sure signs of amateurism.

En dash: This dash is an en long. It is used with numbers, spans, or ranges. For example, pages 24–39 or 6:00–9:00 or May 7–12. It is a typo to use a hyphen in these cases.

Finally, do not think you will not be caught. Hyphens are about half as wide as an en dash. They are often higher above the baseline than en or em dashes. Also, they are often slanted with little swashes on the ends, whereas en and em dashes are normally rectangles.

5. No underlines

The next difference has to do with the physical nature of typewriters. Because they only have one size of type, there is no way to emphasize words except for all caps and underlining. Underlining is necessary here. In typesetting, underlining ruins the carefully crafted descenders. In addition, the underlines that come with the type are usually too heavy and poorly placed.

When copy to be formatted is received from nonprofessionals, underlined type is normally set in a bold face – unless it is the name of a book or periodical, in which case it is set in an italic font. If you decide that an underline is an appropriate solution, please use a narrow box or a hand-placed line, as in the following example:

Typing not Typing

The goal of typesetting is to make clean, elegant type that is read without distraction. Underlining is almost as bad as outlines and shadows as far as professionals are concerned. They ruin the unique

characteristics of the font. At times they serve a useful design function, but this kind of modification should be used very discreetly — and always intentionally.

In general, you should never use the character styling built into the computer: bold, italic, outline, underline, or shadow. They are a sure indicator that you have no typographic understanding. These styles were developed for crude, non-PostScript printers like 9-pin or 24-pin. Because this is crucial, we will cover this again in chapter ten.

6. No ALL CAPS

As just mentioned, all caps is the other way to emphasize words on a typewriter. Typesetting has many more options. There is *italic*, **bold**, SMALL CAPS; larger size, extended, and so on.

There is something else, however. Studies have shown that type in all caps is around 40% less legible than caps and lowercase or just lowercase. All caps is also much longer than the same word set caps and lowercase. Because our major purpose is to get the reader to read our piece and act on the message, you should never use all caps (unless you have a good reason). For example, caps can be used very effectively to de-emphasize a line of copy. All caps in six-point type was a standard method used to keep people from reading the small print on unscrupulous contracts.

By the way, all caps reversed is even less legible. In fact, text set that way will not be read unless you force the reader graphically with size, color, or some other such ploy. Sometimes this can be used to the client's advantage. For example, you will regularly see the antismoking warning on cigarette ads set small, all caps, reversed out of a gray box.

7. Real quotes and apostrophes

Here is another place where typewriters are limited by the lack of characters. All typewriters have is inch and foot marks (technically they do not even have that, but use prime and double prime marks). Quotation marks and apostrophes look very different. This is another typographical embarrassment when used wrongly.

Inch/foot' " Open/close quotes' ' " "

An apostrophe is a single close quote.

8. Kerning and tracking

Here is another typesetting capability that cannot even be considered by typists. We mentioned letterspacing earlier. Letterspacing has a peculiar meaning in digital typesetting, much like leading. This is caused by the fact that with hot type you could only space the slugs apart by inserting slivers of metal. Digitally, anything can be done — and often is.

Tracking is the official term used to replace letterspacing now that we can move letters either closer together or farther apart. In

reality, either term can be used and understood. The actual procedure simply inserts or removes space around every letter selected or affected. In typical software programmer style, FreeHand uses a digital invention called RANGE KERNING which is measured in % em and applied to selected type.

Although RANGE KERNING is used all the time by typographic novices, it is despicable to traditional professionals. Quality typefaces have the letterspacing carefully designed into the font. Changing the tracking for stylistic reasons or fashion changes the color of the type at the very least. At worst, it can make the color splotchy. It always reduces the readability, which is certainly a mortal sin.

Kerning is a different thing altogether. Here the problem is with letter pairs. There is no way to set up the spacing around letters to cover all situations: AR is a very different situation than AV; To than Tl; AT than AW. Literally thousands of different kerned pairs are needed to make a perfectly kerned font. Most of them can only be seen at the larger point sizes. Some pairs kern together and some kern apart.

Quality fonts have kerning designed into about a thousand letter pairs. In addition, all professional publishing programs allow you to adjust kerning for individual pairs. FreeHand gives you keyboard shortcuts. ⌘–left arrow and ⌘–right arrow (PC: Control Alt) move letters 1% of an em. Adding the Shift key moves the letters 10% of an em. The best way to show the basic difference is seen in the illustration to the left.

Normal: Edges of character slugs touch	Awkwardly
Tracking: All letters are moved equally	Awkwardly
Kerning: All pairs are adjusted	Awkwardly

As a graphic professional, you are expected to kern everything over 14 point or so – certainly all head-lines and subheads. It is entirely normal to spend fifteen minutes to a half hour getting the letterspacing perfect for that logostyle or headline. In fact, in FreeHand it is not at all uncommon to kern the best you can and then convert to paths and modify some of the lettershapes so they fit even better.

9. Use returns only at the end of paragraphs

It seems stupid to have to mention this, but it has become a real problem once again. The culprit is HTML and text copied and pasted off the Web. Every line will have a return at the end of it. If you have a lot of copy you need to use EDIT>>FIND & REPLACE>>TEXT. Search for line breaks (^n) and replace them with spaces. Then search for para-graph breaks (^p) and replace them with spaces or returns as needed. The only returns left should be the returns at the ends of paragraphs. If you need a return without ending the paragraph (a line break), use the soft return (Shift Return).

10. Be careful with hyphens

Because typeset line endings are automatic, so is the hyphenation. You can turn it on or off. Hyphenation in FreeHand is done by dictionary, which is the best method. Always make sure that you add the proper hyphenation when adding words to your user dictionary by typing in the appropriate discretionary hyphens. Look for bad line breaks caused by unhyphenated words. If necessary, add discretionary hyphens using ⌘ Hyphen (PC: not available). These must be used to cause words to break where they should. Proof very carefully: cleaned is not acceptable (or the many others of its ilk).

Another problem is that automatic hyphenation can create hyphens for many consecutive lines. Here there is sharp debate. Most of us agree that two hyphens in a row should be the maximum (a three-hyphen "stack" looks odd). FreeHand allows you to set that limit.

Yet another problem comes when you run into something like two hyphens in a row; then a normal line; then two more hyphens. The final problem comes when the program hyphenates part of a compound word. Be careful with hyphens!

11. Eliminate widows and orphans

As Roger Black states, "These are the surest sign of sloppy typesetting." A widow is a short line at the end of a paragraph that is too short. What is too short? The best answer is that the last line must have at least two complete words and those two words must be at least eight characters total.

Bad widows mess up the type color. They allow a blank white area to appear between paragraphs that stands out like a sore thumb. There is no way to eliminate them except by hand. The best way is editorially. In other words, rewrite the paragraph! However, graphic designers do not often have such editorial authority. In that case, you must carefully adjust the hyphenation, point size, word spacing, or tracking (in that order).

You must be gentle or your corrections will stand out worse than the widow. The point size should never be changed more than a half point, for example. Always make your changes to the entire paragraph. Extremely short paragraphs cannot be fixed, except to "break for sense." This means placing soft returns so that each short line makes sense by itself (as much as possible). This is especially true with headlines and subheads. Widows can make headlines look like they are balancing on a point – which causes visual tension, makes the reader uncomfortable, and may cause the reader to go elsewhere for a more friendly, relaxing read.

Do not confuse widows with orphans. An orphan is a short paragraph or paragraph fragment left by itself at the top or bottom of a column. A classic example is a subhead left at the bottom of one column with the body copy starting at the top of the next column.

THE CHICAGO MANUAL OF STYLE prefers A.M., but it accepts AM.
The use of small caps is required, assuming your equipment is capable of creating or using them.

FreeHand allows you to control this fairly well with its KEEP TO-GETHER ■ SELECTED WORDS option (found on the Type Spacing Inspector). Orphans are normally a two-line minimum, either top or bottom of a column.

The absolute worst orphan is a widow at the top of a new page. Other horrible typos are: widow at the top of a column; subhead at the bottom, as mentioned; a kicker separated from its headline; and a subhead with one line of body copy at the bottom of a column. These errors must be eliminated at the proofing stage. This is what we mean by massaging a document into shape. Corrections like these are among the primary factors that cause people to react to a design. If they are missing, the design is classed with amateur productions like school and bureaucrat output.

12. Use real small caps

Small caps are a specialized letter form. Correctly speaking, they are little capital letters, a bit larger than the x-height, that are designed so they have the same color as the rest of the font. Here you have to be careful, again. FreeHand creates small caps by proportionally shrinking capital letters. THIS MAKES THEM APPEAR TO BE TOO LIGHT. The best method is to use fonts that have custom-designed small caps (they usually have lowercase numbers also).

There is one place where small caps are not an option. This is with times. The appropriate typographic usage is not 9:00 A.M. or 9:30 AM or 9:45 a.m., but 9:53 AM. As far as I know, AM and PM are the only two words where small caps are required.

This has been a small review of type usage

The Chinese showed their wisdom again by considering calligraphy to be the highest form of art. Once you understand type, you will see its beauty. Well-drawn type is absolutely gorgeous. After a while, you begin to understand why some of the best graphic designs are simply type. Excellence in typography is invisible to most readers, but it adds grace, elegance, and trustworthiness to your designs.

Three categories of people produce words on paper – typists, typesetters, and typographers. We have been discussing the first two. Typographers make typesetting an art. You should now have an inkling of how difficult that is. They are some of the finest artists in existence.

100,000 type styles...

Now that we have briefly discussed typesetting, we need to quickly review the typefaces themselves. There are many classification systems for type. For the purposes of this book, there are five classes: serif, sans serif, script, text, and decorative. It would probably be acceptable to combine script and text or even script, text, and decorative, but these five categories have served well over the years.

Bringing it into perspective

Out of the 100,000 faces mentioned earlier, only 1,000 or so are used all the time by many people. Out of those, there are about a hundred or so serif fonts that a majority use for body copy and another hundred for heads and subheads. There are a huge number of decorative faces. Most of these are unsuitable for serious work. Many are totally illegible on a practical level. Probably 30,000 are multiple-derivative, differently named copies of the 200 popular fonts. So it isn't as scary as it sounds – quite. However, you will have to learn to recognize several hundred fonts by sight. It will help a lot to learn some of the history. That way learning Baskerville will cover that style plus its three or four dozen derivatives.

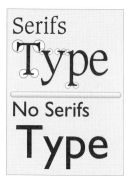

Serifs
Type

No Serifs
Type

First, we must define a serif

A *serif* is a flare, bump, line, or foot added to the beginning or end of a stroke in a letter. I'm sure you already know this, but do you know their importance? They seem totally insignificant, but they certainly are not. They strongly influence how we react to type. In fact, on a subconscious level, serifs can be one of the most powerful influences on the reader's perception of the product. Most people are totally unaware of the effect type styles have on their lives.

Reading has many habitual associations. The type read during or about an occasion takes on the flavor of those events. To be functional in modern American society, we must read, and we do it constantly. Each of us reads thousands of pieces every day. In our homogeneous, franchised society, most of us see the same things every day.

The result of all of this is that virtually every person in the United States has similar reactions to various type styles. This has greatly accelerated as we enter the twenty-first century. For example, Century Schoolbook is a very common serif typeface. In fact, many (if not most) reading primers are set in Century (hence the name). As a result, people who read well and like to read have very positive reactions to this face. An additional effect is that most people find Century Schoolbook very easy to read.

Almost every good book you have ever read was set in serif type. Virtually every textbook was also. All body copy from before the 1950s was serif. Because of these things, serif typefaces are perceived

Baskerville

ABCDEFGHIJKLMNO
PQRSTUVWXYZ
abcdefghijklmnopqrst
uvwxyz 0123456789

One of the great classic serif faces by John Baskerville, cut in 1757.

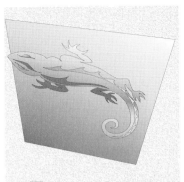

Helvetica

ABCDEFGHIJKLMNO
PQRSTUVWXYZ
abcdefghijklmnopqrstu
vwxyz 0123456789

The first widely
fashionable
sans serif typeface.

as warm, friendly, nostalgic, and easy to read. Designers began to use these connections consciously during the 1940s and 1950s. As a result, serif faces are used almost exclusively in ads promoting quality, stability, good value, integrity, and warmth. They are also used to reinforce family values, patriotism, and the emotional content of character traits considered positive by our culture. Serif faces produce these types of reactions in the reader (at least subconsciously).

Sans serif is relatively new

Even though sans serif faces have been around since at least the nineteenth century, they were never popular until the 1950s. Up until then, they were used extensively only by the modernist, Bauhaus movement in Germany during the 1930s, where geometric type was promoted as modern. Futura is a classic example of this style. Most people saw them as plain and unadorned or aggressively modern. Ties to Germany during the time of Hitler's ascent are not friendly.

In the late 1950s, Helvetica became extremely popular. It was designed by Max Miedinger in 1957 and was quickly accepted as a new standard type style by many in the business, scientific, and advertising communities. Most logos from that period (like CBS, Exxon, and many others) were created with Helvetica or modified Helvetica. Sans serif faces, in general, became de rigeur for scientific publishing. It is likely that many of you have bad memories from physics and math books set in sans serif.

Businesses of the time saw sans serif faces as modern, clean, cool, unemotional, and businesslike. Recently, there has been a fad among the avant garde computer byteheads of setting body copy in sans serif. They use distorted, condensed versions, but they fit the stereotypical usage pattern. Their usage is more a rebellion from convention, which fits nicely into the gestalt of sans serif usage.

Again, graphic designers have consciously reinforced these reactions. At this time, sans serif faces can be used effectively to produce these feelings and responses. The usage was almost unanimous until desktop publishing brought in designers with no design education. So the reactions are predictable enough to be very useful. Sans serif faces are clean and mechanical. Serif faces, in general, are more elegant and "beautiful."

The Times/Helvetica problem

One of the more interesting phenomena of digital publishing is the use of Times and Helvetica. Although these are very well-designed typefaces, their excessive usage resulting from their specification as

the default fonts in so many applications and operating systems has completely changed their perception in the mind of the "typical reader." At this point, most serious graphic designers avoid these two fonts like the plague. As a result, the only place people see them is in output by people who are untrained in publishing and simply use the software defaults — think schools, bureaucracies, the IRS, collection agencies, and the like. Because of this uncaring usage, Times, Times New Roman, Helvetica, Geneva (Apple's system font), and Ariel (a Microsoft version of Helvetica) have been virtually ruined for serious use by designers.

Can you read it?

We mentioned that serif faces are considered more readable. This is probably due more to their overwhelming use as body copy than any other factor. However, there is good reason to believe that the serifs do provide more distinctive letter shapes. The serifs also help the eye follow the line of type across the column, making body copy easier to read. Whatever the reasons, serif typefaces are clearly easier and more comfortable to read.

Studies have shown, though, that sans serif faces are more legible (as opposed to readable). What this means is that for short bursts, sans serif type can be grasped more quickly. As soon as several lines are read, this effect is lost. The eye becomes tired, wanders, and loses the ability to easily find the beginning of the next line. You can compensate for this effect by increasing the leading. Typically, people just quit reading sans serif body copy. Typically, you should pick a serif for body copy and a sans serif for heads and subheads.

For things like billboards and outdoor signage, sans serif is often the best choice. (Especially with billboards, where the rule is a maximum of eight words.) The difficulty, of course, is finding a sans serif that is warm and friendly with trustworthy overtones.

I WANT SOMETHING FANCY!

And all the rest?

What about all the type that is neither serif nor sans serif? First of all, proportionally there isn't that much of it. Decorative is the term for the miscellaneous grab bag, but most of it is either serif or sans serif anyway. Decorative type is defined as typefaces that are so highly stylized that they cannot be read in body copy sizes. For that reason some people call this category display. Display is the term used for the large, splashy ads in newspapers, as opposed to the classified ads.

You need to be very careful in the use of these fonts. Legibility is the obvious problem, but that can usually be solved by size and location. Simply making them 36 point or larger is often enough. Some of the more complicated and/or abstract faces must be used several

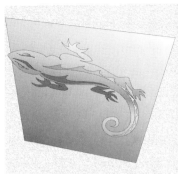

inches tall. Often they work only for posters and billboards. Here you need to understand that, for these pieces, body copy may have to be 2 inches instead of 10 point. To be readable at fifty feet, decorative faces might easily have to be two feet tall.

It goes beyond that, though. Circus type and western or Victorian type are commonly so fancy that they defy classification. Decorative faces can have shadows, fills, outlines, inlines, or any combination of these attributes. Sometimes they are three-dimensional. But even Hardwood is considered decorative, though it is merely a stylized sans serif. Old Towne and University Roman are a bit more obvious. However, they are still relatively legible, especially at the larger (display) sizes.

The good thing about decorative fonts is that they have very specific connotations. Fonts are available in art deco, art nouveau, Victorian, and almost any other artistic or decorative style of the past several centuries. They are the best (and usually the easiest) method of promoting an instant, emotional, stylistic reaction from the readers to your design.

Handwriting

There are two other general classifications that must be considered. Script and text fit nowhere and must be dealt with separately. Basically they are both handwriting. Script is modern handwriting. Text is medieval handwriting. Text is also known as Blackletter. Blackletter was used in Germany until the Second World War. How they could read it fast is beyond me.

The 1950s saw an explosion of script styles. This was primarily due to the fad for hand-drawn headlines brought about by photographic pasteup. The problem with scripts is making the letters match up. This is one place where you have to watch the tracking very closely. The letter forms are designed to overlap precisely. If the tracking is too loose or too tight, they miss each other. Last chapter I showed you the basic procedure with the word *Getting* in "Getting Fast." In truth, this is one of the major benefits and uses of FreeHand. It is very easy to fix scripts so they fit.

Old Towne #536
ABCDEFGHIJKLMNOPQRSTUVWXYZ 0123456789
abcdefghijklmnopqrstuvwxyz

Hardwood
ABCDEFGHIJKLMNOPQRSTUVWXYZ
abcdefghijklmnopqrstuvwxyz
0123456789

University Roman
ABCDEFGHIJKLMNOPQRSTUVWX
YZabcdefghijklmnopqrstuvwxyz
0123456789

121

type type type
Too tight Too loose Correct

Because script and text are so difficult to read, both of these categories have very restricted usage. In fact, they are limited to products where people are extremely highly motivated to read them, like invitations, greeting cards, and the like. Occasionally you may find a use for them as headlines or banners or other such items, but you must always be aware of reading difficulty. Use all the tricks you can muster to enhance readability, such as emphasizing with white space, large sizes, extra line spacing, and so on.

Italics and obliques

One original standard for type is the carved type in Roman columns honoring emperors' great deeds. They are still the classic standard, and the reason why many old-time pros call vertical faces "Roman." You should check out fonts like Trajan, Augustinian, and their ilk. The problem with these carved letters was that they were all caps. Lowercase letters crept in as people wrote the words. As they wrote faster and faster, what we now call lowercase letters developed out of the handwriting of the day. The second time this happened was in Italy in the early Renaissance. In Venice, a man named Aldus Manutius developed a font based on the handwriting of his day, which he called "Italic." It became very popular, but because of the slant of the letters, it was not as legible – and still isn't.

In this day and age, every normal vertical style (sometimes called roman) has a matching italic: Diaconia Roman foxy, *Diaconia Italic foxy*. As you can clearly see in these six words, italic is a very different font. The *a*s, *f*s, *x*s, and *y*s show the most obvious differences. One of the aberrations of the digital age is a new phenomenon of fake italics called oblique. These are not true italics, but merely slanted roman characters. Obliques drive type purists nuts!

Remember, legalism kills

The factors discussed so far in this chapter have to be considered, but they cannot become rigid rules. If you have a good reason, ignore the rules. Make sure you do it on purpose, though. The relationships described here are real and they work on a practical, predictable level. You ignore them at your own risk. Some fields, like snowboarding, try to require that you break all rules (but that's just another rule). Many have strict requirements – often unwritten. For example, accounting firms will occasionally ask for something special. But, even then, they usually approve only small formal type, caps and small caps, huge leading, centered designs (usually Copperplate). The main thing is to be conscious of what you are doing and why. As the designer, you are responsible for every mark on the sheet. If you cannot think of a good reason to use it, delete it!

Your task is to control the reader's eye, directing it to the message.

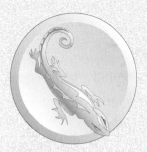

UPPERCASE AND LOWERCASE are letterpress typesetting terms. Originally, there were capital letters and minuscules.

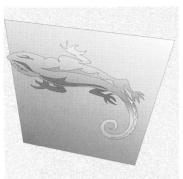

Some guidelines

Before we go on to FreeHand's tools and panels, here are some techniques to help you control the flow of text and the reading order :

- Lines of text more than ten or twelve words long make it difficult for the eye to track back and forth. You should use columns.
- Indents at the beginning of each paragraph create a visual cue that a new thought is being introduced.
- Drop caps tell the reader, very effectively, where to start.
- One of the most important elements to control is contrast: serif versus sans serif; light versus bold; large versus small; simple versus ornate; and so on.
- You need to consciously and carefully guide the reader's eye through the document.

Much of this is obvious stuff, once you become aware of it. Common sense plays an extremely important part in design. If you look at the piece and you have to concentrate to read it, readers certainly will not bother. Examine what you are doing, carefully. You will find that you have solved many problems without having to call in "expert" advice.

FreeHand's typographic tools

The place to start is the Type Inspector, which has five buttons that include all of the typographic options. We will do this to get it over with. In reality, you will rarely use the Type Inspector. It contains all of the typographic page layout capabilities that should properly be done in PageMaker, QuarkXPress, or InDesign.

It is true that FreeHand can vertically justify columns, balance column length, set indents and styles, adjust paragraph spacing, and add paragraph rules (plus virtually everything else that can be done by professional page layout programs). It can even do fancy things like hang punctuation, copyfit text automatically, set up columns and rows with or without rules, and so on.

One problem is that all of these options require such a large quantity of copy that you are really much better off in one of the three page layout programs mentioned above. FreeHand is superior for short, one- or two-page, graphics-intensive designs. It really excels in display ads for newspapers and magazines.

The other problem with the Type Inspectors is that most of the options in them are more easily controlled in other places. In the Type Character Inspector to the left, for example, font choices, point size, alignment, and leading are much easier to deal with in other ways. The toolbar contains all of these options, and both size and leading are much easier to control by dragging handles on the text boxes (which we will play with in a bit).

Three options in the Character Inspector are available nowhere else. RANGE KERNING and BASELINE SHIFT must be done here, and you will use these options a lot. The third set of options, EFFECTS, is yet another of those nouveau riche temptations that only serves to conclusively prove that the person using the effects has no sense of taste or style or class.

This is especially true of the ZOOM EFFECT, but the others are just as bad. It's not that the effects are so horrible; it's just that there is almost never a legitimate reason to use them. Effects like HIGHLIGHT, SHADOW, STRIKETHROUGH, and UNDERLINE are better drawn by hand *IF* you should ever come up with a genuine need for that type of style. As you can see, the INLINE effect merely makes type less legible. So, as usual with most fancy abilities, the question always has to be, "Why?"

The rest of the Type Inspectors can be quickly examined. But remember, when you get into them, the instant question ought to be, "Should I really be in page layout?" For example, with the Paragraph Inspector to the right, you may occasionally use the space above or below paragraph (if you have that many paragraphs). But the indents are far easier to control with the text ruler that automatically appears above every text box as you type. The RULES option is extremely clumsy. You are better off to hand-draw them. However, this is the only place to deal with hyphenation or to

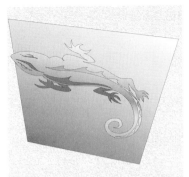

TYPOGRAPHY, TYPE INSPECTOR, AND TYPE MANIPULATION

hang punctuation. But then, how often are those options really needed?

The Type Spacing Inspector would seem to be a little more useful. But, as we will see, it is almost never used except to set up word and letterspacing defaults. HORIZONTAL SCALE will almost always be accomplished by Option–dragging a text box corner handle (PC: Alt–drag). The standard SPACING % values seen to the right work all right. However, I agree with Dan Margulis when he suggests values of 75, 95, 150 instead of 80, 100, 150 for word spacing, and –3, 0, 15 instead of the –10, 0, 10 for letterspacing. This will give better type color and more professional spacing for the longer paragraphs.

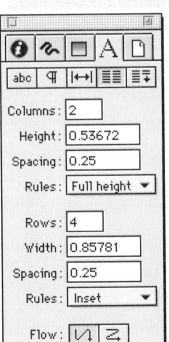

This is also where you can force FreeHand to keep selected words or lines of type together to avoid orphans. Because that only applies to multi-column pages, you will be dealing with this in environments designed for this type of control most of the time (PageMaker, QuarkXPress, and InDesign).

The Type Column and Row Inspector is yet another set of options better exercised in other software or with the tabs in the text ruler on the top of every text box in FreeHand. Tabs are much more flexible and much easier to use in actual practice. This Inspector obviously has powerful controls, and there will be rare occasions when this solves a real design problem you face. But the operative word is rarely. You should, however, remember that this option is available for those times when you do really need it.

The final Type Adjustment Inspector is yet another amazing option that sounds wonderful, yet leaves a bad taste in the mouth. It allows you to take a multiple-column setup and make all of them the same length. This can obviously be very handy, but be careful of the MODIFY LEADING option. Leading differences in side-by-side columns are very obvious and visually irritating.

COPYFIT % promises to make your copy fit an area or a shape. It is primarily helpful when you have copy flowing inside a shape. However, copy flowing inside a shape is very difficult to read and therefore violates ABSOLUTE GRAPHIC DESIGN RULE #1:

"It must be easy to read!"

FIRST LINE LEADING gives you control over the distance from the baseline of the first line of type to the top of the text block. Why?? There are so many easier ways to deal with this "problem" (if and when it ever arises) that I won't even bother to tell them to you. Remember that text blocks in FreeHand are simply graphic parts that can be moved anywhere they are needed and aligned using the ALIGN panel. This is yet another of those things that the engineers at Altsys added to help convince you that FreeHand is really page layout software. It is that, of course, but all of us who have FreeHand also have PageMaker, Quark, InDesign, or all three — and they work so much better for page layout!

The text toolbar

If you look at the recommended customized toolbar for version 8, you will see that FONT, POINT SIZE, LEADING, and ALIGNMENT are already there. Many of the other Inspector options can be added also, if you desire. In the case of type, you will find the toolbar much more expeditious than the overly complicated Inspectors. However, the real power of FreeHand's typographic controls is found in the text block itself. You really are enabled to treat type as a graphic.

The text block

Every time you click with the Type tool outside an existing text block, you get a new text block set to the defaults (which are normally changed to the last type you set). This text block is so powerful that

This text block is an object of amazing typographic power.

This text block is an object of amazing typographic power.

This text block is an object of amazing typographic power.

This text block is an object of amazing typographic power.

127

basically all you have to do is choose the font you wish to use. Size, leading, scaling, horizontal scaling, tracking, word spacing, and paragraph spacing can all be intuitively controlled by simply selecting the text block with the Selection tool (usually by merely holding down the ⌘ key [PC: Control]). Once the block is selected, it can be resized at will by click-dragging on any of the corner handles with the Option key (PC: Alt) held down.

This is what was done to transform the top text block below to the second block down. Notice that the second block was resized non-proportionally. If you desire to keep the type proportional, simply add the Shift key in either platform. Here, I enlarged both the point size and the horizontal scale with a quick click-drag until it "looked right."

Next I decided that the letterspacing looked a little wide. So, I click-dragged the right center handle to the left until I liked the appearance. If I had wanted to change the word spacing instead of the letterspacing, all I would have had to do is add the Option (PC: Alt) key after I started the click-drag. Often, I quickly do both.

I decided that the leading was a little too large. So, I click-dragged the bottom center handle up until it looked good. If I had multiple paragraphs, and wanted to add space between the paragraphs, I could simply click-drag down, adding the Option (PC: ALT) key to increase the paragraph spacing. If the line breaks are a problem, I can add soft returns or simply click-drag any of the corner handles. To make the text block handles fit the type as close as possible, simply double-click on the little box below the lower right handle with the selection tool.

So the basic typesetting procedure in FreeHand is to simply pick a font, type in the words, and then manipulate the text block with the selection and/or transformation tools until it fits the shape you need for your design. Needless to say, this makes the assembly of multiple-word logos and graphics an amazingly quick process.

Sometimes, however, you need to add tabular materials, bulleted lists, or custom indents. With FreeHand's typical production insight, these controls are always attached to the top of your text block whenever an insertion point is flashing inside that text block. It is a visual irritant, but it goes away as soon as you deselect or change tools. You will get accustomed to it very fast.

The text ruler

This ruler should be very familiar to you. It is very similar to the tab rulers found in Word, WordPerfect, PageMaker, and Quark. The measurements are in the measurement system you have chosen (inches, millimeters, points). The

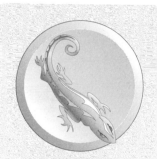

little black triangles pointing right are the default flush left tabs every half inch. Interestingly, this half-inch standard remains even if you are in millimeters (about 12.75 mm) or points (36 points).

The split triangle to the left (or the two little right-angle triangles on top of each other) set the left indents. The bottom one is moved first to set the left indent, and then the top one is moved to set the first line indent. As always, you move the left indent to the right and then move the first line back to the left, placing a flush left tab on top of the left indent to create a hanging indent for bulleted or numbered lists. The right triangle to the far right sets the right indent.

Above the ruler are the buttons that allow you to choose the five different types of tabs — yes, five instead of the normal four. In addition to the normal left, right, centered, and decimal tabs (that you are already familiar with), FreeHand has added an automatic wrapping tab. This lets you tab straight across from Product Number to Quantity to Description to Price while allowing the description to take up as many lines as it needs. Here's an example to the right. Some kind of party ...

It will take you a little while and a little experimentation to get comfortable with the wrapping tabs, but they are a wonderful addition to our typesetting tools and available nowhere else! It makes it worthwhile to set tabular matter in FreeHand and import the graphic into PageMaker or Quark.

Party Supplies:

PRODUCT #	QTY	DESCRIPTION	PRICE EACH
1. XT345	6	Tubular electric vibrator, 110V, stainless steel, 2" x 36", w/knurled rubber tip and rosewood handle	$75.37
2. VPM23	45	Stir rods, glass, 24 inch	$1.23
3. STY312	2	Mixing vats, vulcanized rubber, acid resistant, 18"H x 4' x 9', top edges rolled rubber reinforced with .25" steel rod	$1,322.75
4. PUU22	144	Formaldehyde, 1 gallon, brown glass jars with glass stoppers	$37.00

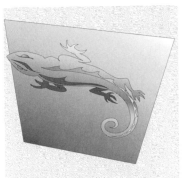

TYPOGRAPHY, TYPE INSPECTOR, AND TYPE MANIPULATION

Skill exam #4

This is the little tab exercise that you see on the lower portion of the opposite page. The fonts used are not important. The only thing that matters is that you can see how to set up a complicated tabular text block and then do it.

As you can clearly see, except for the headline, everything is in one text block. For a project like this, it is important that you begin with a text block large enough to hold all of the tabs. This way you can set up tabs for the first line that will apply throughout the block of type. So here's the procedure:

1. Open a new document and save it to a place that can be found by your replacement (if you call in sick tomorrow).

2. With the Text tool, click-drag to marquee an area large enough to hold all of the tabs (about 5"W x 4"H).

3. Begin click-dragging on the appropriate tab button to drop tabs on the upper half of the text ruler on the following locations: Left 3/16"; Left 7/8"; Wrapping 1 1/4"; Wrapping 3 1/4"; Wrapping 3 3/8"; and Right 4". Then simply type in the copy. The two extra wrapping tabs at the end of the *Description* are necessary to make it work. For example, with the first item (the vibrators), after the word *handle* you will have to tab to get out of the wrap, tab again to initiate the next tab, and tab again to go to the flush right starting point for that last tab. After you have entered the dollar figure, hit the Return key to start the next item. The first line is very small to make the words fit.

PRODUCT#	QTY	DESCRIPTION	
1. XT345	6	Tubular electric vibrator, 110V, stainless steel, 2" x 36", w/knurled rubber tip and rosewood handle	$75.37
2. VPM23	45	Stir rods, glass, 24 inch	$1.23
3. STY312	2	Mixing vats, vulcanized rubber, acid resistant, 18"H x 4' x 9', top edges rolled rubber reinforced with .25" steel rod	$1,322.75
4. PUU22	144	Formaldehyde, 1 gallon, brown glass jars with glass stoppers	$37.00

4. Add the decorative elements. "Party Supplies" is obviously converted to paths and filled. The other elements are just rectangles arranged under the tabular matter.

5. *Enjoy!*

129

Attaching to path

Here is yet another place where FreeHand far surpasses its competition. Type can be attached to any path, open or closed. Once it is attached, the type can be aligned to the path by ascender, baseline, or descender. The characters themselves can be set to ROTATE AROUND PATH, VERTICAL, SKEW HORIZONTAL, or SKEW VERTICAL. The type remains editable at all times for typos, tracking, kerning, baseline shifts up or down, and font or size changes.

One of the more important features of ATTACH TO PATH is a little thing. If you are binding to an ellipse, you can type in the copy to go around the top and then hit a return and type in the copy to go around the bottom. The type, both top and bottom, remains upright and readable. This little trick is used for circular logos with the motto running around outside the circle, for example.

SKILL EXAM #5
This exam is on the CD. It's very similar to Miniskill #4, but it's much more lockstep. It is a required exam.

Miniskill #4 — Extra credit

This will be a rough one for several of you. Ask the instructor to demonstrate, if necessary. There will be no visual aids this time, just a list of instructions:

1. On the standard default page, draw two concentric circles from the 0,0 point (which should be moved to the center of the page). The inner circle is .75" in radius – clone it and scale 133% for the second. Both circles have a half-point black stroke. The outer circle is filled 24% Black. The inner circle is filled radial 35% Black to White.

2. Using Nördström Black at 13 points, type in the words. Clone the inner circle and ATTACH TO PATH. Adjust the type to match the sample. I used a –10% Range Kern, added a space after the word NORTHWEST, and selected "• SINCE 1879 •" to apply a –1-point baseline shift. The upper letters are on Ascent and the lower letters are on Descent.

3. Using AeroScript, set "Eli's" at around 50 points. CONVERT TO PATHS, UNGROUP, DESELECT, SPLIT PATHS on the *i*. Move the *E*, *l*, bottom of the *i*, and the *s* into position and combine them with

130

México para las naciones

the UNION operation. Move the i dot and the apostrophe into position, SELECT them, add the unioned word, and JOIN. Fill the composite path with a vertical gradient from White to 68% Black, then SKEW and SCALE the word into the proper shape.

4. Using Nördström Black again, at 12 point, type in "YUM!", move it into position, fill White, stroke .25 point.

5. Voilà!

Below left is a quick rough I tossed off yesterday for an AD mission office in Baja California. They supplied and required the AD. As you can see it is similar in concept, except that the motto is attached to a simple open path. It was designed as a Web logo GIF, and it's a little large at 18K, but it's what they asked for (see sidebar).

One of the nice things about FreeHand's version of attach to path is that after the words are attached, they are easy to move. All you do is select the attached phrase with the Selection tool, and a little white triangle appears on the path. You click-drag the triangle to adjust the type along the path, moving it into position. The points on the path also remain editable. You can add points, delete points, and manipulate the path as much as you need to while the type is attached.

Path direction

One of the other options to consider (and one of the problems you'll occasionally have to troubleshoot) is that the type will flow along the path in the direction it was created. To reverse the direction of the type, use MODIFY>> ALTER PATH>> CORRECT DIRECTION. The type will now flow the other direction on the path (upside down). If you reverse the direction of an ellipse before attaching, the type will attach around the inside of the bottom of the ellipse.

AD FOLLOW-UP:
Actually, they loved the logo after they swapped the globes, outlined Mexico, made the outline blend into a subtle heart shape, and changed the colors three times.

131

Path: left to right

Direction

The path

Direction

Path: right to left

Converting text to paths

By now you have already done this several times in the context of skill exams or miniskills. It is one of the things you will do most often in FreeHand. It is one of the simplest yet most powerful tools in your arsenal. CONVERT TO PATHS changes your text in a fundamental

way. Once it is converted it is no longer type. It is merely a collection of shapes that happen to look like type. You can no longer edit those shapes or apply kerning, tracking, baseline shifts, or anything else you do to edit type and move it into the proper relationships on your page.

So why would you want to do this? Again the answer is simple: because you need to manipulate type shapes as graphic objects instead of as a font. The most common reason we have already used several times in the last few exams. In order to fill a word or words with a single Gradient fill, you have to convert to paths and then join paths to make the character shapes into one composite path with one fill. You will do this so often that you should memorize the keyboard shortcut. On the Mac it is ⌘⇧P (PC: Control Shift P).

There are several advantages to this procedure. The ability to use a single fill is obviously one. The ability to use a word as a clipping path (PASTE INSIDE) is a second reason. As far as logos are concerned, converting text to paths allows you to disseminate that logo without needing to send the font along with that logo. As I am sure you have discovered by now, the number one printing problem is not being supplied with the fonts contained in the imported graphics. Once the text is converted, you no longer need a font – it is simply a graphic that looks like type.

However, the number one use of converted type is probably the ability to modify type to fit your need for logos and simple graphics. You will do this a lot in the following chapters as you design various projects. The graphic to the right is not intended to be real. It merely shows you the basic concept of type modification and graphic assembly.

Miniskill #5

Just so you won't pout, let's do a quick miniskill. This type of simple graphic works well as a filler illustration in a newsletter or magazine.

1. Set the word *Fact*. This example is set in Gills Sans Extra Bold, but you can use any bold sans serif you like.

S'park

Southpark's Fourth of July Celebration

Fact

132

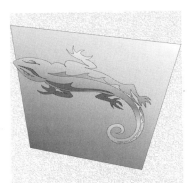

2. CONVERT TO PATHS, UNGROUP, and modify the shape of the *F* until it looks something like this. This simple-looking change is actually relatively complex. First of all, group the *F* so you can resize it easily. In this case, I enlarged the *F* about 125%, then made the crossbar shorter and matched it to the top left terminal end of the *a*. When you have the *F* fitting as you want it to look, SELECT the bottom two points of the character and drag straight down (holding down the Shift key) until it looks approximately like the example to the left. Finally, add two points with the Bezigon tool, as you see to the far left. This will give you the points you need for the next modification.

3. Holding down the Shift key, multiple-select the bottom two points on the right of the elongated vertical bar. Release the Shift, click on either one of the two points, and drag both points to the right (adding the Shift key again to keep the move straight sideways). Then adjust the two points you added until you have the box shape seen to the right.

4. SELECT ALL and JOIN PATHS. Fill the resulting composite path with a gradient from top to bottom. I used 57% Black to 7% Black, but I had to drag the bottom swatch up the gradient bar to make the fill change to a flat fill just below the top of the new box shape created with the bottom of the *F*. This is one of the more helpful uses of a multi-color fill: being able to quickly and easily determine where the gradient will break or change

colors. Often you do not need or want multiple colors changing into each other. You simply need to set where the gradient will end (as in this case).

5. Add the final copy and export as a PDF to attach to an email to send to your instructor for grading.

It should be noted that this little factoid is accurate. Business is rapidly coming to recognize that they cannot compete without a professionally designed graphic image. Their customers will not take them seriously. In a very short time, digital publishing has reached the mainstream, where it has become an assumed and necessary part of the marketing strategy of all businesses seriously pursuing survival in the new millennium.

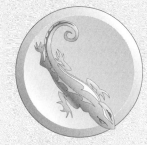

Fact

> Graphic design is rated as one of the top ten careers for the new millennium, in terms of growth and demand, by the U.S. government.

The fact of the matter is that FreeHand graphics are one of the distinguishing factors that make your designs stand out from those of the untrained masses of so-called desktop publishers; these folks, in reality, are mere desk jockeys doing the best they can to satisfy bosses and owners without the knowledge necessary to understand the requirements of the industry.

Flowing text inside a path

This is yet another of those capabilities that are highly touted by the warring marketing operations. In reality, you will never use it — better put, you should never use it. The reason gets back to the heart of graphic communication. If you step very far outside the reader's subconscious norms, you reduce readership to the point where the client's money is being wasted.

Now, it is true that for things like snowboards, skateboards, and inline skates, graphic rebellion does help reach the target audience. If your goal is to reach an audience whose best reaction is, "Cool!," then this type of capability is appropriate. It also works if your market is digital geeks whose main concern is having the latest and greatest

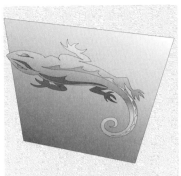

TYPOGRAPHY, TYPE INSPECTOR, AND TYPE MANIPULATION

One can always find some reason to use most new ways to do the things that have always been too trying to conceive of before.

whatever. As time passes, these difficult-to-read digital capabilities may actually reach mainstream audiences who have disposable income. That time has not arrived yet. Readability will always be king of digital publishing until that long distant day when marketing is no longer seen as the salvation of American business.

That being said, you can flow any existing text inside any open or closed path. You can also choose TEXT>>FLOW INSIDE PATH and begin typing. Text flowed inside will start at the inside top center of the path and flow until the path is filled. The type will fit inside open paths as if there were an invisible straight segment connecting the two end points of the path.

The real problem is that it is very difficult to fit something as variable as type into a graphic shape. It is hard enough to fit it into a rectangle. In the example to the left, I had four options – flush left, centered, flush right, and justified – once I had committed to this rather ridiculous example of this capability. Left, centered, and right created many ugly empty spaces at the ends of the lines of type. Finally I forced justification of every line, which butchers things typographically but at least works better conceptually. You will have even more difficulty with more irregular shapes.

Wrapping text around objects

You have seen a great deal of text wrap in this book, and FreeHand also has the capability. The two rules are that the object you wish to wrap text around must be on top of the text and you can only wrap around graphics. You cannot wrap one text box around another text box.

The procedure is simple. You simply select the object (or objects) you wish to wrap the type around and move it to the front ⌘F (PC: Control F). Then select TEXT>> RUN AROUND SELECTION. This will call up the dialog box that allows you to control the wrap. A tight controlled fit will need a custom path drawn on top of the text, with a stroke and fill of None, and TEXT>> RUN AROUND SELECTION applied with an offset of zero on all sides.

135

Working with inline graphics

Our final typographic capability is the ability to add graphics as type. These graphic are called inline graphics (same as PageMaker; Quark calls them anchored graphics). As with PageMaker, inline graphics are created simply by pasting any graphic into an insertion point in a text block. Graphics come in with the bottom of the graphic on the baseline and leading added to allow room for the height of the graphic in points. Once graphics are inline, applying stroke or fill changes to the text block does not affect the inline graphic.

Inline graphics have an automatic text wrap. You will find the editing box for this by looking under the Text Character Inspector on the Effects popup. The graphic will be listed there as a Graphic Element. The normal wrap applied to an inline graphic is flush tight on the left side with a little room added on the right.

Positioning inline graphics

- LEADING – by default, FreeHand places the graphic with the bottom on the baseline and adds leading up to accommodate the height of the graphic.

- KERNING – The inline graphic is merely another type character as far as FreeHand's text box is concerned. Kerning applied between the graphic and the following character will bring that character closer or farther, as usual.

- BASELINE SHIFT – You can move the graphic up or down relative to the baseline by applying a positive or negative baseline shift, as usual.

- TRANSFORMATIONS – Any transforming of the graphic must be done before you paste it into the text block. After that, all transformations are applied to the entire block of type.

Yes, you can attach inline graphics to paths. Once the graphic is inline, it is simply type. You can use this ability to wrap repeating graphics or dingbats around a shape for borders and so forth.

Miscellaneous utilities
Spell checker

FreeHand's spell checker is good; access it by Text>>Spelling. It has a User Dictionary. It shows you possible errors in context, scrolling the document to the error if desired. It will check all selected text blocks or check the entire document if nothing is selected. The only real problem with the checker is that three of the important options – FIND CAPITALIZATION ERRORS, FIND DUPLICATE WORDS, and EXACTLY AS TYPED – are found only in File>>Preferences>>Spelling. It would certainly be better if they were available directly in the spell checker. You will have to type in discretionary hyphens when you add them to the User Dictionary for them to hyphenate properly in use.

Author's note:
I realize that I have slighted the page layout capabilities of FreeHand. I have done this on purpose. First of all, those capabilities are very similar to true page layout programs, except for the major omissions like facing pages, margins, table of contents generation, indexing, autoflow, and so on. Secondly, FreeHand is not efficient for any page layout other than very graphic-intensive, single-page, front-and-back flyers, posters, or brochure layouts.

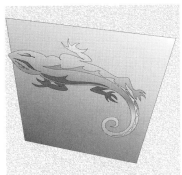

TYPOGRAPHY, TYPE INSPECTOR, AND TYPE MANIPULATION

Special characters (version 8)

A variety of special typographic characters are found on a submenu off TEXT>>SPECIAL CHARACTERS. This is not too handy for most of us who have learned the keyboard shortcuts in the other programs. However, you can add the shortcuts you need with FILL>>CUSTOMIZE>>SHORTCUTS. There is also a very necessary (though not very handy) TEXT>>CONVERT CASE command.

Find & replace

One of FreeHand's best features is its EDIT>>FIND & REPLACE function. It is the only program that gives you global control of not only text, but also graphics. The interface is familiar, working like those in PageMaker, Quark, InDesign, and word processors.

Text editor

A remnant of earlier versions is TEXT>>EDITOR. This gives you a simplified word processor interface. It is the only place where you can SHOW INVISIBLES. It is not used very often, but it comes in handy for transformed type or type attached to complicated paths.

Linking boxes

Below the lower right corner of all text boxes (including text attached to paths) is a small square. If it is filled with a dark circle, then you know there is more text in the box that is not showing (over-flowed). If I need to link one text block to another, I click-drag on this linking box to the block I wish to link to. To break the link, I click-drag in this box to an open area of the document. To make the text block shrink to fit the type in the block, I double-click the linking box.

Summing up

FreeHand has an amazing wealth of typographic capabilities. It is easy to argue that there is no better place to generate complicated typography. It does not work nearly as fluidly as PageMaker or Quark for long documents. But then, it is not designed for long documents. It is designed for short documents. It works best for complicated, graphically intensive display ads, flyers, posters, and brochures.

Many of its capabilities seem like overkill, but when you need them they are deadline savers. You need to continue to review them on a regular basis so you know where they are when needed.

Knowledge Retention:

1. What are the two methods used for tracking?

2. What is the most interactive method of resizing type?

3. Why do you think FreeHand is the best tool for type?

4. Why is the copyfitting option played down in this book, and do you think it would ever be useful?

5. Why is the Horizontal scaling field usually used only to bring type back to 100% (or normal width)?

6. What are the advantages of converting to paths?

7. How do you wrap type around both the top and bottom of a circle while keeping the type upright and readable?

8. What is the problem with type effects?

9. What is the easiest method of changing leading?

10. Why is it hard to use FreeHand for long documents?

CHAPTER SIX:
TYPOGRAPHIC
CONTROLS

Where should you be by this time?

Except for color usage, you should be ready to go. You should be producing small projects and feeling relatively comfortable with the interface (even though you will still be mousing a lot). More than anything, you should be familiarizing yourself with the flexibility of the text box. You should type in a couple of paragraphs and play with all eight of the handles, adding modifier keys until you can manipulate text blocks intuitively.

DISCUSSION:

You should be discussing the typographic benefits of FreeHand, plus the integration of words with graphics. Analyze each other's font choices for readability and style. Discuss the importance of style and fashion in typography. Try to come to grips with the current typographic styles in your community.

Talk amongst yourselves...

138

PRINT & WEB
GRAPHICS
USING FREEHAND

Chapter Seven

Color

Controlling your color choices in FreeHand graphics

Chapter Objectives:

By teaching students the options and capabilities of FreeHand, this chapter will enable students to:

1. describe the basic color spaces and systems used in publishing
2. control color palettes to avoid using conflicting color systems in the same graphic
3. understand the need for printed swatch books
4. describe the difference between spot and process color.

Lab Work for Chapter:

- Practice with the various options.
- Finish exams from previous chapters.
- Continue to develop skills with the Pen tool.

Color:

..."but they don't match!"

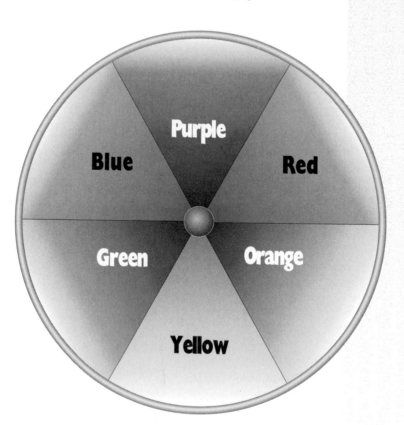

Beyond
black and white

As you have already seen, black-and-white design is compli-cated enough. Color increases the complication to an entirely new dimension. For this reason, it will be wise for you to work in black and white as much as possible to develop your skills. More than that, you will find that even your color pieces should be proofed in grayscale so you can see the structure of the design more clearly. Color usually lessens contrast and confuses your eye.

Remember that sizable portions of your readership are color-blind. Statistics would suggest more than 10%. Up to a third have some sort of color vision deficiency, however slight. Having perfect color vision is like a musician having perfect pitch. It doesn't happen often. Your pieces have to work even if reduced to grayscale.

Add color only when it is required by your client and/or circumstances. We'll just mention the cost increases created by more color — every additional color adds the same costs as the first color. Every different color of ink requires an additional plate or toner cartridge. On a regular press at a commercial printer using offset lithography, every plate will cost from $25 to $150, depending on its size and the quality level of the printing company. To rephrase: two-color is almost twice as expensive, three-color is three times as expensive, etc. Because of these costs, a huge proportion of your work will normally be black-and-white or maybe two-color.

Having said that, we must acknowledge reality. One of the primary results of the digital revolution is a vast increase in color usage. It has become increasingly easy to work in color, proof in color, and print or publish in color. The problem with this is the same one that arises over and over: many new (and quite a few experienced) desktop publishers know little or nothing about commercial printing or Web publishing necessities. Therein lies the uniqueness of this book.

A note on the illustrations

All of the illustrations in this chapter are available in color on the CD. This chapter was done in color and then converted to gray-scale for printing purposes. Some of the illustrations (as noted) are also printed in color in the color section.

Entirely new color theories

You need to thoroughly understand that the colors used in digital publishing come from several color sources and theories, none of which are reproducible in the other color spaces. In other words,

reality is not reproducible. Fine art cannot reproduce reality, and fine art cannot be reproduced either. Monitor color cannot be calibrated (as far as general Web use is concerned) and it certainly cannot be reproduced by printing inks without substantial color shifts. Printing color cannot be viewed on the screen (unless you spend a lot of money for the software and hardware to calibrate your monitor, printer, scanner, and so forth). Spot color cannot be reproduced on the monitor or by digital presses. All of these color spaces are different, unique, and come with their own advantages and disadvantages.

Reality is not reproducible.

Color spaces or color systems?

Color space is the term used to describe the colors available in a given color theory that uses primary colors. A *color system* is a standard set of colors — the classic example being the sixty-four standard colors found in the Crayola system (which are extremely useful). There is a color space for TV, a color space for printing, a color space for fine art, etc. The problem is that the different colors existing in the various color spaces may not be available in other systems of color. To work with publishing, it is necessary to be familiar with three color spaces plus several color systems.

Red, Blue, Yellow (RBY)

The first of these three spaces is the one you learned in elementary school. As you all were told in early childhood, there are three primary colors: red, blue, and yellow. You were told that any color could be made with these three. As you found out (if you played with color at all), this is not so. I still remember the frustration of trying to generate a strong, vibrant purple by mixing red and blue.

The red, blue, yellow (RBY) color space was the first one you learned. It claims to be all-encompassing, but it is not. Unfortunately, color does not lend itself to neat, tidy analysis. Actual physical production of colors can be immensely frustrating. There are many colors you can see in reality that cannot be reproduced by any known mixture of pigments or dyes (especially flowers).

The problem with the RBY color space is simply that there are no true RBY primary pigments. The theory works reasonably well when trying to predict what colors will result when mixing cobalt yellow and ultramarine blue, for example. However, the practical use of the color space has nothing to do with mixing primaries. It simply becomes a way to describe how the various fine art pigments are going to interact with each other.

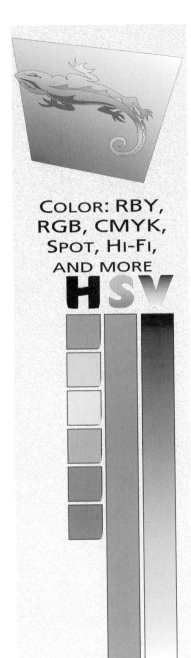

COLOR #1

In the color PDF.

143

The complexity of color vision

It's amazing that we can see at all. The eye sees in a different, nonpigmented color space – red, green, blue (RGB). What we see as specific colors are in fact the reactions of our optic nerves to mixtures of electromagnetic waves. How that really works is of mere scientific interest. What you need to know is that our eyes see trillions of colors. You also need to understand that we can publish, at most, millions of them in any given publishing color space.

We will get into this much deeper in the companion Photoshop book, *Image Manipulation*. At this point we will pass over reflected color, color temperature, complex color, and many of the other variables involved in color reproduction. However, we do need to review basic terminology.

Color terminology

Color (like all areas of design and publishing) uses terms that are unknown to the layperson. Some of these will be familiar to those of you with fine art training. Some are specific to printing. Some are specific to the Web. Again, the goal is communication with our peers. There is no room here for such undefinable frivolities as blush, mauve, lime, peach, and so on. These names are simply fashion and mean different things to different people. For example, I could easily mix fifty or more colors that could each be called apricot yet are very different from each other. What we are looking for is a language that can be understood by anyone who is not colorblind.

Fine artists are taught to break color down into three parts: hue, saturation, and value. Printers tend to substitute the word brightness for value. Software programmers (as usual) just do what they are told and have no idea how the words are used in the real world.

Hue is the name of the color: blue, red, yellow-green, red-orange, orange-red, and so forth. There are only six hues plus white and black: red, orange, yellow, green, blue, and violet (or purple).

Saturation is the intensity of a color, or how far it varies from neutral gray. For example, grass green in the spring is more saturated than forest green in late summer. Saturation should be used instead of terms like dull or brilliant, because these terms could include value variations. What we call neon colors (which are produced by a company called Day-Glo™) are the most saturated.

Brightness or **Value** refers to the lightness or darkness of a color. The same hue of green may be a dark green or a light green. This is different from the saturation changes that would be referred to as dull green or intense green.

Any color can be described in terms of hue, saturation, and brightness or value (HSB or HSV). A neon red, for example, could be described as an extremely saturated red. Barn red, however, could be

referred to as an unsaturated, very dark red. The hue could be exactly the same for both. Color figure #1, in the sidebar on the previous page, makes absolutely no sense as a grayscale image. You will have to go to the color PDF version on the CD for comprehension of the differences between saturation and value.

Two more terms that further define value may also be of interest when talking to fine artists and helping them get their ideas into printable form. These terms are used by fine artists when mixing pigments. A fine art *tint* is a hue with white added. A *shade* is a hue with black added. White and black cannot be added in publishing color spaces. This only works in reality and RBY. However, these terms do help us communicate with people who are not publishing professionals. A tint of red is pink. A shade of orange is brown. Pastels are tints. Jewel tones are shades.

Most perspective problems caused by color are value problems. Distant objects of the color must have a much lower value to be seen in the proper place in the distance of your image. Of course, distant objects also become much bluer as they are covered by the haze of the air (the saturation also diminishes with distance). All of these terms are useful when trying to explain a color to another person (when she is not present to see your sample, for example).

The artists' color wheel

The color wheel is a diagrammatic illustration of the color space that was taught to you in grade school. What you need to understand is the relationship of colors. It does not help very much to understand that each color is a certain wavelength on the electromagnetic spectrum. It may be of interest to a color scientist, but has little to do with what designers use in color.

The wavelengths of visible light are measured in billionths of a meter and cover the range from 400 millimicrons to 750 millimicrons. The color change here is linear, starting from invisible ultraviolet through violet, blue, green, yellow, orange, red, and invisibly ending with infrared. This is the spectrum we see in a rainbow. In fact, the interesting thing about double rainbows (which we see frequently in the high desert) is that one of the rainbows has red inside and the other violet. The rarer triple rainbow has a band that goes from violet through red and back to violet again. We also see three bows, and very rarely, the inside is also doubled for a total of four.

The fascinating thing about a color wheel is that though the spectrum is linear, the color relationships are circular. In other words, red does not end things. Instead, it blends through violet-red, and red-violet, to violet, and then continues. In addition to being continuous,

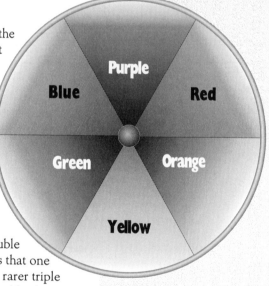

COLOR #2
In the color PDF.

COLOR: RBY, RGB, CMYK, SPOT, HI-FI, AND MORE

THE SPECTRUM

A color illustration of the electromagnetic spectrum is in the color PDF version of this chapter on your CD.

some color relationships seen in the wheel work in a circular fashion. Of course, there are specialized terms to describe these relationships. These terms will help you greatly when adjusting colors to make them more reproducible.

 TIP: As an aside, when you are drawing a spectrum, a rainbow, or whatever, do not make all the bands equal in width. To look correct, the yellow band must be much narrower. It is not much more than a yellow line between the red and orange bands on the one side, and the green-blue-violet bands on the other.

We have already mentioned one of these relationship terms: primary colors. The three primary colors here (of pigment) are yellow, blue, and red. With these three you can theoretically make any color. All three together make black. You can mix any two primaries and produce the color between them on the wheel. These are called secondary colors. This is true even though red is at one end and blue at the other end of the spectrum. If you mix them you get violet or purple (even though highly saturated purples cannot be mixed).

Complementary colors

A *complementary color* pair is a primary color and the secondary color on the opposite side of the color wheel (i.e. red/green, blue/orange, and yellow/violet). Again, all these colors have the same relationship to each other. Two complementary colors of equal saturation and value will produce a vibrating edge between them: harsh, garish, exciting, compelling, maximum color contrast.

More interesting is the fact that when you mix a primary with its complementary secondary, you get neutral gray. This again boggles the mind, because the same neutral gray is produced no matter what the complementary pair is. Purple and yellow produce the same gray as red and green — assuming you have theoretically pure hues. Of course, the complement is made up of a mixture of the other two primary colors and all of the primary colors mixed together give you black, so it makes sense once you think about it.

Available pigments

Theory works fine until reality smacks you in the face. The theoretical colors available can almost all be seen by the human eye. Finding pigments is another story. This is why artists' paints have hundreds of color pigments. A pure red is rare. The closest would have to be one of the multitudinous cadmium reds. A pure yellow does not exist. They are all either orange-yellow or green-yellow to some degree. Cadmium yellow tends toward orange, strontium yellow toward green, cobalt yellow toward green, and so on. Blues are a real problem. Those that seem pure blue are low in brightness and/or saturation.

145

Most pigments are muddied by their complements or a neighboring primary. As a result, most common pigments tend toward brown or muddy green. However, because of all the different pigments available, artists can reproduce almost every color in nature except for the most saturated.

Additionally, fine art pigments are often very poisonous. I remember working on a gouache painting (opaque watercolor) several years ago. I absentmindedly shaped the tip of my brush with my tongue when using cobalt yellow and got extremely sick for several hours. In fact, all of the pigments mentioned by name earlier are poisonous, to one degree or another.

Finally, the better, purer, more saturated colors are all extremely expensive. Common colors like barn red (which is iron oxide or rust) might cost $3.60 per artists' studio tube. It is very low in saturation and brightness, plus the hue tends strongly to orange. The same tube filled with the best cadmium red could cost more than $20. A pound of printers ink runs $5 to $10. A pound of cad red medium could be as much as $300 or $400. Originally, ultramarine blue was ground lapis lazuli. Because lapis is a semiprecious gem, a tube of ultramarine blue would cost well over $1,000 a tube (if it hadn't been removed from the market several years ago because of price). Obviously, printers had to find a better solution.

Printers' problems

When printing color, economics plays a huge role. Every separate pigment requires a separate plate, an additional printing cylinder, and so on. In practical terms, every additional plate costs about the same as the cost of the first color to produce (when paper costs are disregarded). So, a fine art painting that used thirty different colors of paint would cost thirty times as much to print (plus the cost of the paper). Even if such a thing could be done (and it cannot, under normal circumstances), the economics would prevent it. The only place we find such a thing is in classical Japanese woodcut prints, for which dozens of plates were used.

The solution involved using a different color space: cyan, magenta, and yellow (CMY). With the addition of black (for reasons we'll mention later), printers use a full-spectrum printed space that gives a convincing illusion of reality using only four colors. These four colors use cheap pigments that only cost about 60% more than black (which is by far the cheapest pigment). Black is simply soot collected in a variety of ways from a variety of sources.

Permanence

Before we pass on to the other color spaces, there is one more consideration to be touched. Those who come from the world of fine art are horrified to find out how nonpermanent printing colors are. To

fine artists, permanent colors are pigments that will last for several centuries or more. In fact, in fine art, permanent means 200 years with no visible fading, at barest minimum.

Except for black, no printers ink is permanent by this definition. It is possible to specifically order permanent inks and pay premium prices. However, this is rarely done. Printing inks are considered permanent if they retain their color (indoors) for a year. Outdoors, in the bright sun, they fade after a month. The reds go first, followed by the yellows. After a year, many process color pieces are reduced to cyan and black. After several years, even the cyan disappears. This is an area you should check out if you buy contemporary fine art prints. Most of them are simply printed with normal printing ink (and are therefore almost worthless as investments).

This is really not so horrible. First of all, printers inks fade very little if kept indoors away from bright light and/or ultraviolet light sources. Secondly, exactly how many printed materials are kept for more than a year? Most of our production is almost instantly disposable. Even critical color work, like fashion catalogs, is only good for a few months. Premium coffee-table books are another, very different story. Permanent color ink is one of the reasons why they are so expensive.

There is an attribute of pigment that causes severe problems. This is *fugitive color*. A fugitive color is only good for about a month. In bright light, some colors fade severely in a week. Severely fugitive color like Day-Glo™ will fade in a matter of hours if not protected. If your client is concerned, suggest the use of permanent inks (warning about the expense, of course).

The colors of light (RGB)

Humans see color through the rods and cones of the retina in the eye. The rods measure value. The cones, however, are more complex. There are really three different kinds of cones. Some are sensitive to red, some to blue, and some to green. That seems really strange to those of us used to the color wheel mentioned earlier.

This second color space is the first that you will need to thoroughly understand in the publishing industry. The color space our eyes use is called *RGB* by our industry, for the three primaries used: red, green, and blue. These are the primaries used by light and light sources. They are called *additive color*. They are additive because adding all three primary colors gives white light. White light contains all the colors. More light produces lighter colors.

This is the color space used by monitors and scanners. This is where you live in the GUI, or graphic user interface used on the desktop. Everything seen in the environment on your computer screen is RGB. RGB is a full-spectrum color space like RBY or HSV. However,

RGB is the first color space we have discussed that is severely limited. Many colors that are seen in reality are not available in RGB color. In fact, only about 60% to 70% of the colors seen in the real world can be duplicated by RGB. (Actually it's far less than that if you consider that the human eye can see trillions of colors and RGB is 24-bit and only produces 16.7 million colors.)

This is normally not a problem. When in the color space, it seems as though every color is available. This is because it is a full-spectrum space — there is a good representative sampling of all six hues, most of the values, and quite a few of the saturations available in reality. However, if you bring a television set with a video of your garden into your garden, you'll see a vast difference — and not just brightness/saturation differences. Many of the hues will be different on your TV screen.

In fact, if you visit your local electronics superstore, you'll quickly see that every TV reproduces the colors differently — not only in brightness and sharpness, either. Some TVs will show that shirt as blue, some as purple, some as teal. For the first time in our little discussion, we have run into the bane of our industry, accurate color reproduction. Accurate reproduction of color is a virtual impossibility, even on a theoretical level. You need to burn that into your consciousness, now. Things will get worse.

Accurate reproduction of color is a virtual impossibility, even on a theoretical level.

The colors of ink (CMY)

Now things get complicated. First of all, we are no longer dealing with light. So we are closer to our color wheel? Well, sort of. The problems of printing full-spectrum color were severe. Most of the problems originally involved the number of colors needed. Japanese woodcuts often used thirty to sixty colors and even they were not remotely realistic. After a full-spectrum space for printing inks was discovered, the main problem became *registration*. We will define this term in chapter ten. For now, let's define it as the ability to place two or more colors in exact alignment with each other.

But how did we come up with a full-spectrum printing system? Around the middle of the nineteenth century, a Frenchman wrote about RBY theory. However, this was never developed into a usable printing system. In the last two decades of the nineteenth century, a man named Frederick Ives turned from printing to an intense study of photographic color reproduction. By using pigments that are the

COLOR: RBY, RGB, CMYK, SPOT, HI-FI, AND MORE

complements to RGB hues, a printing system was developed, which Ives showed the world in 1893. By the turn of the century, almost all printers knew the general theory. Publications like *National Geographic* were being printed in full color.

To understand how this works, we need to leave additive color and reenter the space of *subtractive color*. RBY is subtractive. Subtractive color uses primaries that, when added together, produce black. These primaries absorb light. When added together, they absorb all light, leaving black.

This is the major full-spectrum color space you need to know for printing. It was discovered that reproductive camera shots of color originals using red, green, and blue filters created negatives that could be printed in the subtractive primaries to reproduce the original colors. These subtractive primaries are cyan, magenta, and yellow (CMY). This process is called *separation*. The following shows you how CMY colors are related to RGB (assuming that we are starting with white light and white paper):

- Magenta — The color seen when all green light is eliminated.
- Cyan — The color seen when all red light is eliminated.
- Yellow — The color seen when all blue light is eliminated.
- Black — The color seen when all RGB is eliminated.

Process color (CMYK)

Process color uses the separation concept to print full-spectrum images. There are some real problems, however. Even though process color covers the entire spectrum, it misses many colors. Remember, RGB only covers 60 to 70% of all colors in reality, and CMY covers a little less than that. This is further confused by the fact that RGB cannot reproduce some CMY colors and CMY cannot reproduce some RGB colors.

Again (due to the fact that process color is full-spectrum), if you restrict yourself to the color space, it seems real. However, we are in worse shape now. CMY cannot reproduce RGB. Neither of them can come close to the real world.

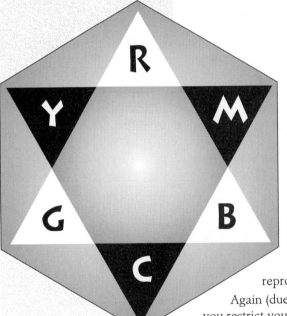

COLOR #3
is in the color PDF on your CD.

149

RGB is not CMY is not RBY, and none are reality.

For our purposes, we are discussing three totally separate color spaces. This is true on a practical level, even though reality contains all RBY. RBY contains all RGB and all CMY color. This explains why fine art reproduction is such a frustrating exercise, and why it is so difficult to print the newest fashion colors, and why a photograph of the Grand Canyon can never capture the reality.

So, why is it four-color process?

We have been discussing three color primaries – CMY. Again, reality strikes! The problem is the pigments. CMY inks are really not very close to theoretical CMY. Some of this is due to economics. The CMY pigments available are not economically feasible, or they are not quite the right color, or they are not strong enough, or they are poisonous, or some combination. The compromises we presently use are reasonable and economically viable. They are all a little more expensive than black, but in the acceptable range. (CMY inks are about $8 a pound if black is $5 per pound.)

However, they are inaccurate. The three primaries added together do not make black; they make an ugly, muddy brown. This is primarily because the cyan used is weak. In addition, all three pigments have impurities. As a result, a fourth color is used: black. There are several methods of producing the negative used for the black printer. They all involve recording the neutral gray information created by the complementary color graying in the image.

In this introductory analysis, that's all you need to know. Otherwise, this would quickly begin to read like a physics text. At this point, though, the only ones who care are the computer programmers. They talk to the scientists and produce software that does this at the click of a button. All we have to know is what color space we are working in and why.

RGB/CMYK differences

In practical terms, what are the differences between what is seen on your screen and what can be printed from that image on the screen? RGB is very weak in yellows, plus it has a lot of trouble with subtlety in darker shades of any hue. This is why dark movies are so hard to see on the TV screen. CMYK lacks a lot in the highly saturated reds and violets. Brilliant purples are very difficult. In general, what you see on your monitor is very much brighter and more saturated. This is to be expected, because you are looking at colored light. You will not be able to see subtle creams and beiges.

For the first several projects, you will be continually dismayed by the color shifts when converting to process color. We will talk about adjusting for that later in this chapter. However, process color has its own beauty that cannot be seen on the monitor. The problem, of course, is that you are designing on the monitor.

NO SUBSTITUTE
is available for a good, relatively new, process color swatch book when selecting process colors for a project. Only then can you really have any idea what that color is going to look like when it is printed. These swatch books will cost you nearly $100 or more, but they are an essential part of your designer's tool kit.

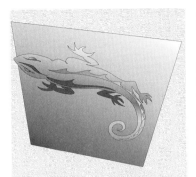

But there's more — spot color

Spot color is really not a printer's term. It is a term made popular by software applications. However, it is useful even though it means many different things to different people. In the context of what we have been talking about, spot colors are RBY colors printed by themselves, with their own plate and ink. They can be custom-mixed or bought by the can. They can fit into a system of color or not. The main thing is that they are printed separately, on a separate plate.

Before we go on, we have to redefine a term used earlier – *tint*. A tint for the publishing industry is a screen of a color. We have no way to add white other than letting the paper show though. In other words, a tint is a solid color broken up into dots described as a percentage of area covered. A 50% screen of square dots looks like a checkerboard. Half the area is one color square, half the other. For printers dealing with negatives, half the area is solid and half is clear.

In the example to the right, the tint screens have been generated at forty lines per inch so you can see them with the naked eye. Notice that the colors are named as a percentage of the area covered by the black dots. By the time we have a 68% screen, the black dots are dominant (leaving little white dot remnants that cover 32% of the area). 100% is solid black.

Process color is created by printing tints of the four process colors on top of each other. This is covered in detail in our companion book, *Image Manipulation*. A typical color might be described as 100c 50m 0y 10K. *K* is used for black to avoid confusion with blue, which is written c because it is really cyan. Anyway, 100c 50m 0y 10K stands for the tints involved. In this case, there is solid cyan, overprinted with 50% magenta, no yellow, and 10% black. This produces a very rich shade of royal blue.

Spot color, however, is mixed pigment – blended not by overprinting tints, but with a paint knife on a mixing table. Brilliant red, warm red, Van Dyke brown, and so on have no specified relationship to CMYK. In fact, many of these colors cannot be produced with process color. These colors are referred to as standard colors. This is sort of funny because they are not standards for anyone. They are really colors manufactured by a specific ink company. They are only standards for that particular company. One company's warm red might be very different from another's warm red.

7

13

24

35

46

57

68

Standard color systems

Standard colors became a real problem. In the mid-1960s, a company named Pantone gave our industry the first standard color system that was accepted industry-wide. It is called the Pantone Matching System or PMS. PMS color is available at almost every printer in the United States. Although there are some others around the world, PMS is the only universal standard color system that you normally need to be familiar with, in the United States.

The first thing you must understand is this: PMS color is not a full-spectrum system. Even though it covers many colors outside the RGB or CMYK color spaces, it is not based on primary colors. All PMS colors have to be described by RBY or HSV. 35% of PMS colors cannot be reproduced with the tint overprints of process color. Many of them cannot be reproduced with RGB.

PMS is a completely separate system

At present, PMS uses fifteen standard colors that can be mixed into 1,000 standard mixes. The mixes can be seen in swatch books, which have a swatch of the actual color printed next to a formula. This formula tells the printer which of the standard colors to use and what percentages to mix to create the specified standard mix.

With a swatch and a PMS number, anyone can match any PMS color in any facility that puts offset lithographic ink on paper. PMS inks are also available for some other printing methods. However, you must be careful: unless your printing method can use Pantone inks, PMS colors cannot be matched. Pantone sends employees to work in the various ink manufacturing plants to ensure color accuracy. All Pantone-approved color has the word Pantone in the label name.

High-fidelity (hi-fi) color (CMYK GO)

Recently, there has been a flurry of activity trying to solve the problem of the different color systems and their color reproductive inadequacies. Pantone has released a six-color system called Hexachrome, which seems to have won. The goal is a process color system that can reproduce most of the colors of the PMS system plus all the colors of CMYK. The common term, at this point, is hi-fi color.

The ink manufacturers are assuming that some hi-fi system will become the standard. They are also assuming that hi-fi color is perceived to be of high value by the printing industry. The overriding issue, however, is, "Will customers pay the extra costs?" It will obviously cost more money, simply because more color heads are needed.

Hi-fi color will help a lot in such relatively small niches as fine art reproduction, fashion color catalogs, and the like. Companies like Spiegel, for example, can save a great deal of money with more accurate color. The primary reason for returned clothing is that it doesn't "look like it does in the catalog." Hi-fi can cut the return rate

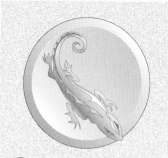

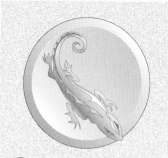**CHAPTER SEVEN: COLOR**

NO SUBSTITUTE is available for a good, relatively new, PMS swatch book when selecting spot colors for a project. Only then can you really have any idea what that color is going to look like when it is printed. These swatch books will cost you nearly $100 or more, but they are an essential part of your designer's tool kit. Pantone has the normal PMS book, a metallic book, and a Day-Glo™ book.

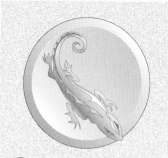152

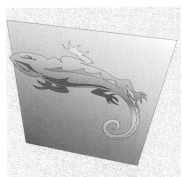

COLOR: RBY, RGB, CMYK, SPOT, HI-FI, AND MORE

PRESSREADY
Adobe has recently released a program that is a PostScript Level 3 RIP to enable you to print relatively accurate color from cheap inkjets.

153

substantially. For normal process printing customers, the color accuracy possible with hi-fi color is not yet enough of a difference to justify the increased cost. It may never be.

The push may come through the cheap six-color inkjets. However, these do not produce calibrated color. The people using them are not usually involved with top-quality color reproduction. For that you need a calibrated computer processor or RIP, which is beyond the budget of the cheap inkjet users. Accurate color still costs a lot of money to print, and will for the foreseeable future. Accurate color on the Web will probably never happen, because surfers don't care. All they want is lots of color. Who cares if it is the same color on their neighbor's set (except for catalog shopping)?

Commodity color

This is the bottom line with digital color. Most people don't care as long as it "looks good." As an industry, printers have spent trillions of dollars developing the capability to produce relatively accurate color and no one cares except printers and designers. **When is the last time you tossed a brochure in the trash because the color was not accurate? When did you even notice?** All most consumers demand is what the industry calls "acceptable color."

Acceptable color means simply that the reds are red and the greens are green. That skies are blue and skin tones look healthy. This will satisfy 90% of printing customers — though it is absolute heresy to the printing industry. However, reasonably well-calibrated, process color, digital presses are becoming ubiquitous. The corner copy shop has the capability to sell a cheap color print that makes the customer ecstatic (even though they still tend to think it is too expensive).

The spectacular growth of color

The traditional portions of our industry are hoping that hi-fi color will keep their traditional presses running. What will probably develop is an additional niche in the printing industry. In fact, traditional printing in general will be converted into merely a rather large niche in the publishing industry. Our industry is developing along the same lines as many others in the late twentieth century. We are becoming increasingly diversified. Each niche will have its own preferred printing method. The mass-media color space is rapidly becoming process color, CMYK. With all of its deficiencies, it works well, plus it is universally available.

With CMYK printers now cheaper than black-and-white Laser-Writers were in the late 1980s, we are seeing phenomenal growth in the amount of color printing. Full-bleed, tabloid, duplex-color digital presses now cost far less than $30,000. Acceptable production speed only boosts the cost to a little over $100,000. This is phenomenal in an industry that as recently as 1990 assumed that a multimillion-dollar

press was required to print process — plus hundreds of thousands of dollars for prepress equipment. Now process color can be easily printed directly from $3,000 computers to $3,000 color laser printers.

Hi-fi color may never become common enough to appear in copiers and hi-fi color laser printers, although the technology is certainly possible. Several six-color inkjets have been released. The governing factor is likely to be economic. Modern technology is not primarily concerned with increasing quality. Its main concern is the increase of perceived quality at the same price or cheaper than is currently available. Quantity instead of quality is the normal goal in a economically based, marketing society.

The early part of the millennium

So what do you have to prepare for in color usage? The percentages are still shifting rapidly. In 1990, it was about 60% black and white, 38% spot color, and 2% process color. As we enter the new millennium, the best guess is about 55% black and white, 35% spot color, and 10% process color. Hi-fi is still too small to count. My guess is that by 2020 we will be at 45% black and white, 5% spot color, 45% process color, and 5% hi-fi.

In other words, we will be about half black and white and half process, with a small amount of spot and hi-fi being done around the edges as specialty niches. A lot will depend on whether a digital alternative comes about for spot color. One thing is clear: press operators (and ink mixers) will be a very rare species by then.

So how does this affect FreeHand?

Not at all. FreeHand is the most versatile software available for handling color. As you can see to the right, in the listing of the color libraries that come with FreeHand 8, any color you desire is available: spot, process, hi-fi, Web, or any common system of color (including the one I tend to use the most, Crayola's Crayon palette). It does mean that you must be fluent in the various color systems and spaces. You cannot mix them without troubles.

```
Crayon
DIC COLOR GUIDE
FOCOLTONE
Greys
MUNSELL® Book of Color
MUNSELL® High Chroma Colors
PANTONE ProSim EURO®
PANTONE® Coated
PANTONE® HEXACHROME Coated
PANTONE® HEXACHROME Uncoated
PANTONE® Process
PANTONE® Process Euro
PANTONE® ProSim
PANTONE® Uncoated
PANTONE© Metallics Unvarnished
PANTONE© Metallics Varnished
PANTONE© Pastels Coated
PANTONE© Pastels Uncoated
TOYO COLOR FINDER
TRUMATCH 4-Color Selector
Web Safe Color Library
```

Before you start a project, you must know if you will be working in spot, process, or RGB. The only times you can ever mix them are those rare occasions when the budget is large enough to allow you process color plus spot color. These five-, six-, or even eight- or more color jobs are great fun, but most of us only have rare occasion to use those capabilities. Even in magazines that are eight-color every issue, like *National Geographic*, the eight colors are very standardized with no creative variation. No matter what, these jobs will remain the exclusive domain of the highest

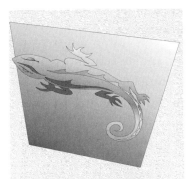

quality offset lithography, dryography, and gravure printing. They do not fit the digital paradigm, at all. There is little likelihood that they ever will. There is not enough demand to encourage the development of the technology required. The only digital presses currently available with the capability are the Indigos, which are six-color. Only time will tell if Indigo develops spot color and varnish options for those two additional colors. The likelihood is that they will end up as the Green and Orange expansion into hi-fi color.

FreeHand's color tools

As I have hinted several times now, FreeHand's color abilities are the best in digital publishing. You can work in any color space. More importantly, you can always tell what color space you are in with a simple glance at the COLOR LIST panel. This is the core of color in FreeHand. It allows you to see at a glance what system or space you are working with.

Roman names (using the word to mean "not italic" or, more accurately here, "not oblique") are spot color. The bottom color is a PMS color, for example. The colors with six digits in front are from the Web-safe palette. The obliqued names are full-spectrum color spaces. If they have the three little balls they are RGB. If they don't they are CMYK. If they have the little black hexagon they are Hexachrome. You have noticed that the PMS 206 also has the three balls behind it. This means that PMS206 is being described by RGB on the monitor (as well as possible).

You can add colors to the list in a number of ways. The most obvious way is the COLOR MIXER panel. As you can see to the right, it has five buttons across its face allowing you to mix CMYK (here),

RGB, HSV (Hue Saturation Value), Apple's color picker (and all its variations), and the ADD COLOR TO LIST button. The two you will actually use a great deal are the process color mixer on the last page and the RGB mixer to the right. The HSV and Apple Color Picker have many options but HSV is not very intuitive and Apple's picker is a very slow process. The far right button is used so seldom that I just saw it for the first time while writing this book (not to say it might not be useful). However, the normal method of adding color uses one of FreeHand's best abilities: drag'n'drop color.

All you have to do is click-drag on the new color side of the Split Well (the right side). This picks up a swatch of that color, as you can see in this reduced view. When I release the mouse over the COLOR LIST the color is automatically added and named with the appropriate color. In this case, the ugly mustard color will be added as 177r,131g,46b.

It will take you a while to get accustomed to using color builds like this. It is difficult at first to know what color 35c,10m,0y,10k is. However, there are some strong advantages to naming colors in this manner when it comes to accurate proofing and communication with your service bureau and/or printing firm.

Although FreeHand's drag'n'drop color is extremely handy, it also gives FreeHand a small Achilles heel. You need to cultivate, from the beginning, the habit of always adding your colors to the COLOR LIST. Using colors directly, by drag'n'dropping them directly onto drawn shapes, gives you unnamed colors. Unnamed colors can cause severe printing problems with some RIPs. If you find it too onerous to add to the COLOR LIST first, then you *must* use the Xtra that adds unnamed colors to the list (XTRAS>>COLORS>>NAME ALL COLORS).

Drag'n'drop color

There is no doubt that you will become almost addicted to the ease of drag'n'drop color. It seems like such a small thing, but it greatly adds to FreeHand's production speed and economy. Drag'n'drop is the

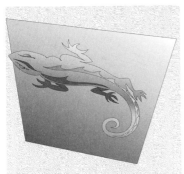

only method of adding colors to multicolor gradients. What is often not known is that FreeHand uses drag'n'drop color for the quickest, easiest, and most intuitive method of adding gradient and radial fills to your designs.

There is no graphic method of illustrating this (that I can think of, anyway). However, it is very simple in both concept and execution. By clicking on one of the color wells on the COLOR LIST, then click-dragging adding the Option key (PC: Alt) as you drag, you can add the location and color of the center of a radial wherever you drop that color in the shape. To do the same with a graduated fill, use the Control key instead (the PC version of this is not documented in the manual, so it may not be available).

This makes it very simple to drop highlights into balls or to

randomize colors to make a headline flash. Although this effect is not wonderful, there are many times when this capability greatly speeds up the process of design.

Using the COLOR LIST popup menu

The popup menu adds, removes, controls, and modifies the color on the list. This is where you add colors from the various libraries. As you can see, Pantone alone has a dozen libraries with PMS Coated and Uncoated, the metallics, the pastels, process, European process, Hexa-chrome, and the process simulation (as close as it ever gets) of the PMS spot colors.

Using this popup, I can convert any color from process to spot or vice versa. I can convert any process color from RGB to CMYK (or its closest equivalent). I can remove colors from the list, import color libraries as they become available, or even create my own custom libraries.

This custom library option got me excited about custom palettes until I realized that I still have to laboriously add colors to the COLOR LIST from my custom library one at a time. Adding colors from libraries is much more time-intensive than it could or should be.

However, it should be mentioned that setting up a custom palette is something you do at the beginning of a project and save as a special FreeHand Defaults document. There is no reason why you couldn't have a stash of these default documents (on a ZIP, for example) with the palettes you need on a regular basis. Then all you would have to do is drop the defaults you desire into the FreeHand folder before you launch FreeHand. Because custom palettes

should only be a dozen colors or so, it's not a big deal.

The COLOR TINTS panel

One of the minor frustrations of FreeHand is the fact that you need to add any tints you want to use to the COLOR LIST also. There are times when it would seem nice to be able to change the percentage of any color with a simple popup menu like PageMaker and Quark have available on their color palettes.

However, adding tints to the COLOR LIST requires you to make a conscious choice of tints that builds consistency into your graphics. One of the reasons that modern computer graphics look so unfocused (aside from a guess that self-discipline is a lost art) is the ease of building huge color palettes. Again, as usual, discretion is the better part of excellence in design.

Another nice side benefit of the TINTS panel is that you can make tints of process color builds. It is very difficult to make a lighter version of a process color. The TINTS panel enables you to make a 45% tint of 37c, 21m, 0y, 12k, for example. The hue and saturation will remain constant, but the value lightens. This is a very nice capability.

Controlling stroke and fill

At the upper left corner of the COLOR LIST are three little squares that tell you about the stroke and fill applied to selected objects. The left square indicates the fill, the center square indicates the stroke, and the right box tells us about both. In the example to the right, the fill square has a heavy dark line around it, indicating that it is active. You can see

that the color of None is selected below it. Because None is selected, the fill indicator is square with an X through it. The center box has a 45° line. In this case, that line is black, indicating a black stroke. The right box has what looks like an em dash in the center of it. This means that the stroke and fill are different. If I have multiple shapes selected, this little em dash tells me that the shapes have different strokes or fills or both depending on where the dash is located.

Managing the different spaces and systems

Aside from the obvious difficulty in picking a color scheme that is beautiful or fashionable, color adds a great deal of complexity to all publishing. The major point to remember is that you can only work in one color space per project. If it is a Web project, you must work in

CUSTOM PALETTES

If you use custom color palettes a lot, the easiest way to deal with it is to have several default documents stored in your FreeHand folder with different names. Then you can switch from one to the other by using the Preferences option we mentioned in chapter three.

RGB. If it is a printed project, you will normally be working in spot, CMYK, or Hexachrome. It's also important to remember that adding color to printed projects adds a great deal of complexity and expense. This is a decision to make *before* you begin the project. It is a decision based on budget coupled with the real needs of the project.

Color is like any other piece of the collage you are making. Just as you are not allowed any mark on the paper or screen without a reason, you should not use a color unless you can give a reasonable justification. Many times that justification is simply, "I needed to bring attention to this portion of the page," or, "This is the color scheme chosen by the client." As with all things in graphic design, your task is to use what you are given to solve the problem posed by the project.

As we shall see in the next chapter, that problem is always basically the same. Color is one of the tools we use to come up with a competent solution to the design need. The main thing you must keep together as the designer is simple: are you working in spot, RGB, CMYK, hi-fi, or spot plus process? Those are your choices. The spot-plus-process choice is relatively rare because it is so expensive.

Protecting yourself

You cannot mix color spaces without disastrous results. Those consequences will hit you in the pocketbook. The client is not going to pay for your design errors; neither is the service bureau nor the printing firm. Always keep close tabs on what colors you are using. In printing projects, the basic decision is always spot versus process.

If you are working in spot color, all of the color names in the COLOR LIST will be roman type (vertical). There will only be the spot colors you have chosen (one or two plus black) and tints of those two or three colors.

If you are working in process, all the type names will be oblique (slanted). There will be no three little RGB balls at the end of any name. There will be no roman type. If you are working on the Web, everything will be oblique and every color will have the RGB symbol.

With these simple steps under your belt, and a basic knowledge of all the tools and commands available to FreeHand within your grasp, we are ready to go on to designing real projects.

Remember, all lens fills convert spot colors to process color!

Knowledge Retention:

1. Why is spot color so limited?

2. Why do you think it is so important to control value in distant objects in a landscape?

3. How does 24-bit color compare to reality in scope?

4. Why can't you print RGB?

5. How do you compensate for color in printed projects while designing on a monitor?

6. Why are process colors so weak in the reds, violets, and blues?

7. Why are swatch books essential to design?

8. What do you think the problem is when trying to proof spot color?

9. Why do you have to keep track of what color space you are using in your current project?

10. Why is process color becoming so popular and common?

Where should you be by this time?

You should be ready to go. You should be producing small projects and feeling relatively comfortable with the software. You need to be current with the skill exams and miniskills given in the previous chapters before we can go onto the design problems in the rest of the book. The major areas you need to work on are type manipulation, use of the Pen tool, and transformations. They are all used constantly in the design of virtually any project, as you will see while the book continues through its conclusion — kicking you out of class to make a living at this stuff!

DISCUSSION:

You should be discussing how to get impact with two colors or three; how to control process color to keep a coherent look to your projects; and how to use color on the Web that is not dependent upon the reader's monitor (because you do not know what your color will look like in her monitor).

Talk amongst yourselves ...

PRINT & WEB GRAPHICS USING FREEHAND

Chapter Eight

Logos

Using FreeHand to solve fundamental design problems

Chapter Objectives:

By teaching students the options and capabilities of FreeHand, this chapter will enable students to:

1. describe a functional procedure for developing a logo design solution

2. design a logo in response to a given job ticket

3. work within a prescribed color scheme

4. give a client a variety of options.

Lab Work for Chapter:

* Miniskills #6, #7, and #8
* Skill Exams #6 and #7

Logo design

CLOTHING FOR THE NEW MILLENNIUM

Bad Rags

Kodak

BAYER
BAYER

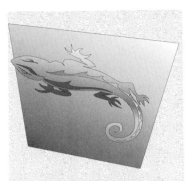

Where we've come from

Graphic design history is a very interesting phenomenon. Until very recently in human history, graphic design didn't even really exist as a separate identifiable career. Conceptually, it was not even considered until the later part of the nineteenth century.

The history of graphic design is tortuous, to say the least. The career itself is relatively new. It dates to World War II at the earliest. Before then we had writers, editors, illustrators, and compositors in the printing industry. The earliest forms of graphic design were simple identification marks — often not so simple.

The origins of what we today call the logo are found in crests, trademarks, hallmarks, and chops. All of these are identifying marks. Crests identified families. Trademarks identified the products of a particular craftsman, artisan, or designer. Hallmarks provided the seal of approval from guilds, trade unions, and authenticating organizations. Chops were the personal signature carved in stone in China and Japan where a hand-painted signature was worthless (because almost everyone was good enough to copy anyone else's brushmark).

These marks gradually increased in importance, as it became more and more necessary to distinguish an original from the copy. Thus, logos are truly the sign and core of graphic design in our marketing economy. The entire focus of our economy is summed up in the logo: My product is better than my competitors' product. My logo reminds you of that. In addition, my logo gives subtle reinforcement to the strengths of my product.

Logos as the company signature

Today, the logo is one of the most important tools used to give a company a graphic presence in the world. Even though, contrary to the opinion of many, the logo is not earth-shaking, it is the core of a company's style and graphic presence in the marketing community. Because we live in an economy totally governed by marketing, advertising, and promotion, this mark is obviously foundational for a company or corporation.

This is not to say (as some do) that the logo will make or break a company. It is important but not crucial. There are levels of competency that must be reached, but even here there is room for wide variation. More important than the actual design are the usage patterns. These guidelines for use should be codified or at least written out in simple form to give nondesigners help in usage.

However, before we can actually get into logo design, there are terms to review (or learn). You need to understand some of the basic concepts of design, and necessary principles.

Getting the ideas on paper

The idea of covering design in a book like this is pretty ludicrous. This is the subject of four-year degrees. However, it must be done, so we'll start with a quick review of design terminology. These basic terms are important. They enable us to talk with each other in a language that conveys certain things to everyone in the design field.

Subjectivity

Probably the most difficult aspect of design is the simple fact that everyone sees things differently. This means that there are very few hard-and-fast rules. This is why the field is so difficult. When you are discussing a design with another designer, the most common reaction is something like "That doesn't work" or "That really pops!"

Work and *pop* are two very common terms. These terms are absolutely undefinable. However, after a while you will know exactly what each one means. The problem is that they can be understood only experientially and subjectively, by those with trained eyes.

Needless to say, this type of conversational approach is less than satisfactory to the neophyte. Fortunately, there are many terms that are much more precise. As we cover them, think of them as a vocabulary exercise. It is simply learning a new language (which really doesn't have many words). More than that, they give us common definitions for words we are already using.

Design terminology

You have known most of these terms since you were little, but let's review, because there are some differences.

Line

This most basic term, for example, is not the one-dimensional object you learned about in high school physics that only has length (no width or height). In graphic design, lines have infinite variety: thick, thin, light, dark, angular, curved, complex, simple, smooth, textured, hand-drawn, descriptive, or simply organizational. If your line is two inches wide and two inches long, how does it differ from a square?

Shape

This is even more complex. That short, fat line is better called a square shape. There are entire drawing systems based on the three basic simple shapes of the triangle, rectangle, and ellipse. It is said that any shape can be made of combinations of those three basic forms (though that is stretching things to their absurd limit). Though it can be argued that a rectangle is simply a very wide line, all the other shapes vary in width and/or height.

Shapes differ from lines primarily in how they are used. However, the shape is often the easiest identifiable unit that can be discussed in a graphic design.

REMEMBER THIS:
To me, there is something superbly symbolic in the fact that an astronaut, sent up as assistant to a series of computers, found that he worked more accurately and more intelligently than they.
— Adlai E. Stevenson

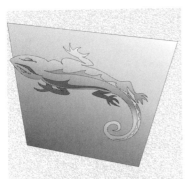

THIS ONE ALSO:
The economic and technological triumphs of the past few years have not solved as many problems as we thought they would, and, in fact, have brought us new problems we did not foresee.
— Henry Ford II

Volume

Here we add the illusion of an apparent third dimension — depth. Simple volumetric relationships can be created with simple layering techniques. Others require an understanding of perspective. Three-dimensional (3D) illustration is becoming more common all the time (although its use is mostly fashionable).

Symbols

These are shapes that have additional meanings not directly attached to the shape. For example, what we call stars look nothing like stars. Five-, six-, seven-, eight-, and nine-pointed stars all have specific symbolic meanings that go way beyond their simple shapes. In fact, stars with odd numbers of points mean different things depending on whether the single point is up or down and something else if none of the points is vertical.

Symbols are often used as logos. However, there is a real danger here. In a society as large as ours has become, symbols mean different things to different people. The swastika is no longer the quaint sun symbol of the native Americans of the southwestern pueblos. The rainbow means very different things to the Jew, the gay activist, and Jesse Jackson's followers.

Texture

This is difficult to define but easy to recognize. Some textures are graphic techniques that indicate how a surface would feel: hard, soft, smooth, furry, slimy, oily, scratchy, and so on. Other textures are stylistic. For example, Rembrandt's crosshatching has a very different feel from the crosshatchings found in the engravings on paper money. Textures can be dense, loose, light, fluffy, and many others.

Color

This is so complex that we have already devoted an entire chapter to it. Yet, we have not even begun to cover its actual use as a component of design. Color is very tricky. It is extremely easy to add color that lessens contrast and therefore impact. However, well-designed color can cause a strong reaction. Color is often one of the main indicators of fashion. It can have strong emotional content (although the Japanese use of white for funerals shows how tricky that can become).

Arranging the pieces

Balance

Balance is concerned with the visual weight of the pieces of a design. A piece top left needs to be balanced by a piece bottom right; an area on the left needs to be balanced by an area on the right; and so forth. A large light area can be balanced by a small dark area. Darks

are stronger than lights. Large is stronger than small. Shapes are stronger than simple rectangles. Color is weaker than black and white.

Symmetry

Coupled with balance is the concept of symmetry, which has to do with a image reflected across an axis. In other words, on a symmetrical image, both sides (as divided by the axis) are identical but flipped. Normally, the axis is vertical, as in the example below right.

Asymmetry

Asymmetrical design forgoes the balance of equals by replacing it with conceptual balance. Currently, asymmetrical balance is by far the most common sort of layout. The question to ask is, "Does everything hold together, or is it scattered?" A work can be built of widely varying pieces with huge differences in size, color, texture, shape, and line. Yet an asymmetrical balance can be maintained that pulls the pieces together into a powerful and focused statement. Zen landscapes are often 75% to 95% blank sky, but the feeling of space is compelling and awe-inspiring.

Once the three concepts of balance, symmetry, and asymmetry are tied together, we can talk about two basic styles of arrangement, formal and informal. They are used for very different purposes. Formal designs are a very small proportion of the pieces produced. This is more true the farther west we go in the United States. Our culture has become very loose (some would say impolite). As a result, our communications tend to be informal, so we do not get accused of snobbery, arrogance, or elitism.

Mirror Image Mirror Image

Symmetry Reflection Axis

Formal designs

Formal designs have developed a strong set of normal usage situations. This is an increasing trend because our culture is so rarely formal. Norms govern much of what we do in design. Most of the control we exercise over our readership comes from habitual subconscious reactions that we trigger by normal usage.

Formal designs are almost always centered compositions; that means the pieces are either centered or exactly balanced symmetrically. They usually use small point sizes with a great deal of leading. This often seems extreme. For formal invitations using script faces, 16/24 is not uncommon. In addition, the tracking is usually loose.

LOGOS, BASIC DESIGN PRINCIPLES, AND GUIDELINES

Miniskill #6

Your task is to design a formal invitation that is 5"x7" — font choice is yours, as is the layout. The logo is an eight-pointed star centered in a circle with an H in the center. (Do the best you can.) The copy is as follows: The Hobrund Group proudly invites you to attend an open house celebrating the release of Hobrund's new three-ounce satellite transceiver, Touchnet. Time: October 17, 7:00 PM Location: Lobby of Hobrund's new tower suite, twenty third floor, 1429 Wysoky Drive in Palmdale. Black tie RSVP 329 497–3111 by October 2.

Typefaces are normally light. Book is often the best choice because it is a little lighter than medium and often more elegant. Type styles are chosen for their elegance. Either classic examples of excellent design or type from the late 1800s or early 1900s are chosen. You should be careful of extremely stylized or "heavy" faces. Formal is always restrained. White space (empty area) is used lavishly.

Formal layouts tap off the fine art world for its images. There is a much greater use of beautifully drawn illustrations (as opposed to photos). If photos are used, they must be extraordinarily good "art" prints. There is also a large body of work that may be called semiformal. These use formal type conventions with flush left alignment.

Informal designs

In this day and age, informal layouts are the most common by far. In general, they are asymmetrical but balanced. As mentioned, almost all work must be balanced. Purposely unbalanced work is very disturbing, yet even there an asymmetrical focus must exist to evoke the intentionally created reaction. Unbalanced layouts only work for psychological thriller books and movies, haunted houses, and the like.

Asymmetrical balance is a subjective thing. When a piece is balanced, it is obvious to any professional. The comment will be, "That works!" Getting to that point is a little tricky. Large light pieces can be balanced with small dark pieces. That is obvious. What many do not realize is that small intense areas can be balanced with large empty areas. Large areas of grayscale (type and graphics) can be very effectively balanced with a tiny intense area of color.

Blank paper is one of the design elements used in design. It must carefully controlled. It is usually referred to as *white space*. However, it is white only if the paper is white. The empty spaces are just as much a part of a design as the drawn elements. You are required to control them. Elegant pieces have lots of white space. "Down-and-dirty" warehouse-style ads have almost no white space (it's part of the style). When you look at a warehouse-style grocery store ad, you will have to search for any white space.

This is one area where you may have to fight with your client. Many clients are loath to leave any white space because they are already freaked out by the "high cost of printing." You may well have to tactfully explain the effectiveness of white space. In a vast sea of tightly filled ads on a newspaper spread, an ad with a great deal of white space stands out much more than just another bold burst of typographic shouting.

Your layout choices will greatly affect the first reaction of your readership (or surfership). This must be one of the first design decisions you make on a project, along with the font choices. This is not one of those areas where you can spontaneously slip into an arrangement that makes the reader react as necessary.

Controlling the eye

Guiding the reader

One of the most important aspects of graphic design is guiding the reader's eye through the piece from start to finish. Our purpose is communication. All our work occurs because a client is paying us to communicate a specific message to a specific readership about a specific product. There are many methods and techniques that can help us realize that goal.

Contrast

Probably the most useful method of directing the reader's eye through your design is contrast. There are countless contrasts that can be used: light/dark, large/small, simple/complex, thick/thin, complementary colors, and on and on. Through the careful use of contrast, we can make one item pop off the page and grab the reader's eye (hopefully without offense).

Rhythm

Rhythm is produced by some sort of repetition, either obvious or subtle, that causes the reader to expect and look for the next piece in the pattern. A good example is a bulleted list. After a couple of bullets, the reader looks for the next one. In addition, the repetition of bullets down the side of the column is probably what attracted the attention in the first place. Rhythm must be used with care. Too much rhythm simply becomes texture and disappears.

Unity

Unity must also be used carefully. Too much unity becomes bland, trite, and invisible. What we are looking for is unity of content; a better word might be consistency. The illustrator at my first professional position in graphic design carefully showed me that decorative art must be unified in technique and palette but absolutely diverse in detail. For example, a painted bouquet of flowers had to be consistent in technique, consistent in color, consistent in every way— except that every flower had to be different in shape and color combination.

Another use of unity concerns shape construction. Adjusting the position of shapes until the curves and angles of one flow into or point to the next brings the two shapes into oneness, visually. In fact, you will normally find that pieces that "work" have this kind of relationship between the shapes.

CHAPTER EIGHT: LOGOS

Here is an example of shape flow. It is certainly not great design, but it clearly shows the concepts. Note how the black star tucks between the *T* and the dot over the *i*. "A division of Lembeton" lines up with the vertical strokes of the *T* and the *r*. The rest of the type justifies within the enclosing box, which also lines up. There are several other examples.

The Quality Lighting Group

invites you to join them

as they celebrate

the opening of

their brand new

interior design gallery.

·····

February 30, 1999

15721 Le Grande Boulevard

in downtown Yuppietown

11:00 am to 7:30 pm

·····

Wine, cheese & door prizes

169

Cultural usage

It is imperative to be aware of the culture of the reader. In European cultures (like ours), reading order is left to right, top to bottom. Therefore, an American reader will normally try to start at the upper left corner of the design and read through to the bottom right.

Different cultures react differently. For example, readers from Middle Eastern cultures would tend to read right to left, top to bottom. Asian readers would be prone to look from top to bottom first, then right to left. This is simply a function of how their language is written. You need to be aware of these things.

We know what works

The centuries of printing experience and decades of advertising and marketing have given us a great deal of knowledge about what works and what does not work in graphic design. Huge amounts of money have been spent on market research to determine who reads what, and why; what historic styles cause which responses; what type styles are more readable, and why; which layouts are effective; and so on.

Beyond all the studies and statistics, the fact remains that good design is always a subjective judgment. It is easier to identify the reasons why you do not like something than to identify why you do. Nevertheless, there is much you can do to increase the effectiveness of your work. When you set out to design a page, think of the purpose of your design. For any design, someone is paying the bills and someone is receiving the message. You need to be clear about who these people are and design accordingly.

The basics are constant

Our job is communication. We do this primarily with words. This is why so much time has been spent on typographic matters. However, the same things apply as we deal with logos. We communicate a message about a product to help our client explain to the reader why a desired action is necessary and/or appropriate. In the case

Looking for
peace & quiet?

of a logo, the product is the company itself and the message is "Trust us!" But the task is always the same. It is the designer's job to convey that message effectively. This is true no matter what the job is and no matter who the readers are.

Graphic design is about communication and little else. Everything is subordinate to the message. The most important thing about the message is: can and will it be read? If it is not read, who cares what the message was?

There are many other books focusing on the intellectual design process. Many of them are concerned with design for design's sake (think in terms of inbreeding). Almost all avoid production realities. The five principles discussed here are a basic starting point, applied before design can begin.

The important thing to remember is that these principles help very little without adequate production skill. If you cannot meet the deadlines, the best design does not matter. The problem, of course, is that in digital publishing the designer and producer are usually the same person. We have taken over the publishing industry (with all of its responsibilities, of course).

These general guidelines contain questions that must be answered for every design: logo, corporate image, brochure, poster, or whatever the client needs. They should be considered before you start and all along the way. Not covering these principles means that you are relying on luck to sell your client's product. Needless to say, this tends to be dangerous to the size or receipt of your paycheck.

A FIRST PRINCIPLE OF DESIGN

Design for your reader, not your design opinion

The best design does not call attention to itself. It should not be noticed. It is very bad if the reaction is, "Wow, what a great design!" The message should be easily available to the reader. The product should be obvious. It merely has to be made attractive.

There are four goals you should keep in mind regarding readers:

- Attract the reader. It won't happen by accident.
- Make your work easy to read and visually accessible. The surfer or reader is subconsciously looking for an excuse to skip your design, flipping to the next item in her inbox or pile of mail, or clicking a link and moving on.
- Give the reader something to do. Without a proposed reaction, your piece is just a pretty picture. It can be an 800 number, an order link, or just a directive to remember us favorably.
- Give the readers the desire and ability to act. Give them something to do now, something to get that meets their need or at least their want. "Order Now! Just click the Order button."

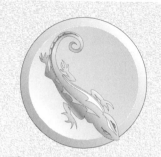

**CHAPTER EIGHT:
LOGOS**

CLASSIC ELEGANCE IN LOGO DESIGN
The Kodak logo sometimes looks like a K, sometimes like a simple camera, but it is always instantly recognizable as that camera and film company that can and has been trusted.

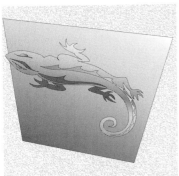

LOGOS, BASIC DESIGN PRINCIPLES, AND GUIDELINES

171

Some designs attract through beautiful layouts or dramatic impact, yet totally fail in leading the reader to a desired action. Some designs would do very well at motivating the readers, if only the designs could get their attention. You wouldn't believe how many times readers are enthusiastically ready to respond to a piece, but cannot because the designer forgot the address or telephone number! I have seen many instances where even the logo was forgotten.

A SECOND PRINCIPLE OF DESIGN

It's their money, they're the client

Your clients are the ones paying the bills. Even though the reader is arguably the most important person in the design solution, the client is the one who has the products that need promotion. They often know their market better than you do. The fact that they are still in business (when most businesses die within six months) tells you that they have something going for them.

You must stay within their budget. If the client likes brown, don't insist on blue unless you are convinced that it will cause a better reader reaction and can give reasons why (tactfully). Get all the information you can from the client. Ask as many questions as the client allows or time permits:

- What is the budget?
- What is the due date or deadline?
- Who is the audience, customer base, or demographics?
- What does the client want the reader/visitor to do?
- Who are the client's known competitors?
- What messages have worked in the past?
- What is the existing graphic identity?
- What corporate image is being pursued?

Find out what goals the client wants to achieve with the project. If the client has not formulated them, help get them in writing. (Yes, this is an additional source of income.) You are getting paid for your expertise, so offer suggestions. Remember, though, because the clients are paying the bills, they also have veto power. Don't let your ego get in the way. Your job is to serve the client and his customers. You need to be focused on helping your client achieve what she lacks the skills to do and/or the time to produce.

Considering yourself as the design extension of the client often helps you to walk in their shoes. In a very real way, designers are hired guns. We are brought in to do what the client is unable to accomplish. Don't make the assumption that they are creatively deficient. Often they simply do not have the time to spend in design. We become their creative ability for their concepts (but don't tell them that!). We are

literally hired specialists. Our clients have very different concerns than we do. You should focus on their needs and how to meet those needs. This is a service industry, not a gallery offering design objects d'art.

<u>A THIRD PRINCIPLE OF DESIGN</u>

Pay attention to detail

Once you get involved in actual production, make sure you clean up all the details. Nothing affects the reaction to your design more than typographical errors or sloppy mistakes (such as strokes that don't meet, elements that do not align, or widows). WYSIWYG is still a distant goal. What you see on the screen only superficially represents what will be printed (remember, it's only 72 ppi). In fact, 300 dpi proofs are really only roughs compared to imagesetter output.

It is always difficult to see your creation in an objective, fresh way; that is why it is a good idea to have someone else proofread for errors, consistency, and detail in your layout. Most professionals have at least two other people proof their work. If you made a mistake the first time, you are probably going to make the same mistake when you proof your own work. (That is why you made the mistake the first time – *you didn't see it!*) You cannot proof too much or too often.

To help see problems, try looking at your proof upside down or backward (use a mirror). The proofs the customer sees should be perfect. One typo per page is pushing it.

 Many budgets have been destroyed because the designer left mistakes on the proof. The client was thus given a golden opportunity to employ the old "since you have to make these changes anyway" routine. It is almost impossible to charge for client changes when they know you are making changes already to correct your own sloppiness. This is a common cause of very poor client relationships. Much of your repeat business can come from the quality of your proofs.

Always, one final check

Just as important as proofreading is taking the time to run out final laser proofs before sending the file for final output. It doesn't matter how urgent the deadline is. Even though you already have an approved proof signed by your client, skipping this crucial step invites disasters ranging from missed deadlines to a budget destroyed by the cost of extra imagesetting. The worst case is a job that must be re-printed, at great cost to your client or maybe yourself. Always check out this final laser proof and send it along with the disks to the service bureau or image assembly department (with appropriate comments written on the proof, if necessary).

CHAPTER EIGHT: LOGOS

HISTORICAL USAGE
If this didn't have the name, would we have any idea what the company did? An example of where the symbol used has no real use or need, other than the fact that it has been used historically. It certainly doesn't indicate quality veggies or fruit other than the eating memories attached to the product line.

172

LOGOS, BASIC DESIGN PRINCIPLES, AND GUIDELINES

HISTORICAL HELPS

This logo is instantly recognizable only because of the name inscribed. The many graphic remnants of historical styles greatly help this logo create a sense of stability, trustworthiness, and reliability.

173

When in doubt, write it out!

A FOURTH PRINCIPLE OF DESIGN

Know yourself

You cannot do more than the constraints of your time frame, budget, or abilities. More than that, you cannot do anything that your imagesetter refuses to print. As the designer, you interpret what is possible within the given needs. Evaluate your strengths and weaknesses. Then you will be able to design according to your abilities. Illustrate, if you are a good illustrator. Don't attempt to create four-color process artwork if you don't understand how to trap it and print it. You will be much more successful if you do what you do well. Ask for advice when you need it. It is a sign of strength and confidence to know and admit when you need help — and seek it out.

Study constantly to learn the capabilities of both your equipment and your software. Work to expand your own abilities and polish your skills. Fill your brain with all the design data you can. Then the ideas will flow relatively easily.

Be sure to design within the limitations of your equipment, as well. A 75 MB, CMYK separation is going to be a little difficult on your old Performa with 24 MB RAM. If the only printer available for final output is 600 dpi, process work is pretty much out of the question. Common sense helps a lot.

A FIFTH PRINCIPLE OF DESIGN

Be compassionate to those who follow

Output realities greatly influence electronic design decisions. For instance, if you plan to use an ordinary 300 dpi laser printer to run off 200 flyers, it would be foolish to scan graphics with a high resolution. These printers can only print at 300 dots per inch and 60 line screens (no matter what you do). If you are sending your publication by modem to a service bureau, you must build in the time it will take to send the files, especially if they are very large.

It is easy to design documents that are complex enough to choke an imagesetter. Remember K.I.S.S. (Keep It Simple, Stupid!). You should add complexity only when you know it is necessary. Dense (very complicated) designs are usually difficult to read. If complexity is called for, pay special attention to the readability of your type.

Another part of this is making sure that you communicate clearly with your production staff. This is true whether they are the

next department down the hall, a service bureau across town, or even a printer in another country (like this book). You must include all necessary files and fonts. Give them a marked-up laser proof with full instructions. Send a practice file to new suppliers.

Talk to the rest of the team

The importance of this cannot be overstated. Publishing is a team sport. Talk to them, be polite, make friends with them. Make certain you make friends with the receptionist and your personal contact. You should know who will output and who will print your work. You need to know the shops' capabilities. This is still true if you are working in-house. Have your questions answered before you begin to design. You should design a checklist to note down the answers to all of the following questions, plus any others you consider necessary:

- Do you need camera-ready art, composite negs, or do you go direct-to-plate?
- Who are your contact persons?
- Are the financial arrangements understood and available?
- Where can money be saved by making design changes?
- Who should do the image assembly tasks needed for this job?
- What linescreens will be used for halftones and tint blocks?
- What color matching systems are used?
- Will I see a blueline, color-key, laminated, or digital proof?
- Will I do a press check?
- When will the work be finished?
- What is the rush charge policy?

Professionals are helpful

Industry professionals are happy to answer these and other questions because they know that planning early pays off. If you work with them in the same company, they'll be tickled to find out you care. If you have to go outside, thoroughly go over your documents with the service bureau and your camera-ready art or negs with your printer. It is time well spent.

If a project is complex or large, a professional will be happy to talk to you about it before you begin working. If she won't talk with you, find another company. You will find out much that can save you time and trouble later. Often a simple (and small) change in the page size can save you a great deal of money.

The function of the logo

Things changed a great deal during the twentieth century. Graphic design not only became a viable career, to a large extent it has become the core of our culture. In a marketing economy, the

CHAPTER EIGHT: LOGOS

FONTS THAT CONVEY FRIENDLINESS

Much like the Del Monte logo, this one is helped greatly by the subtle feelings of history and old-fashioned value. In this example, a script typeface in an out-dated style, almost by itself, gives that increased sense of trustworthiness.

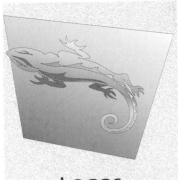

LOGOS, BASIC DESIGN PRINCIPLES, AND GUIDELINES

REPETITION WORKS

An artificially developed symbol that has great impact almost entirely through the use of incessant, repetitive marketing campaigns, the golden arches work. It does not matter if we like them or not — we know them.

designer is the person who makes it all happen. We have left behind our roots as a manufacturing, farming economy. Whether that is good or bad is not the issue here. The fact is that we survive and thrive by marketing things that others make.

The graphic designer

The 1930s and the picture story brought in an entirely new career — the art director. This was the first time that graphic design reached the masthead. Formerly, only editors were listed; now artists joined the ranks of the elite. Before this point, artists were mere illustrators, at the beck and call of the editors. Graphic designers did not reach equality until very recently, but it started here.

By the 1950s and 1960s, advertising agencies had grown incredibly powerful and transformed our entire culture. Our culture developed under market pressures. The arbitrators of our lives have increasingly been people whose job survival was based on their success in selling us items of little intrinsic value or differentiation. Everything we use is now marketed. Without mass response, items are no longer available.

We have gotten sophisticated enough to reject lies and false claims; our marketing has to be based on real benefits to our customers. The differentiation has to be real also. Why should you use my product or service? Because I can better meet your needs in the following areas: price, ease of use, convenience, emotional gratification, quality, durability, or whatever the truth is for the product.

What does all this have to do with logo design?

Simply stated, without understanding the history of your client you cannot design effectively. Without an awareness of graphic design history and the historic styles, it is very hard to communicate clearly. It is close to impossible to produce excellent designs that work without historical knowledge. You have to know the difference between Victorian, Art Nouveau, Art Deco, Arts and Crafts, and the others. You must know the graphic styles of the 1920s, 1930s, 1940s, 1950s, 1960s, 1970s on up to current fashion. You certainly do not have to be fashionable. In fact, my serious counsel is to avoid fashion whenever possible (especially for long-use projects like a logo). However, you absolutely have to know whether you are fashionable or not.

The toughest job

It may be sandbagging to let you get this far, but here goes. Many people get into desktop publishing because they "like to draw." This is not sufficient. This will give you an enjoyable hobby, but it will not sustain you in this very difficult career. Professional design is impossible without constant study, undying curiosity, and an insatiable drive for excellence. Graphic design is almost certainly the most difficult job description in terms of complexity, at the very least.

Graphic design is the most difficult job.

It can be argued that fine art is even more difficult, because there you have to invent the rules in addition to developing skills. However, graphic design makes that look easy when you consider that first you have to figure out who is making the rules, what the rules are, and who determines which set of rules will be used in a particular situation. Then you have to make yourself conform to the rules someone else made and produce designs that they are proud of. Fine artists please themselves. Graphic designers have to please themselves, the client, and the reader, in reverse order, all at the same time.

In addition, you need a great deal of printing knowledge, software knowledge, hardware knowledge, business knowledge, design knowledge, and much more — coupled with the ability to remember all of this and have it on tap to use.

Design responsibilities

As a graphic designer, you are responsible for every mark on the paper. You need to have a reason for everything. That reason can rarely be whimsical, and it has to increase accurate communication. All of this has to be done in an environment run by people who rarely understand creative necessities. In fact, that last statement is not only true, it is also a good thing. When designers gather together and pat each other on the back, design quickly degenerates into the pit called "art for art's sake." We commonly need others to keep us in line.

There is no room for the egomaniac in graphic design. This is a service industry. Properly viewed, we are hired guns who provide the creativity others lack, for a fee. Our services are as valuable and at least as difficult as the services offered by doctors and lawyers. It has been accurately said that the only equipment a doctor or lawyer needs is a phenomenal memory. Designers, in contrast, have to tread where others fear to go.

More than that, designs are such an integral part of the personal expression of our character that critiques can be taken as offensive attack far too easily. We have to become persons who use our skill professionally. It helps a great deal to remember that you are offering your creativity for the client's use to serve that client. In most cases, she couldn't care less what you want. What she wants is for you to express her ideas and concepts — clearly, accurately, and beautifully — the way she would if she could.

So, now we are finally ready. I can hear you all squealing, "Enough, already! Let's get on with it." Let's do that. As you can tell

CHAPTER EIGHT: LOGOS

BAD RAGS STATIONERY:
This is an in-class session. The pieces are found on the CD or the Website on the Miniskills page linked from the home page — it is Miniskill #7.

CLEAN AND CLEAR
Even as a poorly printed Yellow Pages ad, this trademarked logo has stood the test of time by increasing business and providing an excellent image for this vet's clinic.

from the title of this chapter, we are starting with streamlined design, what some would call "pure" design. In fact, it is still customer service.

Why a logo?

It's necessary for survival. In the new millennium, a logo is the beginning of a company. We have gone far beyond the original concept of a distinctive mark that lends authenticity to our products. In fact, as digital publishers, it is considered quite uncouth for us to place a hallmark on our products. There are signs that this is changing, but not very quickly.

So, what is a logo used for, and by whom? It has developed into the core of a marketing strategy, the bare bones of the company or corporate image. Often it is the only consistent portion of that image. In fact, here we run across the first major attribute of a good logo: well-defined and consistent usage.

Logos only work over a period of time. For this reason, unless you are selling fashion, as in the example on the opposite page, logos should not be fashionable. They should make a stylistic statement that the company can live with for a decade or more.

Even for a client who is selling fashion or who is on the cutting edge of technology, a logo should be designed to allow for upgrades in style if at all possible. This is not a place for hip phrases, radical colors, and so forth. You can use these in the marketing pieces themselves. Even the most radical company has to convince the banker that it is stable and reliable– therefore the term "official letterhead."

A logo also has to be used in a huge variety of situations and still remain the logo. Think of where you have seen the Nike swoosh – shoes, ads in magazines, TV ads, T-shirts, billboards, in the center of football end zones, clothing tags, and on and on forever. The logo has to have the same image huge or tiny; in color, black, or grayscale; as a patch; on the front or back of a T-shirt or doofus hat (sorry – baseball cap); on the hood of a stock car; or wherever the needs of marketing take you. This means that photos are out. In fact, continuous tone in general is a real problem.

A logo has to work no matter what method of publishing is used. A JPEG photo might work on the Web (if you can get it small enough to download fast), but it will never work on a baseball cap. It certainly will not work at a half-inch square at the bottom of a small newspaper ad two inches square.

Only now do we get to what most of you consider the fun part. Does it accurately reflect the true nature of the company? It must give the company a quick, accurate statement of its core image. This is where the cleverness of the designer comes into play. Look at that stylized paw print with the bandage that works so well for the local emergency veterinary clinic, for example.

The five parts of a logo

1. It must be clean, simple, and graphic for any publishing purposes – print, Web, fabric, video, and more.
2. It has to be as timeless as possible for long-term use.
3. It must be usable in any situation required.
4. It must accurately reflect the company's unique character, product, and purpose.
5. It must have a standard consistent usage program.

That's a lot to ask of a tiny, simple graphic. This is why the companies that can afford it spend thousands of dollars on logo design as part of their entire marketing strategy. Some years ago, Coca-Cola spent something like $25 million just to make sure that its logo was being used consistently around the world. One of our local statewide hospital chains spent more than $25,000 on its logo, and one of the local banks spent nearly a quarter of a million dollars on its.

However, these massive (and often simply obsessive) efforts toward corporate image are not our focus here. You will find them to be a real hassle. With that amount of money at stake, the client committee members usually provide sufficient grounds for justifiable homicide.

Our focus (and a good deal of your future business) is on the new boutique, gift shop, strip mall, construction company, television station, newsletter flag, photography studio, car dealership, restaurant, bar, hotel, auto parts store, drilling company, candy manufacturer, or whatever comes into your office on a given day. These people genuinely need your help to make themselves known to their clientele. They truly need a distinctive image to set them apart in the live-or-die atmosphere of the modern marketplace. They need a core strategy to build their business around, and they need you to help them explain this graphically to their customers, suppliers, and financial supporters.

This is not the place or the time for cuteness or your latest graphic ego spasm. You must seriously find out who they are, what they sell, and why their company is better than their competition. Then you can help them go out and do their job by giving them an image they can be proud of, that accurately shows who they are, that answers questions instead of posing problems to their customers, suppliers, and financial supporters.

Kinds of logos

Symbolic

It would certainly be nice if we could always come up with a clean, clear graphic symbol that would explain accurately to everyone what your client's company is all about. In these logos, the name (which has to be short) is encased in a simple graphic shape while using a distinctive typestyle: Bayer, DuPont, and Levi's come to mind.

SYMBOL LOGOS
Notice how cold and businesslike they are, even though two of them have a retail image and Levi's sells warm comfortable clothing.

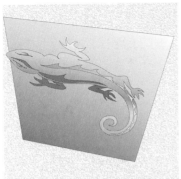

In the three examples on page 178, some interesting characteristics appear immediately. First of all, they are very cool and business-like. This has been the typical stance for logo designers. The logo is the official symbol or graphic sign of a corporate entity. So, here's a question for you. How much of Levi's current financial troubles and slippage in sales comes from its image as a cold, impersonal corporation only concerned about profits?

Logos from initials

Here we come to the most common problem you will face as a logo designer. How do you convince a client that making a logo from its initials is a very bad idea? You will usually hear, "What about IBM?" – or RCA, or AT&T. You will then have to educate them about the realities of the effort needed to make initials an effective name and logo. Even a company like Volkswagen isn't commonly called VW, even though it has an initial logo.

As easy and as tempting as it is to make a logo out of the company's initials, you should resist that temptation. There are times where initials may work fine ... maybe for lawyers or accountants. But even here the lawyers are selling their good name and reputation. What do you know when you see a logo like the GT to the left? Absolutely nothing! You can't even begin to guess what this company is, what it is selling, or even what type of company it is. There's a logo something like this for a cross-country trucking firm that has a terminal in my city. If I saw the logo anywhere except on the side of a truck, I wouldn't have a clue what it meant.

The VW logo is closer to a monogram: those fancy initials affected by the very rich, and meaningless except to those people and their staff. The hood ornament or car logo is a special breed. The stylized H of Honda or Hyundai, M of Mazda, T of Toyota, or L of Lexus are effective only because they are often the only identifying mark on huge quantities of automobiles that we see every day. Even then they are only effective for people who love cars and really care what brand they are. Only the VW is common enough to use in advertising without the company name attached.

IBM is in a similar situation. It has invested billions of dollars in its image. Even its street name is attached to that logo – Big Blue. It is a huge company. However, there was a study some years back asking people if they knew what the initials IBM stood for, and the vast majority had no idea (it's International Business Machines).

All of this brings us to the first major point we need to understand about logos: as important as logos are, it is not wise to look at the huge international conglomerates for ideas. It is very unlikely that you will ever get a project to redesign Ford's logo, for example. It might be possible that you might get to design a logo for a portion of Bill Gate's empire if it gets busted up like Ma Bell did. But opportuni-

ties like that are very rare. Logos with budgets like that are not every-day projects. With that amount of financial and market-share clout, even the mistake of initializing a company like IBM can be turned to marketing advantage.

This is not and will not be true for your local software entrepreneur, bank, coffee shop, or whatever. Even though the bell works well for Taco Bell (all jokes concerning Latino telephone companies aside), a bell doesn't ordinarily work for a restaurant. I'm not saying that you shouldn't look for and use obvious visual puns to help your client's visibility. However, you need to remember that it will be a long time (many years) before the community at large thinks of the company when they see the symbol or graphic.

The name as logo

This is why a company's name is so important. You will be using the logo to help market the name. The company name is what customers will remember. More than that, it is what you want them to remember. You will find that cute graphic symbols attached to that name tend to come and go as fashion statements. What matters is the corporate or company image attached to the name.

This is where your focus must be when beginning a logo design. What is the company's image: position in the community, position in the industry, reputation among customers, reputation among noncustomers? Your task is to design a graphic style that builds on the positive points and minimizes the negative aspects of the image.

A logo is merely part of the overall marketing strategy.

There are many books on logo design. However, few of them tell you the obvious: your logo is often a meaningless waste of money unless it is part of a comprehensive plan. Let's give a small example related to customer experiences with your client. Studies have consistently shown that if a customer has a good experience with your client, she will tell seven friends. This is by far the best type of advertising — word of mouth. However, if that same customer has a bad experience, she will tell forty people! Then every time one of those forty-one people sees your fancy logo, they will get angry or have a negative reaction. It makes the counter help more important than your logo!

When beginning a logo design project, you must deal with these questions we are hinting at now. As far as a logo is concerned, your wonderfully clever ideas are a complete waste of time unless they are

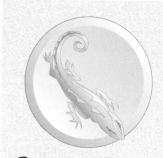

CHAPTER EIGHT: LOGOS

SKILL EXAM #6
Redesign the Bad Rags logo. See the instructions on the CD or Website.

MINISKILL #8
LOGO DESIGN

A logo is needed for Charles P. Atkins who is a Certified Public Accountant with offices at 1439 Barberos Road, San Flan, Arizona 93142. His phone number is 623.892.3547 — Fax 623.892.3548. However, his entire business is done on the road out of his Power-Book. So the primary items on his stationery are his initials and his email address: wiredcpa@cyberport.com He wants a round logo centered at the top of his BC, LH, and EPS. A motto is optional. The fonts are your choice.

tied to an accurate view of the company's true image and character. More than that, the primary thing your logo must convey is the trustworthiness of the company. Even if you are dealing with a radically fashionable boutique, you must give the customers a sense that they can trust the fashion judgment of the shop's buyers, that the clothing purchased is worth the money, and so forth.

The importance of the font

Here we truly need to look at current usage long and hard. The standard belief is that logos need to be clean, clear, and businesslike. The Bayer, Levi's, and DuPont logos from a few pages back come to mind. However, as was mentioned in the sidebar, maybe some of Levi's difficulties can be attributed to this clear and businesslike, yet cold, sterile, and unfriendly use of type styles. This is simply a question to ask yourself, not a radical statement of researched knowledge.

If it is true that the most important aspect of your logo design is the trust it engenders in your client's customers, then it would seem obvious that classic serif typefaces would help. Beyond that, there is a strong tendency among designers to use the latest fashionable font for all designs in a given year. Three years later, these fonts look tired, dated, and suspect — not the image your client hired you to provide.

Now, I am not saying that typographic fashion does not have its place. What I am saying is that that place is probably not in a logo. Keep the fashion statements to the rest of the graphics in the marketing package. The logo has to have a certain sense of timelessness. An excellent logo should be usable for decades with only minor refinements. It should give a foundation to build upon.

The need for mottos

If you look at the logo you will be redesigning in Skill Exam #6, you quickly see that the company name, Bad Rags, is virtually useless or meaningless without the motto, "Clothing for the new millennium." It can certainly be argued that the name is not a very good one to start with. However, this is not up for grabs. Often you will be stuck with a name that was picked in a fit of giggle-laden brainstorming. By the time you are called in, the name has not only been picked, but has been used for enough time to make it a given.

The nice thing about mottos is that they can be changed with marketing needs. They can add strong meaning to a logo usage plan while you build that strong, stable, trustworthy image. In the case of a company like Bad Rags, you have to build on what has been done, adding to the good parts of its reputation and turning attention away from those aspects that seem to be counterproductive. With Bad Rags, the motto touches on the good and the use of slang for the name is part of the bad. So maybe a simple change to "Sophisticated clothing for the new millennium" would allow the graphic changes to be taken in stride while you begin building a more accurate and useful image.

Logo sizes and proportions

First — it's used very small

The primary thing to remember when designing a logo is that it will always be used very small and in black and white. This means that you must avoid the temptation toward outlines and tints. It is so easy, with digital production, to add gradients and strokes that it is now even easier to forget the production problems.

No matter how you try to avoid it in your mind, your gorgeous piece of graphic wonderment will be used a half-inch square (or smaller) at the bottom of a sheet that has been run through a black-and-white copier. Don't fight it! Design so the logo is still usable under those conditions. In fact, an excellent use for well-designed logos is as a dingbat on bulleted lists.

Second — it's used many places

The second thing to consider is that all logos will be used in a large variety of locations on a huge list of different projects. Your logo should be comfortable flush left, flush right, or centered at the top or bottom of your designs. (Or anyone else's, for that matter — don't fool yourself into thinking that you will be doing all of the design for that company. It will never happen!)

The result of this is that all logos should be roughly square or circular. You can deal with proportions up to two by three, vertical or horizontal. Anything beyond that is usually a problem. A long, wide logo might work on a ballpoint pen, but it will have a tough time on a keychain, as a dingbat bullet, or as an official seal.

This can be a real problem with companies that have epistles masquerading as names. Sometimes you can make a tight stack of the words in a name to convert it into a usable logo, but legibility is usually the casualty. This is especially true when the logo is reduced to its smaller sizes.

Third — it's used in many color spaces

It should be obvious by now that you are going to need several versions of any logo. Much of this is determined by the publishing technologies used. In general, you will always need to design a black-and-white (grayscale) version, a spot color version, a process color version, and an RGB version for the Web and multimedia. You might well even need a solid black-and-white version to be used to generate a foil stamping die.

When considering the spot colors used, imagine a document designed in those two or three colors. If your two-color spot logo is in PMS 134 (orange-beige) and PMS 278 (pale sky blue), how will that look as a three-color printing job with black? Does your client want to be forced into three-color jobs using those colors? Will either of those colors work well in duotones or tritones?

Chapter Eight: Logos

Skill Exam #7
A personal logo

Your assignment for this exam is simple — right! All you have to do is come up with a logo using your name or your company name coupled with a graphic device that will express who you are as a digital designer or publisher. This is an extremely serious task. This logo will probably help or hurt you when you look for employment after this class. You will design a logo, letterhead, business card, and envelope. The package will be used for résumé imprints, cover letters, and so on for job interviews.

FOURTH – BE CAREFUL WITH SPECIAL PRINTING REQUIREMENTS

You are usually begging for problems if your logo requires trapping; that is, if it has two different inks that touch each other. Even worse is one color with a different color outline a sixteenth of an inch away the entire way around the logo. These designs require a quality of press that can maintain this "hairline" registration, and this will bump production costs by 200% or more.

The use of metallic inks, neon colors, foil stamping, or embossing can be very dramatic. However, if your logo is dependent upon these printing tricks, you are again begging for problems. Both neon colors and metallics will incur special press washup charges. Neon color usually has to be coated with a varnish that protects from ultraviolet light unless you really don't care that the fluorescing effect will fade in a day or two.

Some design practicalities

The questions to ask before beginning an exercise (or paying job) in logo design are many. Because most of you have not done this yet, it seems appropriate to list some off the top of my head. This is by no means a complete list:

- What type of person is this logo meant to attract?
- What am I trying to say about the company or client?
- Are there diverse groups who must be attracted or reassured by the same logo?
- Is there an existing group or organization I can tie to with the style of this logo?
- Are any symbols with clear meaning available?

When I first started teaching digital publishing, back in the very early nineties, I gave out a personal logo project. One of my students, for whom I had great hopes, worked for more than a week and finally came to me with a logo for his résumé of himself flying around a lake on a jet ski. I had a little talk with him about the appropriateness of such an image to a potential employer. The question I asked was, "Do you really think that your new boss really wants someone whose symbol is play on a jet ski?" He agreed that I was probably right.

His new logo, which used a couple of traditional symbols of graphic creation tools, looked much more appropriate. Before he graduated, he went out on cooperative education with a local print shop owner. I saw him several times over the next couple of years. However, the last I heard, he had moved to Oklahoma to learn how to be a jet ski mechanic!

Logos are really that type of self-examination. This young man had accurately portrayed himself with the first logo. He might well be using it now as the proud owner of a jet ski repair shop somewhere in mid-America. As you are searching for the proper graphic expression of

your client (especially if that client is yourself), allow yourself to be brutally honest about what really matters, what the focus of the business truly is, and what the nature of the client's customers really are.

The time is long past when you can truly fool the end user of your graphics. My young student may have fooled his new employer ... for a while. It wasn't long before the truth came out, however. His new boss at the print shop knew he wasn't happy within a month or two. The final move was no surprise to anyone.

It is not at all unusual to find new company direction as the result of a serious examination like that needed for an excellent, functional logo. Conversely, a new logo is often required by a new marketing thrust. When redoing a logo for this reason, be careful not to toss the baby with the bath water. Carefully retain the good aspects of the old image. I'm in the process of a personal logo revision, for example, and strongly thinking about a little "SINCE 1967" somewhere in or around the logo. It's one of my major selling points. That kind of thing can be a major help to your client as she revises her company image and logostyle.

Some little tricks

One of the major methods of subliminal marketing is the subtle things that can be done to add style. The Del Monte logo shows a couple of these. To add a sense of their tradition, they have used an outline. To make it look more friendly and hand-drawn, the white line between the outline and the shape varies in width as it goes around. The three little leaves not only keep it from looking too much like a heart, they also bring in a reminder of some of the flowery "gingerbread" of Victorian styling. The words "Del Monte" are vaguely a text font, but the crispness of new type is long worn away. You may or may not like the logo, but you have to admit it is comfortable. This is a fairly old example. You should go to a grocery store and see if and how Del Monte has maintained its image.

Most of you have probably noticed that the logo for *Digital Drawing* is loosely based on the graphics for the SoBe Energy soft drink — and consciously so. Go look at a SoBe drink. Why does it look current, fashionable, and exciting? In addition, why does it look solid, traditional, trustworthy? (I would suggest looking at the bottle shape and the size of the bottle cap.) It's a very subtle, yet visually exciting piece of design that wouldn't mean a thing if the drink itself weren't so tasty.

My design took that basic look and encased it in a more solid traditional graphic casing. The circle within a circle, type-bound-to-path style harks back to a much earlier age, even though the font certainly has a contemporary looseness to it. Even the 3D bullets

184

were chosen on purpose to give a modern digital flair to the little piece of work. The fineness of the strokes again looks back to engravings and the incredible detail found in illustrations from the nineteenth century. (I was an etcher and engraver in college, you know.)

Like the description of my little *Digital Drawing* logo above, you should have a reason for every single mark, every single stroke and fill, every single shape in all of your designs. This is even more important when dealing with the simple sophistication of a logo design.

A basic procedure

The normal starting price of a logo is about $600. This assumes that you can do it in about a dozen hours or so of work. For yourself, you need to plan on spending several days on any logo design. The creative process requires thinking time. We'll go into this in more depth in chapter twelve. Let's just say that you need to ask yourself every question you can think of (ask the client, too). Then think about it. Like many of us, you might find it very helpful to keep a little sketch pad next to your bed.

Visually jot down your ideas as they surface – quick thumbnail sketches (about the size of a thumbnail, done in a minute or two). You'll know you've seriously covered the territory when you have a dozen or so thumbnails. By then, you will be finalizing your concepts into a few solid ideas. Rough them out, either by hand or on the computer. Doing it by hand often allows the human touch to enter your designs.

Finally, scan your roughs and place them in the background as a rough guide to your final image assembly; or just pin them on the wall next to your computer; or do the entire thing in your mind; the methodology is not important. It should only take a few hours to actually render your idea. If it takes much longer than that, you are probably being too precious and too detailed for a logo design anyway. Pin them on the wall and live with them for a day or so – THEN show them to the customer.

Do not be surprised or hurt when the client picks the one you like the least. The one you like best probably just has associations to a happy personal memory. Logo design is about pleasing the customer. Your logo should make him or her proud of the company.

Avoid logo design by committee like the plague – it's more deadly!

Knowledge Retention:

1. Who is more important, the reader or the client?

2. Why are typos so important?

3. Where would you use an unbalanced layout?

4. What's the major problem with symbols?

5. Why is FreeHand perfectly set up for logo design?

6. What's wrong with logos made of initials?

7. Why do you need to design three-color versions of a logo?

8. Describe the relative importance of the logo entering the new millennium compared to the beginning of the twentieth century.

9. Why would a logo have a different graphic style from an ad?

10. What core values should be expressed by a logo?

Where should you be by this time?

You should be familiar enough with FreeHand to use parts of it without thinking. A small repertoire of keyboard shortcuts should be subconscious. The capabilities of FreeHand, and its position in digital publishing, should be clearly understood. You should be reviewing what you have learned as you go. By now it would be appropriate for you to have your own FreeHand Defaults file (you might even carry it around with you if you do not use the same computer every day).

DISCUSSION:

You should be carefully looking at yourself and discussing your plans and goals with each other. It's probably too early to have enough of a handle on that to have developed your own logo yet. However, this should be your focus for the rest of the course. Questions that should be discussed are: "What job do I hope for? Where am I going to apply? Do I really want to freelance and work on my own? What are my best abilities? Where am I weakest?" This is your life we are talking about.

Talk amongst yourselves ...

CONCEPTS:

1. Manipulating type

2. Controlling color

3. Meeting deadlines

Definitions are found in the Glossary on your CD.

Chapter Nine

Manipulated Words

Using typography to solve fundamental design problems

Chapter Objectives:

By teaching students the options and capabilities of FreeHand, this chapter will enable students to:

1. convert type to paths and work with it graphically
2. design a typographic illustration to use in a given project
3. work within a prescribed color scheme
4. design within a deadline.

Lab Work for Chapter:

- Miniskills #9, #10, and #11.
- Skill Exam #8.

Playing with words

Nuevo
DECO
TYPOGRAPHY

La Femme Fatale Beauty Salon

don't even have to write those words — they are offered as part of the copy you have to use anyway. So, what we want to do in this chapter is give you the tools and structure to effectively use words as graphics. Most of these things have been an unofficial part of the skill exams you have already completed. What we need to do now is give you conceptual control of what you have been doing.

Type classifications

First, let's remind ourselves of the basic type classifications: serif, sans serif, handwriting, and decorative. We've described serif faces as by far the most common, more readable, friendly, warm, traditional, subjective, and so forth. Sans serif is seen as cool, business-like, objective, clean, crisp, legible, and the like. Handwriting was seen as illegible yet adding the human touch to type. Decorative faces are anything that does not tidily fit in the first three categories, coupled with a reading difficulty in smaller point sizes.

So, your assumption is that now we get to use those fancy decorative faces. Well, maybe. There is really far more to it than that. What has to be used, more than anything else, is beautiful type, perfectly kerned, immaculately spaced, and modified to fit perfectly. Beyond that, you must learn what can be done and what will simply make you look stupid, ignorant, or uncaring. How many of you, for example, noticed that the dot over the *i* is missing in the little graphic to the right?

Type readability

There are several things you need to know here. First of all, we generally recognize words by looking at the distinctive top half of the shape. This is the reason why all capital letters are so much more difficult to read. This little graphic, for example, is OQGCRBD or is it QOGCBRD or ...? Obviously, there is no way of knowing without being able to read an actual word in context. Even then things are not easy, as you can see in these three examples. The

ATTRACTIVE WOMAN

Cowardly lion

intellectual snob

first words, *ATTRACTIVE WOMAN*, are not too difficult. *Cowardly lion* is really fairly easy to read, but *intellectual snob*? Those bottom two words are virtually illegible, unreadable in the normal course of a book

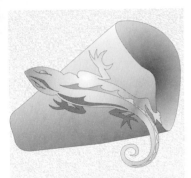

The fastest and most common graphic

We've already briefly mentioned the speed necessary in the digital publishing arena. One of the results of that is the use of words as graphics. However, this does not touch on the real reason why words are most commonly used for graphics.

To cover that reason, it is helpful to remember that old saying attributed to some ancient Chinese wise man, "A picture is worth a thousand words." Actually it sounds more like Shakespeare, but it makes no real difference. There is really a major problem with that old proverb. A picture does indeed speak volumes. The problem is found in controlling (or even predicting) what it talks about.

I am not saying that an accurately directed, impeccably crafted illustration is not a wonder — and extremely effective. The problems are the normal ones: time and money. Now, you may be one of those incredibly talented (and fortunate) designers who wind up working for a superstar firm as one of their primo talents. Then you don't have to concern yourself about those two little worries just mentioned.

Just listen, then, while the rest of us talk about the real world of illustration and digital graphics. In most cases, you will be paid about half what it's worth to do a graphic in a third of the time you really need. Gradually, you'll get faster and better known. Eventually, you will even make money at it. However, the deadlines will still be ridiculous. The result of all of this is that graphic treatments of words will regularly be the solution of choice.

The frequency of this choice is increased by the simple fact that often there is no real graphic conceivable to describe what you really need to help sell that copy about the lifetime warranty, the graduation certificate, or that brochure offering seminars to help with depression (that has to be ready for proof by noon).

Words are direct and precise

When you really need it, and can say it accurately, what works better than **FREE**? How about a snappy graphic saying whatever you need? The graphic to the left would not make a good headline or logo; it's not strong enough. But it certainly adds interest as a subhead on a page where some sort of graphic is visually necessary.

In general, you will find many occasions when a quick graphic made of words will solve your graphic dilemma handily. Often you

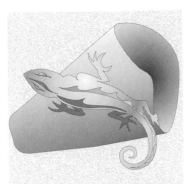

or magazine. Even *ATTRACTIVE WOMAN* or *cowardly lion* would not be easy, and here we arrive at the heart of the matter. As designers we must make our copy easy to read.

Let's just talk about advertisements. Studies have consistently shown, for the past decade at least, that each of us sees 2,000 to 3,000 ads per day or more — newspaper, magazine, TV, billboards, flyers, signs, and so on. Those same studies claim that it's normal to remember one or two of those, but not more than that.

This is coupled with a scenario that most of us are involved in every day. It gets worse with increased age, experience, and income, but most of us get piles of mail every day. Our procedure for sorting the mail tells us a lot about the necessity of readability. The normal piles are three: to read, bills, and to toss. Our goal is to put as many as possible in the toss pile, because we really do not have time to read them anyway.

The same is true with books and magazines. Some of you may not be there yet, but in this industry it's coming. There is no way to keep up with the developments in hardware and software without reading the magazines. Our country is controlled by readers. Almost all of our leadership are regular constant readers. Realizing this, the marketing industry floods them with free magazines. The Internet has increased this phenomenon by marketing with free e-zines.

Because I have to write about these things, my example is a little extreme. However, just to give you an idea, I get approximately eight email magazines per day. I get two to five print magazines per day, five to fifteen mail offers, and we have quit the newspapers because there was no way we could add that to our reading schedule. My wife, who is a pastor, gets about the same quantity, except that hers are more in the printed newsletter arena — plus all of the magazines and mail offers.

The point is this. We, and all of you, have finely developed discrimination procedures to eliminate all unnecessary reading materials as soon as possible. We try to put them in the toss pile without even opening the envelope, if possible. The important thing to understand is that readability and font choice play a much larger role here than you might realize.

Times, Helvetica, and poor font choices

I mentioned the problem with Times and Helvetica in chapter six. However, there's more to it than a simple mention can cover. First of all, there are many varieties of the same font. Times, Times Roman, New York, and Times New Roman are all variants of the same basic font with differing x-heights and character widths. Helvetica, Helvetica Black, Helvetica Narrow, Arial, and Geneva are also just one font family under differing names. Because these are the default fonts in virtually every publishing program, they are everywhere.

However, we are going far beyond their ubiquitous nature to look at who uses them and why. More importantly, how do you react when you see one of those fonts? I suspect that this varies somewhat. Nevertheless, there are characteristics we can recognize that are almost universal.

First of all, we need to identify those documents created by desk jockeys and pencil pushers who don't care how their document looks and/or are too ignorant to know any better. This list contains tax forms, school announcements, bills, traffic tickets, statements, government documents, class schedules, ballots, commission reports, and the like. That's an exciting reading list, isn't it?

Second, let us add secretarial newsletters demanded by the boss and done in Word or Publisher using the templates; flyers and announcements output by bureaucrats because of legislative mandate; class handouts in the basic required courses at school; cheap textbooks; hardware documentation; official announcements and rules; and so forth. I can hardly wait to sit down in my comfortable chair with a reading lamp over my shoulder and a cup of fresh coffee to devour these items of literary prowess.

You have just been afflicted with a large batch of bad memories, of documents you threw away as soon as possible, of distasteful relationships and bad experiences. Even if you enjoy school, you don't enjoy registration. Every document just listed was printed in Times, Helvetica, Times and Helvetica, or in one of the variants. Is it any wonder that the envelope fearfully opened because it looks official is thrown away in disgust as soon as you discover it's just junk mail?

Using standard default fonts ties your work to bad memories.

Do you really want to use these fonts in your designs? Our readers are largely unsophisticated graphically and therefore are not going to notice these things anyway. If you believe that, you desperately need an attitude adjustment and reality orientation. Our readers are extremely sophisticated graphically, but it is on a subconscious level. They react to all of those documents just as we do, and materials set in those fonts trigger those same reactions.

There has been a huge gap between professional design and nonprofessional output for many years. It has not escaped the notice of our readership. They may not be conscious of why they trust one

SOME CLASSICS

Dashingly
CASLON

Dashingly
BEMBO

Dashingly
GARAMOND

Dashingly
BASKERVILLE

Dashingly
CHELTENHAM

Dashingly
**CENTURY
SCHOOLBOOK**

Dashingly
BODONI

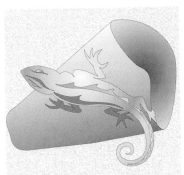

company and distrust another with the first glance at their printed materials, but that does not make the reaction any less real. The same kinds of distinctions are caused by any bad font choices.

Choosing fonts well

Now, here's a problem. How do we choose fonts that will promote a good reaction from our readership? First of all, we train our eye to recognize excellence in font design. You can read books on typography, but that is dangerous because many of them contain little other than overblown pomposity. One of the best is *Stop Stealing Sheep & find out how type works* by Spiekermann and Ginger (Adobe Press, 1993). It has hundreds of clear examples to demonstrate which fonts might be appropriate to which situations. You may well disagree, but you will be off to an excellent start.

You should go through type catalogs and look carefully. Pick fonts you like and those you do not, looking for genuine reasons. The fourteen fonts in the sidebars are good places to start. They range from very old to very new. On the serifs, look at the serif shape progression from top to bottom. By the time we reach Bodoni, the serifs are simply thin, squared lines. These would be called modern faces, but it is a strange twist of the language that *modern* means old-fashioned, in that the style comes from the late nineteenth and early twentieth centuries. The more elegant fonts, to our contemporary eye, are the older ones: Caslon, Garamond, Bembo.

The same is true in the sans serifs. But here there really aren't any common old fonts. The so-called modern fonts, like Bauhaus, Futura, and Kabel, are all from the 1930s and look very dated. The newest font is Corinthian, from the 1970s. The so-called Humanist sans serifs like Gill Sans and Frutiger are probably the warmest and friendliest of the sans serifs.

The most conservative in style are those in between the old and the new. Times and Helvetica fall here. This again is why they tend to look boring to our contemporary eye. However, it is important to realize that there is no such thing as a bad font (except for cheap fonts that are poorly spaced). All fonts look good when used in the proper context for the appropriate content and message.

There is no such thing as a bad font

Your main task is to pick fonts that are appropriate in style and readable. You have a huge variety to choose from. In fact, a large part of your personal design style will be the font library you build. This is something to start working on now. Do not just pick

Classic Sans

Strongly
BAUHAUS

Strongly
FUTURA

Strongly
KABEL

Strongly
UNIVERS

Strongly
GILL SANS

Strongly
FRUTIGER

Strongly
CORINTHIAN

styles that you like. There are too many instances in which a type style that you find abhorrent is the perfect solution to a design need for a particular client's readership.

But enough talk, let's look at a real project. I have a little type foundry that sells type online. I needed a small graphic, almost a logo, to identify the foundry. All I had was the name, NuevoDeco Typography, and a strong sense that the logostyle should use only the fonts from the foundry.

I started with the word portion, *DECO.* I wanted it to be dominant, so I used one of my fonts called Adept-Heavy (a newer, modified version is on the CD). Because I wanted this word fragment to be a solid unit, I tracked and kerned it tightly. I deleted some of the excessive Celtic flares. The even/odd overlap of the *D* and *E* had to be eliminated (and are on the newer font), so I subselected the two outlines and used the UNION command. Finally, I joined the entire word fragment and filled with a gradient and a .3-point stroke to lighten it a little.

Next I added the word *typography.* I must have used five or ten different fonts. Like Artz, below right, they were all too stylized for this location, so I finally settled on Nördström Black (which you should recognize from the heads in this book — there's a free copy of this font on the CD). Nördström is conservative yet friendly and seems to fit the need well.

The word fragment *Nuevo,* in contrast, needed more style, almost a handwritten look. Of course, I had the option to use handwriting. It's one of my common choices in logo design. However, I was limiting myself to NuevoDeco fonts. So I chose one of my nostalgic fonts from the fifties, AeroScript (on the CD).

I had to do a lot of work here. The word is skewed and scaled; converted to paths; ungrouped and the paths split; all of the outside shapes were made into one path with the UNION command; and the word was joined together again with a light basic fill and the same .3-point stroke.

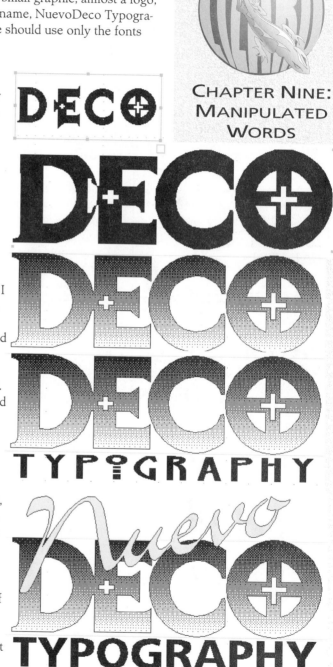

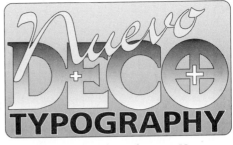

Because I needed a small graphic for my Web page, I decided that I needed a frame to hold the graphic. So, I dropped a round-cornered box with vertical gradient (because it compresses better) behind the words. I added quite a bit of color, which I cannot remember to describe right now. However, the color made the word *TYPOGRAPHY* disappear into the background, so I added a .3-point white stroke around it. The whole process took an hour or two. I think it accurately gives a sense of my typographic style and shows off three of my fonts.

What is appropriate?

In general, you have to define that. There is a general sense of what works and what doesn't. The stop sign on the left would be proof of that. It's doubtful that the logo below would sell much $300-per-ounce perfume either. Sometimes type usage is this obvious. Most of the time it is not. Normally you have to come up with a general sense of the style of type that appeals to the readership of your particular project. A lot of that is keeping track of the various fashions in your area at a given time. You can get a feel for this by watching television show openers that are targeted at specific demographics. There is a large difference in the style of type used by The Nashville Network and A&E or Bravo, for instance. *The Practice* has a very distinct typographic style that is very different from *La Femme Nikita* or the *X-Files*.

Another area to watch is fashion retailers. In my area, for example, the extremely expensive, high-fashion boutiques in Santa Fe around the Plaza use very different typestyles from the malls in Albuquerque. The malls are much closer to the national usage found on TV in ads for the Gap, Sears, Penneys, and other national chains. Austin will have a different style from Dallas or Houston. San Francisco is different from LA is different from Seattle. If you want to see a clear regional style that has spread worldwide, look at Starbucks, from Seattle. You will not only have to educate yourself, you will have to continuously feed your eye and your mind with current images for the rest of your career. It's part of being a graphic designer.

More than that, it is one of the reasons your client is paying you (or your boss) the big bucks. You have to be able to see, explain, and replicate the expensive look of a BMW, Cadillac, Infiniti, or Saab. Why do Apple ads look more expensive and higher quality than Compaq? It's the fonts, the leading, and the layout. The more expensive a product, the more white space is used in the advertising.

I was looking at a fancy sixteen-page, full-color brochure mailed to me yesterday by Compaq. Because I have always had Macs, I am used to the Garamond Light, open layouts, gorgeous photos, generous white space, and striking copy of Apple's company standards. In contrast, Compaq's booklet was solid, dark color, very little (if any) white space, with a very small, generic body copy that looked a lot like Times and Helvetica Bold condensed headlines.

Compaq's offering looked like what it was: a solid, business decision selling a machine for number crunchers. It was like most PC advertising and Windows in general: too much color, poor fonts, boring layouts, overly complex, and crowded. For all its fanciness, it looked cheap.

Skill exam #8

Here we have a logo from a sophisticated shop in the midst of a trendy section of town. The owners are a young couple who are into LA swing. Frankie is actually affecting zoot suits, spats and all, with a snappy fedora, sharp padded shoulders, leather braces, and the whole routine. Eva wears tight slinky satin gowns that look like they were movie costumes from a Busby Berkeley dance spectacular. She actually looks quite a bit like the woman in their logo (which is a bit of clip art they found in an old Dover book).

They love their logo, but the type has always bothered them. It is far too mechanical and cold for their tastes. The original designer didn't understand where they were coming from and simply picked Bauhaus because he knew that it was from the thirties. Their current color scheme of royal blue and silver is also entirely too cold and impersonal. Their business is based on warm personal relationships. Frankie and Eva are extremely involved in the nightclub scene that surrounds their establishment, and their little medallion is simply too much. They are looking for a redesign more in keeping with their aesthetic, leading their friends into the rich decadence they enjoy.

They have just completed a major redecoration of their shop along with doubling its size. The new decor has soft but rich green walls, warm wood furnishings with a lot of copper and brass, many palms and ferns, and a very soft, warm, feminine feeling as soon as you walk in the door.

They pamper their customers, enveloping them in an ambiance of richness, decadence, and comfort. They are, by far, the most expensive shop in town and worth every penny. Women leave their shop feeling like they have been amply prepared for the grandest world premiere. From massage therapy to pedicured toenails, Frankie and Eva make women feel beautiful and desirable. It's a wonderful, woman's beauty emporium.

Their instructions to you are to get rid of the font and the enveloping circle that makes the logo into the medallion. They really like the illusion of the colored dress that sweeps up between the words around the bottom of the circle. They really like the woman in the logo, and do not want her changed at all except to get rid of the blue-and-silver color scheme. They're thinking that a green-and-brown two-color logo will work well with their beauty tip handouts and brochures. They think the green of their walls is about a PMS 563U. The wood in the shop is rich and dark, with many antiques (mostly cherry and mahogany). They hate the cheapness of metallic inks and there is no time to deal with foil stamping now. They need a process color version with the exact same colors (they are savvy enough to want to avoid the necessity of going to six colors just to maintain their logostyle). Finally, they need a grayscale version for the newspaper ads.

Frankie assures you that there is no hurry. The only deadline is the dance contest they are sponsoring at Club Metro next month. The posters for that have to be to the printer by the end of next week. The entire contest is an elaborate promotion of their new look. They are really excited about it (actually, Frankie whispers in your ear, as they prepare to exit, *she's* a little tense about it).

Some basic guidelines

Now that I have given you one of my examples, and you have worked on one of your own solutions, we can probably talk a little more clearly about basic typographic choices. When you first begin, choosing an appropriate font is one of two things: "I really like that one," or, "Oh my gosh, which one is the right choice?" To rephrase, you tend to pick fonts because you like them or you're unable to choose because of all the choices (and you might be wrong).

THE FIRST OPTION – YOUR PERSONAL TASTE

When you begin as a designer, this is almost always the wrong choice. Your eye is not educated enough to have good taste. Your personal font favorites are appropriate only when you are a member of the client's readership. Like everyone else, your taste is a result of your

personal experiences: cultural, academic, social, and political. If you are under forty years of age, your typographic choices are greatly affected by the television shows you have been watching since youth. They have been trained by ads for the Gap, Millers Outpost, Levis, Sears, or wherever you buy your clothes.

Unknowingly, you have been herded into a demographic grouping (even if that grouping is the rebellious ones). I remember one of my more talented students, whose entire existence was colored by the graphics and lifestyle of snowboarders. He kept talking about the typographic freedom his group used, and how he wanted to design for them. It was a massive comedown when he realized how rigid the graphic style was that had been used to appeal to him and his "buds."

It took almost two terms before he realized that the "freedom" he was so excited about was really a very rigid style. The rules were simple: "Break all the rules!" He eventually became an excellent typographer once he realized that he had an easier time than most understanding normal usage. It was simply the absolute opposite of his group's norms. If he liked sans serif body copy, the norm is serif. He found that he could effectively design for very conservative clients by simply choosing the opposite of his natural inclinations.

The problem with personal taste is personal experience

It took me several years to grasp why my clients always seemed to pick my least favorite choice when I gave them a set of options for a logo or layout. Over the years, I have listened to countless designers who were virtually spitting on their clients, "They picked the ugliest one. I almost didn't include it. I should have tossed it." Then one day I realized, while doing a flyer project for a client, that the one I liked best simply reminded me of some of the posters I had designed for my rock group back in Minneapolis in the 1960s. It had nothing to do with good taste. It was all about happy personal experiences.

Since then, I have seen countless examples of designers who made absolute statements of taste and style based on good memories of former times. You are also strongly colored by bad periods of your life. For example, the Retro fad of sixties nostalgia triggered many horrible memories in me and all of my friends. You will never convince me that stuff from the fifties or sixties has any value at all. I have spent much of my life fighting that culture and mentality.

Our personal tastes are all based on those types of emotional reactions to fonts, colors, layouts, styles, and so forth. We have to train ourselves to recognize the difference between merely personal taste

A LIBRARY OF STYLES

As you are training your eye, you should be mentally defining specific styles that appeal to specific people. If your memory is limited (or damaged by time and/or drugs), you should literally write down different styles (with a tear sheet sample) with font, size, color data. These should be stored in your morgue.

and genuine excellence in design — between personal taste and truly ugly graphics. More than that, we have to learn what appeals to various cultural subgroups. For example, I know that the group known as the Spanish, here in New Mexico, is strongly attracted by Art Nouveau. This probably has little to do with similar ethnic subgroups with different titles in Southern California or Miami, but it certainly works around here. This is what you have to learn.

You must learn your local culture. We are strongly, and proudly, multicultural around here. When I grew up in Minnesota, the culture was much more homogenous. There was a strong Japanese influence that I really liked in Oregon, especially Eugene. You must become intimately familiar with the graphic heritage of your area. It's a language you have to speak fluently.

THE SECOND PROBLEM: OVERWHELMED BY CHOICES

One of the major problems faced by my students is their reaction to the font list I give them at the beginning of every term. I have about 5,000 fonts, and I print out a restricted list of the 300 or so that I make available on all my computers. This list varies yearly, with new fashionable fonts added and ones I'm bored with removed. However, the reaction is usually the same.

Most new designers are overwhelmed by the choices. Beyond that, they can hardly see the differences between Baskerville, Garamond, and Caslon. It is always fascinating to watch who chooses which fonts to use in their projects. When I start explaining why Avant Garde is a bad choice for body copy, for instance, they fall into bewilderment. They plaintively ask, "How do I know?"

The best way I know is to immerse yourself in excellent design to the national market. Communicating graphically to the entire nation requires two things. First of all, you have to avoid all local stylistic distinctions. Secondly, you have to make excellent, classic typographic choices to avoid boredom in your more generic audience.

So, you need to look for excellent, well-designed magazines. I would suggest going to your local book superstore and perusing the magazines. This time, avoid those that really appeal to you. I am always sucked in by Taunton Press and *Fine Gardening, Fine Woodworking,* and the rest of their line, for example. They are excellent and a good source of graphic style. However, for our purpose here, you need to look at *Look, People, Times, Newsweek,* and magazines designed to appeal to the mass market of North America. There are similar publications in New Zealand, Australia, Europe, and Southeast Asia. These magazines, and the people who advertise in them, have made a science out of typography that offends no one yet remains interesting.

Study their basic layouts. Which fonts do they use? How are they structured? Look at ads for the major car companies and ask the same questions. Closely analyze advertising from Procter and Gamble,

Sears, Wal-Mart, and others that have made such an impact on our national graphic taste. The people who design for them often have research budgets that would make us blush (or turn green). They rarely use type styles by whim or by accident. Take their ads and try to match the fonts used to your font lists. If you have few choices, at least get a good font catalog from Adobe, ITC, Agfa, or Bitstream.

Become very familiar with the short lists of classic faces on pages 192 and 193. There are many others. You can tell a lot by the free fonts given with Adobe products. With PageMaker 6 and Illustrator 5.5 and 6, for example, there was a free set of 220 "standard" fonts. The Classroom in a Book series for PageMaker includes a large group of current classics. The free fonts given with Adobe Type Manager are another good source of fonts that have been so popular they can hardly be sold any more. The same is true of the Standard 35 fonts that come with any PostScript laser printer.

Build off these choices. The classics will almost always work and work well. In general, the fancy decorative fonts are used only for the most prominent headlines or logostyles. If you are forced to use the Standard 35, start with Bookman, Century Schoolbook, or Palatino. Most of you will have at least one of the Garamond families or Caslon. Remember that everything Apple does is in Garamond Light.

Once you learn how to handle one font family well, it is much easier to move on to other fonts. It is a marvelous exercise to design complete documents with only one font in various sizes of caps, small caps, and cap/lowercase. Beyond that, the use of only one font is often an extremely elegant solution to your graphic needs. It's also good practice for the Web.

Miniskill #9: Letterhead

This monkish gentleman to the left is the logo for a very eccentric man who has a large, solid reputation as a copywriter, poet, and spiritual leader. He actually looks a little like the drawing, and he identifies strongly with it. You are working for a small quick printer, and Jakov has recently come in and ordered a new stationery set. He uses his stationery a lot as a major part of his image and self-marketing. He is very irate at the printer who did his last stationery for him. Evidently (you decide from reading between the lines) that printer's designer thought that Jakov and his little logo were a joke, and he treated the design as a cartoon using Microsoft's Comic Sans for the type.

Jakov described his efforts as large, gross, and mocking. However, the sample of the letterhead he flashed at you (and wouldn't let you keep) looked fairly standard, although the logo seemed a bit large. Nevertheless, Jakov has been very emphatic. He thinks that design is an abomination (he's into overstatement). He wants something clean, elegant, formal, and impressive. In response to your font queries, he looked over your font list and picked Diaconia, saying, "This one will work fine, but no bolds or italics – clean and elegant is what I need." After picking paper and inks, he leaves. His presence was kind of overwhelming and you sort of collapse over the counter. One of your coworkers comes over all excited, "Do you realize who that is? He's an icon. He's the reason I am writing. If I can ever be half as good as he is, I'll be satisfied."

You write everything down on the job ticket and go back to your computer. He has picked a natural 100% cotton, 28# writing stock from Crane. He picked two colors: PMS498 and PMS561. He ordered 2,000 letterheads, 5,000 business cards, and 1000 #10 envelopes. Plus 15,000 second sheets, using a 24# bright white called Classic Crest, and 1,000 9"x12" manila envelopes. He uses the second sheets for manuscript and article submissions. He only wants the logo and his name there.

The copy is:
Jakov Pritikan, Esq.
Wordsmith
1726 Penwale Road
Mesaugan, Washington 97312 USA
891 532 4655
Fax 891 532 4656
wordsmith@princeline.com
http://princeline.com/wordsmith

Jakov expects a proof by the end of the week. He strongly hinted that if he liked your work, he might let you design some small books of poetry and prose that he intends to self-publish. Your colleague assures you that this is the chance of a lifetime.

Standard usage

One of the things you quickly discover as you begin designing is that people have very strong ideas about what is acceptable and what is not. These standards are what I call norms. They are type usage parameters that almost everyone assumes.

We have mentioned before that the only way you can keep your designs from being boring is to break at least a couple of rules in every design – and that those departures from the norms must be done intentionally and with good reason. However, this assumes that you know the normal assumptions that everyone is using. So, what I want to do now is give you a list of some of these norms. You will find that

many of them are quite rigid. When I wrote my first book, for example, I was using a font with a small x-height and extra leading built in. I decided to set it in eleven-point type with twelve points of leading. My publisher bounced that, forcing me to use the standard 10/12.

This brings up another set of standard conventions that I will use as I list the norms. 14/15 is pronounced fourteen on fifteen, and it means fourteen-point type with fifteen points of leading. [means flush left, rag right;] means flush right, rag left;][means centered; and [] means justified. So, 20/22][would mean twenty-point type on twenty-two-point leading centered. Let's go to the list.

Typographic norms

Business cards:

2"x3.5"; .25 margins on all sides; logostyle 18–30 pt; name 8–11 pt (often bold); title 6–8 pt (often italic); telephone 9–12 point (often bold); address 6–8 pt; motto 8–12 pt (often italic).

Letterhead:

8.5"x11", .5 margins or larger (unless it bleeds); logo 18–24 pt; address 7–10 pt; phone 8–11 pt; motto 9–14 pt (often italic) – it's very important to design the letterhead so a letter looks good on it. It should look empty without a letter.

Envelopes:

#10 business (4.125"x9.5"); logo 12–18 pt; address 6-8 pt.

Newsletters:

The paper size varies widely; flag or logo 36–99 pt; headlines 24–36 pt; first subhead 14–21 pt; second subhead 10–14 pt; body copy 9–12 pt, but the almost absolute standard is 10/12 either left or justified (unless the newsletter is getting federal money for senior citizens; then the body copy has to be 12/14).

KEEP IT INTENTIONALLY VARIED

As you format type and lay out the document, consciously prioritize the copy to organize it. What is the most important copy on the page (from the reader's point of view)? What is the most important copy on the page (from the client's point of view)? Often, for example, important information from the client's viewpoint is different from what the reader will choose to read.

If the executive secretary tells you that meeting attendance is a real problem and he wants that emphasized, this does not mean that the reader will be drawn to read the newsletter to get that information. She's reading the newsletter because she is interested in the background of next month's speaker. So, in a gray sidebar of trivia and required legalese, a strong little graphic splash giving the meeting time, date, and location will serve as a quick attention getter without competing with the main headline and photo of the speaker on the front page. It could be something like the fact graphic (Miniskill #5).

SIDEBARS

Bits of information like this — which are not important to the main copy — should be placed in a subsidiary position. It often helps to use different fonts and to place the copy over a gray or colored background to de-emphasize it.

202

WORDS, MANIPULATIONS, AND GUIDELINES

The important thing to keep in mind while you are prioritizing is the need for simplicity and clarity. Too many attention devices function much like the expert roundtables on CNN: that many people talking at the same time is very irritating and causes many (if not most) of us to switch channels. The same is true of multitudinous headlines, subheads, and specialized headers all competing for your attention on the same page.

Even if it is true that all of these pieces are important, the reader needs help to sort through the chaos. Sometimes you have to arbitrarily assign priorities simply to make the piece readable. This is so even in logo and stationery design. In a business card, for example, which items are most important? To understand that, you need to figure out why you keep a business card in the first place.

Is the logo most important? Probably, but that is not why you keep a card. You need to be able to instantly recognize that card as belonging to the business you are looking for, but why are you looking for that card? If you are thinking clearly, you'll see that you keep the card for the phone number, email address, and office address – in that order, usually. The most important information on the business card is the telephone number (coupled with the name of the person, so you can call them by name when they pick up the phone). The email address is increasingly important, and the Website URL might generate some sales. The physical address is rarely why you keep a card. Once you have been there (if you ever go there), you can remember where it was. The phone number and email address you need for reference.

Closing the sale

It might help to use a little sales parlance. The main thing you are taught in sales is to close the sale. "They won't buy unless you ask them to buy." Giving the phone number priority of place and size on a business card is closing the sale. Giving the 800 number equality of impact with the company logo on the front page of a mass-mailed catalog is closing the sale.

There are basically four methods of giving priority to items: location, size, weight, and color. The location importance is determined by cultural usage. In our European culture, the two prime places are the upper left to start and the lower right to finish. For the rest of the world it is upper right and lower left.

Subheads look like subheads because: (1) they are larger; (2) they are bolder; and (3) they have more white space. In addition, they look like subheads because there are not very many of them. If a page has dozens of subheads, the subheads merely become some sort of weird body copy with no impact. That is why, for instance, I didn't make "Business Cards," "Letterhead," "Envelopes," and "Newsletters" bigger or bolder on the opposite page. I just gave them a little space for emphasis, so they wouldn't detract from or compete with the subheads.

Scanning and tracing logos

I didn't really know where to put this section. It almost deserves its own chapter, especially if I was giving priority of place based on frequency of use. However, because the last three chapters are centered around production issues, it seems fitting to conclude our creation and drawing portion of the book with a discussion of one of the most common and most important skills you will use in your everyday work: integrating other people's logos into your designs. It is so important that we will have your final three skill exams here, about the subject of scanning and tracing.

When talking to a client about a project, the question always used to be, "Do you have a camera-ready logo?" All that has changed is that we now ask, "Do you have an EPS of your logo?" This EPS is much better than the older page of logo slicks containing various sizes of the logo. An EPS can be resized at will (almost — as we'll discuss next chapter). This is one of the primary advantages of FreeHand. It produces logos that can be resized as necessary (and it is always necessary). Scans, TIFFs, and Photoshop images cannot be resized without incurring the wrath of the pixel gods (Blur, Pixelate, Choke, and Megabyte are their names).

So, on an almost daily basis, you will be forced to deal with projects for clients whose only copy of their logo is on their business card, in their brochure, or (worst of all) on their Website. You will have to trace it to get the paths necessary to make that logo into a functional EPS that can be used in your project. In most cases, if you can get away with charging for it at all, you will get about $25 or about a half hour of billable time for this task.

Even though you know it will take four hours, the client will question your competence if you make an issue out of it. He sees a tiny, simple graphic where you see a complicated torture device of tiny dots produced by the linescreen necessary to print those color tints.

Skill Exam #9

Before we can go on to autotracing techniques, you must have your hand-tracing skills honed by using the Pen tool. This skill exam is simple in concept yet very difficult in execution until you get used to handling the tool. Let me walk you through it, because I do not want you getting frustrated. You really need these skills. There are some things to be covered before we begin.

Logos must be duplicated exactly!

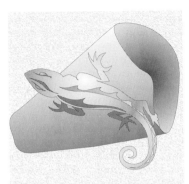

This is a cardinal rule of logo work. One of the things that makes logos work is that you can *never* resize them nonproportionally. The colors always have to be exactly right. The shapes have to be perfect. The client usually paid what he thinks is an exorbitant amount for that logo. The designer drilled into his head that the logo *must* be used consistently and repeatedly to be effective. The result is that copying or duplicating logos is an exact technical procedure. The only thing you can do is clean up obvious errors, generational destruction, or bad copies.

Exam procedure

You start by opening a new document and PLACING TriStar.tif into it. This TIFF can be found on your CD or off your Website. Once it is in your document, move it to the background layer and lock it into position (by clicking on the little padlock icon until it is closed). Then you select the Pen tool and begin to trace.

1. There are twelve shapes to be traced (including the center of the *a*). Three are clones.

2. The three stars are identical. The procedure is simple. Click to place the points for the first star and fill it. Then CLONE it. Click and hold on it with the Selection tool until the four-sided arrow appears, then drag the clone until the lower point lines up with the lower point of the middle star. Then, using the Rotation tool, click on the tip of that lower point (to establish a rotational center) and rotate the middle star into position. Color appropriately. Repeat the procedure by cloning the middle star; move and rotate the clone to the position of the top star.

3. In the letter forms, all obvious horizontals and verticals are exactly that. You can help the placement of points by holding down the Shift key before you make the next click with the pen (when appropriate). This will cause the new point location to be constrained to exact horizontals or verticals relative to the last point placed.

4. The two *rs* are identical. You make one and CLONE> SHIFT/MOVE the second one into position.

5. Guidelines will really help for this project. Drag them out of the rulers whenever you think them relevant.

205

6. The spacing between shapes is critical to duplicating this logo. As you can see to the right, all of the shapes tend to line up with each other. This illustration shows the intersection of the *T*, *r*, *i*, and the lower tip of the lower star. Notice that the white space between the T–star–dot is equal and that space is also equal to the space between the *r* and the bottom shape of the *i*. Notice also that the bottom of the *i* dot lines up with the bottom of the crossbar of the *T*.

7. All of the rounded corners are created with two curve points with symmetrical handles across a 45° axis passing through the point where the horizontal and vertical lines appear to intersect. Drag the handles with the Shift key held down to constrain them to horizontal and vertical.

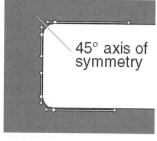

45° axis of symmetry

8. The *ta* combination shape is two paths made into a composite path. The center of the *a* is a very simple shape with five points at the extrema. This is a very good thing to remember. The extrema are points placed where a bounding box would touch the shape: the far left, the far right, the top, and the bottom. Paths made using extrema often look more balanced (especially when making fonts in FreeHand's cousin, Fontographer). But I think that PostScript just prefers extrema.

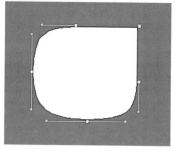

You really must do this one perfectly. There is no room here for "close enough for government work." In many instances in design, as we have discussed already, there is no real right or wrong and design solutions can quite often start on an arbitrary basis. When you are duplicating a logo, the key word is *duplicate* – exactly. After duplication, you must resize proportionally. The only excuse for transforming a logo is to make it fit perspective or to map it to a 3D shape.

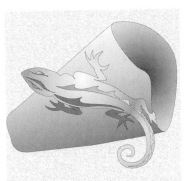

Tracing a logo

Here we have to discuss, a little, the use of Photoshop. So far we have successfully avoided one part of reality: the simple fact that digital publishing cannot be done in any one program. We will discuss this much more in the next two chapters. Digital publishing requires a page layout program (PageMaker, QuarkXPress, or InDesign), an image manipulation program (Photoshop), and for the purposes of this book, FreeHand.

A good trace requires a good scan.

First of all, you must understand that you will get what you prepare in your scan. If shapes are bumpy and misshapen, if letter forms touch each other, if outlines are broken, your trace will be useless. There is no alternative other than opening the scan in Photoshop and cleaning it up.

If your computer has enough RAM, you should end up with a 600–1200 dpi bitmap (1-bit) TIFF to be traced in FreeHand. If you have an image that must be scanned in grayscale or color, try to do it 300 dpi or more (then convert it to the high-res bitmap for tracing). This is determined by the resolution of your scanner. If you have a 600 dpi scanner, you should use 300, 600, or 1,200 dpi. If you have an 800 dpi scanner you should use 400, 800, or 1,600 – and so forth. You want to use an even multiple of the basic optical resolution of your scanner.

Although it is true that FreeHand can trace multiple colors, grayscale images, and even full-color images, you will find that (in most cases) the time involved to clean up these multicolor images is counterproductive. One of your biggest problems will be getting rid of pre-screened tints. If you try to trace pre-screened tints, you will end up with hundreds (if not thousands) of little traced dots that are very difficult to deal with.

I am including two skill exams that I use which I find extremely useful to my students. Because they require Photoshop, I will make them miniskills and not required, but you should certainly do them if you have Photoshop on your machine. This type of work is extremely common, and you need to be highly skilled here to avoid losing money through unbillable time. Remember that logo tracing is something to help you and not the customer. Often you have to eat the labor costs involved, under the assumption that you will get it back later when you can simply drop in the logo whenever needed. I wouldn't make a big deal over this with the customer. All it will do is give your client doubts about your competency. They are assuming that this is no big deal. Occasionally, of course, the supplied logo is so bad that you have to bring it up and charge for the conversion work. Just be careful.

Miniskill #10: Bubba's

Here we have a nice, seemingly clean logo to trace. However, it is pre-screened and you will need to get rid of all the gray areas before you can trace it. We've given you a nice clean 800 dpi scan on your CD/Website. You will quickly discover that this seemingly innocuous graphic is a real pain in the ... mouse. After dealing with this one, you will have a much better idea why there has been all of the talk about unpaid time spent cleaning up preprinted graphics.

Your clients will seldom have any idea that every tint printed is broken up into tiny dots. You actually got off easy here, because the scan you will be dealing with is of an 85 linescreen, which (as you know) is relatively coarse. In fact, unless you have already gone through our course on image manipulation to learn about linescreens, you might not know about these dots either. I have a screen capture of the base of the microphone that will show you the problem. As you can see, those seemingly smooth gray shapes are infested with a sea of dots. It's the only way printers and presses can give the illusion of tints to their images without a separate plate with special colored ink for each tint (which would drive printing costs through the roof if it were even possible). In every preprinted graphic that you have to scan and trace, you will be forced to deal with these dots. If you are given a full-color, preprinted logo, you will usually be dealing with four layers of these dots (cyan, magenta, yellow, and black). Then you have a real problem, especially if much of the detail is held in the yellow portion of the image.

In this case, however, you have a good clean scan. It is relatively simple to clean up (though a little tedious). Before you can autotrace it in FreeHand, you will have to get rid of the dots in Photoshop. There is no way you can get a clean trace of all those little dots; also, you can see what those dots have done to the edge of shapes.

Once you have the dots cleaned up, save the piece as a TIFF, place the scan into a new FreeHand document in the BACKGROUND layer of your LAYERS panel, and lock it. Then AUTO-TRACE it, adjust the fills, and refill the gray areas with appropriate gray tints. When you are done, export the logo as a PDF and email it to your instructor for grading. The final result should look exactly like the sample above.

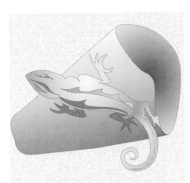

**HERE IS WHERE
WE START**

This is a grayscale
version. The color
JPEG is on the CD
and the Website.

Moving on to reality

Logo tracing, of course, is rarely as sweet and simple as these two exams would depict. For our final skill, I have located a "real" project that was inflicted upon my students a year or so ago in the context of one of our Service Learning projects for a local nonprofit corporation. They were having an award competition and we were doing the program. The program was financed by advertising from local businesses and my students had to generate all of the ads.

The ad that serves as the basis for this skill exam was a simple eighth-page ad of 2.25"x3.25" with simple congratulatory copy. The problem was the logo. The ad was for a Best Western motel and the only copy we could ever get out of them was their business card, which had a small, process color version of the official logo that we had been ordered to place into the ad. Of course, this was a single-color job and the logo was not only out of register, but it was a half-inch wide and three quarters of an inch tall. You enter here.

Skill exam #10: Logo Trace

We start with the little JPEG image you see at the left. Again we have to open it in Photoshop to have any chance of a clean trace. Once open in Photoshop, the first thing to do is use the Magic Wand (with a tolerance of about 60) to select the red areas of the crown that are out of register. As you can see, they are too far to the right and too high. Once the crown is carefully selected, move it until it is centered, as you can see to the right.

Then you can deselect, increase the tolerance on the Magic Wand a little, change the background color to white, and select the yellow areas. Then you can hit the Delete key to change them to white. Next you have to clean up the "Best Western" type a little. As you can see, it is a little messy. You need to get in there carefully with a single-pixel pencil and carefully separate the letters a little. Do not worry about the registered mark. You will fix that in FreeHand. Once it is separated it looks like this. As you can see, the separation between some of the letters is a single pixel of white.

You can do a little more cleanup, but the bottom line is very simple. Don't waste your time! You can quickly draw the round-cornered boxes in FreeHand and the type (other than *Best Western*) is obviously Helvetica Bold. Like the ®, it is much quicker to do these

things in FreeHand — and much more accurate, not to mention cleaner. One of the skills you need to learn is to recognize which things need cleaning and tracing, which work better as a template to hand-trace, and which are easier to simply draw. If you look carefully at the final cleaned TIFF to the right, you will notice that I cleaned up things a little more — mainly making the background round cornered boxes black with the Magic Wand.

However, even that is not necessary. It was just quick and easy. I did it just in case the preview in FreeHand would be a little better.

Next you open a new document in FreeHand and place the cleaned TIFF. Enlarge the TIFF 400% (remember the original scan was 1,200 dpi, so you can do this with no trouble). Then use the Transformation panel to rotate the TIFF -.3° (yes, that is minus three-tenths of a degree). Move the transformed TIFF to the background and lock it. Then trace the crown and the *Best Western* type. The result will look something like what you see to the right.

You will end up with an extraneous box from the Autotrace marquee. You need to delete that. Then color the traced shapes appropriately. The red portions of the crown go to 60% gray, the type black, and the crown shape itself white. Make sure you use no strokes. Any stroke will clutter up and plug the image. Once you have that done, it is a quick and simple matter to put a white round-cornered rectangle behind the type, and the large black one behind the crown and white box with the type. Both of these rectangles have a corner radius of about a tenth of an inch. The outline is another round-cornered rectangle, no fill, four-point black stroke, with a two-tenth radius.

Convert to Keyline View so you can see the grayed-out TIFF behind your paths. Next set the type for "Worldwide Lodging" in twelve-point Helvetica Bold (or Arial) centered. Double-click the overflow box to make the text box fit the type snugly, move the text box until the upper left corners of the *W* match. Then go to your Selection Tool, click on the lower right handle, and, holding down the Option key (PC: Alt), resize the type until it matches. It will be a little thin (probably because of generational damage on printing and reprinting). Convert to Paths and fill white with a white half point stroke. Then set the register mark (twelve-point Helvetica Bold), move it over the busted-up scan, line it up carefully, and Convert to Paths, black fill, no stroke. Export the cleaned-up logo as an EPS and you're done (except for grading; for grading you should export a PDF to attach to an email to your instructor). You should end up with a very

cleaned-up exact replica in grayscale of the logo (that looks better than the original). Actually, you have probably rebuilt it to the place where it closely resembles the original logo supplied by Best Western.

 When you recreate a logo like this, always be careful to check with the client or corporate headquarters to make sure that you have not changed something by mistake. These logos are trademarked and registered (often at great cost). You can get yourself in a lot of trouble if you inadvertently modify a logo.

Summing it up

So, why have we spent all of this time on logos, avoiding ad design and the other practicalities of real-world graphic design? We needed a restricted design problem that we could cover thoroughly. When you are designing an ad for a magazine, you ask the same questions, follow the same procedures, and execute to the same level of competent professionalism.

FreeHand is probably the best software for creating advertising for newspapers and magazines. It enables you to treat the entire ad like a single intense graphic. When you are done you have the capability of directly generating whatever format is needed for the publication you are working on, be that a magazine, a Website, or a CD–ROM.

For the rest of this book we will talk about those practicalities. The skill exams are over. You are ready to move on to real-world production, using the same principles.

It's time to have fun!

Knowledge Retention:

1. Why is your personal taste a problem in font choices?

2. Why is knowledge of typographic norms important?

3. What is the most important copy on a business card?

4. Why should you start by using classic typefaces?

5. What are the functional differences between Caslon, Baskerville, Garamond, and Bembo?

6. Why should you avoid Times and Helvetica?

7. Why is logo tracing such an important skill?

8. Why is font choice more important in a logo?

9. Why is manipulated type the most common graphic?

10. Why do you have to know the clients and some of their history before you can design effectively for them?

Where should you be by this time?

You should be champing at the bit, ready to go, off to design some real graphics for real clients. We have covered all of the design basics. You are probably a little scared (at least if you have any sense you are). Can you actually do all of this? In fact, some of you will have a real gift for this. Many of you will merely add these tools to your arsenal as you focus on other aspects of publishing. Regardless, you should have a good grasp on what is required and a running start on using FreeHand professionally.

DISCUSSION:

You should be talking about the real uses of FreeHand in the publishing industries. When is it appropriate? When should you use some other software or hardware?

Talk amongst yourselves ...

PRINT & WEB
GRAPHICS
USING FREEHAND

CONCEPTS:

1. Preflight

2. Trapping

3. Imposition

4. Linescreen

5. Banding

Definitions are found
in the Glossary on
your CD.

Chapter Ten

Printing Problems

*Designing to avoid
production difficulties*

Chapter Objectives:

By teaching students the options and capabilities of
FreeHand, this chapter will enable students to:

1. avoid banding
2. properly manage links
3. avoid font problems
4. work in a team.

Lab Work for Chapter:

• Work on fulfillment of grading requirements.
• Real world projects.

Printing
Problems

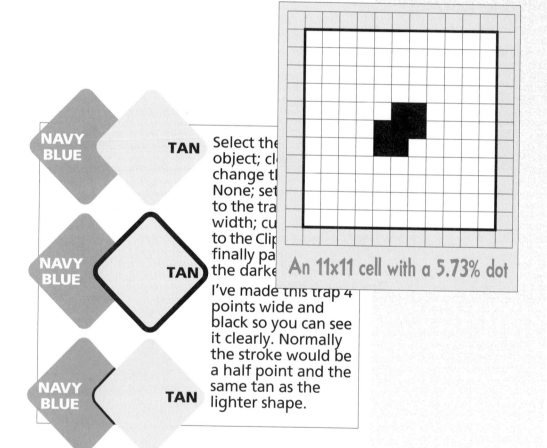

An 11x11 cell with a **5.73%** dot

Select the
object; cl
change t
None; set
to the tra
width; cu
to the Clip
finally pa
the darke

I've made this trap 4
points wide and
black so you can see
it clearly. Normally
the stroke would be
a half point and the
same tan as the
lighter shape.

214

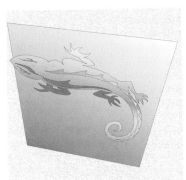

Making it printable

This is the core of the matter. Printed documents are made of dots. Here we have to talk about some semi-complicated theory that causes many people conceptual problems. The basic question is, "Why do I need 1,200 dpi or more to produce professional-quality output?"

The problem is that continuous tone, tints, and gradients cannot be printed without going through contortions. Printers and presses require dots. Most of the reproductive processes are unable to print areas that vary in color. More than that, even digital presses that print variable dots cannot print dots that are different colors. This is the key concept you must remember. Presses and printers use dots that are a constant color. They might be all black or all red or all blue, but for any given print head, toner cartridge, or plate cylinder, only one color of ink is possible. To rephrase, every different color of ink or toner requires a different print head.

The varying colors and the appearance of continuous tone or tints on a printed product (or a monitor) are an optical illusion. This illusion is created by using dots that are so small the human eye blends them into tints, shades, and continuous tone. This is the basic concept we deal with in publishing.

There are two basic types of dots

Before we can go on, we need to discuss the two basic types of dots. The basic difference is simple. Can the dots vary in color or not? Those that cannot are better called *dots*. Those that can vary in color should properly be called *pixels*. This invented bit of computerese is a contraction of "picture elements." In the trade, groups of pictures are often called pix.

The amount of different colors that a pixel can express is determined by its *color depth*. Color depth is an expression of how many bits of data are assigned to each pixel. If one bit is assigned, there are only two possibilities: on or off. If 2 bits are assigned to a pixel, there are 4 possible colors; 3 bits = 8; 4 bits = 16; 5 bits = 32; 6 bits = 64; 7 bits = 128; 8 bits = 256; and so on. These numbers represent possible colors. For example, a four-bit monitor would have sixteen colors available.

A two-bit screen would have four colors — maybe white, green, red, and blue. These colors would be it. Each pixel would be one of those colors and nothing else. There would be no grays, no yellows, no browns; nothing else. But what would happen if the screen was drawn in a checkerboard pattern of red and blue alternating pixels? Probably some sort of purple, depending on the hues involved. This technique of

generating the illusion of additional colors by using patterns of pixels is called *dithering*. Dithering can be in defined patterns — think uglier than sin — or in a random arrangement called diffusion dithering.

For clarity's sake, I will attempt to remember to use the following codes to help you separate dots from pixels. Basically, scanners and monitors use pixels. Printers and presses normally use dots. The problem is that everyone uses the measurement *dpi* for any type of dot or pixel (dpi obviously stands for dots per inch).

Here are the codes we will be using :

- spi = samples per inch for scanner pixels
- ppi = pixels per inch for monitor pixels
- dpi = dots per inch for printers and imagesetters
- lpi = lines per inch for halftone screens on plates, masters, toner drums, and traditional printing presses

You can certainly continue to call everything a dot, and all resolutions dpi, but this artificial differentiation into the four types of dots will be helpful as we get a handle on dots in the workplace.

The halftone revolution

Photography was the trigger for the search for an ability to print shades of gray. All printable artwork before that time was lineart (primarily engravings and etchings). These were made up of tiny, overlapping, and crosshatched black lines cut or etched into copper plates. In the latter part of the nineteenth century, a technique to solve the problem of printing photographs was developed. This methodology produced what came to be called halftones. A halftone broke a continuous tone image into tiny little dots that vary in size.

There are two basic ways to vary the tints that are apparently created by the dots. (Remember that a tint is a percentage of area covered; in a 15% tint, 15% of the paper is covered with ink or toner dots.) The most common method at present is the original technique that varies the dot size, with dots that are in a rectilinear grid. This is the halftone technique. It has been used with increasing frequency since the 1880s. It is the method used by FreeHand to generate its tints. Only since the 1990s has there been a digital alternative.

This second, alternative method varies the dot location and frequency. Here the dot size remains constant. This is commonly

Round Dot Halftone

Stochastic Halftone

called the *stochastic* technique. In appearance, it resembles the technical pen technique of stippling or the old intaglio method called *mezzotint* (but the stochastic dots are often much smaller). This is a brand new capability made possible by the extremely fast computers that are now readily available, and it can only be produced digitally.

Most commonly, what we tend to see as stochastic is really diffusion dithering. True stochastic requires great computer processing power to precisely place extremely tiny dots. Cheap inkjet printers all use diffusion dithering. Photoshop's diffusion dithering capabilities can be used to solve problems with low-resolution printers. There will be times when you have to post-process your FreeHand drawings in Photoshop, ImageReady, or FireWorks, but because that is mainly a Web problem we'll cover that in the next chapter.

For now, what you need to know is that all presses, copiers, and digital printers require dots. There are only a few digital color presses (and copiers) that use pixels. More than that, all printers (except dye sublimation color proofers) need what are called hard dots. These dots are a specific size and a uniform density. It is very important that they be predictable in size and location, so they can be calibrated to produce tints that are accurate to plus or minus half a percent or less in color. Needless to say, the cheap printers (under $10,000) cannot be this accurate, except for a few color laser printers.

The example, on the facing page, should give you a much better feel for how these dot structures appear when magnified. As you can see, the dots for both types have very hard edges and destroy all fine detail. Notice that halftone or stochastic makes no difference. At the dot sizes used, all we see in our mind is smooth gray gradations. Once the dots are formed, the image cannot be enlarged without making the dots visible to the naked eye. If they are reduced in size, the dots can easily get so small that they will not reproduce, and the image will get muddy, blotchy, and ugly.

Linescreen usage

So, printers require dots, and the vast majority of those dots (except for the cheapest inkjets and some of the most expensive imagesetters) come in regular patterns. These regular patterns are normally called linescreen. The name comes from the original screens, which were made of plate glass with tiny parallel lines scribed into the front and back surfaces at right angles to each other. Linescreens were measured by the number of lines per inch. This is a physical measurement; for instance, a 133-line screen has 133 horizontal lines and 133 vertical lines. The term is in such strong usage that no one even questions the fact that lines haven't been used for many decades. Linescreen now refers to the grid size that holds the dots, not the actual size of the dots themselves.

First of all, notice that the dots produced by the halftone screens are very close together. The number of lines per inch is commonly 150 for the normal "slick" magazines you read. For ultra-premium art reproduction printing, 300, 500, and even finer line-screens are used. Second, notice that linescreen is much coarser than the dpi ratings of digital printers. Printer dpis start at 300 and continue up to 4,000 to 6,000 dots per inch. The question becomes, "Why does traditional linescreen need so few dots per inch while digital dots need many times more?" Hold on, the answers are coming.

Lines per inch

There are two reasons why we use the dot sizes commonly available. The first (and most powerful) factor is the capability of the human eye. At normal reading distance (around eighteen inches), dots that are a seventy-fifth of an inch (75 lpi) or smaller are blended into smooth colors. We might notice a grainy texture at 75 lpi. Even this disappears at 133 line or higher. With anything coarser than 75 lpi, almost everyone can see the dots with the naked eye. There are always one or two students in my classes who can see 85-line dots fairly easily, and always a couple of others who cannot see even 65-line dots.

The second factor controlling dot size is the technology of the printer or press. For example, for years newspapers were limited to 65-line screen. They were printing on unsized newsprint paper with relatively liquid ink. If the dots were any smaller than 65 lpi, they soaked into each other, plugged up in the shadows, and disappeared in the highlight areas of the tints and images.

What we need to do is consider all the linescreen ranges in common use. It is important that you understand which printers use which linescreen and why. You need to know what linescreens are used where and why. This knowledge will greatly help the production of your printed designs.

Zero to 25 lpi: Billboards (grand format inkjets)

Sometimes these very coarse screens are used for purely graphic reasons by designers, but basically, only billboards use them. They are also used for the building-sized posters (100 feet by 300 feet) on the sides of city buildings in our larger cities. Remember, the use of 75 lpi is based on the 18-inch reading distance. Let's compare billboard quality to commercial printing quality (150 lpi): 150 lpi @ 18" is the same visual quality as 75 lpi at 3', or 37.5 lpi at 6', or 19 lpi at 12', or 10 lpi at 24', etc.

Billboards are normally read at 100 feet or more. On top of that, they are usually read by someone flying by at highway speed. Billboards

AN INTERESTING ASIDE

If you place this book more than ten feet away and look at these two pages, you will not be able to see the difference in these photos of my basset when she was a puppy. It will really help you understand how distance affects your ability to visually render dots at various sizes. Do it!

are commonly 4-line to 12-line. But their resolution capabilities are superior to those glossy photos in National Geographic or Smithsonian magazines. To help visualize, 8-line at 100 feet is roughly equivalent to 512-line screen at 18 inches or reading distance. (Printed billboards make wonderful wallpaper. All you normally have to do is call the local outdoor advertising company. Ask them for outdated ads that they are tossing. A twenty-foot Clydesdale makes a wonderful mural.)

25–50 lpi: Graphics and foil stamping

Linescreens of 25 to 50 lpi are rarely used except for graphic effect. These screens can be very effective. In addition, they are very easy to deal with. They usually produce very small file sizes. They print beautifully and even low-res printers (300 dpi) can render them clearly. As we will see, these screens can be used to solve banding problems.

If you are designing a foil stamp and want to use tints, I would not recommend anything finer than 25 lpi. If you can figure out a way to make it look good, a 10-line screen would be better.

50–75 lpi: Cheap copiers and 300 dpi printers

This is the area inhabited by cheap copiers and 300 dpi laser printers. As you will see in the discussion of halftone cells, low-resolution printers are only capable of photo reproduction in this range (50 to 75 lpi). These dots are still easily visible to the naked eye – disturbingly so. Only the most uneducated eye can ignore the low quality of artwork rendered with these large dots. In fact, they cannot even print these screens well, so you should consider the graphic option mentioned above.

75–100 lpi: Newspaper and screen printing

In the days of letterpress, newspapers were limited to 65-line. Now newspapers printed with offset lithography normally use 100-line. Some older papers with outdated equipment still cannot handle anything finer than 65- to 85-line. This is due to the poor quality of paper and the relatively liquid ink used. When designing newspaper ads, be sure to call and ask what your newspaper requires. You may be pleasantly surprised; you may be disappointed.

Screen printers are limited to this range partially by the size of the holes in the screens they use. There are rumors of 120- and even 133-line screen printing, but don't believe it until you see it. Screen printers are also limited by the surfaces on which they print. Clothing causes trouble with dots that are finer than 50 lpi. The fabric weave is much coarser than that. Even here you will occasionally see 100-line artwork on relatively smooth materials like T-shirts and sweatshirts.

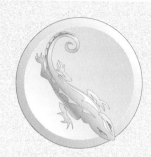

85–120 lpi: Quickprinters (using duplicators)

Most quickprinters are proud of the fact that they can print 100-, 120-, or even 133-line images. Most should stick to 85-line. Again, this is due to the equipment used. Quickprinters are built around the duplicator and/or copier.

A duplicator is a cheap, mass-marketed press and its resolution capabilities are fairly crude. A big problem, as far as linescreen is concerned, is the size and number of ink rollers. Duplicators do not have anywhere near as many as presses do. As a result, the ink is not ground as fine. Ink particle size limits the dot size. A larger problem is the integrated duplicator, which carries the water on top of the ink on the same roller. It makes the duplicator easy to run, but the inevitable emulsification limits the size of the dot.

The plates used contribute to the situation. Most quickprint plates are exposed on platemakers. These specialized cameras are designed to save money, not to increase quality. The quality of the lens optics is relatively poor. Many of the lenses do not even focus well. Their sharpest focus is still soft. The plate materials are yet another factor. The paper and plastic used cannot normally hold dots smaller than 100 lpi (if that).

A newer problem involves digital plates. Many of these plates are output on plain-paper laser printers. These 1,200 and 1,800 dpi printers claim 133 lpi. In fact, due to the nature of toner melted onto paper or plastic, these printers often give very mottled screens at anything finer than 85 lpi.

In many cases, 85-line screen will give better results. The equipment used by quickprinters can handle 85-line screen well, with no effort. Trying to print fine linescreens on quickprint equipment is analogous to trying to road race the family sedan. It can be done ... with extreme care, a lot of work, and many special parts. However, neither the printing nor the racing can match the real thing.

133 lpi and up: Commercial and process printing

This is where the printing professionals live: 133 lpi and up. Many are quite snobbish about it. You need to remember that there is

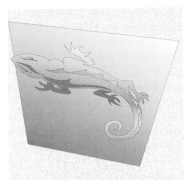

Getting
it printed,
banding, file
preparation

221

nothing wrong with coarser screens. They have their place. In some situations, these large dots are a real advantage. However, for reading, 133 and up is where it's at. (Although it hasn't bothered you. This book is printed at 120 linescreen, and most of you would not have known except I just told you. That's why there's no 133 lpi sample.)

For many years, 133 lpi was the commercial printing standard. Recently, with technological advances in presses and platemakers, 150-line screens have become the norm. Much of the improvement is determined by two main factors: equipment and paper. Equipment has gotten so good that 150-, 175-, and 200-line screens are no big deal. If the shop is set up to handle them, these fine screens give superlative results. All it takes are good materials, a relatively dust-free environment, and excellent personnel.

Magazine publishing has made a similar turn. The large heat-set web presses used to print full-color magazines have developed to the point where 150-line images are common. The change from 133- to 150-line has been gradual, but much of what you buy at the newsstand these days is 150 lpi.

The finer linescreens have been encouraged by the fashionable trend to use coated papers. These sheets hold the ink on the surface of the paper, making it much easier to control the dot size. The negative side is the slick look. Some artists have been relieved by a more recent turn toward uncoated, fiber-added stock. As long as the paper is calendered (smooth and compacted), the fine linescreens will do very well on these new sheets. In all cases, the look of the final product is controlled more by the quality of the artwork than by the size of the dots that render that artwork. Excellent designers produce beautiful printed pieces, even on 300 dpi black-and-white laser printers.

The upper limits of linescreen and practical considerations

The upper limit is primarily a function of the technology. Offset lithography is normally limited to around 200-line screen. At this point, even presses have enough emulsification to limit dot size. However, many printers brag about being able to print 300-line screens. A printing firm in Phoenix has developed proprietary processes that allow 500 lpi or more.

Gravure uses no water, so emulsification is no problem. These presses function comfortably in the 150 to 300 lpi range. Their limitation is primarily the grain structure of the plate and the ability of the resist to prevent the acid from breaking down the dot edges. Also, the plate can deform if the dots are too small.

Waterless printing is limited only by the grain of the plate. Some waterless jobs actually use the granular structure of the aluminum in the plate for the dot. These measure around 600 to 700 lpi.

Quite often, it is undesirable to print with too small a dot. When you push the limits of the available technology, there is a tendency for the larger (shadow) dots to plug up. As a result, 300 lpi can have much less shadow detail than 200 lpi, even though the midtones are sharper. Also, the finer the dot, the higher the cost. Ultrafine screens require better equipment, better facilities, better personnel, and more time.

In most cases, screens finer than 175-line are not cost-effective. In fact, unless you are printing on supersmooth, cast coated stock, the ultrafine screens might easily muddy the image. This is the same problem mentioned in the quickprint section. A printer using a duplicator might be able to print 133-line screen, but can the duplicator handle the paper necessary to benefit from the tiny dots?

Design for the technology

As a desktop publisher, you need to understand the client's needs and the printer's capabilities. You need a stable of suppliers that can produce what is needed, in the most cost-effective manner, at the highest practical quality. There are certainly times when you need very high resolutions. Maps, for example, have extremely fine colored detail to print. Fine art reproductions also require the detail allowed by the higher resolutions (although you will have a hard time convincing the artists of the costs involved).

THE PROBLEMS WITH DIGITAL DOTS

The illusion of variability

Digital dots fit a tight grid called a bitmap. In addition, these dots do not vary in either size or location. There are a couple of new laser copier/presses that use dots like pixels (i.e., they vary in color), but this is not the normal situation. As a result, digital printers have had to come up with what are called *halftone cells* to produce the illusion of variability.

These cells are made up of groups of dots. Each cell corresponds to a single linescreen dot. There are several problems with these cells. To start, they use the bitmap we keep referring to. This means that our formerly well-shaped linescreen dots become jagged assemblies of squares. This is more of a surprise to traditional printing professionals than anything else. They still cover the required percentage of area to make a tint. The dots that constitute the cell are so small that the irregular dot shapes are invisible without magnification.

A larger problem is the way the dots vary in size. Traditional dots gradually changed with virtually infinite variability. Halftone cells

An 11x11 cell with a 5.73% dot

are limited by the number of dots available within the given cell. If the halftone cell is three pixels square, there are only ten levels of gray (3x3=9 plus one for all white) or ten different tint %percentages. This means that, with a 10-level halftone, I only have 0%, 11.1%, 22.2%, 33.3%, 44.4%, 55.6%, 66.7%, 77. %, 88.9%, and 100% tints to work with. This would ruin a halftone photograph by posterizing it. With one of FreeHand's gradients, it could cause severe banding.

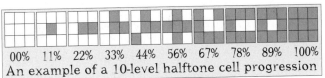

00% 11% 22% 33% 44% 56% 67% 78% 89% 100%
An example of a 10-level halftone cell progression

The only way you can achieve more levels of gray is to use more dots per cell. For example, the following cell sizes produce gray levels in these quantities: 3x3=10; 4x4=17; 5x5=26; 6x6=37; 7x7=50; and so on. The problem is that the human eye requires at least 100 levels of gray to see smooth gradations in a photograph — in fact, more than 200 levels of gray are preferable. This requires cell sizes of 10x10 to 16x16, or 101 to 256 levels of gray.

This is why digital printers require so many more dpi than linescreens need lpi. If you have an 85 lpi screen with 101 levels of gray, you need 850 dpi, because each dot of the linescreen requires 10 digital dots. A 150 lpi screen with 256 levels of grey needs 150x16 = 2,400 dpi. As you can easily see, a 300 dpi laser printer is not going to get you very far. With enough dpi in the printer, PostScript resolution allows for 256 levels of gray (or more).

Printer resolution requirements

Now you know why digital printers require such seemingly ridiculous resolutions. When you divide it out, it quickly becomes apparent why 300 dpi printers are limited to the standard 53- or 60-line screens; 600 dpi printers can barely handle 85-line screen (with 50 levels of gray); 1,200 dpi plain paper printers work best at 85-line, though 1,200 dpi imagesetters that output film can output 100-line or even 120-line. However, as you can see, 120 line at 1,200 dpi only gives 101 levels of gray.

THE FORMULAE ARE SIMPLE:

- dpi ÷ lpi = the horizontal dimension of the halftone cell
- dpi ÷ the horizontal dimension of the halftone cell = lpi
- lpi x the horizontal dimension of the halftone cell = dpi requirements of the printer

Professional output is normally 2,400 or 2,540 dpi. This allows 256 levels of gray at 150-line screen This is one of the reasons why many industries are switching to 150-line from 133-line. The 150-line

composite negs allow easy production of 150-line plates. Increasingly, the plates are output directly. However, quickprinters still output plate at 100 line or less at 1,200 dpi or 1,270 dpi.

Practical considerations

Therefore, the question is, "When do I use what?" The answer is obvious. The linescreen used is determined by the capability of the hardware that will be used to print your project – not the printer you use for proofing at your desk.

The first choice you should make when beginning to design a project is the technology to be used: print, Web, video, multimedia. If you are going to print it, you must know the printer, service bureau, or printing firm you are going to use to produce the project. Everything in your project must be designed within the capabilities of your printer, imagesetter, or press.

The problem of banding

One of the major new problems with digital output is banding. This is when a gradient fill, or an area that gradually changes color, shows bull's-eye rings or parallel bands when it is output. On the Web, as we'll cover next chapter, this is caused by too low a color depth (or too few bits per pixel). In print, banding is caused by too few levels of gray (or a halftone cell that is too small).

You need to understand how PostScript produces the illusion of a smooth gradient fill. The easiest way to understand this is with a blend. In the sample below, the top box is blended from white to black in 256 steps. In the bottom box, there are five steps. The five-step box

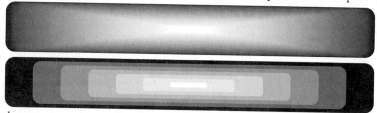

demonstrates severe banding. So here we see one obvious solution to the banding problem: use more steps in blends.

However, many times this is not enough. First of all, you must realize that all gradients in FreeHand use this layering of multiple shapes to produce the illusion of smooth color changes. The reason gradients look smooth is the same phenomenon we talked about with linescreen. If the bands are narrow enough, the eye blends them smoothly into the illusion of a graceful transition from one color to another. The problem is that there are not infinite bands available.

The number of bands in a gradient is equal to the levels of gray produced by the halftone cells multiplied by the percentage of color change. White to black, or 0% to 100%, uses all the available levels of

gray. A gradient from 30% PMS345 to 50% PMS345 would only use 20% of the available levels of gray. A tint band becomes visible to the naked eye when it is a fiftieth of an inch or wider.

Banding is caused by insufficient colors.

Banding results when there are not enough different colors, color variations, or levels of gray to span the distance of a gradient with bands less than a fiftieth of an inch. On a monitor this would be bands two pixels wide or more. To make it more real, if I have a gradient from 20% green to 30% green output on a 1,200 dpi printer at 100 linescreen, then I have 10% of 145 levels of gray or 14 bands of color. If my gradient is two inches long, there will be seven bands per inch and each band will be more than one-eighth inch wide – easily visible.

There are several ways to solve this problem. One is to increase the resolution of the printer. At 3,000 dpi, there are 900 levels of gray, or 90 bands for this gradient. This would make the bands almost invisible at forty-five to an inch. However, there are very few 3,000 dpi printers and not many can print this many levels of gray.

Second, we could go to 25 linescreen. This would make the halftone cell 40x40 or 1,600 levels of gray. This would solve the problem, if we can print that many levels of gray, but the dot size becomes easily visible.

Third, we can change the gradient from 15% to 35%, which would give us 20% of the available levels and double the resolution to 2,400 dpi, which would give us plenty of gray levels so that we could have 50 or more bands per inch. We've had to change the design a little, but the elimination of the bands is usually worth it. In this sample of the four gradients, I have banding with all four shapes on my 600 dpi laser printer. There should be some left in this book. The point I'm making is this. Banding is a simple mathematical problem. The solutions are also mathematical. A good designer will not have this problem – design around it!

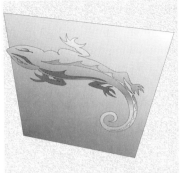

60%–25%

55%–25%

55%–35%

55%–40%

The solutions to banding include:

- Increase the output resolution
- Decrease the linescreen
- Increase the percentage of color difference

Remember, these are things you need to control in your designs. No one can fix a bad design on your part. At least, no one can fix it without added expense out of your pocket or profits (unless you are fortunate enough to have a client that doesn't care about things like staying in a budget).

Getting it ready to print

One of the most important steps in digital production is preparing for output. It is also one of the steps most commonly ignored. What most designers forget is that image assembly specialists cannot read the designer's mind. This is one of the things that separates a designer from an image assembler.

The creative thought process

Creativity, in general, is incomprehensible to most people. Creative persons make decisions based on intuitive reactions that cannot be explained. As a result, designs are normally misinterpreted by the noncreative folk in a production setting.

This says nothing about the people involved. Creativity is something people have or do not have. It is like coordination and athletic prowess or mechanical aptitude. Diversity is what makes the human race so wonderful. However, this very diversity makes communication absolutely essential. This is terribly easy to pass over or ignore. Production people will usually guess wrong.

Preparing for output

A good deal of the responsibility for efficient page processing lies with the designer. If you fail to consistently prepare printable pages, no amount of work at the service bureau or output site will make things go smoothly. The overwhelming majority of problems encountered during output are created by designers. Complicated designs cause problems in general.

Printable artwork

A few fundamentals cause most production problems. Most involve a lack of understanding about image assembly, presswork, and printing in general. The following is a limited list:

- BLEEDS — You will not believe how many jobs come in for output with unprintable bleeds. Many designers do not even know what a bleed is. If you happen to be one of them, a *bleed* is when the ink appears to go to the edge of the sheet of trimmed

226

GETTING IT PRINTED, BANDING, FILE PREPARATION

paper. For that to happen, because of the variances in cutters and trimmers, the ink has to be printed beyond the edge and trimmed back to size. A bleed always extends one-eighth inch or nine points beyond the trim (although some digital systems now ask for quarter-inch bleeds).

The bleed problem is exacerbated by a general PostScript solution. Anything that goes beyond the edge of the trim is automatically cut off at exactly the trim edge. Page layout programs allow you to go over the edge with your images, but this often causes problems. FreeHand's solution is elegant and unique, as usual. It allows you to specify the bleed on the Document Inspector. As you can see to the right, I am using my normal 5x5 document with an eighth-inch bleed. However, anything that extends even a point beyond that bleed mark will be cut off.

- GRIPPER — Unless the job will be printed on a large-format sheetfed or web press, the designer needs to consider this. A sheetfed press or duplicator needs a certain amount of blank paper on the edge to mechanically grip the sheet to pull it through between the blanket and the impression cylinder. Basically this means that unless you have at least three-eighths of an inch of blank paper along at least one edge, you can end up paying for oversize paper that has to be trimmed back. That means that you have to add four cuts and that your paper costs will go up from 25% to 100%.

- SPOT AND PROCESS MIXES — Many projects cause problems by putting process color in a spot job or spot color in a process job. Unless your budget includes more than four colors, these systems cannot be mixed.

Digital complexities

What most designers do not understand is the vastness of the difference between printing on a laser printer and outputting to an imagesetter. An 8"x10" image in a laser printer document at 300 dpi contains 7,200,000 dots. That same image on an imagesetter at 2,400 dpi contains 460,800,000 dots. In 24-bit color, we're talking 1.4 gigabytes of data. This difference is what causes documents to print fine at low-res but crash the raster image processor (RIP). It is all too easy to create documents that are too complicated to print.

A professional digital publisher prepares documents with efficient output in mind. She is responsible for making sure that pages output correctly, with a minimal amount of time and labor going toward fixing problems (and with minimal unexpected charges).

Graphic artists have always had to be concerned with prepress and press problems. This is still the case, but now much or all of what used to be called prepress is being done by the artists. As a result, they have to be very careful. The safety net of professional production staff has largely been eliminated.

Considerate production

The biggest concern is attitude. When designers start thinking that certain designs are "necessary" or "the only possible solution," they are in trouble. Design is problem solving. Excellence comes with consideration for the rest of the process. Only then can pieces be produced that even come close to the original inspiration. Many designers seem to assume that there is an unlimited budget (which is then forced to stretch to fit overly complicated and/or difficult printing routines).

Just remembering that some poor slob has to print the piece will greatly help the printability of the design. There are indeed reasons for complication. They should be used carefully, on purpose. If the budget is unlimited, anything can be tried. This is rarely the case, however.

The number one problems — fonts

Service bureaus are still committed to PostScript fonts. They have invested huge sums of money to have the thousands of fonts they need to keep their customers happy. Most have that investment in PostScript. TrueType and Multiple Master fonts will have to be supplied to them. In fact, you are safer to send the PostScript fonts also. Most font licenses now allow you to send your fonts to the service bureau or printer (but you should check to make sure).

Font parts review

There are two parts to a PostScript font: the screen font, which is used to display the typeface on the desktop; and the printer font, which is a small PostScript program that defines all the curves, lines, and shapes that make up each individual character in a given typeface. When you select a font from a menu or dialog box, the screen font is loaded by the program, or it is created by Adobe Type Manager and displayed on the page. When printing, the PostScript printer font is downloaded to the printer (unless it is already resident) to write the type on the page at the resolution of the printer.

The following points are some things to remember:

1. SELECT THE CORRECT FONT.

In the early days of desktop, if you wanted a bold version of a font, you simply selected the area of type you wanted bold, and

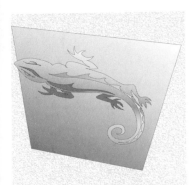
selected the "bold" option from a formatting or font menu. The screen face was made bold, and the proper printer font was sent (downloaded) into the printer. Now this will cause you problems, for a number of reasons. Applying "bold" by clicking a formatting box causes the printer to print the type twice, with the second image offset down and to the left. This works fine on a 24-pin printer but looks ghastly at high resolution.

The only time formatting like this works is if you have a font family set up with regular, italic, bold, and bold italic in it. These families are getting more and more uncommon. If your fonts are not in a family, the imagesetter will whir and click until it finally decides that the font does not exist. At this point it usually substitutes the dreaded Courier.

Don't use the bold, italic, and bold italic formatting menus or boxes available in most programs. Select the actual font you want from the list of fonts available in your system. This often slows you down, but it is necessary to ensure proper printing.

 PC Users beware! The way Windows works makes it difficult and complicated to eliminate TrueType fonts and use only PostScript. If you are forced to use TrueType with styling boxes, you will have to look specifically for a service bureau or printer that can print TrueType. TrueType is often a major problem in a PostScript workflow, and regularly causes RIPs to refuse to print jobs or to substitute Courier.

2. **BE CONSERVATIVE.**

The number of fonts designed into a document should be kept to a minimum. Remember that typefaces used in illustrations add to the total number of fonts in your document. It's usually better to convert type to outlines in the graphic before exporting, to reduce the total number of fonts contained in your document. If you use even one character from a type family, PostScript processes the entire font—even if that character is a space, tab, or carriage return. If that font is missing, the RIP can choke as it endlessly looks for it.

3. **CLEAN UP ANY EXTRANEOUS FONTS.**

Often there are pieces left over in documents where you changed fonts during the design process. These usually take the form of paragraph returns, spaces, and other invisible items (invisible to the eye, not to the RIP). You can list all the fonts used and then search and replace. Better yet, be careful as you design.

4. **SEND THE FONTS.**

Of course, you must observe the legalities contained in the shrinkwrap agreement on your fonts, but this is largely a "former" problem. You can avoid this if you are absolutely certain that the

service bureau has the same version of the same type style from the same font house as you use.

Be very careful here. There are thousands of fonts. There are well over a hundred versions of Helvetica, for example. These all just show up on the font menu as Helvetica. All of them are slightly different, whether in width, spacing, kerning pairs, or the like. It has gotten so ridiculous that the same fonts from the same company from different years cause problems. A different printer font can cause text to flow differently. This can make text boxes overflow. Your wonderfully crafted copy can end up missing words, sentences, or even paragraphs.

It is possible to design your own custom fonts using a program like Fontographer or Icarus. It does take a relatively large amount of skill and typographic knowledge, so this is not a common solution. It is a possibility to be remembered as you increase your skill in your craft.

Another solution is to provide your service bureau with a PostScript file (or increasingly accepted) a prepress PDF. These document formats embed all of the page layout, graphics, and fonts the imagesetter needs to output your document. Ask your service bureau about this if you've never attempted it before. Many of them have specific procedures they want you to follow. The printer for this book sent me a thirty-six-page book, and I am sending them PDFs. Also, keep in mind that a PostScript file will be large (because of all the font information included in it, among other things). The PDF will usually be much smaller.

A larger concern is that these files cannot normally be changed or fixed by the service bureau—what you send them is what you'll get. There is now software that allows PostScript and PDF files to be edited. However, this also allows noncreative personnel to make adjustments to the file. This often causes much grief to the creatives.

5. COMMUNICATE WITH YOUR SERVICE BUREAU.

Make sure that complete and accurate information concerning the fonts in your document is included. Find out what the service bureau prefers with regard to fonts and comply with its wishes. Print out a list of what fonts you used, who produced them, and so on. After you develop a relationship with the imagesetter operators, this need will greatly lessen, but you will still have to deal with newly purchased or created fonts.

In version 8, FreeHand has a good COLLECT FOR OUTPUT command under the FILE menu. It tells you to save your document (I recommend saving it to a new folder before you start the process), then it collects all the fonts and imported, linked graphics into that folder and generates a text report with a complete description of everything about the document. The only thing it cannot do is gather and move fonts used in imported EPS files. This problem with nested graphics will be covered soon.

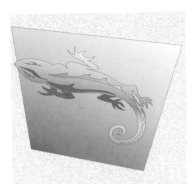

Convert to Paths

As far as your FreeHand graphics are concerned (and remember that they are almost always going to be placed into a PageMaker, InDesign, or Quark document for final output), the best solution is to convert all of your fonts to paths before exporting. There will be times when you have too much type to do this or the type is too small (less than ten points is usually a problem). However, in general, this is the best solution for everyone. The only time you will not want to do this is when you are going to open the graphics in Photoshop for post-processing. Photoshop will then convert the fonts to pixels.

Graphic problems

Illustrations created with PostScript illustration programs like FreeHand can be another area of possible problems when it comes time to print. The more complicated the drawing, the longer it will take to RIP. It is relatively easy to create objects in a drawing program that will never print. You must try to keep your drawings as simple as possible.

RIPs handle PostScript illustrations differently from bitmapped images. A bitmapped image can often be rasterized a portion at a time. Because the pixels are described one by one and row by row, the RIP can decide to print only the first 100 rows, then the second 100 rows, and so on, for example.

With a PostScript illustration, especially one with shapes pasted inside shapes, all the associated objects have to be rendered before the RIP can toss out portions that are cropped or knocked out. This means that the entire image has to be held in RAM. The RAM requirements can get huge.

On my 300 dpi printer with 9 MB of RAM, I have never seen an image choke the printer. On my 1,200 dpi printer with 32 MB of RAM, bitmapped images never cause a problem. PostScript illustrations often choke it, however, and such drawings must be redone.

EPS illustration tips

1. Keep the number of compound paths and patterns to a minimum. Tiled patterns take an especially large amount of memory.

2. Processing masks or items pasted inside other objects cause major memory problems, so think about your drawing before you actually draw it. Execute the drawing using the fewest masks or clipping paths possible. *Masks* are paths used to cover, hide, or otherwise block out portions of a drawing or image. Remember, FreeHand calls this function PASTE INSIDE. They enable using one shape to crop another shape. They can be handy, but they can prevent output. This used to be a major problem, but the new PostScript Level 3 RIPs have almost completely solved this one (to handle all the masks in software

like InDesign, PageMaker, and Quark). The clipping path fad has temporarily eclipsed the gradient fad of the past few years.

3. Check the "smoothness" setting (how much curve a curved line really has). You can often reduce the smoothness considerably without causing visible results in your drawings. What we see as a smooth curve is really a huge number of very short, straight line segments. This is why PostScript illustration is still called "vector art." Reducing the smoothness greatly simplifies your drawing by making those short lines longer so there are fewer of them. Low-res images can use a smoothness setting of 1 to 4 or so. High-res images can be set in the low double-digit range without visible vectors. I would just leave this at the default unless you begin having output problems that seem to be related to the overcomplexity of your drawing.

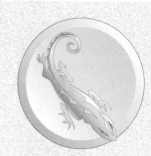

4. Limit the number of fonts in your drawings. We've already covered this a little. As mentioned, this doesn't work well on smaller type sizes, but it works great for logotypes and headlines. Converted type is no longer a font. The letters become normal PostScript shapes, and a few shapes take a lot less memory to deal with than a font. Just make the conversion after all formatting is complete. Kerning, for example, can no longer be done after conversion except by individually selecting the letters and moving them by mouse or keyboard.

5, Make the element as close to its actual final size as possible. When the RIP has to enlarge or reduce a graphic, it takes time. If you are putting in your own trapping, resizing a graphic also resizes your traps, which is not desirable.

6. Avoid nested graphics whenever possible. A *nested graphic* is an image that is imported into your illustration and then exported along with your finished illustration. Nested graphics greatly complicate your illustrations. They can be used, but discretion is a marvelous thing. They are the first thing to check when a print job chokes.

 If the graphic you think you need to import is an Illustrator or FreeHand document, open it in FreeHand. Then select the graphic (or the parts you actually need) and use the Clipboard to copy and paste the image into your new graphic that you are working on. Copying and pasting within FreeHand just adds those pieces to your new document without links or embedded graphics. This is one of the major advantages of FreeHand: the ability to open files from a wide variety of sources. With any amount of reasonable planning, there should be no reason for embedded graphics except for TIFFs from Photoshop.

7. Keep only one image in each exported drawing file. In one situation I heard about, an ornate typeface was drawn for use as drop caps. For each drop cap, the designer placed in the whole

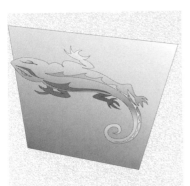

file and cropped out all but the character he needed. This forced the imagesetter to RIP the entire image and then throw away everything but the one character for the drop cap. Students regularly try to save one EPS that contains several images, or even several pages of images. It always causes problems. **Use a separate document for each graphic you create.**

8. Simplify blends. Use the minimum number of steps when calculating a blend. Remember, the shorter the blend distance, the fewer steps you need. Using the number of steps suggested by the program is usually wise. The general principle is to use enough steps to avoid banding. For example, if you blend in five steps over an inch and a half, each step will be one-quarter of an inch wide.

9. For large areas that contain a blend, consider using an image created in a paint program and saved as a TIFF rather than one created in a drawing or page layout application These blends will print very smoothly and will not cause any problem on output. Make the resolution high enough to avoid banding.

 If you do not have enough resolution available, try using the Noise filters in Photoshop. Adding a minimum of noise scatters the dots at the edges of the bands, which makes them much less visible. It will take some experimentation. The important thing is to stay light on your mental feet. Do not get stuck in PostScript or bitmap. This is where you need to be inventive. If what you just did doesn't work, try something else!

Be careful! Preparing for output

Finally, when all is said and done, you will have the job ready for output. This is a time when extreme care is advised. Most output sites provide their clients with a form to be filled out before files are sent to them. If your service bureau does, use it as a checklist to be sure you have provided all the files they need: fonts and any other information that's important to the project.

If you have preflighting software, like the plug-in that comes with PageMaker, use it to make sure that everything you need for printing is with the job. Remember that all graphics must be linked instead of embedded. This means that all the graphics have to be in the same folder as your final document (and not in a folder inside that folder). All fonts must be included (but no extras).

When sending a file to an output site, be sure also to send a laser proof of the project, pasted up, with the color break marked up on a tissue overlay, so they'll know how the film should look. Or send a color proof. It's important that any proofs be printed at 100%, even if you have to tile the pages. Don't send reduced proofs unless you also

provide a proof at 100%. Be sure to send separated proofs for all jobs containing two or more colors.

You must remember that the service bureau personnel have never seen your project. They have no idea what it is supposed to look like. Unless they have a proof, they could easily think that the little hole is planned white space (not just a graphic that you forgot to send along). They might assume that you meant that paragraph or headline to be Courier. Service bureaus are often typographically untrained and cannot tell Galliard from Garamond. In addition, fonts that cause text to reflow normally create widows and orphans. The bureau either will not recognize them or will not be able to fix them to your satisfaction.

Check your Print dialog box

Use the printer driver that the service bureau is going to use. Most of them will gladly provide you with a copy. Make sure all the options in your Print dialog box are correct: page sizes, registration marks, scaling, page orientation, and any choices that will affect the output. These settings are often completely different when output on a high-resolution imagesetter instead of on your laser printer. Don't leave it up to the service bureau to make all these choices. They can't read your mind to determine what you meant to set as options; they see only what you actually selected for these choices.

What to send

Here is a list of what to include:

- The final document file, so that changes can be made, if required. Be careful with output sites that take PostScript files; remember, the service bureau often cannot make changes to them or correct any errors.

- Any illustrations contained in the document. Send the originating illustration file as well as the exported graphic.

- Any scanned images that will be used for output, such as scanned logos, scanned graphs, or color separations. If you use low-res FPOs, remove or suppress them (unless the service bureau has told you to use their OPI image substitution setup).

- The screen and printer fonts that you used to do the layout. Be sure to check your license to come up with a legal solution. Carefully note any TrueType fonts used. In fact, don't use TrueType at all without prior approval.

- A set of instructions about the project, a full-size composite proof, and a set of separations (if necessary).

Put all of the elements that make up your document in one folder, including graphics, scans, and the final document. Be sure you include all nested items (graphics or files that you imported into graphics before they were imported into your page layout program). That way, the program will usually find any graphics and imported

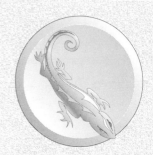

items at print time. Even if the application doesn't find it automatically, the operator should be able to find it easily (that's why a set of instructions is needed).

Never send originals or your only copies.

Your output department should never be responsible for the only copy of anything. An output site is very busy managing lots of incoming files, and things can get lost there. In addition, floppy or removable disks can be damaged in transit, and may be unreadable by the time the service bureau gets them.

Good relationships are the key

No matter how careful you are in using your system, and no matter how many checklists you fill out, things will still occasionally go wrong. That's where a good relationship with a truly professional output site will work to your advantage. Professional desktop publishers don't want to eliminate their teammates—only to work more closely with them. A low per-page price might seem attractive, but when the inevitable problem does rear its ugly head, the truly client-oriented vendor will come to your rescue.

Yes, this is a pitch for establishing long-term relationships. Governmental jobs may require multiple bids. They are really rather foolish, however. Unless you are inordinately careful with your bid specs, the low bid will almost certainly be lower in quality also.

Other factors being equal, a lower price has to be either cheaper materials, less experienced help, older equipment, or a cheaper location. What is usually missing is the service. You can underbid most quality vendors by eliminating service. The cheapest quickprint, for example, eliminates pickup and delivery (plus anything else they can get away with).

Basing custom manufacturing on the cheapest sources is very dangerous. Thousands of things can go wrong with any print job. Usually at least a couple happen on every job. If you have a long-term relationship with a company that prides itself on service, they will call you before they ruin your paper (even if it's entirely your fault).

Digital job preparation — preflight

You need to understand that preparing for output is not a minor problem. The national statistics are still that nearly two-thirds of all jobs received by service bureaus and printing establishments are unprintable as received. The fault almost always lies with the designer: either the design itself or, more commonly, the production techniques used, or the collection techniques.

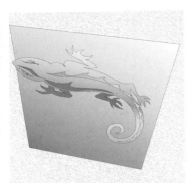

Two-thirds of all jobs are unprintable as received.

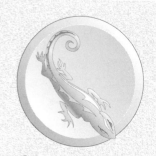

The method used to help deal with this almost overwhelming problem has been called preflight. "Toss it up in the air and let's see if it will fly." The method is obvious from the name "preflight checklist." The job disk is opened on a computer. The document file(s) are opened if possible. Then the person runs the project through the checklist to make sure that everything is in place and available — fonts, graphics, color names, and so on. Every shop needs its own checklist. More and more, shops (and designers) are using dedicated preflight software. As mentioned, PageMaker comes with it. You can buy Xtensions for Quark. Or you can buy several different pieces of excellent software like Marksware's FlightCheck or Extensis's Preflight Pro. There also several Acrobat plug-ins to preflight PDFs.

Every law is the result of a specific problem. Preflight checklists are the same. Every problem that occurs should be checked off on that list. For example, if one client regularly uses a service bureau that outputs unacceptable film (low density and it does not fit), there should be an area to indicate that the negs have been checked and that they are all right.

We are not going to go through an entire list, because many of the problems only involve page layout or image manipulation software. However, we really need to review the problems you can cause with FreeHand documents and graphics.

I. ALL THE PIECES

Are any elements required to complete the job missing?

Layout files	■ Yes	■ No
Screen fonts	■ Yes	■ No
Printer fonts	■ Yes	■ No
Placed scans, graphics, and illustrations	■ Yes	■ No
Hard copy proofs	■ Yes	■ No

Note any discrepancies between the supplied proof and the electronic files.

Note that all the pieces have to be there or the job is immediately bounced back to the creator. Without all these pieces, the job cannot even be proofed, let alone output. The easiest method of determining whether all of the necessary pieces are present is to use the menu commands in the page layout programs. Quark has a COLLECT FOR OUTPUT command. PageMaker has Save for Service Provider, which is actually a pretty good preflight program on its own. FreeHand's works much like Quark's.

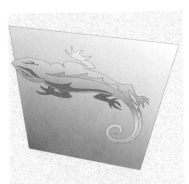

II. PAGE CONSIDERATIONS

- ■ Page size defined as final trim size
- ■ Bleeds set at $\frac{1}{8}$" or 9 points
- ■ Pages imposed in printer's spreads
- ■ Miscellaneous items in the pasteboard area deleted

These will vary a lot from shop to shop. They are all items that affect imposition. If they are not taken care of now, the entire image assembly process can get jammed up. If these items are not fixed, the only way to fix them involves resizing the created document.

TRIM SIZE

This deals with a very common mistake. Newcomers to printing often think that they must make their page size the size of the sheets of paper coming out of their laser printers. This is not true. The page size must be the trim size of the actual document, that is, the size of what you are eventually going to hold in your hand.

BLEEDS

This is a major area of confusion. Remember, if you want it to look like the ink goes to the edge of the paper, you must print beyond the trim size and trim it back. It is extremely common for desktop publishers to make their bleeds stop at the trim size. After all, they have never seen the oversize sheets before they are trimmed back to the bleed.

SPREADS

Next we need to review reader's spreads versus printer's spreads. Reader's spreads are what the reader sees while reading the printed piece. In other words, the reader sees pages 2 and 3 at the same time. A printer needs the pages imposed very differently. For example, on an eight-page, saddle-stitched booklet done in one signature, the printer's spreads would be pages 8 and 1, pages 2 and 7, pages 6 and 3, pages 4 and 5. The odd page is always on the right.

Some shops impose all of their pages into printer's spreads. This works for them because all of their presses are set up for four-page sigs, 11x17. These spreads also work when you have to hand-impose smaller booklets into eight-, twelve-, or sixteen-page sigs. If your supplier will be using dedicated imposition software like TrapWise that can handle these larger sigs, you will then need every page set up separately.

PASTEBOARD

There are two problems here. The first is obvious. Beginners often leave many scattered pieces of copy or graphics littering the pasteboard. The worst problem is pieces on the pasteboard in a graphic. If SELECT ALL – GROUP is performed before the graphic is exported, the resulting EPS will often refuse to print. You will know that this has happened if the

graphic's handles are far outside where you think they should be. PostScript illustration programs cut off the image at the trim or bleed. If there is anything outside those lines, the graphic will sometimes print, sometimes not. Even if it prints, the handles will include enough blank white space to allow for that nonprinting piece. If the pasteboard piece is a nested graphic, you are in trouble.

III. TYPE-RELATED PROBLEMS

Improper styles that may cause RIP problems:

- Underline style
- Hairline rule
- Bold or italic style
- Outline style
- Shadow style
- TrueType fonts
- Widows, orphans, hyphenation problems

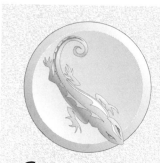

This is just a reminder. Certainly you must have this one under control by now. Basically, do not use the styling buttons unless you are on a PC and forced to use TrueType. But then, TrueType usually causes printing problems anyway. So, in the spirit of reinforcement:

UNDERLINE STYLE

The underline style is too crude and messes up the descenders. The client should either use the paragraph rule options or underline by hand using a line or shape tool.

HAIRLINE RULES

These should be set as a specified line width. A quarter-point (0p.25) is often used, but some companies might prefer 0p.33 or even 0p.15. It is all a matter of the capabilities of the plates and presses to hold the line. I used three-tenths of a point in this book.

OUTLINES AND SHADOWS

These type stylings should be hand-created. The outlines used to create these styles use the hairline. Many times high-res output causes hairlines to disappear. If a hairline is rendered at one dot and you are setting at 1,200 or 2,540 dpi, you won't see the line on the neg, let alone on the plate or printed piece. The shadow option is usually simply ugly and clumsy. The shadow is too dark and merely compromises readability.

TRUETYPE

You need to note these. It is quite possible that the RIP cannot handle it. Even if it can, TrueType is rasterized differently and can cause problems. Supposedly this is finally solved with Acrobat 4 and PostScript Level 3. But then, it is always in the state of being "finally solved." **Get rid of all your TrueType!**

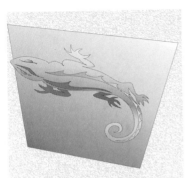

WIDOWS, ORPHANS, HYPHENATION

Only the best shops will note these errors. However, they are serious if you are concerned about quality and excellence in typography. In fact, they are the standard method of determining professionalism in a designer or a design studio.

IV. COLOR DEFINITIONS IN LAYOUT FILES

- Are all colors named?
- Color names defined exactly the same in graphics software and page layout programs
- CMYK colors defined as their build amounts
- Pantone colors defined as PMS plus the number, e.g. PMS186
- Black set to overprint. Note areas where black knocks out
- Rich black needed? ■ Yes ■ No Values ___C ___M ___Y ___K

Bad color naming can cause all kinds of problems. At the very least, colors with different names will output to different negs or plates. This will, at a minimum, incur additional plating charges.

UNNAMED COLORS

This is specifically a FreeHand problem. Make sure that all of the colors used in your FreeHand documents are named and listed on the COLOR LIST. If they are not, you may find that they won't print. It is extremely easy to make a color in the COLOR MIXER panel and then drag'n'drop it onto a shape without ever adding it to the list. It will look good on the screen, but it will cause many problems.

This is not difficult to stop. It's a relatively easy procedure. First of all, add the color to the COLOR LIST before you use it. It's a habit you need to develop. If you can't get that one under control, there is an Xtra that names all the unnamed colors and adds them to the COLOR LIST (XTRAS>> COLORS>> NAME ALL COLORS).

BLACK OVERPRINT

Black normally overprints. In other words, it does not knock out any colors underneath it. This enables type to be put on a color background without being deformed. Because it is black already, the background color does not affect it much. Sometimes the black has to knock out. This is unusual and should be noted. Otherwise, the defaults will cause the black to overprint regardless.

RICH BLACK

In pieces that are solid process color, plain 100k is a very weak black. It often appears to be an 80% gray or even weaker. As a result, blacks in the midst of color are often printed with an addition of 60c or even 60c 60m. These undercolors are choked when trapped so that color does not leak around the edge of the rich black. If your final output is coming from a color laser printer or copier, you can often get an embossed look with a rich black of 60c60m60y100k.

V. IMAGE CONSIDERATIONS

Mark off each image for the following:
- ■ Vector or ■ Bitmap ■ Are they trapped?

For vector files such as lineart illustrations or charts, mark each image on proof:

File format _____ Software and version _____

Scaled percentage in layout _____

 I've eliminated all the checks for bitmapped images. There are a lot more of them than there are for FreeHand EPSs.

 If there are output problems with the RIP, it will help a lot in chasing down the difficulty if the operator can see at a glance whether a graphic is vector or bitmap. For vector graphics (FreeHand EPSs), the imported format, the originating program and version number, and the scaling percentages should be listed. For example, our digital press at school refuses to print Illustrator, CorelDraw, or QuarkXPress files. If we receive graphics in these formats, we have to open the graphics in FreeHand and reexport them as EPSs.

Trapping

 This is an area it would be nice to avoid. We hope you discussed trapping considerations with the output supplier before you started designing. In most cases, it is better to let the service bureau or printing establishment apply its own traps. This is especially true if they have dedicated software.

 Let's step a little into the future. You've already taken your image manipulation class and your two or three page layout classes. You have finally produced all the pieces: copy, illustrations, and photographs assembled into a final page layout document. Occasionally the pieces will be assembled in FreeHand to be printed directly. However, the normal procedure is to finish production in page layout.

 There are still some problems, though. Presses are typical mechanical devices. In other words, they have play or tolerances. They do not run perfectly. In our world, it is called *registration*. They cannot feed paper consistently.

 This is a very specific problem. Most people think that every time the colors do not match up perfectly, it's a registration problem. This is not true. Registration is a press problem. If the plates do not line up exactly, the problem is called fit. This is an image assembly problem. In general, fit is solved digitally.

Perfection is the only fit that is tolerated

 Negatives and plates must line up perfectly under a loupe or they should be tossed. Some shops will tolerate a quarter-dot or so of bad fit,

A Registration Problem

A Fit Problem

but it is assumed that the negs and plates fit perfectly. Because presses and press operators are usually the most expensive equipment and labor in the plant, much effort is expended to allow them to run as smoothly as possible. Bad fit is a major problem and must be corrected.

Registration problems

Registration, however, cannot be avoided. It refers to fit problems caused by the paper in the press. The largest source of misregistration is inconsistent feeding of the paper. If the paper bounces at all, the various colors will not line up properly.

In addition, paper changes size with humidity changes. With offset lithography, the water from the plate causes the paper to change size. This can cause fit problems. Most of this has been solved by climate-controlled plants and multicolor presses, costing millions of dollars, that apply all of the color in one pass. All it requires is attention to detail and good operators.

The registration fix

What printers use is the same solution used by carpenters: they apply molding to the edges. The printer's molding is called a trap. Traps are created wherever two different colors touch.

The dark gray star knocks out an exact hole in the gray rectangle.

In other words, wherever two colors touch, the weaker color is made a little larger so it slips underneath the stronger color. These traps were made photographically with chokes and spreads. The color that grows was called a *spread*. A color that shrinks was called a *choke*.

In printing, colors usually do not overlap or overprint. In digital production, this is absolutely true. If you place one color on top of another, it will knock out the color underneath — perfectly — edge to edge with a kiss fit. This would seem to be an excellent solution. Certainly it must have seemed that way to early software programmers. The printing industry screamed bloody murder, however. "Kiss fits are unprintable!" The problem was solved with controlled overprinting.

The press problem

Until relatively recently, presses have been unable to register well enough and traps have been necessary. Without traps, most presses bounce enough so that kiss-fit objects always had a white line on one side or the other. This seemed intolerable. The solution is to build in a tiny overlap "molding," which is very tedious to build by hand with dupe film and vacuum frames. It took many layers of film or flats to construct traps.

The digital trap

Software has solved the problem of trapping. Now the problem is operator error, usually on the part of us, the designers. With relative ease, digital traps can be generated that were physically impossible before the 1990s. More than that, they can be generated almost automatically. At this point, the two biggest problems point directly to the designer.

First, and probably most importantly, trapping is being done with inadequate software. It only happened recently that desktop publishing software could handle trapping needs. In fact, in many cases, it can be argued that it still cannot. For our purposes here, we are talking about PageMaker, Quark, and FreeHand.

There are several levels of trapping. In the illustration at right, you'll have to forgive the grayscale and imagine that every different gray is a different spot color. The simplest level can be handled by everyone: a single object of one color inside a single object of another color (i.e., a red circle in a green square). Some programs make you do it manually, but it is a simple matter of stroke overprint.

Everyone can handle the next level, where a colored object is inside two or more touching objects. You can see that the gradated ball in the center would have to have three different colored traps around its perimeter. To understand, let's say the three ellipses are yellow, orange, and red; the ball is royal blue; and the background is a light tint of the blue.

Only FreeHand and PageMaker can handle the next level, where part of an object touches various colors and part is over blank paper. Most have no way to leave part of a shape untrapped.

This still leaves two very common situations that none of the programs can handle. First, none can handle a variable-width trap when a gradient fill is trapped inside another gradient fill. In fact, none can deal with a trap to a gradated object where one end is darker than the background and the other end is lighter. Second, none can apply traps to imported graphics. This where we are. FreeHand produces those imported graphics. We must trap our own stuff.

Level One
Easy

Level Two
Medium

Level Three
Hard

Level Four
Impossible

The problem with FreeHand is that you have to understand traps well enough to create your own. There is a TRAP XTRA on the OPERATIONS panel that works well, but you must understand how and why that Xtra works. Before we can do that, we have to discuss how trapping works in general, in PostScript.

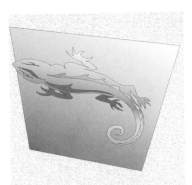


GETTING
IT PRINTED,
BANDING, FILE
PREPARATION


I've mentioned a couple of times the term *stroke overprint*. Look again at the illustration on page 241 if you do not understand the concept of knockout. All objects in FreeHand knock out unless you tell them differently or except for black type in text blocks (which overprints by default). The hand-trapping solution is to make a stroke that overprints (does not knock out). But how could this possibly help?

To understand that, you have to understand how a stroke relates to the path. A stroke is always centered on the path – half to one side and half to the other. As you can see, on the far right, I have drawn a line directly on top of the stroke on the edge of the round-cornered box. The heavy black stroke is twelve points wide. I then cloned it and changed the clone to a .3 point white hairline so you can clearly see the center of the stroke. As you can see, half the stroke overlaps the box, half is outside the box.

This is how you build traps. The procedure is simple for a level one trap. I select the contained object and apply an overprinting stroke that is twice the width of the trap I actually need in the lighter or weaker color. When this prints, the portion of the stroke overprinting the weaker color is invisible (it's the same color). The portion overlapping the stronger or darker color prints on top of that color, producing the trap.

Obviously, there are a couple of difficulties here. First and foremost, you have to know how large to make the traps. The standard answer is kind of the chicken's way out, "Call your service provider." It's the truth, but it doesn't help you understand what is going on.

Trap sizes

Understand that traps are very small. They have to be wide enough to cover the registration capabilities of the press used. However, they should never be large enough to be seen easily. Modern color presses can easily handle what is called "half dot registration." In other words, they can feed paper with a consistency equivalent to half the size of the dot in the linescreen used. Because commercial printers normally use 150-line screen, a half dot is a three-hundredth of an inch. $1/300"$ is around .003 (three thousandths) of an inch, .07 mm (seven hundredths of a millimeter), or .2 point. This is a tiny trap. Personally, I think it is often a waste of time and money, but printers find that attitude anathema. Seriously, they tend to get very upset if you even suggest such a heresy.

243

In fact, for the foreseeable future, until you establish yourself (and who knows, you may come to believe in the necessity yourself), printers will force you to trap your projects. Only with the new digital presses like Agfa's ChromaPress will they tell you not to do that (the Chromapress can hold registration to less than .001 of an inch, far below the visible threshold).

When you call the service provider (be it the service bureau or the print shop itself), they usually respond with "give me a quarter point," or maybe a half-point trap. A half-point trap is very large, and can usually be seen as an additional outline around your shapes. In fact, traps can often be seen that way, which is why I don't use them unless I have to.

Trapping strategy

You must be aware of your trapping needs, project by project. You must be aware of the capabilities of your software. You must refuse to be embarrassed by asking for help. You must not overestimate your own experience and capabilities. Finally, you should look for a printer or service bureau that knows what it is doing and has the dedicated software to handle the job. Dedicated software can handle all levels with ease.

The key is dedicated software.

Several programs on the market can handle any kind of trapping at the click of a button. TrapWise is one of the best, but there are several others. These dedicated applications calculate custom traps for every individual point around the circumference of every shape. They can create a trap that varies in width and color as it passes around an object. They are the true solution to all your trapping needs.

They are also the only software that can add traps to imported graphics. This is the real problem, coupled with our modern propensity for graduated screens. Basically they are the only real solution to making accurate traps that work. One of our local service bureaus told me that he just "lets them do their own trapping in Quark." If you come across this attitude, find another service bureau. Quark is the most limited trapper of the big five (PageMaker, Quark, FreeHand, Illustrator, and Photoshop). What he actually did is prove my point: that traps are currently so small that they are invisible. So it doesn't really matter that Quark's aren't very good.

Applying the traps

Having said all of this, you will be creating traps on a regular basis. Not every project has the budget to go to a firm that has a press capable of holding quarter-dot registration. This takes an excellent

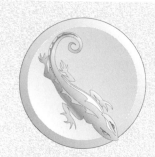

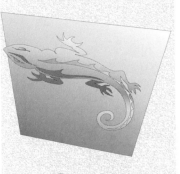

press, with excellent press operators, plus an owner who is focused on quality and only hires people who further those goals.

There are thousands of small printers who can barely hold half-dot, and many that can hardly hold full-dot registration. Beyond that, the very nature of quickprinting requires duplicators and old, dated presses. Even a brand new duplicator cannot do what is called "hairline registration" unless it has what is called a T-head (two plate cylinders imaging the same blanket). Usually, all you have to do is begin talking about traps and hairline registration and carefully observe their faces. You'll know quickly whether this is a normal part of their workflow — and ask for samples.

So ... when you need to, how do you do it? Basically, traps are overprinting strokes. The key to understanding how they work is the knowledge that the fills of shapes only extend halfway into the stroke. Make the overprinting stroke twice the width of the trap you need. If you have a dark red object in a sky blue field, you simply make the stroke of the red object twice the size of the trap needed, color it sky blue, and set it to overprint. The blue background will touch (kiss-fit) the fill of the red object. The inside half of the stroke will overprint the red shape with a very thin sky blue line.

If you reverse the colors (a sky blue object in a deep red area), you simply set the overprinting stroke of the blue shape to blue at twice the trap width. The blue shape now appears to spread under the darker red background without enlarging the blue shape.

Remember that, in both of these cases, there is a thin, very dark purple line surrounding the interior shape. In the first case it makes the red shape a little smaller. In the second situation, the purple line is outside the blue shape.

Supposedly it is so thin that it is invisible. In fact, it adds a hairline outline to all trapped shapes, unless you reduce the color of the trap by tinting it. This is a much worse problem with some colors than with others. Complementary colors are going to tend to make a black trap. Neighbors on the color wheel will make an invisible trap.

If it is that thin, is it necessary? Your printer will probably insist that it is. You should let the pros do what they want, unless it adversely affects the thickness of your wallet. Then, do not fear kiss-fit printing. Modern quality printers have no problem holding quarter-point registration, and often the thin white slivers are virtually invisible. In

NAVY BLUE · **TAN**

NAVY BLUE · **TAN**

NAVY BLUE · **TAN**

Select the lighter object; clone it; change the fill to None; set the stroke to the trap color and width; cut the clone to the Clipboard; and finally paste it inside the darker shape.

I've made this trap 4 points wide and black so you can see it clearly. Normally the stroke would be a half point and the same tan as the lighter shape.

addition — please think a little — when was the last time you put down a slick four-color brochure because the trapping was bad? Probably about the same time you refused your burger because of ugly printing.

Even when chokes and spreads were being done by hand, by experts with dozens of years of experience, it was common to see them in conference figuring out which approach to use. Normally there are several ways to create a trap. They all work equally well. The method is determined by the trapper, at the time, for the specific project's problems.

The actual production of digital traps is absurdly simple. It is all done by the computer. All you have to have is a capable program; then you type in the parameters necessary and click okay. If the application is well written, the resulting traps are exquisitely precise and absolutely accurate. The trapping software takes the two colors involved, calculates the differences in neutral density, and builds the appropriate trap.

As you can see to the right, Free-Hand's Trap Xtra is very good. It allows you to reverse traps in case you think that the weaker color is different from what Free-Hand determines by its lookup tables. You can also use tint reduction at whatever percentage you think you need if the traps appear too dark.

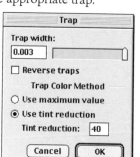

The Trap Xtra actually draws little shapes to create its traps. The trap to the right (which I again made dark by hand so you could see it) is actually a skinny shape made with six points. Just above it I've dropped a little screen capture to show you how it looked before. The original ellipses were bright red on the right and hunter green on the left. As you can see in the screen capture, the trap just looks like it grows out of the red ellipse — as, in fact, it does. However, what you cannot see is what the trap will look like overprinted on top of the green. Only dedicated trapping software can actually show you the traps so you can check them out visually on the monitor.

There is no way to proof traps on the screen.

This is one of the major problems with traps. You normally cannot see them until they are on the press. They will take practice, and the first traps you create will be done in fear and trepidation. They are a necessary skill, however. My advice is to pay the pros to do it

246

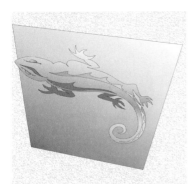

whenever you can get away with it. This will save you a lot of time, money, and hassle in the course of your career.

Scaling percentages

The last preflighting problem with FreeHand graphics is excessive scaling. In FreeHand you can scale without limit. The SCALING TRANSFORMATION page on the TRANSFORMATION panel has complete control of the process. However, there is a real limit in either PageMaker or Quark as to how much you can scale down EPSs. When you scale an imported graphic in a page layout program, the poor RIP has to recalculate everything in that graphic to the new scaling percentage. If there is a one-point stroke, and the graphic is scaled 25%, the resulting stroke will have to be a quarter point. If it started out at a quarter point, the final result will be a sixteenth of a point. As you know now, this is unprintable.

More than that, the RIP has to recalculate everything: strokes, fills, placed graphics, blends, clipping paths, and so on. This puts a great weight upon the RIP — enough to cause it to go on a sit-down strike (commonly called choking).

So what is the solution? If the graphic must be scaled to tiny proportions, you should simply make a small version in FreeHand. This is such a common problem that I now routinely generate a large, normal, and small version of every logo I design. Remember, that nice delicate half-point stroke will be an eight-point monster when the logo is scaled up 800% for that poster or billboard. Making small versions, inparticular, gives you the control you need to make those tiny graphics look like you want them to look.

PDF workflow

There's a whole series of books coming about how to deal with printing. All we have done here is touch the necessary pieces that involve FreeHand. However, there is one area that we must cover, because it is about to become the center of your workflow procedures. Most of you have heard of PDFs by now, and many of you have used them to send in your skill exams for grading.

What's the big deal? From our point of view here, limited to FreeHand, we will not get into the entire procedure for using a PDF workflow. However, FreeHand is a great tool for PDF. It not only creates beautiful PDFs, it can also edit PDFs (if they are not encrypted). We'll cover more of this in the next chapter on the Web.

For now, let's just describe what they are. PDF stands for Portable Document Format. It was one of a group of formats developed in the late 1980s and early 1990s to solve the cross-platform dilemma. The basic idea is a universal format that can be read by anyone on any platform. PDF does this well. Acrobat Reader is free. You have a copy of the installer on your CD and it can be downloaded

free from http://www.adobe.com for any platform you need: Mac, PC, UNIX, Sun, Silicon Graphics, Next, and others. This reader can read any PDF regardless of what platform it was created on.

More than that, the image will be crisp, clear, and will not suffer badly when you enlarge it to see things better. This is because the PDF format is a streamlined, cleaned-up version of PostScript. All the fonts are embedded, so you do not have to convert them to paths – and once the fonts are embedded, they show up perfectly on PC or MAC. This solves the major cross-platform issue: the fact that Macs cannot read PC fonts and vice versa.

InDesign reads PDFs directly, and you simply import them like EPSs. This will happen more and more as Quark and others join the standard. Part of this is because PDFs are not only clean and easy, they are small. Acrobat makes very small files with many compression options. You will be using them a lot!

Link management

This ability is one of the key features to making FreeHand work in PostScript production. In the earlier versions (5.5 and earlier), FreeHand's link abilities were invisible and often did not work very well (if at all). This was why I spent almost four pages in my first book describing the horrors of using nested graphics.

Before we go on, we have to describe what happens when you import a graphic into FreeHand or any page layout program. First of all, you have two options: to embed or to link. Embedding inserts all of the code for the imported graphic into the document being worked on. Linking simply imports the *preview* of the graphic imported while establishing a link to the high-resolution graphic for printing purposes.

EMBEDDING IS A MAJOR PROBLEM

It would seem logical to embed everything. This way the entire graphic is there and all problems are solved – right? Wrong. There are three major problems with embedding.

1. Embedding makes the file size very large and clumsy. Last week I had to help a student (she happened to be working PageMaker on this occasion) who couldn't work anymore because her mouse kept freezing up. When I went over to help, the first thing I noticed was that the mouse wasn't frozen, it had merely changed to the little watch Mac uses instead of the hourglass. As I started examining what was going on, I found that she had embedded eight files that were all more than twenty megabytes. Her PageMaker file was 183 MB! This is extreme, to be sure, but the same thing can easily happen to you if you embed files into FreeHand.

2. Embedding files makes it impossible for preflighting software to check for fonts in the embedded graphic. This is obviously not a

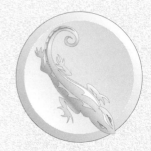

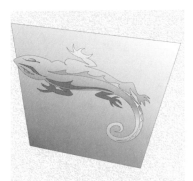

problem with embedded Photoshop files, but it certainly is with embedded FreeHand and Illustrator graphics.

3. Making corrections and changes to embedded graphics is very clumsy — if it is even possible at all. I cannot tell you how many times I have received files from students with embedded clip art from Word. It's horrible stuff, but there is nothing that can be done. There is no way to get the file back out of FreeHand, PageMaker, or Quark to fix it and bring it up to high-resolution, professional standards.

LINKING GIVES CONTROL OF THE PROBLEMS

When you import a graphic without embedding it into FreeHand, there are a couple of things you can do that are impossible if the graphic is embedded. You immediately have much more control.

First of all, you can launch an external editor. If, for example, you bring in a halftone from Photoshop, you can launch Photoshop from within FreeHand and open the imported graphic in Photoshop for editing. A dialog box in FreeHand remains open with a DONE execute button. After you have fixed the problem, you save the changes, go back to FreeHand, and click DONE. Freehand automatically re-imports the image to the same location.

Secondly, and this is amazingly useful, you can relink with a different file by simply clicking the CHANGE button. This ability, which FreeHand shares with PageMaker, is incredibly handy. Quite often, you will have two or three different versions of a graphic. You import one, trying to remember what you called the one you really want, and it's the wrong one. Just click the CHANGE button and relink to the one you really want. If you are a Quark user, this won't seem like much because it is not a part of your paradigm, but believe me, once you realize it's available, you will be using it all the time. In Quark, you have to delete and re-import.

Third, you can see that, for embedded graphics, you can extract the placed graphic. This is a feature unique to FreeHand. Embedded graphics are listed in the Links dialog box with the word embedded after the name. Clicking the EXTRACT button extracts the embedded file into a separate file, and automatically establishes a link to that file. The problem with that is that it is a peculiar type of FreeHand file that cannot be opened by double-clicking on the icon. If it is a TIFF, for example, you will have to open Photoshop and then open the newly extracted TIFF in Photoshop to get the TIFF normalized. FreeHand has the best linking controls I have seen in any of the Big Five.

UPDATING LINKS

FreeHand basically handles this automatically, which is much better than the page layout giants. If you fix an imported graphic, merely save it under the same name into the same location and FreeHand will update the corrections automatically.

BREAKING LINKS

Links can be broken in several ways. If you rename the file, the link is broken. If you move it to another folder (unless you move it to the same folder you are working in), the link will be broken. If you change the path (by changing servers, for example), the link will be broken. Broken links get a placeholder graphic (like you get with a broken graphic in a browser) and the graphic will neither preview nor print. A broken link will show in italic with ???? in the size column of the LINKS box. Simply click CHANGE and show the computer where the file has moved or the new name by going through the normal file management boxes you are familiar with in OPEN and SAVE.

When you open a file with linked graphics, FreeHand automatically checks links. If it cannot find a graphic, you will get a dialog box asking you to locate the missing file. Until you find it, all you will see in the document is a "busted graphic" placeholder. This is far superior to Quark or PageMaker, where the preview is still there and everything looks fine. There, you just don't know about the broken link until it refuses to print, or until you check the LINKS or PICTURE USAGE command. In general, FreeHand's solution should be adopted by all.

Do not think that this is an imposition upon your precious time and effort. This is a normal part of the PostScript workflow. We are no longer playing secretarial games with graphics. This is one of the reasons we get paid the big bucks.

Exporting graphics as TIFFs

Sometimes you will really need to convert your graphic to a TIFFs or printable bitmap image. Most often this happens when you have to give a graphic to someone working on a PC with a non-PostScript printer. FreeHand does allow you to export TIFFs directly. However, this causes the same problem as was mentioned in extracting embedded files. The TIFFs produced have a FreeHand ID and will not open for editing properly. The better method is to export your graphic as a Photoshop 4 RGB EPS. Then you can open it and rasterize it in Photoshop beautifully, in any color space you need. FreeHand's ties to Photoshop are not quite as good as Illustrator's (Adobe is prejudiced), but they are very good. Anything you need to post-process in Photoshop should be saved in the Photoshop 4 RGB EPS format.

Basically you need to remember that there is no program as good as FreeHand at producing fancy lineart graphics that use type. In top-end printing, there are only two formats you can use:

EPS and TIFF. As long as you are in a PostScript workflow, FreeHand's EPSs are the superior format to use. This is primarily because type really should be rasterized at 1,200 dpi or better. The TIFFs produced in Photoshop are never more than 300 dpi, so the type is decidedly inferior (unless it is over eighteen point or so, then it is just a little blurry).

When in doubt, call for help

High-resolution printing is not a simple process. Until the advent of desktop publishing in the mid-1990s, this normal level of commercial printing required many highly paid, very experienced specialists to accomplish. Now we, the digital designers, are responsible for most of the process.

The sensible thing to do in a case like this is to consult the experts, as necessary. I mentioned earlier that you must choose your output services before you can begin designing. There are very different needs for screen printing, signage, Websites, and offset lithography. Once you know what type of output you will need and the capabilities of your suppliers, the sensible thing is to call them and say something like this: "Hi. I'm _____ of _____. I've got this project that you are going to be producing for me and I wanted to find out if there is any way that we can streamline the process. What do you need from me? How can I help make this go smoother?"

This simple attitude will do more to build your relationship with that supplier than any other (except, of course, for paying your bills on time). Publishing is an extremely complicated process. You cannot do it on your own (speaking as one who has tried). It is not embarrassing to ask for help and input; it is silly not to do so. The pros will be happy to be asked. You have no idea how rare it is for a designer to try to work with the supplier.

There is no substitute for experience.

In this business, there is no way to compensate for a lack of experience. Five years from now, you will be embarrassed by your feeble attempts at this time. After more than thirty years in the business, I am seriously embarrassed by my writing and design of my first book, *Printing in a Digital World*. This one is a lot better. This is now my fifth book and I understand a little more what is needed. Your career will follow that same path. I can tell you all these things, but all I can really do is hope that when you run into trouble you will remember these things. Once you do it, it will all become clear.

Knowledge Retention:

1. Why is preflight essential in today's industry?

2. What is the real problem with TrueType?

3. Why do you need to know the linescreen for FreeHand graphics?

4. What are the three methods of eliminating banding in FreeHand?

5. Why do you need a small version of a logo?

6. What are the problems with embedding graphics?

7. Why do we trap conceptually?

8. Is trapping necessary?

9. Why is the relationship with your service bureau important?

10. Why is a 5"-tall, graduated rectangle going from 45% Black to 30% Black a bad idea?

Where should you be by this time?

You should be getting comfortable working in FreeHand. As you design, appropriate tools should come to mind.

DISCUSSION:

You should be having fun, working on projects with your friends in class, helping each other remember FreeHand's capabilities, and proofing each other's work.

Talk amongst yourselves ...

PRINT & WEB
GRAPHICS
USING FREEHAND

CONCEPTS:

1. GIF

2. JPEG

3. ShockWave

4. Flash

Definitions are found
in the Glossary on
your CD.

Chapter Eleven

Designing for the Web

*Dealing with low resolution
and tiny files*

Chapter Objectives:

By teaching students the options and capabilities of
FreeHand, this chapter will enable students to:
1. avoid banding
2. choose appropriate formats
3. control file size
4. choose functional colors.

Lab Work for Chapter:

- Work on fulfillment of grading requirements.
- Produce real-world projects.

253

Designing for
the World
Wide Web

HYPERMEDIA
PARADIGM
CHAPTER 22:
PRINTING WELL
IN BLACK & WHITE

Doing black & white well.

Contents

Check out a Rembrandt etching.
Most jobs are limited
B&W brings clarity
The single color majority...
Linescreens
Continuous tone
Tips on halftone production
Dot gain
Commercial printers use presses
Quick printers use duplicators
Generational shifts
Miscellaneous problems
Target dot ranges
A 7 step process
#1—Photo Location
#2—Set the size & resolution
#3—Adjust the scan
#4—Crop the scan to size
#5—Clean up the image
#6—Adjust the levels
#7—Sharpen with unsharp mask
Final comments
Terminology
Suggested Reading

RADIOZ
PRESS

©1998 David Bergsland Radioz Press

The Front cover of a Web-delivered PDF book.

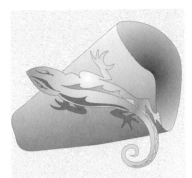

A different world

This is where many designers with a print history will begin having a rough time. On the World Wide Web, we are entering a world of coarse, crude graphics, with little layout control, no color calibration, and no output control. However, like all design problems, this is just another problem to be dealt with. There is hope. Some of the new software, like Dreamweaver and GoLive, promise layout control, but it is still dependent on the defaults of the individual browser that is reading the site.

The software only changes a little

The best software applications for Web graphic creation are still FreeHand and Photoshop. FireWorks and ImageReady are more specialized. Flash offers new and powerful animation capabilities, but readership is still low. Surely you can recognize that we are still talking about bitmap and PostScript illustration programs. Graphic communication is about using graphics to communicate, and the FreeHand/Photoshop combination is the best no matter what the medium.

This is the primary reason why Website design and creation are still dominated by desktop publishers. It is basically the same skill set. The drawing and creative skills are almost identical, compromised only by the limitations of the formats used. The layout and design techniques are still largely the same, except for the fact that many normal options are no longer available.

Print and Web have different requirements.

Limited by the environment

This chapter revolves around a discussion of Internet and graphic format capabilities. Then we can talk about methods to cope with those limitations. First of all, the Web is severely limited by its output devices — the monitor. Although it is true that the Web looks better on high-resolution monitors, most people do not have them. Even if high-res monitors are available, the graphics are still limited to 72 dpi. Most people still use 640x480 pixel monitors.

Beyond low resolution is the problem of color depth, or the ability of the monitor to display enough colors to satisfy the designer's desires. As of late 1998, the average monitor was still 8-bit, at best. Average means that many are less and many are more. If your client's customers are mostly graphic designers, then you can almost count on

resolutions of at least 1024x768 with 24-bit depth. If those customers are small business owners, you'd better design for 640x480 and 8-bit. If you are marketing to ancient bureaucracies in small towns or dated agencies, you better plan for 4-bit or less. The subtlety we take for granted in print is simply not available on the Web.

Platform differences with monitors

On the Web, you have to be cognizant of the vast differences between PC and Mac. It sounds like a simple difference. PC monitors use a gamma of 2.2, and Macs use a gamma of 1.8. If you remember from the halftone production section, *gamma* is a measurement of contrast. In practical terms, gamma makes your monitor look lighter or darker. So, to translate the gammas just mentioned. Mac monitors are much brighter, and usually much higher resolution. Images created on a high-res Mac, that look great there, often look very dark and dingy on a PC — not to mention that they look huge. Images created on a PC, that look fine there, are often far too light, with all the highlights blown out; often they are also much too small.

This is even true of type. On my high-res monitors, I usually use 14-point type or larger to make it legible on the screen. The type looks absolutely huge on a PC. This is also why many Websites created on a PC are completely unreadable on a Mac, because the type is too small to be read — especially if it uses small, light type on a dark or graphic background (see sidebar on facing page).

This is probably not the place to mention all those who surf with the graphics turned off. The figures I saw most recently, in mid-1999, were that somewhere between 15% and 30% of surfers browse with the graphics turned off because of the speed of their connection. We have to remember that the average modem is still 28.8. In fact, virtually all of us who access the Web over a phone line are limited to that speed by the phone line.

Pretty depressing, huh? Actually, it's not that bad.

This is an environment where color has no penalty — you can always work in color, if you want to, at no extra cost. Although we are not talking about the impact of four-color process on cast-coated stock with the photos popping off the page, highlit by gloss varnish in front of a dull varnish background, the color available is good enough to get the reader's attention — 256 colors are definitely better than black and a spot color. All we have to do is design within the medium's capabilities. Careful attention to detail still provides excellence of design. Don't fuss about the limitations. Design within the medium.

The limiting factor is bandwidth!

WEB GRAPHICS
The lower crudity is the top graphic converted to a 72 dpi grayscale image. On the Web it is in color, but still rough.

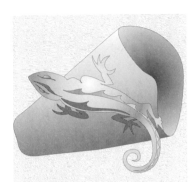

BACKGROUND IMAGES

Placing an image into the background of your Web page severely compromises its legibility. Web pages are hard enough to read as it is. Do not use background images.

This problem is actually worse than the limited palette and low resolution. As I mentioned, the average surfer has a 28.8 modem at best. Normal phone connections max out at about 3K to 4K per second. Even the 56 kilobit standard is glacially slow when we consider that normal color separations are dozens of megabytes in size. At 28.8 kilobits (which is well under 4K per second), a 10 MB graphic would take forty-two and a half minutes — minimum (if there is not a break in communication that requires you to start over). In general, modem connections over phone lines work at 28.8 to 33.6, no matter what hype sold you your particular modem.

Surveys often state that the average surfer cancels out and moves on if the entire page takes more than thirty seconds to appear. I have read articles that suggest anything over ten seconds is a problem. An informal study of my students indicates that fifteen seconds is a practical limit. This means that the entire page must be under 45K (though many agree with me that under 30K is wiser). Even at the community college where I teach (where we have a T-1 line on an EtherNet network), I consider myself fortunate if I can download at 20K per second, although an excellent connection will work at more than 30K per second.

Of course, there are always the storied cable modems and even satellite modems. I'm sure you have one — right! I know something of that ilk will probably come in the next decade, but we don't know what it is yet. So the sum of the limitations is that your Web graphics have to be 72 dpi, usually 8-bit, and always under 30K (3K is obviously far superior). Take a close look at the bottom graphic in the sidebar on the opposite page. Fortunately, we have been given three files formats that deal with these limitations fairly well, plus a format that circumvents the limitations entirely, if necessary.

WHAT WE HAVE TO WORK WITH

The four formats: GIF, JPEG, PNG, and PDF

All graphics you see on the Web are in these formats. In fact, as I write, the only two formats actually used are GIF and JPEG. PNG is still very rare, and PDFs must be downloaded and then read with Acrobat Reader. Until things change a little more, I would stick with GIF, JPEG, and PDF. PNG has received some hype, but there is no overwhelming advantage other than that the software writers do not have to pay a royalty to CompuServe to use the standard.

You have heard a lot about ShockWave, and I'm sure there are and will be many more formats bandied about (by Microsoft and others). The key is that many of your clients are interested in getting in touch with their customers who are using AOL. AOL's built-in browser

257

does not even have full version 3 capabilities, let alone the version 4 capabilities like dynamic HTML, etc. ShockWave has a chance now that Netscape is including it in Communicator, but there is no way of knowing if Netscape will even be here next year. Shocked sites are certainly fun, but as yet there is no evidence that it serves any commercial purpose other than entertainment. Disney's sites are amazing, as are several others. There's a gallery link off the home page of this course. But you'll quickly see, if you are honest, that the sites have little content other than the animations themselves (except for Disney, of course, which sells animations).

I am not going to give you a technical analysis of these formats. What you need to know is their capabilities: color depth, compression, and transparency. This is easily shown:

GIF: 8-bit or less, LZW compression, transparency, and animation.

JPEG: 24-bit, lossy compression, no transparency or animation.

PNG: 24-bit, zlib compression, partial transparency (alpha channel).

PDF: Anything you can do in print, plus links, movies, and sound; embedded fonts, print control, PostScript.

As you can see, it is pretty straightforward. You determine what type of graphic you are producing and use the format that meets your needs best. The biggest problem is still the byte size you must attain. On the Web, a graphic of more than 10K is large. An image of more than 30K is much too large. This is certainly a massive change from the 30–40 MB files we have become accustomed to when dealing with process printing. Even print's small 300K grayscale halftones are absurdly large for the Web.

However, this is one place where the Web's limitations work in our favor. Because we are forced to use 72 dpi, our image sizes are much smaller to start with. Remember, if you cut the resolution in half the file size is 25% smaller, because the resolution is cut in half both vertically and horizontally. So, instead of working at 300 dpi, we are now working at less than an eighth of that. Even there, though, it is obvious that a 32 MB file would still end up at 4 MB.

Web compression

The solution to these problems is the built-in compression schemes used by the various formats. Basically, there are two type of compression: lossy and loss-less. The names make obvious the capabilities. Remember, the purpose of compression is to save on file size — compression makes files smaller. The question is, "What happens when you decompress something?"

If you have loss-less compression, nothing happens. The decompressed file looks exactly the same as the original file. You lose nothing. However, if you have lossy compression, you lose data with every compression. In other words, if you compress and decompress,

CHAPTER
ELEVEN:
DESIGNING FOR
THE WEB

PNG FORMAT
This looks like it might be a good future solution. It can basically do everything that is now done by both GIFs and JPEGs. However, even the most advanced browsers do not support it reliably, so far — wait a while.

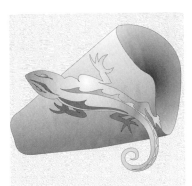

compress and decompress, and compress and decompress, you end up with obvious compression artifacts. Details disappear and things appear in your images that were not there when you started.

An obvious question is, "Why would you ever want to use lossy compression?" The equally obvious answer is: when it is the only solution to your specific problem. Lossy compression must be approached with care and handled correctly, but given that, lossy compression can make your files 5% of their original size. Beyond that, we need to discuss how the different compression schemes work. You must design your graphics so that they compress well and are not visually damaged by the compression process itself.

LZW compression

LZW is the compression scheme built into GIFs. It is also an option when used with TIFFs, so you should remember how it works. It is a type of run-length encoding. In other words, LZW reads all of your pixels left to right, top to bottom, row by row, looking for patterns. The basic concept can be expressed this way. Pixels are located and named by row comma column, so the first pixel in the first row is 1,1; followed by 1,2; followed by 1,3; and so forth. An uncompressed image has to define every pixel by location and color. The color is indicated by a number representing the PostScript level from 0 to 255 (0 being black and 255 being white).

So, if we have an image that is two inches square at 300 dpi with a white background and a one-inch black box in the center of the two-inch document, we then have an image that has 600 rows and 600 columns. Uncompressed, this would be written: 1,1 255; 1,2 255; 1,3 255; 1,4 255; and on and on for the 600 pixels in the first row; the 600 pixels in the second row, etc. With LZW the document would be described something like this: the first 150 rows are all 255; the next 300 rows are 150 pixels of 255, followed by 300 pixels of 0, followed by 150 pixels of 255; the final 150 rows are all 255. The LZW description is completely accurate, yet describes the entire document in a couple of hundred bytes of data (.2K!) Uncompressed, the file needs from 8 to 12 bytes per pixel (minimum). Because there are 360,000 pixels, we are talking well over 2 MB to describe the file.

However, there is an obvious problem. In the example I just gave, we have a very simple image that can easily be described in sentence form. What happens with multicolored vertical stripes? Or worse yet, what happens if you are dealing with a photo in which every single pixel is different? The simple answer is that LZW will not save you anything in these cases. In fact, it will make the file size larger.

Thus, the rule with a GIF is this: GIF is the superior format with relatively large areas of flat color, or with horizontal instead of vertical patterns. In other words, GIFs work best with what we have come to know as PostScript illustration that uses no gradient fills or patterns. If

you do use gradients, you will want to use vertical ones, where the color changes in horizontal bands. For graphics like these, the GIF format can make file sizes very small.

JPEG compression

JPEG is a completely different type of compression. With JPEG you lose data and detail. JPEG compresses by taking areas of pixels — 3x3, 5x5, and so forth. This sample is then averaged and the average color is applied to each pixel in the sample. It would seem that a 5x5 averaged would give you 25 to 1 compression ratios, and that is nearly true! However, the averaging process breaks the image into little squares and you do lose detail. However, because the Web is so crude, the images look great on the monitor.

JPEG is the only solution to getting photos on the Web, at this point. PNG will probably be used more in the future, but there is not enough support for PNG yet. The problem with JPEG in the printing world is that the little averaged squares are visible in top-end process printing at 150-line screen. As a result, the huge compressions available cannot be used. On the Web, this is not a problem. Web graphics are so crude that the JPEG artifacts are too small to be seen, even with the most extreme compression options offered by the format.

For print, you often cannot get away with even the 50% compression option. For the Web, you will find that the 10% option will do nothing more than make your files small enough to use. You obviously still have to be careful of the pixel dimensions of your image, but it is not at all unusual to have an RGB photo that is 5 or 6 MB reduce to 700K by converting to 72 dpi, and reduce to 30K by saving as a lowest-quality JPEG. It will still look remarkably good on the screen (as long as the monitor is 24-bit color).

As far as I know, the Alpha Channel option is of no benefit on the Web. JPEGs cannot be transparent. However, GIFs can and we'll talk about that in a little bit. The anti-aliasing has little effect, to my eye. In fact, most of these issues are much better dealt with in Photoshop. You'll see those soon.

A reality check

Please remember that, outside our community of designers, the average monitor is still 8-bit or less. As recently as 1996, the average monitor in my department at school was 4-bit. All of those gorgeous, too large, Web graphics were crammed into the sixteen colors available. It was a sorry sight. JPEGs viewed in 8-bit are still severely compromised. Be aware of your viewers!

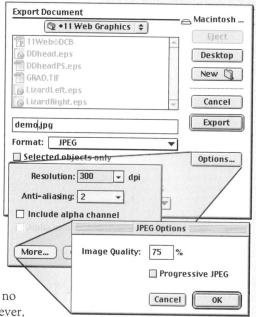

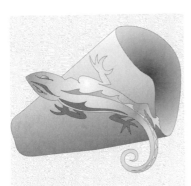

DEALING WITH LOW RESOLUTION AND TINY FILES

Those of us in the design community tend to forget how limited the average business PC is. Remember, the Mac is designed by graphic designers for graphic designers and the PC is designed to be cheap. Always check out your designs on both platforms.

System color variances

The final platform difference we need to discuss is commonly seen when using GIFs. GIFs use indexed color (8-bit or less). Both PC and Mac have a standard set of 256 system colors (8-bit). Of course they are different sets. Actually, it's not as bad as it sounds, as there are 216 common colors in the two different systems.

Much has been made of using the Web-safe palette. FreeHand calls its the "WEB SAFE COLOR LIBRARY," and it is located at the bottom of the options popup on the COLOR LIST panel. In my humble opinion, it is simply more of that anal-retentive nitpicking commonly found in designers who think that the perfect color/design/layout really matters. Basically, "Web-safe" is an oxymoronic concept. It is barely possible to have a calibrated PC monitor, so you have no idea what the colors are going to look like anyway. The real solution is not a Web "safe" color palette, but clean, crisp design that looks good no matter how the colors are modified. The concern for dithering is more of the same. Design your graphics so dithering doesn't matter.

 Software limitations are simply part of the problems we have to solve as designers. Design is problem solving. Think of what bridges would look like if we had a material that was so strong that a half-inch-thick plate could span a mile while carrying a full load of cars. Your task is not to fight reality, but to use available capabilities to create beautiful solutions that communicate clearly to the selected readership.

Some suggested production procedures

First of all, my suggestion for graphic creation on the Web is to work from FreeHand. The key to small, easy-to-read, functional graphics is that they be small, clear, and communicate clearly. One of the major tests of your design is that your pages download in less than ten seconds on a 28.8 modem over a regular phone line, so it is imperative that you use no graphics without a good reason. When you use a graphic for a good reason, it has to be SMALL (in bytes).

The result of this is that many, or most, of your graphics will be words or will contain words. Photoshop is terrible with type, unless it is very large and high-res. Even with Photoshop 5, and its much vaunted type layers, type is clumsy at best. In print, everyone knows that PostScript illustration is the only real solution for powerful type manipulation. FreeHand gives you a freedom of design that simply is not available in a bitmap or paint program.

In addition, Photoshop is a lousy drawing program. It is not designed for, or meant for, drawing. It is an image manipulation program that deals with scans and original art from PostScript illustration, such as what FreeHand produces. It cannot do composite paths, complicated blends, or most of the other capabilities we take for granted in FreeHand. However, it is necessary for adjusting your graphics to the smallest size after they are created.

If you do a lot of Web work, you will probably have Image-Ready or FireWorks to make these size adjustments. However, for most of us, Web is an addendum to our skills, not the focus of our life. Even if the Web is your focus, you'll be amazed at how many requests you get to turn that Web page into a brochure or ad. You already have FreeHand and Photoshop.

If you start in FreeHand, you'll have a high-resolution graphic available for the conversion. They are actually more powerful, in many ways, than the specialized Web tools which are totally incapable of being used for anything other than the Web. Most designers who do only Web design have simply never paid the money necessary to get the good tools that are a normal part of our graphic design experience. (Or they may be animators trying to make a living.) Without the graphic knowledge we have been covering in this book, they cannot come close to the communication effectiveness we have available with the software we use.

A sample procedure

This is offered merely for your titillation. The most common reaction I get from my sites is, "It's so clear and colorful!" I put it to you that this is not a bad response. I don't expect you to use my methods (though I find they work very well for me). I offer them in hopes that they will solve some of your production bottlenecks.

1. I draw my graphics in FreeHand. I have a Web graphic version of FreeHand Defaults with my custom RGB color palette that I created using the Crayola color palette. I do not worry about Web-safe colors at all. By starting with a common color palette, I achieve a consistency that is often lacking in other sites. I draw it to size (roughly the size I expect it to be on the Web page). Because the fluidity of change is so powerful in Free-Hand, I have the total design freedom allowed by PostScript illustration. Changes are an easy part of design.

 TIP! I am very careful with my stroke widths. I know that a line will not appear crisp on a monitor unless I make it at least two points wide (even then you might have to go to a three-point stroke). Hairlines can work well in this environment because they tend to give a slight color edge to shapes that helps crispness.

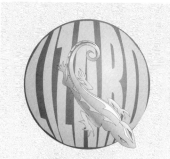

FRAMES VERSUS TABLES

My recommendation is to avoid frames entirely. There are two major problems with them. First, your readers cannot bookmark individual pages if you use frames. Second, the average browser is still less than level 3, so many of the surfers cannot read frames anyway.

DEALING WITH LOW RESOLUTION AND TINY FILES

Remember that the tiniest thing you can do on a monitor is one pixel, which is one point. Anything less than that is going to give subtle, colored edges when the anti-aliasing (edge blurring for smoothness) appears in the resulting GIF. For example, a one-point vertical black line will look like you planned, if it hits the pixel grid exactly. However, if the line is half on one column of pixels and half on the next one over, you will get a 50% gray line two pixels wide. If it falls 30% on one column and 70% on the other, you end up with a 30% one-pixel line next to a 70% one-pixel line.

2. I save the original and then export it as a 72 dpi TIFF (or as a Photoshop 4 RGB EPS). This gives me a very accurately rendered RGB image. More and more I am using the RGB EPS because I can determine the size when I rasterize it into Photoshop. It never seemed to work well with Photoshop 4, but with Photoshop 5 it works very cleanly.

3. Sometimes a little cleanup is necessary in Photoshop, sometimes not, and sometimes I have to go back to FreeHand and make changes. Sometimes I just do the framework in FreeHand and do the colorizing in Photoshop. I even add tiny type in Photoshop upon occasion.

4. Using modes, I change the image from RGB to indexed color. Then I try several options. First, I go for 4-bit color, adaptive. Many times the sixteen colors picked by Photoshop look great, and I have made my graphic much smaller. If I don't like it, I undo and try 5-bit or 6-bit indexing.

 This is the major reason why we have to go to Photoshop to finish our images. All GIFs generated with FreeHand are 8-bit. They look good, but they are usually too large. Photoshop allows us to reduce the pixels to 3-bit, 4-bit, 5-bit, 6-bit, 7-bit, or 8-bit. Going to 4-bit cuts the image size in half.

5. Occasionally there is some minor final cleanup, and I often export it out of Photoshop with a transparent background (GIF89a). I usually end up with very pretty graphics that are less than 10K (often 2K or 3K).

 TIP! Don't go by the size listed in your window on a Mac. Use the GET INFO box under the FILE menu. It will give you accurate byte figures. The size is also inflated by icons and thumbnails. You should save your images without them to keep an accurate byte count.

Are ImageReady and FireWorks faster and slicker? Yes, they are. The fact is, personally, I only design about 500 pages in a half dozen Websites per year. I can't justify the money to save maybe two or three hours.

263

Animation, image maps, button bars, cascading style sheets, and DHTML

Now you are going to get very upset with me. None of my students wants to hear this part. Many, if not most, of you have been patiently waiting for me to get to the fun parts: Javascripting, Flash, ShockWave, animated GIFs, CGI/Perl, and all of that. You will have a long wait. You don't need or want to do any of that! Heresy! I can see the crossed fingers fending me off around the world. You will probably need CGI, and your applications will probably be written in Perl. However, if you are a typical designer, the entire process of programming is slightly less exciting than watching Howdy Doody reruns. The rest of them are stuff for the next millennium, once satellite modems are commonplace.

At this point, we are still governed by phone lines, at the minimum. In most cases, we are also hemmed in by AOL, with its ancient and outdated interface. We have to design for our customers. At this point, the only excuse for the fancy stuff mentioned above would be if our customers are young gamers. Beyond that, focusing on fancy graphics, wild animations, rollovers, full-page imagemaps, and the rest really misses the point entirely. Most of the Websites that are done professionally (for money) are greatly inhibited by extraneous graphics and a cluttered interface. You've only got a few seconds to keep them on your site.

The best thing I have ever read about the Web was on one of the Web design sites, and it went something like this:

People do not come to your site to see the killer Web site — they come for easily accessible data.

Your customers (or your clients' customers) are not looking for amazing digital dances to amuse and pass the time. They want to know what you are offering, why they need it, and how to get it. The fancy stuff does not help. It irritates! It's the same reason why most of your printed projects are still (and will remain) black and white. In printing, process color is the fancy stuff – and even that is much easier to justify than that incredible animation with the embedded row of changing interactive buttons where you have to wait seconds for each new image.

At school, I am running a fast G3, with 128 MB RAM, on a 100BaseT WAN, to a T-1 line – and I still find the fancy stuff merely mildly irritating (entertainment at best). There are many pages, even with this exceptionally fast access, where pages take so long to download that I simply click off in disgust. Even Yahoo's Home Page

IMAGE MAPS

There are also major surfing problems with image maps. First, they are huge and require long download times. Even if you solve that problem, the major problem is that the links do not ever tell you where you have already been. In other words, there is no direct feedback to the surfer, and many leave in disgust because they cannot tell where they have been on your site.

265

was like that for a long time. Imagine how a surfer feels on a Quadra or 486, with 16 MB RAM, using a 28.8 modem through AOL. Heck, maybe your customers even live in rural areas where good phone lines are a luxury that hasn't arrived yet.

This is a serious problem!

If you need to do the fancy stuff

I suggest you buy the relevant software, go through the tutorials, join a user group, and do it. There are certainly situations in which Java, animations, and cascading style sheets are appropriate. However, they are a very small percentage of most people's workload, so they will not be covered here. Imagemaps are almost always too large to be used.

I know many of you are expecting a long dissertation on Flash and ShockWave. You are not going to get it. Even though this is Macromedia's focus recently, I am convinced that a lot of that is to keep the market for Director and DreamWeaver growing. Animation is neat and fun, but there has never been any study to indicate that it increases sales. On the contrary, in many surveys, the most irritating graphic on the site is usually that little animated image that keeps flashing in your face.

For you animators!

FreeHand does offer some real help here. The FLASH EXPORT Xtra allows you to animate either layers or pages from FreeHand into Flash. The RELEASE TO LAYERS Xtra allows you to design a blend attached to a path, and then release it to individual layers for each step. Then you can export it to Flash as an animation. You will find all the particulars in FreeHand's documentation.

The advantage of Flash and ShockWave is that the animations are vector images, like FreeHand. That means that complex animated graphics can still be very small and fast to download. The disadvantage is that you need a plug-in to run the animation. Even though the plug-in is free, it is still a hassle. You do not want to add hassles for your surfers. How many sites have you clicked off because you were tired of waiting for Java and its scripts to load? Java is built into the new browsers. The ShockWave plug-in comes with the new Netscape Communicator, but over half the people now use AOL or Explorer.

We have to remember that average browser again. Most of our customers on the Web are not very sophisticated graphically. Therefore they do not have the huge computers with the fast access that we tend to take for granted. When you ask them about animations, Shocked sites, or PDFs, they do not have any idea what you are talking about.

Keeping images small

We need to spend some time showing some design tips to make your images as small as possible without compromising quality. I have drawn a small ordering button. I have kept it very simple so you can clearly see what is going on with the LZW compression in a GIF. Because these are done in grayscale, you need to imagine them in full living color. It is very easy to make these very colorful without increasing the file size at all. Remember, GIFs use indexed color. In other words, they convert the image to a very limited palette of a certain number of colors. The maximum number of colors is 256; the minimum is 8. By radically reducing the colors like this, the file size can be made much smaller.

Here is the dialog box from Photoshop to give you an idea of the options. There are a couple of important things to keep in mind. First is dithering — that process of giving the illusion of intermediate colors by randomizing the dots. Don't use this, because it eliminates the compression abilities. The color matching doesn't seem to make any practical difference. With a G3, Pentium II, or better, there is no faster, so use better. The procedure is to use ADAPTIVE and the fewest bits per pixel without banding.

With the preview, the banding is obvious. However, there will be times when the banding is not ugly, and occasionally it even helps the image, allowing you to go to very low bit depths. As you will see in a couple of paragraphs, just going from 8-bit to 5-bit can cut the file size in half.

For the first version of this little image (enlarged so you can see what is really going on with the fills), there are hairline rules and multiple, varied fills. The background and the word "HERE" have horizontal gradients. When this one was rasterized to 3 inches wide in RGB (again to clearly show the process), converting to indexed color showed 236 colors were used, and the saved GIF was 17,185 bytes of data. That is a very large file, in Web terms, for such a simple button.

By converting it to 5-bit, I saved over half of the file size. It went from the 17,185 (17K) to 8,354 bytes of data. As you can see, at the top of the next page, there was virtually no change in the image. This is especially true if it had been rasterized at the actual size used (one inch wide). At that size, we can go down to 4-bit and a final image of only 4,615 bytes, which is tolerable. It can be argued that 5K is still a little large, and that is true. However, this

17,185 BYTES

DEALING WITH LOW RESOLUTION AND TINY FILES

4,615 BYTES

compared to

4,479 BYTES

8,354 BYTES

is a button that would be used a lot on several pages. Once this 5K is downloaded, that image is used wherever needed with no additional memory penalty, as long as the image is still in the image cache of the browser.

For the next version of the image, the gradients were radically simplified. The words were made into one horizontal gradient (with the exception of the exclamation mark). The background was also changed to a horizontal gradient. When this was rasterized at 3 inches and converted to indexed color, there were also 236 colors. However, an

interesting thing happened. Because the gradients were longer in length, it proved to be impossible to go to any fewer colors. The banding was severe, especially in the top half of the exclamation mark, even at seven bits of data per pixel. However, because all of the gradients were horizontal, and fit into the paradigm of LZW compression, it compressed nicely. Even though there was exactly as much data as the image that ended up at 17,000 bytes, this image compressed to 9,968. 10K is really too large to be used, but this image clearly shows how much it helps to have the gradients in horizontal bands that compress well.

The final version drops the background. The exact-color GIF had 213 colors. But, because it used horizontal gradients, it compressed to 7,922 bytes on the first try. By taking it down to 5-bit, or 32 colors, the size dropped to 5,422 bytes. On a monitor, this image looks sharp, crisp, and colorful.

There was one more interesting phenomenon. When produced at the final size of one inch wide, this image was only marginally smaller than the first one with the randomized gradients. As you can see to the left, the graphic without the background is only 136 bytes smaller.

 This points out the most important factor in the byte size of images: physical pixel dimensions. Make the images as small as you can. Remember that on PCs, most people are still working at 640x480 pixels. This means that the tiny little image on your high-resolution screen will look much larger on the low-resolution monitor. I clearly remember my shock the first time I saw my site on a computer in one of the PC labs upstairs. It was huge, very dark, and in Times New Roman.

Always preview your site

That original home page didn't even look like the clean, bright page set in Palatino that I had designed on my screen. I ended up redesigning quite a bit of the page, making the logos and the type smaller. This is a much larger problem than you might think.

The first major differences are found in the two opposing operating systems themselves. We have already mentioned that the Microsoft and Mac system palettes are different, with only 213 common colors. A much more important difference is the monitors used. As is true in most things PC, the operative word is cheap. Whenever you have a product and an entire industry that is primarily governed by price concerns, you have a problem. PC purchasers complain if a computer costs more than $2,000 – in fact, many now expect them to cost less than $500. This is absurd!

Even with a PC, to get a computer that will do what we need it to do as graphic designers will cost $3,000 or more. You cannot even seriously run a PC before you buy several cards and peripherals that do not come with the machine as standard equipment. However, this is just a problem in tackiness. The real problem here, as far as viewing your marvelously designed site on the Web is concerned, is that any monitor over $500 is considered ridiculously expensive.

Effects of cheap monitors

First of all, the resolution is usually very low and very crude. 640x480 pixels is still very common. The Mac designer average of 1024x768 pixels on the 15" monitors to 1,600x1,200 pixels for the 21" screens is virtually unimaginable to most surfers. Mac surfers do all right because it is almost impossible to buy a monitor lower than 1024x768. In practical terms, this means that pieces designed on a Mac often look nearly twice as large or larger when seen on a PC.

Secondly, monitor calibration is only a very recent arrival to Wintel machines. In fact, it really wasn't even possible until Windows NT

IF YOU CANNOT design well on the Web, do not blame the system limitations. The blame is found in the limits of your creativity. You are not limited, merely challenged. It's part of the fun of design — go for it!

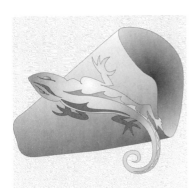

and Windows 98, because the operating system did not support it. A calibrated monitor costs well over $1,000 for a PC, and is a real rarity.

Third, and this is a fundamental difference — Mac and PC use different gamma settings for their monitors. Gamma is one of those things tossed about but few really know what it means.

In practical terms, gamma means two different things. For scans and bitmap images, gamma describes the lightness or darkness of the midtones: higher than 1.0 lightens the midtones; lower than 1.0 darkens them. On monitors, the higher the gamma number, the darker the screen appears. Mac's standard gamma is 1.8, whereas the PC standard gamma is 2.2. In other words, a PC monitor is normally much darker than a Mac monitor. I've changed the gamma on my Mac to 2.2, but the PC monitors are still quite a bit darker than that.

Finally, we have the differences in browsers. We assume that there are only two: Explorer or Communicator. But already you can see the problem. Many do not have Communicator — they are still stuck back in Navigator. In fact, AOL still uses Navigator (or a limited Explorer 3) and they are one of the largest sources of surfers. More than that we have the different version numbers. All of the latest bells and whistles assume that you are using a version 4.5 browser or better. The average is still version 3. Both browsers and all of the different versions of those two browsers show pages differently; check out as many as you can when proofing your Websites.

A word on friendliness

Web sites are unique bits of graphic communication. On the one hand, they are very cold, uninvolved, impersonal assemblages of digital data. For pixel pushers like us, they are great fun and global on top of that. Some of may push the Mac as friendly, but it is not alive and cannot relate to us. The same is true of the Internet, that incomprehensibly vast and intertwined network of most of the computers on Earth. On the other hand, our Web sites reach our customers on a very personal level in a quiet time, where they are isolated within their computer environment, often in the apparent safety of their bedroom, den, living room, or office. Like a Mac, the Web seems friendly, responding easily to our command. More than that, it is a communication medium.

What this means in practical terms is that the Web is a strange type of uniquely personal communication. I've written this book in first person, but none of you really think you are communicating with me. However, if you go to my Website, find out where I am coming from, and we start an email dialogue, we can develop a pretty tight relationship relatively quickly. This is true no matter where you live.

In my commercial online school, I have students from all over the world. The farthest one to register, so far, is from the North Island of New Zealand, but I've had many inquiries from India, Nepal, Malaysia, Singapore, Japan, all over Europe, and the Middle East.

Normally, I don't even find out where they are from until we have talked to each other several times. It really does not matter at all. The only differences I have noticed with my student in New Zealand are: their year is very different, being south of the equator; they use metric (but most do that); they hyphenate words differently; and they use plural verbs with companies. Those small differences are merely enough to make things fun.

The other interesting fact is that I know her better than I do most of my students who are in my classroom for a few semesters. The Web seems to promote that. It seems to have something to do with the safety of distance and the relative anonymity of computer-to-computer communication. Whatever the cause, it seems safer to share.

The visitors to sites you design really need to touch a human there. They want to know names, email addresses, history, background, and so forth. One of the original successful sites, now known as deadlock.com, was for a small hotel in London. It was phenomenally successful via the simple technique of letting prospective guests wander through the hotel in their imagination.

If they wondered about meals, there were pictures, menus, a picture of the cook and her background. The designer (who was then in charge of marketing for this little side-street hotel) said he regularly got bookings from people who made statements like, "I've been wandering around your site for nearly two hours now, having a marvelous time, I guess I'll book a room." The last time I heard, nearly 75% of the bookings were coming from the Website. How did he do that?

The answer is actually very simple. First of all, his writing style is cheerful, friendly, unpretentious, and believable. This is very important. However, more than that, he has a real gift of letting a surfer answer any question he or she might have. Upon visiting the site, you are left with the feeling that the hotel really cares for you — that they genuinely want you to have a wonderful experience staying with them.

The friendliness, openness, and genuine trustworthiness of your site are primary!

This needs to be your focus in Web design. Seems like normal stuff for any type of graphic design, doesn't it? Just as with print, if the surfer reacts consciously to the neat graphics and your incredible design, you've lost him as your client. The best designs are not only invisible, they should also enable the surfer to feel like she can go anywhere she wants and get the answers she needs.

Button bars and communication

By now, you have noticed on the Website for this book that the communication bars are simple tables with colored backgrounds. Some

CHAPTER
ELEVEN:
DESIGNING FOR
THE WEB

270

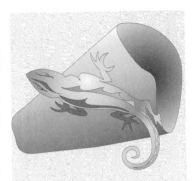

Web Bolded
Web Bolded

BOLDED TYPE

As you can see with the top words, type bolded on the Web is bold all right, but is it readable? Clicking the Bold style merely makes the type appear blurred. It becomes very difficult to read (and ugly). Italic is almost as bad (maybe worse). You do not get an italic, but an oblique. Worse yet, the oblique has a very bad case of the jaggies from the slanted 72 dpi lines.

of you may have even wondered why there weren't amazingly beautiful 3D buttons to guide you on your way through the site. In fact, there are no buttons at all, because tables download like type – and just as fast. Not only that, they are clean and easy to understand. I am a little concerned that they are too dark for PCs, but the goal was ease of use.

"Can't I do buttons?" I can hear your whining from here. Certainly you can. But you need to think it out first. If a page is supposed to be 15K to 35K in size (and 15K is far better), then you really need to plan the button sizes accordingly. If you have seven buttons, for example, 3K each will use up almost your entire graphic allotment for the whole page! As you saw from the little "Order Here" button a few pages ago, we had a heck of a time getting the file size below 5K.

It is possible to make one fancy button that can be used repeatedly for all communication links within your site, but that usually defeats the purpose of a button bar by making every link look the same. The home page of my school (http://www.tvi.cc.nm.us) has beautiful, fancy buttons for every major section of the page. They download wonderfully at school on the EtherNet network. However, even there, with relatively new, very fast computers hooked up via EtherNet, the download times are irritating.

The argument is, "But, you only have to download them once. After that they are in cache, and show up almost instantly." That is almost true, but that first page is a killer (literally) for anyone accessing from outside school on a 14.4 modem with a weak connection. It is certainly not a good first impression for students, who are often coming to school to learn about computers and the Web anyway.

The other problem with the fancy button approach is a little more subjective. Once a person starts with the fancy buttons, it's very hard to stop. The TVI site I just mentioned has that problem. After the first page, the buttons do show up very fast. However, the designer couldn't stop there. Every page has large graphics unique to that page. Worse yet, after you get past those new graphics, the typography is very bad – clumsy and difficult to read.

 TIP! DO NOT USE THE BOLD STYLE ON WEBSITES. Bold on the Web simply means what it did on the old 9-pin and 24-pin printers. The type is imaged twice, with the second image offset to the right a pixel. This is why bolded type on the Web is so hard to read. Simply using the paragraph style for almost everything and changing the point size will greatly improve the look of your sites with no other changes.

Most of your Web design problems will be solved if you simply remember the reason for the site in the first place. If you are getting paid to design the site, the client needs to make income from it. So, you immediately go back to the same old questions.

- **What's the product?**
- **Who's the client?**
- **What does the client want the reader to do?**
- **What's the message?**
- **Who's the reader?**

With the answers to those questions, you can design a clean site, that downloads fast, is easy to understand, and is easy to negotiate. The client's readers will happily do what is desired because you will have helped them to see that the client's product is something they really need plus – it's easy to purchase, remember, or use.

Finally, typos are absolutely forbidden!

Knowledge Retention:

1. What is the maximum usable size in kilobytes for a Web page, including the graphics?

2. What is the most important factor controlling file size?

3. Why do readers visit a Web site?

4. Why do you need to post-process GIFs in Photoshop?

5. Why use FreeHand to design your GIFs?

6. How can the Web possibly be personal?

7. How does gamma affect the OS differences between PC and Mac?

8. Why should you avoid bold and italic stylings on the Web?

9. What are the designing problems when dealing with the average surfer's hardware and software?

10. What about the browser wars?

Where should you be by this time?

You should be having fun, designing up a storm.

DISCUSSION:

You should be enjoying your friends and having fun producing great work for the clients you serve.

Talk amongst yourselves...

Chapter Twelve

Production Tips

Practical steps toward usable designs

CONCEPTS:

1. Production procedures

2. Thumbnails

3. Roughs

Definitions are found in the Glossary on your CD.

Chapter Objectives:

By teaching students the options and capabilities of FreeHand, this chapter will enable students to:

1. set up a functional production procedure

2. develop a system for capturing and rendering creative ideas

3. deal with deadlines and client demands

4. learn an appropriate attitude toward clients and their customers.

Lab Work for Chapter:

• Work on fulfillment of grading requirements.

• Real-world projects.

Illustration Tips

This red bell wreath can be seen in color on the CD. It was done for Target. To contact Tony, his email is: roame@illustratedconcepts.com His Website is: http://www.illustratedconcepts.com

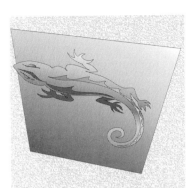

Now I have a job,
How do I get started?

Design is incredibly difficult. The possibilities are endless and there are no rules. In fact, whole schools of design are based on breaking all the rules; the current crop of "professionally ugly" design is but the latest variation on a recurring theme. It's usually told as a joke, but we really are expected to read our client's (and readers') minds. On top of everything else, the deadline pressures are often unreal. Because of all these things and much more, creative block is a real fact of life for the designer.

Fortunately, there is a simple methodology that makes design blockage highly unlikely. Though there are no laws, it is certainly true that norms rule. We have already covered some of those norms. You have been encouraged to train your eye to see and recognize both norms and current fashion. Our cultural history and marketing economy have made it certain that almost all our readers will react according to very definite habits. Because we are all exposed to most of the same general influences, we have predictable reactions.

We discussed reactions to type in chapters six, eight, and nine, but we also have predictable buttons that can be pushed with color, form, texture, smell, and the like. For example, there are certain curves that will attract the attention of most human males.

Design, in general, is like that. Though lockstep procedures virtually eliminate creativity, many things can be done to enhance the creative process. Even though we do not understand where creativity comes from, we can set up an environment in which it is more likely. There is much discussion concerning creativity as a learned technique or an innate gift, but it is clear that we can develop rudimentary talent into strong, competent skills. The technique is simple: Ask questions and get moving.

Ask questions and get moving.

Simplistic balderdash? No, a basic technique. First, you have to understand how ideas are generated by the creative personality. Basically, you toss all the data you can find into the hopper. After an undefined time period, ideas begin dropping out the other end. Or — add huge amounts of data to a large pot and wait for the dumplings to pop to the surface. How this works we are not sure. The most common word used by the geniuses of our civilization is inspiration. However, it is clear that new concepts and structures are an intuitive outgrowth of

an educated (though not necessarily formally educated) mind. Creativity generally builds on a basic curiosity and hunger for facts. It then assembles those facts uniquely.

In our field, that hunger revolves around printed materials, graphics, signs, paintings, Websites, and visual stimuli in general. Graphic designers normally have an almost compulsive desire to feed their mind with images. You should read every book you run across on design, go to every gallery within reach, read magazines and look at the ads. Tear everything apart in your mind and try to improve the designs. Designers do this continuously.

Design

Questions: 1
1. Reader
2. Product
3. Message
4. Client history
5. Budget
6. Equipment
7. Time line
8. Competitor history
9. Client image
10. Client business plan
11. Subcontractors

Idea Creation: 3
1. Research
2. Morgue
3. Thumbnails
4. Size
5. Roughs
6. Typography
7. Style choice
8. Color
9. Photo shoots or cleanup
10. Graphic creation
11. Logo creation

Mental Time Line: What you do while your hands are busy

FOR

Getting started: 2
1. Clean area
2. Read job ticket
3. Replenish supplies
4. Set up file storage
5. Read ALL copy
6. Determine illustration needs
7. Determine photo needs
8. Scan and trace lineart
9. Make sure copy is usable
10. Send photos to scanner
11. Assign graphic production

Composition: 4
1. Document setup
2. Document defaults
3. Style palette
4. Color palette
5. Import copy
6. Format copy
7. Approve graphics
8. Import graphics
9. Adjust layout
10. Proof
11. Corrected proof to client

Physical Time Line: What you do while your mind works

Production

276

If you don't do this, it's quite possible you need to focus on production instead of design. As mentioned, creativity cannot be faked. However, many clients really do not want incredible creativity.

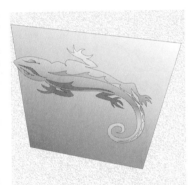

What they truly need is reliable production of projects within budget and on time. This does not take creativity. Nonetheless, the most creative designers are subject to the same production pressures.

The basic technique for creative output

Back to the technique. What questions do you ask? When you receive a new project, find out everything you can:

- Who has editorial authority?
- What are you selling?
- Who are you selling it to?
- What kind of people buy or use the product?
- When does it have to done?
- How are the finances?

Remember, a product may be as obvious as a new car or as subtle as the image of a chemical plant. The product may be love or power or peanuts.

 There is no reason for your printed piece or Website except to convey a message to your client's readers and customers about a product.

The graphic on the opposite page, "Design for Production," demonstrates this technique diagrammatically. Notice that the top half describes the mental time line and the bottom half the physical time line. The reason they are off center is simple. As you recall, the creative process flows as follows: data in; time passes; ideas out; production. The graphic shows how they really should flow into each other: questions, setup, idea generation, production.

You start by asking questions — as many as you are allowed. When you have asked the persons involved all that you can think of, begin meditating on the questions and the answers. It helps to run through a personal list of questions that you ask yourself. At this point try to avoid solutions. You are merely assembling data. Conclusions made before the data is in are usually simplistic, at best.

As the data reaches overload, begin the physical process by organizing your work area. Look over the supplied materials; read the copy; clean the area while focusing on the project.

Before long the ideas will begin. Jot them down in note form (see a contemporary version of thumbnails a little later in this chapter). Just keep organizing. By the time the cleanup process is complete, you will have plenty of ideas to flesh out.

The next step involves finalizing your ideas; creating the resultant graphics; choosing the type, color palette, and document size; and settling on a style. Once you reach this stage, composition becomes a simple exercise in production. You are enabled to produce the documents with minimal hitches, glitches, and redos. You simply build on your decisions and assemble the project.

Now that you understand the basic structure, let's get into the four areas in depth. Remember, there are no rules carved in stone. The structure is necessary merely to channel your rampant creative urges toward the specific project you were hired to design.

 Graphic design is about communication and little else. Everything is subordinate to the message. The most important thing about the message is this: can and will it be read?

Questions: ①

1. Reader
2. Product
3. Message
4. Client history
5. Budget
6. Equipment
7. Time line
8. Competitor history
9. Client image
10. Client business plan
11. Subcontractors

DESIGN — STEP ONE

Questions

The first thing you must determine is what you are communicating — more appropriately, what are you supposed to be communicating? Ask any question you can think of to get at that fact. Ask the client. Do a market survey. Research the benefits of the product. Find out what the competition is doing. Ask your client what has worked in the past. Get a customer profile. Determine the budget, mailing requirements, deadlines, taboos, and customs. Get intimately involved with the project, mentally and emotionally (if possible).

Once you have learned about the product's history and future, the message, and the designated readership, find out all you can about your client. What are her favorite colors? Who does she admire? What is her circle of friends? What is her reputation? Find out if she is part of her readership's culture or if she is marketing to strangers.

Is the client moving by plan or by the "tyranny of the urgent"? In other words, has anyone ever taken the time to sit back and analyze the situation objectively, or has the entire operation been by the seat of the pants? Reacting to difficulty is a horrible way to direct a marketing strategy. If the client does not have a business plan, try to help create one. It is one of the services you offer as a designer. At the very least, as the project progresses, invent the best plan you can (for your own use) based on the data you have collected.

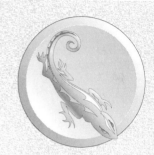

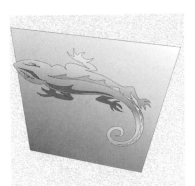

Limitations and strengths

It is extremely important that you determine several key factors early on. These are absolutely necessary to help you determine what you can offer and what is inappropriate with the resources available.

- Budget. Clients are often hesitant about this area. You must earn their trust. This is imperative data for later decisions.

- Equipment. This is so important that equipment purchases are often budgeted into your price quotes.

- Deadlines. Many design decisions are forced upon you, even before the creative process starts, by the required completion date.

- Subcontractors. Portions produced by outside help have deadlines, too.

These four factors will have a huge impact on enhancing or limiting your design. There is no sense even thinking about process color if the client needs 10,000 copies and only has $1,500. Even if you have the budget, being forced to use duplicators often eliminates tight-register projects. If things have to be wrapped up and delivered the day after tomorrow, even the largest budget won't allow the customer much beyond one or two spot colors. In fact, all that will be possible is often just a copier master with that deadline.

In contrast, if the client is willing to go with the best suppliers (service bureau, printer, and bindery), things can be done ridiculously fast with extremely impressive quality (especially if you have a good, ongoing business relationship with the suppliers).

Getting started:

1. Clean area
2. Read job ticket
3. Replenish supplies ②
4. Set up file storage
5. Read ALL copy
6. Determine illustration needs
7. Determine photo needs
8. Scan and trace lineart
9. Make sure copy is usable
10. Send photos to scanner
11. Assign graphic production

PRODUCTION — STEP TWO

Getting started

By this time, it is easy to see that your mind will be whirling with data. You need something to focus on. This is not a time to try to produce ideas. There has not been enough time to process the data. You will discover that first impressions are often very weak ideas.

Organize your area!

The first three steps are obvious, yet often forgotten in the pressure of work and deadlines. Messy work areas slow you down. Not reading the job ticket allows you to design without ever orienting to reality. Running out of supplies in the middle of a project is frustrating at best. Plus this work is simply busy work to keep your hands busy without mental effort. This allows your subconscious to continue at full speed with the data processing that is the natural result of all the questions you just asked.

Step four is a killer. If you do not set up your files and folders (documents and subdirectories) BEFORE you begin production, you will regret it. This is one area where preplanning saves an inordinate amount of time. Unless you plan where to store your pieces, someone will have to spend hours organizing things when you finish.

Many companies have standard filing systems. If so, step four goes quickly. If you have to create a system, make it easy to understand. Please do not think of this as a waste of time. It is actually the first step to organizing the data you are digesting internally.

Organizing your storage focuses on the task at hand.

Remember, someday someone other than yourself will have to figure out your filing system. What will they do when you call in sick, see it at the service bureau, or whatever? KISS — Keep It Simple, Stupid! Make the folders' names obvious and consistent. If working with DOS (or cross-platform), make a printed index of all subdirectories and update the file additions daily. Those eight-letter codes are incomprehensible to anyone but you. Index them with clearly labeled explanations of file content.

Read ALL the copy!

Why is this being stressed so hard? Because it is rarely done! It should seem obvious that reading the copy is the best way find out what is going on in a document. Yet many designers are so caught up in the graphics that they ignore the copy. You'll be surprised how much this simple step helps.

1. You will find and correct many errors before you even format the copy.

2. You will be able to get questions answered before you waste time on wild goose chases.

3. You will download, to your mind, the most important data for idea generation. If your ideas do not help the copy communi-

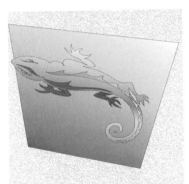

cate more clearly, they are probably a misdirection, at best. Use the copy to generate the concepts. The writer's job is to create copy that communicates.

The writer is the graphic designer's co-creator. With luck, you will get a chance to work with her on the content of the project. This is not the norm, however. Typically, you will receive the copy while you are in the question phase (often with last year's piece as the layout).

Graphic needs

Often the photos are supplied. If not, you need to get them shot, pronto. Once you have read the copy and the questions have been answered, the graphic needs of the project are usually obvious. It becomes a simple matter of budget and skill availability. Only create the graphics that fall into one of your primary skill areas. Your job as designer is to describe the need and find someone to fill it. You do not have to do everything. In fact, that is a foolish policy.

There is nothing wrong with top-quality stock art or stock photography. Most clients do not have the budget to create everything from scratch. Remember, your job as a designer is to solve communication problems, not to demonstrate your illustrative prowess. Top-quality stock art is far superior to inadequate original art.

A warning of experience

Illustrators and photographers are the bane of the printing industry. They are the source of most of the beauty and much of the ugliness. They are often difficult to work with because their priorities are so different. Most illustrators (graphic or photo) are highly opinionated and headstrong. They have to be, in most cases, for their emotional survival. Art creation exposes very personal matters to public scrutiny. However, this is no excuse for rude behavior.

Normally, only the best, most creative graphic designers can use illustrators well. Unless the graphic designer knows clearly what has to be done for a given project, the artists can easily sway design focus with their graphics. Often the message gets lost. This can be a problem with stock art also. Make sure that you know what you need for the design, and do not accept or use anything that changes the direction or focus of the message.

Remember, the message takes priority!

At this point, with graphic production assigned to illustrators able to produce graphics in the needed style, it is appropriate to scan and trace supplied lineart and to send the supplied photos to the scanner for halftone creation. Make sure that the copy is usable. If it is

on disk, make sure your import filters can read the files, or convert them in Word or PageMaker (FreeHand can only read Rich Text Format). If you do not have hard copy, print some out at this point (how did you read the copy if it was not printed out?). You may have to OCR the printed copy in some cases.

While you are doing all of these organizational tasks, ideas will begin popping to the surface. Now you can see why the areas overlap. Do not get sidetracked by working on those ideas yet. Just quickly jot them down (we'll discuss methods in a bit), and keep on with the organizational necessities. It will help you more than you now know to get all of these things done before you allow yourself the treat of creativity and the fun of design.

Idea Creation:
1. Research
2. Morgue
3. Thumbnails
4. Size
5. Roughs
6. Typography
7. Style choice
8. Color
9. Photo shoots or cleanup
10. Graphic creation
11. Logo creation

3

DESIGN — STEP THREE

Idea generation

It seems clear upon reflection that the first three items on this list could have been added to the bottom of the organizational list. However, they are much more directly involved with creative activity, and the four areas had to balance visually.

Often the ideas that started coming during organization require research. In addition, the idea quality might simply not be satisfying. Then you go to the library, search stock photo catalogs and stock art indices, rifle through your personal morgue where you have all those samples stored of materials you like, or check through your bookmarks in your browser to refresh your memory. You need to locate good reference materials.

Research and morgue perusal can trigger solutions when those ideas don't flow fast enough. Then the search for ideas becomes an extension of the organizational process. No matter how the process develops during a particular job, the key is to make visual notes. No matter how good the idea, it's a waste if you cannot remember it. You need notes of your ideas.

IDEA SOURCES
Although most ideas are very derivative, it is extremely important that you make them your own. This not only avoids lawsuits, but also promotes your individual style. The worst designers merely slavishly copy fashion without regard for the client's need for message communication. All you are doing is trying to trigger ideas and design solutions.

Copyrights and theft

One of the major problems with the new digital technology revolves around scanners. All of a sudden it is amazingly easy to "borrow" an actual drawing or photograph to use as the basis for your original artwork. The problem with that, of course, is that it is no longer original if it is based on someone else's talents and skills.

An outstanding example of this phenomenon is the scandal involving the winner of the yearly Corel design competition a few years back. The winning illustration was discovered to be a very beautiful, redone rendering of a stock photo. No credit was given to the photographer. A huge uproar erupted with massive lawsuits.

Even though there are a couple of small legal loopholes, the basic rule is this. Anything that has been drawn, painted, or photographed by someone else cannot be used. The only exception is work that is more than seventy-five years old. Even then, the estate may have renewed the copyright so it is not available.

Getting permission

The only way around this is to get written permission from the copyright holder. Current law reads that copyrights are automatic. The artist does not have to file or register the work to be protected until fifty years after death.

 If you have any doubt about legalities, get written permission.

You should expect that with the permission will come an invoice. The only way writers and illustrators have to make a living is to get paid. This means that they can and should charge for each use of their work. The same thing applies to writers. Do not be surprised if you are asked to pay several hundred dollars for image use. Many illustrations take 100 hours or more to produce. Most illustrators spent years virtually starving. When they can get paid, the going rate is reasonable. Image use without payment is simply theft.

A large source of images

The only major exception is work produced by government agencies. Because you paid to have it produced (with your taxes), you have the right to use it. This includes such outstanding resources as NASA, the Smithsonian Institution, and so forth. You will have to spend some research time, but many of these images can be downloaded from the Net.

Licensed stock art

This is a huge source of images. The problem here is to make sure you read the licensing agreement that came with the clip art or stock photos. Just because you bought a CD of photos does not mean that you can use them anywhere you want. The clip art that comes with the CD version of Photoshop, for example, cannot be used for commercial purposes.

Often, there will be restrictions on use. A typical example is the large and inexpensive library of Dover books. These printed books of clip art usually cost less than $10. The can be used freely — anywhere you want, for any purpose you desire. But there is a limitation. The license printed in the book states that you can only use a maximum of six images from any one book in any one project. To use more than six you have to get written permission. These kinds of usage restrictions are very common. Before you buy, if possible, read the license. If you can't legally live with the restrictions, don't buy or use the work.

Layouts

Although layouts are usually not protected, you have to be careful here also. For example, there was a lawsuit not long ago by Time, Inc. Someone uses the folded page corner, fonts, and color scheme of the *Time* magazine front cover. They paid dearly for the theft. The same problem would exist with the yellow border of *Geographic*. The basic rule is:

When in doubt, don't!

Visual notes

Thumbnails and roughs (or quick design sketches) have been commonly taught to artists and the design community for centuries. When the computer arrived, many designers dropped the practice. It is so easy to design directly on the screen that thumbnails were seen as a waste of time. Everyone wants to work directly. Recently, however, the original value of the practice has been realized.

The problem with sketching on a computer is that it is too perfect. In most cases, you don't sketch a border. You simply drop one in with the rectangle tool — it's perfect. In fact, it is unnaturally precise. The corners are all perfectly square. The edges are all parallel. The lines are too straight. In all ways, it is a mechanical shape. Computerized sketching tends to lead to boring design.

We have rediscovered that quick hand sketches produce glitches and bumps in the shapes that are important. In fact, these "aberrations" are often what your mind sees as the true shape. That misshapen corner allows your mind to see the shape as an irregular trapezoid instead of a rectangle. That four-sided shape with no square corners and no parallel sides turns out to be much more visually interesting than the sterile rectangle. These visual clues are totally missing from computer sketches.

Thumbnails

My use of thumbnails is a bit different from the traditional. My thumbnails are visual notes in personal shorthand. They are very fast sketches (usually less than thirty seconds) that give me only enough data to remember the idea if I decide to develop it into a rough.

As I am organizing, I jot down ideas as thumbnails. These thumbnails are meaningful to me, but no one else can decipher them.

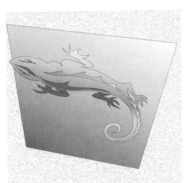

They are small (less than an inch square). They are so quick that others see them as scribbles. Because they are done so fast, all detail is missing, but the overall layout is captured. This is proper procedure. Many designers ruin an excellent idea by developing detail to great lengths but leaving the overall composition with no balance or direction. This type of thumbnail helps to avoid that problem.

Roughs

When you are done organizing, gather the thumbnails and pick out the ones you think will work the best. Develop these into roughs. A rough differs substantially from a thumbnail. Primarily, it is done to size. In other words, make a much more finished sketch the same size as the finished project. If the final printed piece is too large (like a billboard), make the roughs proportional (in the same height-to-width ratio as the final piece, just smaller).

In this case, I chose the thumbnail at the lower right. I liked the way it looked and somehow it seemed to express what the paper mill wanted to convey with its line of bags, boxes, towels, and chipboard.

You do not want to spend any money on materials for roughs, so they are produced with the tools at hand: pencils, markers, watercolors, and the like. Try to use the actual paper you are going to print on. However, this can cause problems with bleeding unless you are using pencils. Do not spend more than a half an hour on a rough. In fact, unless the client requests to see them and pays for the privilege, do not show them to the customer. Unless your clients are visually educated, they will see different things in your rough than you do. Most times, just doing a slightly more careful thumbnail is what you need.

Roughs can be scanned in and placed as templates in the actual digital documents used for production. In the image above, I thought the triangle and type were too crude to be used for anything other than a proportional template. I will place it into the background and lock the background layer, so the image can be used to keep things in proportion. When I am done the rough is simply deleted.

However, the tree has a nice loose feel that helps keep the logo friendly. It's got some problems, but they are easily fixed in Photoshop. I spent about ten minutes cleaning up the image and adjusting it to the

vision I had in my mind. As you can see, I added some delicate detailing; cleaned up the ground; added a few smaller plants and debris; balanced the tree vertically; and made it more solid in appearance. The final result had the basic look of a tree that might be used for pulp.

The next step was to place the cleaned-up tree into a new FreeHand document, locked in a background layer, and autotraced. As soon as it was traced, I JOINed it into a composite path to make the holes transparent. Then I deleted the tracing TIFF and placed the rough into the background. After lining it up with the trace, I locked the background layer so I wouldn't keep on selecting it accidently.

Then, using the rough as a guide, I added the type and the triangle. As you can clearly see, the image in my mind had little to do with the actual type. You'll have to take my word that it is a faithful rendering of the idea I saw in my mind. If this were a real project, I would probably do more with the font choices. These are just ones I had open on the computer while writing this book. For a real client, I would have gone through my library of several thousand fonts to make a choice that was more in keeping with the client's traditional usage — but then, as the client doesn't exist, that seemed to be a waste of time. This final version of the graphic would traditionally be called a comp (short for comprehensive). It should be output on a color-calibrated proofer and shown to the client for approval.

<u>BACK TO THE IDEA LIST</u>

Picking a style

While taking notes on ideas, you will begin to get a feeling for style. This is one endeavor that definitely needs a historical context. For example, if the project is a picture story booklet for senior citizens, it might be helpful to consider the layouts from *Look* and *Life* in the 1940s and 1950s. If the task is a reminiscing article on Jefferson

Airplane (or Starship, depending on your age), a good place to look would be the style of the early *Rolling Stone.* If the client needs an ad for the *Smithsonian,* it is simple common sense to look at that magazine for layout ideas.

It is important to choose a style that will appeal to the chosen readership. A no-holds-barred, professionally ugly, nail-'em-to-the-wall approach will probably work with the snowboarding set. It will spell disaster if you are producing a fund-raising brochure for the Prairie Star Buffalo Restocking and Wild West Nostalgia Fund.

Typography

Some of the first choices to be made as a style is chosen are the fonts to be used. This is an absolutely critical decision that will greatly affect readership. The fonts must be consistent with the style. Art Nouveau fonts do not work well for a financial prospectus. Geometric sans serifs rarely work for brochures concerning support groups for abused women.

As mentioned many times already, the font choices are among the most important choices you will make concerning the general "feel" of the piece. More importantly, it almost entirely controls the first reaction. In an environment where you have only a few seconds to get the reader's interest, an appealing font choice can help a great deal.

Color

Early in step one, you and your client were forced to come to a decision concerning the amount of color that can be budgeted. As you finalize your layout and style decisions, you should pick an actual color palette. This is true even if you are working in process color.

Although you have millions of colors at your disposal with four-color process, a limited and structured palette is much more functional and manageable. More than that, it helps you develop a specific look for your project, thus greatly helping with that prime virtue, consistency. When you pick a color palette, include as much of the spectrum as possible.

With process, that means you'll need a basic yellow, red, and blue, plus an appropriate gray and a brown or green that works with the others. This will enable you to put together a color scheme that is coherent, but not really limited. With choices in all the primaries, it becomes easy to develop a full-color look that remains consistent.

With two-color spot, this usually means picking secondaries or complements that cover a wide spectrum. For example, instead of black, use a deep slate blue, then complement it with a leaf green or a rust. Deep purple works well with lighter greens or orange-browns, and it pops with a deep yellow or mustard.

Remember that the key to making all of these things work is contrast. Without enough contrast, you will never make it work. If you

hit it too hard, you can always pull it back with judicious use of tints. However, hitting it too hard is almost never the problem. Normally, especially with new designers, the problem is timidity.

Talk with the crew

As soon as you have the style finalized, communicate your decision to those producing the pieces of the project: artists, writers, and photographers. The more they know about what you need (and the sooner they know it), the better the results will be. With creatives, holding too tight a rein causes stilted and contrived artwork. Allowing too much freedom gives license that can produce beautiful art that has no bearing on your content or style.

Let them know what you need — no more, no less.

At this point, it is time to gather everything into a neat pile. Put all of your logos and PostScript graphics in a folder (originals and exported graphics). Put all your scanned photos in a separate folder (high-res halftone or sep or the low-res FPOs if you are going to be using an image substitution scheme with your service bureau). Go stretch your back, drink a cup of coffee, or whatever you do to relax and clear your mind. It's time to get to the actual work the client hired you for: the production of finished documents.

Composition:
1. Document setup
2. Document defaults **4**
3. Style palette
4. Color palette
5. Import copy
6. Format copy
7. Approve graphics
8. Import graphics
9. Adjust layout
10. Proof
11. Corrected proof to client

PRODUCTION — STEP FOUR

Composition

Here we are using that old-fashioned term, composition, because at this point the design is largely done and the important decisions are all made. All that is left is assembly. It is important to

stay light on your feet (mentally). Productions always raises questions that were forgotten in the excitement of creation. No matter how tight the rough is, things never fit exactly as planned. Even after a long professional career, a designer's final documents regularly look decidedly different from the roughs and layouts. You are still in creation mode, but the process is much easier because all the pieces are in hand and the stylistic decisions have already been made.

Defaults

The first thing that has to be dealt with is the defaults. Everything we discussed in chapters three and four must be adjusted to this specific project.

The first step of composition is to take control.

Setting up a functional set of custom defaults takes a fair amount of time. The temptation is to skip over this step. Do not do it! Sure, quick half-hour jobs often do not allow the luxury. Even normal one- or two-hour jobs don't seem to require it. But all it takes is a serious copyfitting problem for you to realize what a fool you would be if you didn't SET YOUR DEFAULTS.

You should have your basic defaults already set up, but you'll need to adjust fonts, sizes, leading, tracking, font width, hyphenation, linking control, amount of auto leading, indents, tabs, paragraph rules, leaders, colors, text wrap, margins, columns, master pages, automatic page numbering, typographers' quotes, table of contents entries, line width and color, fill color, guides, and more. Yes, the entire list has to be reviewed. You do get very fast at this after a while, but that skill must be developed and encouraged until it becomes a habit.

Save your document(s) to the proper folder

The first step when you open your new documents is to save them. Before you can even open the new file, you usually have to choose the number of pages, the page size, the bleed, the margins, and the resolution. After saving, you adjust your defaults. This is done by going through the Preferences dialog boxes and by making changes to the dialog boxes. At this point you also want to create your master pages in your page layout document.

If your page layout program uses them, this is when you have to set up your text boxes and linkages. Programs, like FreeHand and Quark, that use text boxes tend to be very clumsy to relink. It is worth your while to spend careful time developing your master pages before you start composing.

The second step is to set up your palettes – style palette and color palette. The STYLE panel is your major organizational tool in your page layout program and in FreeHand. It is an incredibly powerful capability that gives you global control of all the type in the entire document. The color palette was covered thoroughly in chapters three and seven, in the discussion on the interface and the different color spaces. It is also essential for efficient production.

Import and flow

At this point, almost all of your work is done. All that remains is final assembly and massage. By massage, we mean the gentle kneading and shaping of the type and graphics until everything fits the way it should fit. If you have prepared properly, this should be an almost effortless exercise. Here's a suggested order for final assembly:

- Import your text and flow it into position.
- Correct the formatting using your style palette.
- Import your graphics and place them.
- Size the graphics and adjust the text wrap to produce the best-looking, most readable type.
- Adjust the style palette to make the type fit the required space.
- Print a proof.

Here you will find yourself using FreeHand a lot. Even though the halftones and separations are all done in Photoshop, and the final document is assembled in PageMaker, Quark, or InDesign, there will be many times when you want to go quickly to FreeHand to set some type that has be adjusted to a particular space. Or you will discover that you have a little too much white space, so you need a custom manipulated headline. Or you've got a two-page spread that is horribly dull and you decide to make some custom numbers or a custom dingbat for that bulleted list. Or ...

You are not done yet

We cannot emphasize enough how important it is to proof the document thoroughly. Sloppy proofing is one of the surest signs of unprofessionalism. It is the cause of countless problems with client relationships. Everything should be proofed by three people minimum. You can be one of the three, but you cannot be the only proofer. One thing is certain: if you made the mistake in the first place, you will probably miss it when you proof it. If at all possible, turn it over to a professional proofreader (some call this person a copyeditor, but copyeditors also have authority to change the style of the copy).

Client approval

At this point, everything comes to a screeching halt until the client reads, proofs, and signs off on the proof. This is one place where you do not want to be Ms. Nice. Without a client signature on the

proof, any production problems can (and probably will) be made your responsibility. You will be forced to either pay for or absorb any correction costs. These unbudgeted expenses can easily run into thousands of dollars, so be forewarned!

The customer is always right?

Of course not! What we have to keep foremost in our minds is that it doesn't matter whether the customer is right or wrong. Our job is to serve him. Our task is to convince him that we are professional and that we really care about his business. It does not matter if he's wrong: if we treat him like he is, he is gone. That may solve the problem (since he is no longer our client), but it is a poor way of doing business.

A service industry

Publishing has been referred to as a service industry throughout this book. As we draw to a close, it is imperative that we review, and this is the most important fact. Our job is to please the client. We are manufacturers of custom products. We normally cannot just make millions of copies and throw them around, hoping to sell a high enough percentage to stay in business. The best Website has to attract hits and keep them, or its design costs are a total waste of time and money.

We sell custom products for individuals. Even though you may be dealing almost exclusively with large corporations, it is the individuals in the corporation that matter. If we do not make the individual who ordered our services happy, that person will find a designer who will. It is that simple.

Two out of three isn't bad

There has been an adage in the industry for many years. You can have any two of the following three qualities: fast, excellent, and inexpensive. In others words, you can have fast and excellent, but it won't be inexpensive. You can have fast and inexpensive, but it won't be excellent. You can have excellent and inexpensive, but it won't be fast.

But it's not good enough

The problem is that the adage is no longer true. Our industry is extremely competitive. Many publishers now meet all three of those parameters. It used to be considered cute to have a large sign over the door saying, "If you wanted it yesterday, you should have brought it in tomorrow." You cannot blow customers off with cute sayings anymore.

Rush jobs are a major portion of our income. Ridiculously fast deadlines are one of our major opportunities to win customers who remain loyal because of our service.

There was a very common cartoon, printed in various poster sizes, showing a printer collapsing on the ground in gales of laughter, choking out, "You want it when?" In this age, those attitudes will send your customers down the street faster than you can imagine. They have serious problems. Your task is to help them solve their problems.

Sometimes it's impossible

However, sometimes you can't. Most clients are smart enough to realize that 30,000 copies of a 200-page, perfect-bound book will not be done tomorrow. What you have to realize, though, is that there are companies that will give it a real good shot. In an age of digital production, many things are possible that were not possible ten years ago.

THE REALITIES OF PRESSURE

Deadlines

Our industry is run on deadlines. Many of these time limits are ridiculous. We know it. The customer knows it. It does not change the fact that the deadlines are real. If you are producing an event program, complaining about the deadline will not move the event back a day. If the SEC has a March 1 deadline for receipt of that annual report, March 2 is not good enough.

It is common to blame the client for delays. It is common for designers to lose work because they blame their clients for deadlines. Instead, they should figure out what can be done as soon as the job is brought in. This is one of the main reasons for the questioning process. One of the things you are looking for is possible production problems. You can do a great deal to help customer relations by simply explaining reality to your clients whenever possible.

Sales staff and CSRs

Reality checks are primarily the task of the sales personnel. As they locate and close deals with clients, they must be aware of the deadlines involved. However, more and more, we are all involved with the customers — face-to-face, by phone, or by email. In modern digital publishing, all of us deal with the clients.

Usually, only the owner or the production manager has the authority to turn away business. You must accept the fact that they will do so only if absolutely necessary. In most cases, they are driven by the need to get more business. Being able to refuse a paying customer is not a normal attitude of a successful publishing manager. Their goal is usually to get so much business that they need additional help.

*An excellent employee is prepared
to do what it takes.*

That's a scary thought. What if you are asked to work the weekend? What if you have to come in a little early or leave late? Are you willing to be reliable help to your employer? This goes way beyond the normal requirements of showing up every day, on time, ready to work.

The proper attitude

We cannot continue until we cover what you should expect to offer an employer. They do not owe you anything beyond honesty and integrity (even these are sometimes in short supply). When you are hired, you will be given a list of company expectations — sometimes written, sometimes verbally, sometimes through the grapevine.

Your job is to meet those expectations. If you cannot, do everyone a favor and find a place where you fit. Every position has pluses and minuses. You want to find work where the positives meet your needs and the negatives are inconsequential. It is not the employer's job to change the company to satisfy your desires. Their concern is financial survival.

Owners and managers make the big bucks because they have the big headaches. If you want the money, you get the pressure. It is a decision you have to make. You will never be a welcome employee if you are always complaining about reality. Your task is to meet your employer's needs by satisfying the company's customers.

You need to be prepared to work extra hours and to put the company's needs on a high priority. You will discover, as your career develops, that many people do not do these simple things. As a result, they make everyone's life miserable — always complaining, always the bottleneck in production. If you are like that, do us all a favor and find another career quickly.

Publishing is a team sport. All of us need to work together. Many students are almost horrified to learn that they cannot take anything all the way through production. Sooner or later, you have to hand off your baby to someone else. The likelihood is that you will be working on something started by someone else anyway.

The key is communication

How many times has this been said over the past 300 pages? Experience shows that it cannot be repeated often enough. There must be good communication between the sales staff and the client; the sales staff and the designer; the designers and the client; the image

assembly staff and the pressroom; image assembly, the client, and the press room; the client, designer, and ISP; designer, programmer, and ISP; and so on.

The job ticket

The first major communication tool is the job ticket. This is the way the sales staff communicates with the rest of the shop. It is extremely important that these forms be filled out accurately and *completely*. Not only are the complete job specs required, but also the complete client name and address, former job numbers, and the appropriate contact person(s) with both phone and email.

Just as important as filling out the job ticket is reading it. Most jobs that have to be redone were messed up because someone did not read the job ticket. Do not take anyone else's word for what you need to do – read the job ticket! This even covers the bosses' instructions. You make them look good if you discover that what they told you does not match what is on the job ticket. You can save the company thousands of dollars.

Customer proofs

The next most important communication tool is the proof. We've mentioned them throughout. However, we need to examine them from the customer relations viewpoint. The most important proofs from a legal and public relations standpoint are the customer proofs. These are sample prints or a Web page that explains what the client might not know.

Three proofs are usually necessary. This differs a little in print and Web. In print, the first is a laser proof of the artwork, marked up to show the color break. The art or copy proof must be signed off by the client before you proceed to the expense of a color proof. In some cases, it is better to have an artwork proof that has FPO graphics. You might not want to spend the time color-correcting separations if the customer has not even approved the photos yet.

Often, what we are calling the art proof takes the place of what used to be called the comprehensive or comp. The comprehensive was accurate enough to enable the client to approve the artwork (without spending any more time or money than necessary). In many cases, all the budget will allow is a digital color print of the final artwork and the hope that the client doesn't make too many changes.

It is important to make sure that the customer realizes that signing the art proof means that she approves of the graphics and the copy on it, including all typos, spelling, and grammar. If you do not have that, you will find it very difficult later to charge for customer alterations. Supposedly if the client changes her mind, about copy or layout, she should be charged for the time and materials it takes to make those changes. Without a signed art proof, you have no evidence

that she ever liked the artwork in the first place. This is one reason why you need such thoroughly proofed proofs before the customer sees them. Clients are rarely professional proofers. They will not see typos or obvious printing errors. It is very bad form to use their lack of expertise to point the accusing finger when something goes wrong. "But you signed the proof ..."

On the Web, proofs go in stages. One of the real advantages is that Web sites can be updated at any time. In fact, they should be redesigned, updated, or simply changed about once a month or so. Therefore, Web proofs tend to be ongoing emails with a link to the page, saying something like, "I changed [x], what do you think?" Web graphics should just be attached to an email for proofing.

Getting customer approval

The signed proofs become legal contracts. You promise to produce the work as proofed. The client promises to accept and pay for the work as proofed. There are ways to ease the approval process. The primary method is by doing thorough proofing yourself. As a general guideline, you are in trouble if you have more than one correction per four pages. Any more problems or typos than that and you will be considered less than professional.

The basic problem is that clients are used to Madison Avenue, just like the rest of us. Their baseline assumption is perfection, because that is what they are used to. When's the last time you saw a typo in a national slick magazine? A sizable percentage of clients feel the same about artwork charges as they do about dental bills – and it does not make them happy. Many of them are looking for an excuse to prove that they know as much as you do. You will find, in not a few cases, that customers will use your mistakes to try and leverage a reduction in the charges. What is the simple solution? Do not give them anything to pick on. Give them a technically perfect proof.

The customer **is** *always right!*

The old saying, "The customer is always right," is not a joke. It is a truism. In other words, it is so obviously true that it seems stupid to mention it. This is where we started this chapter, but we have not covered it yet. By definition, the customer is right because our job is to serve the client. Our task is to bring their requests into reality.

There will be many times when you are asked to do something very difficult. Remember that you chose this career to avoid boredom. To develop skill, you have to be stretched. If everything is easy, you get bored, relax into bad attitudes, and begin to dislike your profession. Some of your clients' most ridiculous requests are your best

opportunity for growth. Learn to relish the challenges. The boring sameness of jobs can really get you down. For example, when you have something as tightly controlled as a Coca-Cola billboard, they all begin to look the same. They may be difficult, but they are boring.

You do not have to like your clients. You do have to respect them. In a very real way, the success of your business depends on the success of their business. Often clients are headstrong or arrogant or egotistical. Some of this is necessary; some of it is simply obnoxious. It is not your job to tell them that their arrogance is simply a projection of their insecurity (even though this is often true). They are in business to make a profit and your job is to help them. They need help, not hassles.

Business relationships are not social relationships.

Even if you do like your clients (and that is always pleasant), you should not expect a social relationship to develop. Friends that you hang around with tend to make poor clients. There is a tendency to give them favors, put their jobs on a higher priority, and do many other things that jeopardize your relationships with the rest of your clients. The friend who allows you to keep business on a businesslike basis is a rare friend. I hope you have many.

CODIFYING THE PROCESS

Business ethics

There are many lists and several books concerning business ethics and trade practices. For example, there is the excellent *Graphic Artists Guild Handbook: Pricing and Ethical Guidelines.* They put out a new edition yearly. We find their prices extremely high for our locality, but it is easy to make a percentage adjustment. Another reference is *Electronic Design and Publishing Business Practices* by Allworth Press (1996). Don't restrict yourself to this list. Ask your employers for a copy of the list they use. In general, these books are concerned with legislating morality, which is always tricky at best. The basic tenets are always the same: honesty, integrity, keeping your word, and fulfilling written agreements. In this day of constant litigation and adversarial relationships, it is extremely wise to have written contracts.

This is a major pain. However, it is really not optional. Contracts are not about limiting people and keeping them in line. The purpose of a contract is clear communication and mutual agreement. Little is more disheartening than to do exactly what you think you were asked to do and get screamed at for your incompetence. People simply hear wrong, believe it or not.

Your word may be good, but that does not help if clients think you promised something else. This does not count those who are looking to pick a fight to avoid payment. Those people exist also, and contracts help keep them in line. The best thing is a standard printed contract. The *Graphic Artists Guild Handbook: Pricing and Ethical Guidelines* has many of these, of almost every possible variety. That way personal friends and disliked clients get the same treatment. It is all in the interest of fairness and *communication*.

When in doubt, write it out!

Another reason this book cannot be a complete guide to industry practices is the flux things are in. This chapter closes with a series of areas to think about concerning your business and/or your employer. Chances are things are still changing rapidly.

- How are roles defined?
- When will quotes and proposals be ready and what will they contain?
- What proofs will be provided?
- Who pays for which alterations?
- What are all the deadlines and delivery charges?
- Who stores the materials?
- Who owns the materials: the output and the digital files?
- What is the payment schedule?
- What kinds of rights are being purchased (copyright questions)?
- How will disputes be settled?
- Who is paying for production?
- Who is responsible for production?
- Who handles outside services and how are they billed and paid for?

As you can see, it gets very complicated. The likelihood is that your new employer already has a working set of guidelines in use. If the company doesn't, the two books recommended are excellent resources. They are part of your necessary knowledge.

Knowledge Retention:

1. What can you do about deadlines?

2. How does "getting started" help generate ideas?

3. Why is it important to know equipment needs as well as budget?

4. Is the customer always right?

5. How do you deal with a customer when she approved the error on the final color proof (now she wants it reprinted)?

6. How do you handle obnoxious clients?

7. What do you do if you don't have a job ticket?

8. Why do you need a morgue?

9. What is a designer's morgue?

10. How do you use roughs?

Where should you be by this time?

Finishing up, getting ready to move on to the next course. The most important project at this point is your logo, letterhead, and résumé. You should be seriously thinking about future employment.

DISCUSSION:

You should be enjoying your friends and having fun producing great work for the clients you serve. You should be gathering names, email addresses, suppliers, and setting up your network.

Talk amongst yourselves ...

PRINT & WEB
GRAPHICS
USING FREEHAND

Appendix A

Xtras and Operations

Additional tools and abilities

FreeHand's Filters

299

Operations

Options ▼

- Create PICT Image...
- Fractalize
- Trap...
- Crop
- Transparency...
- Inset Path...
- Expand Stroke...
- Union
- Divide
- Punch
- Intersect
- Blend
- Simplify...
- Remove Overlap
- Reverse Direction
- Correct Direction
- Set Note
- Release to Layers
- Envelope...
- Emboss...
- Add Points

Xtra Tools

Options ▼

- 3D Rotation
- Arc
- Fisheye Lens
- Smudge
- Spiral
- Shadow...
- Roughen...
- Mirror...
- Graphic Hose...
- Eyedropper
- Chart...
- Bend...

APPENDIX A: XTRAS AND OPERATIONS

Doing the flashy stuff!

Filters

Now we come to a category of tools that I consider trouble. I am referring to the Xtra Tools and the Operations toolboxes. The first reason that they are trouble is that they cannot be set to a usable location by default. They always pop up in the middle of your screen the first time you open FreeHand every day and they have to be put out of the way. You really do not use them enough to justify wasting the memory on keyboard shortcuts — however, some of you will do that. Mainly they have been used as braggin' rights by FreeHand and Illustrator. FreeHand wins, of course, because it can run all of the FreeHand Xtras and all of Illustrator's filters.

 In general, the best way to use Xtras is by using the XTRAS menu, which you can customize so that it holds only those tools you use. The two palettes have to be used the old-fashioned way by setting up a location that is useful and then zipping them back into storage locations.

The biggest problem, however, has to do with taste. Several of these tools (for that is what they are) merely distort images in ways that tend to make students verge on ecstatic experiences.

"Wow, you can do that!"

Many of them really have little practical use in helping your clients communicate with their readers, viewers, or surfers. They are what I call TOOLS FOR NOUVEAU RICHE DESIGN. Much like a set of gilded longhorns on the hood of a gold-encrusted Cadillac, all they do is clearly demonstrate the designer's conspicuous consumption of program bells and whistles, along with a decided lack of taste. The basic attitude seems to be, "Well, I can't figure out how to fix this, so let me play with this tool to cover up my lack of skill." As we quickly go through the two toolboxes, I will merely note these tools as nouveaux riche. You may certainly disagree with me. But I am almost certain (or should I say hope) that experience will teach you that these tools have little real use other than to distort shapes and make them ugly.

Operations toolbox

After my diatribe in the preceding paragraph, I have to admit that several of these are useful. The first one, however, CREATE PICT IMAGE, will be used rarely. First of all, it is Mac only (although it serves the same function in the MacOS as Windows Metafiles do in Win-

301

dows). PICT is a file format that does not work in a PostScript work-flow. However, if you fax from your Mac, PICTs must be used for the underlying graphics on custom cover sheets. Also, PICTs are designed for monitor viewing, so they are used in presentations and multimedia.

 FRACTALIZE

This is a clearly nouveau riche, "wow you can do that" tool. Amaze yourself for awhile, and then turn it off — please.

 TRAP

This was covered in chapter ten. It is used for advanced printing adjustments for high-resolution, tight-registration printing.

 CROP, TRANSPARENCY, UNION, DIVIDE, PUNCH, and INTERSECT

These operations are often used to combine paths and they are covered thoroughly in chapter five on combining paths. It is recommended that you assign custom keyboard shortcuts to these five Xtras, because you will use them a lot. They are often the simplest solution to a drawing problem.

 INSET PATHS

 EXPAND STROKE

These two options are occasionally the only solution to a design problem. EXPAND STROKE lets you convert a stroked open path to a closed shape by outlining the stroke with a path. It would be much handier if it would outline those flat arrow heads (but then we cannot have everything). INSET PATH lets you do the same thing with closed paths.

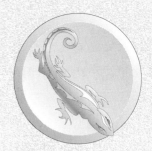

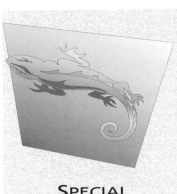

You should remember these two. You won't use them often, but when you need to, they're a lifesaver. EXPAND STROKE in particular provides the only way to apply a gradient fill to a line in FreeHand. Other than that you'll have to go to InDesign or Photoshop for that effect.

 BLEND

Turn it off. You'll have the keyboard shortcut memorized shortly, plus you can put its button on one of the toolbars.

 SIMPLIFY

This operation (when used carefully) can eliminate extra points generated by autotracing and clean up shapes in general. This Xtra can also be used to solve printing problems that might be caused by paths that are too complicated, with too many points.

 REMOVE OVERLAP

This is usually used to clean up overlapping paths generated by graphic pens and tablets. It fixes places on shapes where the path overlaps itself, causing even/odd fills and other aberrations.

 REVERSE DIRECTION and CORRECT DIRECTION

These are rarely used any more now that FreeHand has made path direction completely transparent and functional. This was formerly a problem with FreeHand 4, 3, and earlier. However, I haven't had to use these options for several years. I would turn them off.

 SET NOTES

This one allows you to set a nonprinting note. I've never found a use for this one, but maybe if you send files all over the world?

 RELEASE TO LAYERS

This is that Xtra that allows you to convert blends to make animations in Flash that we talked about in chapter eleven.

 ENVELOPE

This Xtra is often the only one that works to transform an object or group into perspective. It tends to be very handy. It is definitely a keeper. The 3D Rotation tool found on the XTRAS Panel is often much clumsier in actual use.

The envelope gives you much more interactive control that enables you to manipulate shapes into exactly what you need. In addition, there are a number of presets that can really help. However,

like most distortion filters, it
can quickly distort a shape
into meaninglessness.

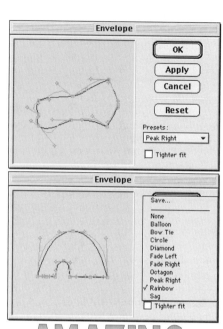

As you can clearly see
with the poor, beat-up
rectangle to the right, the
Envelope tool gives you eight
corner points with extended
handles that you can use to
destroy a shape in infinite
ways. The problem with the
filter is that all you get to
work with is this little preview
box. It's hard to see the points
well enough to actually
control things as well as you
would like.

You can see all of the
presets available. Most of
them destroy shapes. How-
ever, they are useful for
taking type converted to
paths and distorting it into a
given shape — but then again,
maybe not. Here's AMAZING
enveloped to a diamond.

 EMBOSS

This one is one of the
advertising points in the never-
ending war between FreeHand
and Illustrator. I have never been
able to use anything it does. I always give up and draw it the way I
want it to look. It tends to make graphics far too complicated. How-
ever, for those who do not know how to draw an embossed shape, it
can be very helpful. I turn it off. You'll have to decide for yourself.

 ADD POINTS

This one adds a point halfway between every pair of points.
There is no practical use that I know of, but that is probably just
because of my limited creativity.

The XTRAS panel

The XTRAS panel tends to hold drawing tools. Because of this
they tend to be a little more useful, although none of them will be used

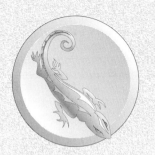

SPECIAL CAPABILITIES

as much as shape combination tools on the OPERATIONS panel. The most difficult thing with the Xtra tools (and the Operations tools) is remembering that they are available. While I was going through, taking a quick review before writing this section, I found several that I will use more (unless I forget they are there again).

 3D ROTATION

This one can be very helpful. Often ENVELOPE works better, though. It takes 2D images and rotates them through 3D space. The obvious problem is that these 3D rotated shapes have no thickness. For 3D extrusion, beveling, image mapping, and so forth, you will need specialty software like Add Depth®, Adobe Dimension®, or MacroMedia's Extreme 3D®. In general, with these fancier 3D drawing programs, you have to make a decision. You must determine whether the time and effort expended to open additional software and to learn how to use it is worth the occasional use you will find for 3D effects.

If you are into animation, 3D is essential for realistic effects. For two-dimensional graphics, you are far better off simply learning how to draw. In most cases, 3D rendering programs are simply cover for a lack of drawing abilities. If you find yourself drawing 3D images on a regular basis, then you should get both a vector and a paint version of 3D software. Be prepared to invest many thousands of dollars to add this capability to your arsenal of drawing tools. Not only is the software very expensive ($1,000 minimum), but you will need to substantially upgrade your hardware as well.

In general, three-dimensional effects tools are in that dreaded "wow, you can do that" category. As with all of these powerful tools, you have remember that they take a long time to apply. They usually take an equally long time to learn. The question is, as usual, "Does this really help me communicate more effectively to the reader or surfer?" The answer is almost always, "NO!"

 ARC

This tool draws arcs that function like grouped shapes. It's a handy capability if you remember it's there.

 FISHEYE LENS

This one works much like SPHERIZE does in Photoshop. You marquee an ellipse and everything inside that ellipse is bent to look like it is bulging. It works well for applying type to balls and so forth. It tends to be a nouveau riche toy for the drawingly challenged.

305

 SMUDGE

This one allows you to drag a shape to a new location, automatically generating a blend from the first location to the second. It is a noneditable blend. I'm not sure why you would ever want to use it. The clone, drag, edit colors, and blend routine can all be done with keyboard shortcuts. You can create the same effect this way before you can even get the dialog box open for the Smudge tool – plus the blend created this way is editable.

 SPIRAL

If you need a spiral, this is the only way to go. Spirals are very difficult to draw by hand with the Pen tool. This tool does it, and does it very well indeed. In fact, you can draw a spiral and then use EXPAND STROKE to get a spiral shape that you can fill as needed.

 SHADOW

Create shadows with ease? Not really. The dialog box is so filled with options that it will take you quite a while to get what you really want. Then when you get the effect you want, you will find that it is made of complicated blends that can bulk up your file size to unprintable levels very quickly. However, it is by far the easiest way to get the appearance of a soft-edged shadow in a PostScript illustration.

 ROUGHEN

When you want to mess up the edges of a shape, this is your tool. Its primary use is to fit into the "professionally ugly" genre, but it works well. The only problem is the "wow, you can do that" aspect. In addition, it can complicate a path so much that you run out of RAM and freeze the application (happened to me a couple seconds ago). Isn't this a pretty spiral?

The one below it is the same pretty spiral from above roughened a little bit more. A fine example of draftsmanship, isn't it?

Wow, you can do that?

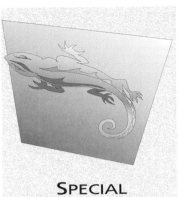

SPECIAL CAPABILITIES

 MIRROR

This one looks like a great deal of fun for making patterns and so forth. It will take a shape and clone/flip or rotate copies around a specified number of axis with mathematical precision. This is a shape mirrored around thirteen axis. It would make a nice little dingbat.

 GRAPHIC HOSE

This one works like Painter®'s, except it sprays vector shapes. It's kinda like flocking — neat, but not real useful. One word of warning. On my Performa with a 603 PowerMac chip, it takes two to three seconds for each image to show up, making the tool rather useless. However, even with a fast computer it can't do much more than patterns and textures.

 EYEDROPPER

This handy capability enables you to place any image (including bitmaps like TIFFs and GIFs) and drag'n'drop color swatches from that image to the COLOR LIST. It greatly helps with keeping a consistent color palette.

 CHARTING TOOL

The mini-spreadsheet enables you to create high-resolution charts that you can edit in FreeHand.

 BEND

What can I say but "distortion tool, par excellence"? FreeHand describes it as being able to create a pinched or bloated look. Why?

Again, there is a certain fascination with tools of this ilk. For

full-time illustrators, many of you will be using these distortions as long as professionally ugly graphics remain in style. Just please be merciful to the rest of us who are afflicted with ugly stuff, day in and day out.

Nonpaneled Xtras

FreeHand has several other Xtras that are only available under the XTRAS menu or are incorporated in other areas of the application. Some of these capabilities are extremely important.

Creating and editing PDFs

The PDF import and export options are found in the Export, Import, and Open dialog boxes. FreeHand directly makes PDFs (without needing Distiller). More importantly, FreeHand is one of the best PDF editors available (without a plug-in). With Acrobat 4 recently released and its promises of double-click editing in Illustrator and Photoshop, this may change temporarily. However, it is almost certain that FreeHand 9 will regain the lead. FreeHand opens multiple-page PDFs on multiple pages, each of which is editable.

Color control Xtras

These options are found under the XTRAS>>COLORS menu.

Color Control...
Darken Colors
Desaturate Colors
Import RGB Color Table
Lighten Colors
Name All Colors
Randomize Named Colors
Saturate Colors
Sort Color List By Name

COLOR CONTROL enables you to adjust the CMYK, RGB, or HLS color of selected objects.

DARKEN COLORS reduces lightness by 5%.

DESATURATE COLORS reduces the saturation by 5%.

IMPORT RGB COLOR TABLE adds the colors of imported graphics to the COLOR LIST.

LIGHTEN COLORS increases the lightness by 5%.

NAME ALL COLORS is very important. Unnamed colors often cause printing problems. You should use this one at the end of every design project until you develop good color application habits.

RANDOMIZE NAMED COLORS **WHY?** This creates color chaos using the COLOR LIST.

SATURATE COLORS increases saturation by 5%.

SORT COLOR LIST BY NAME alphabetizes named colors on the list.

Delete Empty Text Blocks

This Xtra addresses one of FreeHand's interface problems. Every time you click outside a text block with the Text tool, you create a new text block. The problem is that these empty blocks are invisible and can cause problems when you export the graphic. You may find that the handles of the exported graphic enclose an area that is much larger than the size of the actual graphic because they are making room for the empty text blocks. Running this Xtra before exporting will solve this little problem.

Delete Unused Named Colors

This helps a lot when your color palette gets unwieldy. It is relatively easy to end up with a color list that contains dozens of colors, even though you are only using four or five. Deleting the unused colors frees up room so you aren't constantly scrolling up and down on the COLOR LIST.

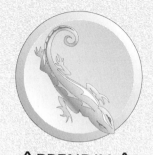

APPENDIX A: XTRAS AND OPERATIONS

Appendix B

Paper

Improving quality with paper choices

Choosing Appropriate Paper

What are you going to print it on?

This probably seems like a strange place to insert a section on paper. It almost seems like an afterthought. Nevertheless, the first material decision to be made is usually the paper, and this book is concerned with production.

Paper is a huge topic in its own right. It has a great influence on printing quality and production possibilities. It has a history that parallels printing (that's right, it began in China almost 2000 years ago). We have not covered — and won't try to cover — the nomenclature, categorizations, limitations, and availability of paper.

This is merely an introduction to the huge world of paper, to try to give you enough knowledge to ask intelligent questions. What happens with every designer is that she develops a standard selection of papers that meet her needs. There are tens of thousands of different papers manufactured by many dozens of paper mills distributed by hundreds of suppliers. What you will have to do is find the best paper available for the given situation.

Getting samples

Do not hesitate to call your paper supplier. Their expertise goes way beyond a designer's or printer's need. The field is too complex to store in your memory banks unless you sell the material. However, as soon as a paper supplier learns that you are designing and will be speccing paper choices for your projects, she'll be happy to provide you with swatch book and idea samples. Some of the best printing in the world is supplied by paper houses with idea books. For years Warren Paper produced some of the best books available on varnish usage, photography ideas, and many more in a series that was one of the best sources of ideas for designers. Sadly, it is out of print, but keep your eye open.

As you begin getting samples, start by finding papers that you like the look of. Then start asking questions about what papers are kept in stock, get the prices firmed up, and start building your palette of papers. You will find that you come back over and over to certain choices that make the most sense for you, your clients, and your budgets. As you develop your style and reputation, you will find that paper choices are a large part of it.

Those strange confusing weights

As we get into paper, there is much confusion about the weights (not to mention the names): 20#, 65#, 100#, bond, text, enamel, tag, pressure-sensitive ... the list seems to go on forever. The good news is that paper weights are very simple to understand conceptually.

The basis weight of a paper stock is the weight, in pounds, of a ream (500 sheets) of the basis size.

The only problem is that the basis sizes vary for each type of paper. As a result, 24# bond is about the same weight as 60# offset; 140# text is comparable in weight to 55# cover; 90# index is thinner than 65# cover. What you have to memorize is the basis size of the common categories of paper you use every day. Thankfully for most of us, this is only three sizes. Although there are well over a dozen different basis sizes for the various types of paper, there are really only three that you will use regularly.

Papers outside the norm

Before we start, let's just mention the papers that you will come across that you can categorize by name. Newsprint, for example, has a weird basis size and strange weights, but who cares? The newspaper publisher worries about that and you will never spec it. Whatever the paper uses is fine with you. All you have to know is that it is extremely cheap and very absorbent, and that you have to make sure you allow for the fact that everything will print like it's on blotter paper. This is much more important for photos than anything else, so we'll leave that for *Image Manipulation*, the author's book in this series about Photoshop and fixing scans.

In addition, at the cheap printers, you will find three papers sold as cover stock that you need to be careful of: Vellum Bristol, Index, and Tag. They are actually the cheapest type of paper – the worst wood pulp. Their only advantage is their price. They look cheap, feel cheap, and cause customers to think your client is cheap. But then if you are making a promo for Billy Bob's Junk Yard, they would work very well. They are very useful, but only if you understand their basic character – cheap.

Vellum Bristol only comes in 67# and it is the only 67# paper in existence. Index comes in 90# and 110#, and these are the only two papers that use this weight. You will use these fairly often, simply because they are often the heaviest papers that will feed through a laser printer or copier. Tag is so rare that you will always look for it

specifically. It's the paper used for those inspection tags with the reinforced holes held to the pipes with twisted wire. Tag is used so little because even most presses cannot feed it — it's too thick.

The papers you'll use

The commonly used papers can be broken down into three neat classifications. For most of your daily use, these will be sufficient. All the other categories are either the extremely cheap specialty papers we just mentioned or expensive papers for a particular use: such as label stock for wine or jam bottles; pressure-sensitive or crack'n'peel paper for bumper stickers and labels; plastic stock for posters and banners; latex-impregnated paper for waterproof and durable menus, and so forth. Most of these have different basis sizes. But if you use them at all, you will quickly learn to recognize them by sight. There really isn't much variety or choice in specialty options.

The three categories of office, printing, and cover stock make up close to 100 percent of the papers sold. Printing papers, by themselves, probably come to three-quarters of the paper manufactured and sold. You may hear figures like "half the paper sold is 60# offset". It matters not. What you need to know is that printing papers contain all the most commonly used sheets and rolls. Of those, 50#, 60#, and 70# offset are by far the most popular, followed by the same weights in coated stock. Almost all paper sold is white. There are hundreds of different whites ranging from almost cream to brilliant, snow white.

Experience is necessary

We will describe these papers in a little more detail, but you need to recognize that this is an unregulated industry. You must learn how specific papers behave on the printers and presses you have to use. Your customers will specify others that you will be forced to use. You will have to be the person who knows what papers cause problems and when and why. Also, some types of presses and printers can only use certain kinds of papers. You will have to learn what papers are available in your area, what manufacturers and what colors are stocked by the local distributors.

No area has all papers. No one stocks all the colors available for all the papers. Sometimes the paper you really want is only available as a mill order which usually requires 5–15 carton minimums. Paper is simply too bulky. A carton of paper ranges from around 50 pounds for 10 reams of 8.5"x11" precut stock to close to 150 pounds for parent sheet stock (typically 1,000 plus sheets of 23"x35" or larger). Buying partial or broken carton quantities normally almost doubles the price. You should ask your supplier about their pricing policies.

THE IMPORTANCE OF YOUR PAPER CHOICES AND TYPES

The most commonly used papers

Office papers: Basis size: 17"x22"

SURFACES: cockle, laid, linen, parchment, ripple, wove, rib laid
COMMON NAMES: bond, ditto, ledger, mimeo, onionskin, rag, writing
CHARACTERISTICS: tough, versatile, often beautiful; has personality only matched by text; is designed for writing; prints better on felt side; can be erased

Printing papers: Basis size 25"x38"

Uncoated sheets

SURFACES: antique, smooth, vellum, wove
COMMON NAMES: book, offset, opaque
CHARACTERISTICS: easy folding; wide variety of colors; most common paper; used for books and virtually anything else

Coated sheets

SURFACES: matte, dull, gloss, cast coat, embossed
COMMON NAMES: coated offset, dull, slick, gloss
CHARACTERISTICS: good ink holdout; produces ink gloss; smooth surfaces (some mirror-like); usually only comes in white

Text

SURFACES: antique, embossed, felt, laid, silk, linen, rib laid, vellum • COMMON NAMES: text
CHARACTERISTICS: premium papers for jobs that require "class"; even cheap grades are distinctive; many are very soft and take embossing superbly; deckle edges; wide range of colors, including deep and "fashion" colors

Cover stock: Basis size: 20"x26"

SURFACES: any of the above as a matching set
COMMON NAMES: C1S, C2S, cover as a suffix
CHARACTERISTICS: durable, stiff, strong; opaque for cards, folders, etc.

Obviously, larger cities have better availability. However, some papers are made on the West Coast, some on the East Coast, most in the Upper Midwest, some in the Desert Southwest. Shipping tons of paper thousands of miles raises costs to the point where local papers are much more cost-effective. The simple building size required for a warehouse limits availability. You need to cultivate relationships with your paper sales personnel for help on what is available. It will help more than you can imagine if you find a customer service representative that you can trust for advice.

313

Office papers

First we cover the top category on the graphic on the other page. Office papers are distinguished by the fact that they are designed for writing. We do print on them, but they have several characteristics that set them apart. First of all, the basis size is 17"x22", an exact multiple of 8.5"x11". That seems insignificant, but it means that bleeds are never cost-effective on office stock unless you design for special sizes or unusual formats.

Because office papers are designed to write on, they are heavily sized. *Sizing* is a coating that controls absorption. Good examples of unsized paper are blotter paper or paper towels. If bond papers were not sized, ballpoint pens would bleed into and maybe through the paper. However, it is important to note that bonds are sized well on only one side. They are not meant for double-sided use.

In addition to the sizing, writing papers use specially chosen, stronger fibers. This enables erasure of mistakes. It also enables office papers to hold up under the heavy use they receive. They are handled, filed, moved around, copied, and mistreated more than any other kind of paper. The only pieces treated more roughly are things like menus, pocket calendars, and membership cards. Those require either special synthetic stock, plastics, or laminated coatings.

These stronger fibers are not usually diluted with fillers. Fillers are used a lot in printing papers to make the paper opaque, but office stock uses relatively little additional fill. Bonds have what is called snap. This is especially true for premium bonds containing cotton fiber. Fillers weaken the paper and dull the sound. Much of the experience of top-quality bond paper is in the feel and sound.

Bonds are usually relatively translucent.

As mentioned, they are sized on only one side, so they normally are printed on only one side. This means that they do not have to be opaque like printing papers. In addition, writing papers are the only category offering watermarks. Watermarks are made in the paper pulp when it is extremely liquid (80 to 90 percent water). Wire patterns pressed into the liquid pulp rearrange the fibers, making them more translucent. There is no dent to be seen. You can design custom watermarks. Paper mills will produce custom watermarked bonds for you with relatively small orders. An order of only a couple dozen parent-sheet-size cartons is usually enough.

Bonds are usually white or light tints. This is because we write on them and because whiteout is available only in limited colors. This may be necessary no longer now that typewriters are gone. With

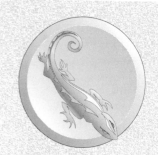

314

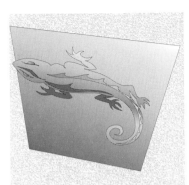

edited copy, printed on laser printers, the darker papers look very classy. The surfaces are often embossed with fabric textures like linen; Chinese papermaking bamboo screen textures called laid; unrolled, baked surfaces like cockle; and so on. The better papers are more conservative. A top-quality 100 percent cotton bond has a richness of surface, snap, and feel that is unsurpassed.

You should plan on spending $12 to $20 per ream on bond paper. Nothing makes a company seem questionable more than cheap, thin, floppy, and polished letterhead stock. In many cases, the quality of the paper used for your letterhead is the first impression a client, or prospective client has of your quality, ability, and reliability.

WHAT WE PRINT ON
Printing papers

As you can see on page 313, printing papers take up far more than three-quarters of the papers used. Printing papers are the papers you will be specifying (speccing) most of the time. They are designed to feed well through a press. They are well sized, equally on both sides, to control absorption. They use a lot of filler so the sheets are much more opaque. This allows double-sided printing without show-through. In other words, even on relatively thin papers, like 50# to 60# offset (even far thinner on web presses), the ink on the other side of the paper is not disturbingly visible.

Most printing papers, except text, are smooth and white. You'll get a feel for this if you try to imagine a novel printed on textured pink paper. These papers are used for all books, magazines, programs, brochures, and the like. The two major types of this smooth white stock are uncoated and enamel (also called coated). Uncoated sheets and rolls do come in pastel colors. Some even come in Day-Glo™ colors (often mistakenly referred to as neon).

Except for very rare cases, enamel stock only comes in white. There is one premium line of highly saturated hues and another that offers a cream coated, but these are very rare. Enamel differs from offset in only one way — it is coated with clay! It is actually coated with the same clay body as porcelain. The clay (kaolin) is polished on with calendering rollers. These highly polished rollers compress and smooth both coated and uncoated printing stock. In fact, calendering is one of the main distinguishing characteristics of these sheets. All printing papers are calendered.

Ultrapremium enamel sheets are supercalendered. These sheets are so smooth that you can see your reflection in the surface. They are sometimes called cast coat. Printing firms tend to think of these papers as the crème de la crème of papers, but this really is not true. They are very shiny and they print process color very well — that is, very brightly and colorfully. However, they are just wood pulp paper.

This is because the clay gives the paper great ink holdout. In other words, the ink does not soak into the surface (hardly at all), so the color is very bright and clean. Because it does not soak in, there is relatively little dot gain on the press. That means that the dots do not get as much larger as they do on uncoated paper. The problem is that the shiny stock tends to be garish, cheap-looking, and overly slick. It is hard to sell elegance and top-quality on superslick stock.

The truly top-quality papers are 100% rag or pure cotton fiber. These last for centuries without yellowing or getting brittle. They are very strong. Printing papers (except for the extremely rare 25% cotton text) are all pure wood pulp. This means that the papers are relatively limp. They tear easily. The surface cracks when folded (especially across the grain).

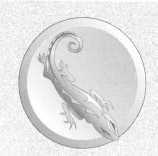

Wood pulp papers are extremely susceptible to yellowing and brittleness when traditional fillers are used. These fillers are typically materials such as rosin (the residue from turpentine production). Rosin is very acidic. Most of the great libraries of the world are in serious trouble because the acidic, wood-pulp papers used in books are falling apart before they can be put on microfiche. The most recent solution has been to use calcium carbonate (think TUMS®) for filler. This is a high pH material used to make paper that is normally called alkaline.

The paper mills are claiming that alkaline papers will last about 200 years. That is certainly better than the 20 to 40 years for traditional wood pulp sheets. However, it still does not come close to the quality of 100% rag stock. Wood pulp sheets do print beautifully. Plus, most printing is trashed within a month of production.

However, we haven't even touched my most used, favorite, category of paper — text. Text has the most fashionable colors, the best textures, the richest feel and look. It is completely uncalendered, so it works beautifully for embossing and foil stamping (especially the cover weights). It is quite a bit more expensive, but it is well worth it. Text sheets are the only papers that come in the rich dark blues, hunter greens, maroons, blacks, and so forth. Many of them look as rich as the finest fabric. In most cases, for short runs, a rich text paper costs less and looks better than a second spot color of ink. If you need to imply top quality, excellent service, and reliability, you really need to use text papers. The historic implications of the textures and colors of top quality text papers can bring an instant reaction of trustworthiness.

HEAVYWEIGHT COMPANIONS

Cover stock

Virtually all the papers mentioned so far come in companion cover weights. This is paper that has the same color, the same texture, and the same look but is much thicker and heavier. One way to get an idea of the difference is to make a basis weight comparison; 65# cover,

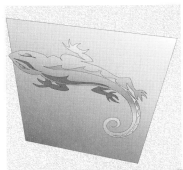

about the lightest cover stock worthy of the name, is roughly equal to 120# printing paper or 48# office stock. It would seem to make sense to use these weights, to help us understand. However, cover stock uses a different basis size (20"x26").

This basis size allows for many things needed by cover stock. Because an eighth sheet of 26"x40" is 10"x13", there is plenty of room for the tabs, spines, and full bleeds often found on covers. It probably wasn't planned that way, however; little seems to have been planned in the entire paper industry. Most developments simply seemed to happen, followed by codification into rather rigid usage.

READING PAPER LABELS

Wausau papers *Royal Felt*®

White Stone

23 x <u>35</u> - 119M

1000 Sheets-Basis 70

7 59598 85262 0

85262

This is a paper made by Wausau Papers called Royal Felt, color White Stone. The carton contains parent sheets at 23"x35" with the grain in the 35" direction (that dimension is underlined — on some it's bold). 119M means that 1,000 sheets of 23x35 weigh 119 pounds. There are 1,000 sheets in this carton and they have a basis weight of 70# (making this a text paper). It is a recycled sheet, 15% postconsumer waste.

HAMMERMILL PAPERS®	Hammermill Laser Plus® (Featuring Wax Holdout) Long Grain 500 Sheets **11 x 17 -24M-S24/60** For Prepress Proofing and Camera-Ready Masters	↑ Print This Side Only	**10452-1**
MADE IN USA		White	0 10199 00452 9

This is a specialized paper made by Hammermill Papers to be used for camera-ready output and pasteup using wax, called Laser Plus, color White. This carton contains cut sheets at 11"x17" with long grain spelled out (that dimension is also underlined — on some cartons it's bold). 24M means that 1,000 sheets of 11x17 weigh 24 pounds. There are 500 sheets in this package and they have a basis weight of S24/60 (making this a dual-purpose paper comparable to 24# bond or 60# offset). The printable side is indicated.

All of this is loosely based on the 8.5"x11" module used by the business community. Legal size, 8.5"x14", is only available in lowest-quality office papers. In fact, when a client asks you to design something on an 8.5" x 14" format, the first thing you should do is determine if this is a real need. It is possible that the client is ordering a template to be printed out on the laser printer in their office. Many laser printers cannot print anything larger than legal size.

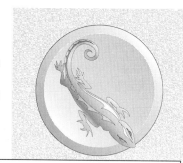

Even with this one legitimate use, legal size stock is always a waste of money. 8.5"x14" does not cut out of a parent sheet well. To do that parent sheets would have to be either 29 inches wide or 42 inches long. As it is, the standard parent sizes of 23"x35", 25"x38", and 26"x40" only allow you to cut out four pieces with a lot of waste. In fact, what you are really doing is cutting the legal size sheet out of an 11"x17" (tabloid) piece of paper.

The result of this is that you can turn these requests to your advantage. Because a standard tourist rack brochure (or any kind of rack brochure for that matter) is 4"x9", you can tell your client, wisely, that for the same price, they can have a 9"x16" brochure folded in half and in half again. The resulting 4"x9" brochure fits better in a standard business envelope for mailing; fits display racks perfectly; and gives the client over 20% more space to work with. In many cases, this will greatly enhance your reputation as a service oriented designer who really wants to help your client (as long as you are not condescending about it).

RECYCLING

A fashionable thing to do, going into the new millennium, is to use recycled paper. This is done with worthy motives. However, it is often executed with woeful ignorance.

Many recycled papers are recycled in name only. For many decades, paper mills have taken the huge quantity of production scrap and tossed it back in the vat of cooking pulp. Recently, these same companies have begun to gather this scrap into piles. The saved scrap is then used to make "recycled" paper — a legal loophole.

POSTCONSUMER WASTE

The key is postconsumer fiber. This is paper that has actually been used and thrown away. There are many problems with this source of fiber. The clay in coatings, staples, paper clips, tape, spiral bindings, and other foreign materials make a pulp unusable. Colored fiber causes problems, although these problems are being solved. Read your labels. There are a few paper lines that are 100 percent postconsumer.

The difficulty with postconsumer fiber is that it is overcooked. You know what happens when you cook beans too long and then reheat and reheat them. The same thing happens with paper fiber. It gets softer, weaker, and dirtier the more it is reused. One hundred percent postconsumer stock is usually a dirty gray, very limp sheet. It works okay; but it certainly does not leave a very good impression except with the enviro-idealism political activist set.

ALTERNATIVES

There are several plant fibers that offer some real hope. The problem is that the paper mills are so large that they own their own forests. Hemp papers used to be common. Ben Franklin used them. In the Southwest, kenaf paper is available, as is a sheet that uses fiber from the seaweed dredged from the harbor of Venice, Italy. These fibers come from plants that have huge growth in a single season. Hemp and kenaf can reach 20 to 30 feet with six-inch-thick stalks, in a single growing season.

Finally, remember that wood pulp comes from junk trees that are grown to be harvested, like any other crop. The real problem is wood for furniture and building. The large hardwoods and strong softwood trees are disappearing rapidly, but they are rarely used for paper pulp. You aren't "killing trees".

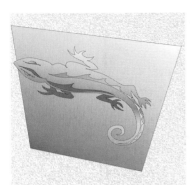

Thickness

One unusual practice is that cover stock is often sold by the point. There is 8-point cover, 10-point cover, 12-point cover, and so on. Here a point is not a twelfth of a pica. Instead, it is called caliper, stands for a thousandth of an inch, and is measured with a micrometer. This is a place to exercise care. Mailing requirements, for example, state that postcards must be between 7 and 9.5 points thick.

Some papers are much bulkier than others, so weight does not matter much here. Often some of the very cheap papers like vellum bristol or index are left uncompressed or use bulky fillers so they may be used for postcards.

What counts is calendering (compression by that tower of milled steel rollers). The more a paper is calendered, the thinner it is. For example, 500 pages of 60# gloss enamel might be .75" thick; 60# matte coated 1"; 60# smooth offset 1.125"; 60# vellum offset 1.25"; and 60# high bulk 1.5" thick. An uncalendared sheet like text will be more than twice as thick as gloss coated with the same basis weight. If you do not know how thick a sheet is, look in the paper supplier's catalog. Caliper is usually found in the paper listings right below the name of the paper. If there is any question, or there seems to be too many choices, called your service rep and ask him.

Planning for final thickness is often one of the considerations for the designer. It affects the thickness of the spine on perfect-bound books; the legal paper for postcards; the maximum number of pages for saddle stitched booklets; and so on. It is usually a simple matter of picking a paper and calling the paper house for a dummy. Most suppliers are happy to supply a folded dummy or the paper to make one (knowing that if it works, they have a sale). Sometimes the paper is sent to the bindery to make the dummy.

AN EARLY CHOICE

Picking the paper is important

Paper is often extremely important for small (short-run) jobs. On long runs, paper becomes one of the major expenses. For short runs, paper is often a negligible cost. On huge long-run jobs, setup charges (which include design and artwork) become ignorable. A $5,000 artwork charge means nothing on a $1 million job in which the paper costs might be as high as $750,000. On small jobs (runs of 2,000 or less), setup charges become the dominant factor. For a typical brochure, the artwork could cost $500, the stripping and plates cost $500, the presswork cost $150, and the paper be only $25 or $35.

On these little jobs, going to the most expensive paper on the market would triple the paper cost, but add only 5% or so to the

overall cost. In the two preceding examples, the short run case adds another $50. In the large job, we would be looking at a $1.5 million increase. For short runs, paper quality is a powerful tool to use for conveying quality.

 The smoother text papers print beautifully in laser printers. With their softness, the shiny areas caused by the hot rollers melting the plastic toner onto the sheet of paper are greatly minimized. The appearance of the project takes a giant leap with these papers.

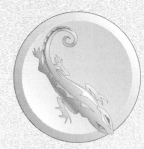
For short run projects,
paper quality is the cheapest option
in quality improvement.

The difference between a ream of the cheapest bond and the best, 100% cotton bond is around $25. Top-quality text paper is about halfway between. If you are printing only one ream, each additional color of ink will probably cost almost $100 in production costs at a normal commercial printer, and every additional hour of design or image assembly time adds at least $50 plus materials.

Even on longer runs, paper choice is critical. Glossy paper is often perceived as cheap because of all the newsstand magazines that use it. Simply going to a dull sheet can greatly increase the perception of quality. Often, for that top-quality image, two-color PMS on a top-grade text works much better than process on cheap coated. In addition, it often costs less.

 In general, any project needing less than 2000 copies is considered short run (unless there are many pages). Projects like these make up far more than half of all jobs you will get to design. Text papers can really help, at virtually no cost, can greatly improve the appearance and quality of your projects.

One of your first, and most important,
choices is the paper you will use.

Appendix C

**Teaching Style,
CD Content and Instructions**

A new
method of
instruction
is necessary

Digital Drawing's
unique teaching style

In reading industry trade magazines, perusing the many books available, and talking to employers in the new industry, it has become apparent that current offerings are not meeting the needs of either employers or students. Most publishers are still focused on books that teach software (both textbooks and retail offerings). To quote the chairman of the author's industry advisory committee of his Business Graphics & Communication degree, "Software is a moving target." There are no titles that teach PostScript illustration from a practical production point of view. This is not graphic design instruction (though that is a part of it). This is not prepress instruction (though this is also a part of it). This is using PostScript illustration as an integral part of the suite of tools needed for digital publishing and Website construction.

The focus is on student needs.

Digital Drawing teaches essential skills needed on a daily basis using the best tool for the task – FreeHand. The concepts and skills taught work equally well with FreeHand 5.5, 7, and 8. The newer versions streamline production with some of the new capabilities. However, the basic concepts work equally well on any version since 4.0. The concepts and skill sets taught in *Digital Drawing* are essential to professional production without the titillating illustration techniques that have little practical use once the student gets hired.

Five instructional goals
- Basic graphic design knowledge without the egocentric techniques taught traditionally in fine art and design schools that are so overly expensive to actually produce.
- Practical job skills covering the production require-ments of offset lithography, screen printing, electro-static printing, and inkjet printing – plus the needs of Website creation.
- Strong thinking and problem-solving skills.
- Strategies to determine when to use FreeHand and when other types of software are appropriate.
- Basic working knowledge of how to integrate FreeHand with rest of the software used by the publishing industry (print, multimedia, and Web).

The problem with tutorials

Digital Drawing is easy to read, very practical, and a reference for basic techniques that will be used during the entire career of a professional desktop publisher. These techniques cover concepts that are not going to change. However, this book is not enough. A new method of instruction is necessary also. Current courses around the country are often simply lockstep software tutorials. These tutorial entrances to PostScript illustration are generally helpful, but they reach none of the instructional goals listed above. They are boring to the students and do not add to skill sets. They merely show software capabilities, not how to use that software.

A new method of instruction is necessary.

Lockstep tutorials are little help to students beyond a bare introduction to the software. They teach the location and capabilities of the various dialog boxes and commands. However, tutorials force students to think in the manner and order of the tutorial creator. The problem is that graphic design projects have thousands of different equally competent and professional solutions. It is impossible for a designer to solve design problems by trying to think like someone else. Creativity is an extremely subjective process that can be promoted, but never codified. Exams must be open-ended.

There is some need for more directly guided tutorials when students first begin. However, experience has shown that the sooner you can set the students free, the faster they learn. We are definitely talking about liberty here, not license. This style of teaching gives freedom within the context of professional production standards. If any solution is unsellable to a real client, the exam should be retaken, until it is obvious that a real person would pay for it.

The procedure and conceptual basis of the skill exam approach

Instead of lockstep tutorials, *Digital Drawing* includes open-ended projects in the form of skill exams. Even the miniskills included in the book give room for student creativity. The skill exams have been tested for many years to make sure that they actually help students internalize concepts in a production environment. After a tutorial, students given a similar project often cannot do the work. After a skill exam, students can easily transfer those skills to real projects. There are ten miniskills and ten skill exams. They are all located on the Website duplicate on the CD.

Students are given relative freedom to pick the exams that will help them the most. This means that some will pick the easiest. We always have the lazy ones. They should be encouraged to look elsewhere

for a career. As you can see on the grading policies page on the Website, student are required to do five of each type of exam. They can earn the additional points needed with additional theory, miniskill, or skill exams. Better yet, they can do real-world projects.

The approach and method of theory exams

Current methods normally implement multiple-choice testing for theory concepts. This style is implemented for ease of grading with no thought to its usefulness in analyzing a student's actual conceptual understanding. *Digital Drawing* includes a complete set of theory exams in the short-essay-question style that enables the teacher to accurately assess the students' comprehension of the materials' conceptual basis. All theory exams are typed into an email for grading and annotation. Experience has clearly demonstrated that annotations to increase knowledge help more than anything.

This style of teaching gives students the opportunity to work together on the exams. In fact, they are encouraged to work together. Robin Williams (in her popular book, *The Non-Designer's Design Book,* Peachpit Press, 1994) calls it "Open Book, Open Mouth" learning. The questions are open-ended, often requiring higher-level thought processes to answer. Often there is no right or wrong answer, but a search for thoughtful opinion. The goal is to learn to think, not to regurgitate data. The process of writing the answers into the email and reading the annotated email responses greatly reinforces learning. The very process enables long-term retention of the materials.

The importance of real-world projects

Students progress (as soon as possible) to real projects for real clients with real deadlines. This enables them to apply what they have learned, making the new knowledge and techniques a permanent part of their skill set. Each school using *Digital Drawing* coursework will have the built-in option to supply their own "real" projects.

At the author's school, they can design and print anything for the school, the local public schools, any government agency or organization, and any state-registered nonprofit corporation. Students unanimously report that projects are their best learning experience in school. Not only do they learn more, but they have much more fun in the learning.

Software versions

Digital Drawing is not version-specific, nor are the skill exams. Whenever possible, the exams are written to use tools that have not changed in usage since version 3, and probably won't change for version 9. The screen captures are from FreeHand 8, but many of the exams have generic captures that can be used with any FreeHand version (and also with Illustrator). Many of the same exams work equally well for Illustrator students.

Even the keyboard shortcuts have not changed greatly. Often students have newer versions at home than at school. When hired, they are often forced to use older versions to produce the projects in their job tickets. The author had a student with training in PageMaker 6.5, Quark 3.32, FreeHand 7, Illustrator 7, and Photoshop 4 who was hired by a screen printing firm that used CorelDraw 3 exclusively (in Windows 3.1). There was quite a bit of complaining about antiquated software and hardware, but the student adapted fast and became a trusted employee generating hundreds of posters, T-shirts, etc.

Distance learning and online training

Digital Drawing includes a complete generic Website on the CD that has been used and tested since 1996. This site is set up for easy inclusion into the distance learning courses taught by any community college, business, or vocational school. The Website includes all the reading assignments, miniskills, and skill exams developed for the coursework using *Digital Drawing*.

Students have the option to do all or any part of their coursework online (if allowed by the instructor). All theory exams are submitted by email. The miniskills and skill exams are submitted the same way. Students simply export the finished projects as a PDF and attach it to an email for grading.

CD contents
and Instructions

The CD-ROM is set up to work entirely through your browser (except for the fonts and the installers). You will need a level 3 or better browser on your computer, plus Acrobat Reader 3 or better to read the PDFs.

The table of contents for the CD-ROM can be seen by loading the file CDHome.htm on the root level of the CD, in your browser. Everything you need is linked from that page.

Fonts

You will also see on the CD a Font directory or folder. This contains some free fonts that the author is giving you. You have a license to use these fonts as you wish for any purpose on your own personal computer. Your instructor has a site license to install them on every computer in your lab.

The fonts are all PostScript Type 1. They should install easily and work well. If there are any problems, email the author and he will see you get a working copy (assuming that you have installed them correctly).

Gallery

The links in the gallery are arbitrary. The linked PDFs are on the CD. The Web links were current as of July 1999 – but that means little on the Web today. They are merely meant to give you a small running start to what is available out there.

Installers and demos

On your CD you will find either a MacInstallers folder or a PCInstallers folder. In them are the installers for Netscape Communicator (which is preferred). The Mac installer folder also includes Microsoft Explorer 4.5. In addition, both folders include the installers for Acrobat Reader 4.0. Reader 3.0 is sufficient, if that is already loaded on your computer.

For the Mac installations, Communicator has a *Start Here* icon; Reader has a Reader Installer icon; and for Explorer you just use the Microsoft Internet 4.5.smi icon. Just double-click on the icon you need, and follow the instructions.

For the PC installations, Communicator has a CC32E45.EXE file; Reader has a AR40ENG.EXE file; and for Explorer there is an ie5setup.exe file. Just double-click on the icon you need, and follow the instructions.

In addition, for either platform, you will find demo copies of FreeHand, Flash, Dreamweaver, and more.

This is a new way of learning, but it is exciting and fun!

Enjoy yourselves ...

APPENDIX C: TEACHING STYLE

ABOUT THE FONTS
These are just a sampling of fonts offered by NuevoDeco Typography. The foundry is accessed through the author's website: http://kumo.swcp.com/graphics and offered in places like makambo.com — There are many other fonts available, plus the line of fonts designed by one of his more talented former students, Seamus Mills. You should go there for site licenses and other extremely functional fonts and dingbats.

Appendix D

Keyboard shortcuts

Aiding your production capabilities

File management

	MAC	PC
New Document	⌘N	Control N
Open Existing Doc	⌘O	Control O
Open New Window	⌘⌥N	Control Alt N
Close Document	⌘W	Control F4
Save	⌘S	Control S
Save As	⌘⇧S	Control Shift S
Print	⌘P	Control P
Preferences	⌘⇧D	Control Shift D
Customize Shortcuts	⌘⇧⌥	Control K Control Alt Shift Y
Quit/Exit	⌘Q	Alt F4

Editing

	MAC	PC
Import	⌘R	Control R
Export	⌘⇧R	Control Shift R
Undo	F1 or ⌘Z	Control Z Alt Backspace
Redo	⌘Y	Control Y Control Alt Backspace
Cut	F2 or ⌘X	Control X or Shift Del

Copy	F3 or ⌘C	Control C or Control Ins
Paste	F4 or ⌘V	Control V or Shift Ins
Cut Contents	⌘⇧X	Control Shift X
Paste Inside	⌘⇧V	Control Shift V
Copy Attributes	⌘⇧⌥C	Control Alt Shift C
Paste Atributes	⌘⇧⌥V	Control Alt Shift V
Clone	⌘=	Control Shift C
Duplicate	⌘D	Control D
(used primarily to duplicate transformations)		
Select All	⌘A	Control A
Select All in Doc	⌘⇧A	Control Shift A
Find&Replace:		
Text	⌘⇧F	Control Shift F
Graphics	⌘⌥E	Control Alt E
Bring to Front	⌘F	Control F
	⌘⇧ Up	Control Shift Up
Bring Forward	⌘[Control Alt Shift F
	⌘ Up	Control Up
Move Backward	⌘]	Control Alt Shift K
	⌘ Down	Control Down
Send to Back	⌘B	Control B
	⌘⇧ Down	Control Shift Down

View

	MAC	PC
Fit in Window	⌘⇧W	Control Shift W
Fit Selection	⌘O	Control O
Fit All	⌘⌥O	Control Alt O
50%	⌘5	Control 5
100%	⌘1	Control 1
200%	⌘2	Control 2

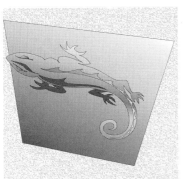

400%	⌘4	Control 4
800%	⌘8	Control 8
Previous View (Custom)	⌘⌥1	Control Alt Shift 1
Preview	⌘K	Control K
Fast Mode	⌘⇧K	Control Shift K
Toolbars	⌘⌥T	Control Alt T
Panels	F12	F12
	⌘⇧H	Control Alt H
Page Rulers	⌘⌥M	Control Alt M
Text Rulers	⌘/	Control Alt Shift T
Snap to Point	⌘'	Control Shift Z
Snap to Guides	⌘\	Control Alt G
Snap to Grid	⌘;	
Previous Page	⌘ Page up	Control Page Up
Next Page	⌘PageDwn	Control Page Down

Panels and Toolbars

Toolbox	⌘7	Control 7
Object Inspector	⌘I	Control I
Stroke Inspector	⌘⌥L	Control Alt L
Thinner	⌘⌥⇧<	Control Shift1
Thicker	⌘⌥⇧>	Control Shift 2
Fill Inspector	⌘⌥F	Control Alt F
Text Inspector	⌘T	Control T
Paragraph	⌘⌥P	Control Alt P
Spacing	⌘⌥K	Control Alt K
Column Row	⌘⌥R	Control Alt R
Copyfit	⌘⌥C	Control Alt C
Document Inspector	⌘⌥D	Control Alt D
Transform	⌘M	Control M
Transform: Scale	⌘ F10	Control F10

329

Transform: Move	⌘E	Control E
Transform: Rotate	⌘ F13	Control F2
Transform: Reflect	⌘ F9	Control F9
Transform: Skew	⌘ F11	Control F11
Transform Again	⌘,	Control Shift G
Align	⌘⌥A	Control Alt A
Align Again	⌘⇧⌥A	Control Alt Shift A
Layers	⌘6	Control 6
Styles	⌘3	Control 3
Color List	⌘9	Control 9
Color Mixer	⌘⇧C	Control Shift 9
Tints	⌘⇧Z	Control Shift 3
Halftones	⌘H	Control H
Repeat Xtra	⌘⇧+	Control Alt Shift X

Combining and Fixing Paths

	MAC	PC
Join	⌘J	Control J
Split Paths (Unjoin)	⌘⇧J	Control Shift J
Group	⌘G	Control G
Ungroup	⌘U	Control U
Blend	⌘⇧B	Control Shift B
Attach Blend to Path	⌘⇧⌥B	Control Alt Shift B

For the tools in the Operations Panel, it is highly recommended that you create some custom shortcuts to UNION, DIVIDE, INTERSECT, PUNCH, CROP, and TRANSPARENCY

Lock	⌘L	Control L
Unlock	⌘⇧L	Control Shift L

Align:		
Top	⌘⌥•	Control Alt 8
	⌘⇧ Left	Control Shift Left

Right	⌘ Right	Control Right
	⌘⌥6	Control Alt 6
Bottom	⌘⌥5	Control Alt 5
	⌘⇧ Right	Control Shift Right
Left	⌘ Left	Control Left
	⌘⌥4	Control Alt 4
Center Horizontal	⌘⌥7	Control Alt 7
Center Vertical	⌘⌥9	Control Alt 9

Tools

Select	0 or ⇧F10	none
Text	⇧F9	none
Rectangle	1 or ⇧F1	none
Polygon	2 or ⇧F8	none
Ellipse	3 or ⇧F3	none
Line	4 or ⇧F4	none
FreeHand	5 or ⇧F5	none
Pen	6 or ⇧F6	none
Knife	7 or ⇧F7	none
Rotate	F13	F2
Reflect	F9	F9
Scale	F10	F10
Skew	F11	F11
Magnify	⌘Space	Control Space
Demagnify	⌘⌥Space	Control Alt Space

Text

One point size		
Smaller	⌘⇧<	Control Alt 1
Larger	⌘⇧>	Control Alt 2
Leading		
Increase	⌘(Num+)	Control Num +
Decrease	⌘(Num-)	Control Num -

Baseline shift		
Increase	⌘⌥ UP	Control Alt Up
Decrease	⌘⌥ Down	Control Alt Down

Kerning:		
Plus 1% em	⌘⌥ Right	Control Alt Right
Plus 10% em	⌘⌥⇧ Right	Control Alt Shift Right
Minus 1% em	⌘⌥ Left	Control Alt Left
Minus 10% em	⌘⌥⇧ Left	Control Alt Shift Left

Style		
Plain	⌘⌥⇧ P	Control Alt Shift P or F5
Bold	⌘⌥ B	Control Alt B or F6
Italic	⌘⌥ I	Control Alt I or F7
Bold Italic	⌘⌥⇧ O	Control Alt Shit O or F8
Strikethrough	⌘⌥⇧ S	Control Alt Shift S
Underline	⌘⌥⇧ U	Control Alt U

Alignment		
Left	⌘⌥⇧ L	Control Alt Shift L
Right	⌘⌥⇧ R	Control Alt Shift R
Center	⌘⌥⇧ C	Control Alt Shift M
Justified	⌘⌥⇧ J	Control Alt Shift J

Nonbreaking space	none	Control Shift H
Em space	⌘⇧ M	Control Shift M
En space	⌘⇧ N	Control Shift N
Thin space	⌘⇧ T	Control Shift T
Discretionary hyphen	⌘-	none

Highlight Effect	⌘⌥⇧ H	Control Alt Shift H
Text Wrap	⌘⌥ W	Control Alt W
Flow Inside Path	⌘⇧ U	Control Shift U
Attach to Path	⌘⇧ Y	Control Shift Y
Convert to Paths	⌘⇧ P	Control Shift P
Spelling	⌘⇧ G	Control Alt S
Text Editor	⌘⇧ E	Control Shift E

APPENDIX D: KEYBOARD SHORTCUTS

PRINT & WEB
GRAPHICS
USING FREEHAND

Appendix E

Glossary

Conceptual help

Terse meanings of selected words

A

Additive color

A full-spectrum color space in which all three primaries add together to make white.

B

Banding

The bands of color that appear in gradients or blends when the resolution is too low, the linescreen is too high, the length of the transition is too long, or the color differential is too small.

Bézier curves

The mathematical equations used to describe PostScript paths.

Bitmapped image

An image described by pixels.

Bleed

Printing ink one eigth inch beyond the trim size to give the illusion that the ink goes exactly to the edge of the sheet of paper.

Blend

The transformation of one path to another.

Bounding box

The invisible box defined the the vertical and horizontal lines that touch the extreme left, right, top, and bottom edges of a shape or group. An image's manipulation handles are located by the corners and centers of the sides of the bounding box.

Burst

A splashy graphic used to grab the reader's eye to a compelling idea or command (such as "free," "buy now," or "no interest").

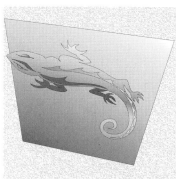

C

Caps

The three options to end a stroke at the end points.

CMY(K)

The full-spectrum color space of process printing. Cyan (C), Magenta (M), and Yellow (Y) are the primary colors, with black added because of the weak cyan.

Color Depth

The number of bits assigned to a given pixel.

Color space

The color environment created by a set of primary colors.

Color system

A color environment that is not full spectrum.

Color wheel

The RBY color space represented in circular fashion.

Composite paths

Converting two or more closed paths into one path with a common even/odd fill.

Continuous tone

Images that continuously vary in color or tone, like photographs and scans of fine art paintings, pastels, charcoal drawings, and pencil drawings.

D

Defaults

The document setup that opens when you hit the New document command under the File menu. They are set by saving a document called FreeHand Defaults into the FreeHand folder.

Dithering

Producing the illusion of intermediate colors by pixel patterns or random spacing of pixels.

Dot

The smallest printable spot for a printer (usually 1-bit).

Extrema

Points placed on a PostScript path at the extreme left, right, top, and bottom of the path.

Fill

The attributes applied to the area enclosed by a path.

Full spectrum

A color space that includes a sampling of every area of the visible electromagnetic spectrum.

GIF

CompuServe's Web graphic format that uses indexed color (8-bit or less) and LZW compression (like TIFFs).

Graphic design

Design in any area of digital publishing production.

Group

Constraining two or more objects into permanent relationship.

GUI (graphic user interface)

A computer interface like the MacOS or Windows that uses graphic analogies to relate to the data in the computer: mouse, icons, popup menus, and so forth.

H

Halftone cell

A group of dpi dots used to generate a variable sized lpi dot.

Handles

The manipulation levers attached to a point, used to manipulate the tangents of the incoming and outgoing segments.

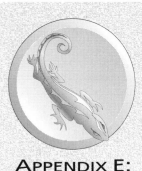

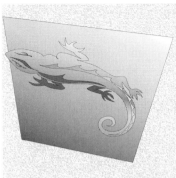

Hi-Fi (High-Fidelity) Color

Process color schemes to increase the colors available to more closely reproduce reality. Hexachrome, by Pantone, seems to be the standard.

HSB or HSV

Hue, saturation, and value or brightness is a color description language that allows accurate communication of color.

I

Imposition

Arranging multiple pages on the front and back of a single sheet of paper so they are in proper page sequence after folding and trimming.

Interface

What you see on the monitor screeen to interact with FreeHand.

ISP (Internet Service Provider)

A company that lets you use its Web server for a fee.

J

Jaggies

The pixelated edge of shapes or lines that appears when the pixels or dots are large enough to see with the naked eye.

Joins

The three manners of rendering the appearance of the bends in a stroke at corner points.

JPEG

The lossy compression scheme used for contiuous tone art on the Web. It works for high-res printing, but compressing too far leaves "plaid" artifacts. Compresses by averaging pixel areas.

K

Kipper

Smelly fish (I had to have a K word).

Leading

Typographers' term for line spacing.

Lineart

Images that are primarily concerned with shapes that can be rearranged and colored at will. The shapes are described with outlines called paths that may or may not print.

Linescreen

The measurement system for dot patterns necessary to print continuous tone artwork on a 1-bit press.

Logo

A graphic device used to distinguish and market a company.

LZW

The lossless compression scheme used by TIFFs and GIFs.

Mask

This is a path used to cover, hide, or otherwise block out portions of a drawing or image.

MB (Megabyte)

A digital data size measurement for approximately 1 million bytes of data or 8 million bits of data.

Menu commands

Capabilities and dialog boxes accessed through clicking on the drop-down menu at the top of your monitor screen.

Mezzotint

A fine art intaglio technique that involves polishing highlights out of a solidly scratched, deep black, copper plate – for our purposes the look of a mezzotint is a random arrangement of very short lines that produces a very arty halftone appearance.

Miter

The extended point, beyond the corner point, of a stroke that changes direction. The length of this point is controlled by the miter limit option.

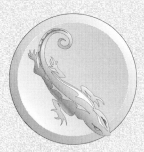

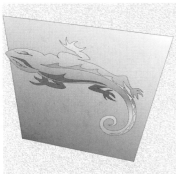

N

Nested graphic

This is an image that is imported into your illustration and then exported along with your finished illustration – a separate digital file, or an image within an image.

O

OPI (Image Substitution)

A process developed by Aldus to enable top-end scanners to supply low-res images to the designer for easy manipulation and then automatic substitution of the high-res images at the service bureau or printing firm, applying all the changes made by the designer to the low-res image.

P

Panels

An arrangement of commonly used dialog boxes into floating palettes for easy mousing access.

Path

The name of the mathematical description used to define lines and shapes in PostScript illustration.

PDF (Portable Document Format)

A file format of simplified, streamlined PostScript that can be read on any platform with a free Reader. It contains all the fonts and all of the graphics, so it's truly portable and can be used as the preferred format to send to your printing firm or service bureau.

Pixel

A contraction of the two words *picture element*. A pixel is the smallest unit of a digital image.

Pixelated

An image in which the pixels are large enough to be seen as tiny squares with the naked eye. This can be caused by enlarging or resizing a bitmapped image.

PMS (Pantone Matching System)

A standardized spot color ink system that is dominant in the United States. It has 1,001 standard colors mixed out of 14 basic inks according to standard formulas listed on swatch books (you need to buy a swatch book).

Point

A reference location on a Bézier curve.

PostScript

A page description language at the core of high-resolution printing. It's the industry standard.

PPD (Printer Description File)

A small piece of software supplied with a PostScript printer that defines the capabilities of that printer to the software being used to print, like resolution, linescreens available, paper sizes, and so forth.

Preferences

Options to change the behaviour of FreeHand set in the Preferences dialog box.

Preflight

Opening up submitted digital documents to see if they will fly.

Process color

The common name of CMYK printing.

Quickprint

Normally low-resolution, coarse-registration printing done on cheap plates with limited paper and ink choices using duplicators instead of presses. This portion of the industry was the first to adapt digital technology, so there are now wide variations in quality and capabilities.

RAM (random access memory)

The ultra-fast memory used by your computer to work in as it creates files and documents. It is wiped out any time power is cut.

RBY (Red Blue Yellow)

The fine-art, full-spectrum color space of artist's pigments.

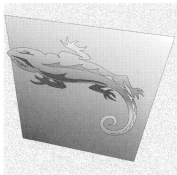

Registration

The ability of a press to feed paper consistantly.

Resolution Independence

One of the basic attributes of PostScript: PostScript vector drawings and type have no resolution attached to the file so they print out at the highest resolution possible on a specific printer with a custom bitmap created to best utilize that printer.

RGB (Red Green Blue)

The full-spectrum color space of your monitor. The additive color space of light.

RIP (Raster Image Processor)

The computer in your PostScript printer that generates the custom bitmap of PostScript information to exactly fit the resolution of your printer, imagesetter, or platesetter.

Roughs

A hand-drawn rendering of an idea to establish layout and proportion.

Segment

The path portion between two points as defined by the handles.

Serif

A flare, bump, line, or foot added to the beginning or end of a stroke in a letter.

Shade

A fine-art term to describe hues plus black.

Sizing

A coating that controls absorption.

Stochastic screen

A new digital halftone technique using precisely placed, very tiny dots with frequency modulation. A hand generated stochastic effect can be created by using Photoshop's Bitmap Mode >> Diffusion Dither which is a random dithering technique.

Stroke & fill

All PostScript shapes give you almost unlimited options to color the outlining path: the strike, and the area enclosed by the path: the fill.

Subtractive color

A full-spectrum color space in which the primaries add together to produce black.

Tabs

An soft return with a leading of zero to implement a new indent and alignment setting on the same line of type.

Tangent

A straight line touching a curve at a single point.

Thumbnails

A fast sketch (a few seconds) done to note down an idea in a personal shorthand that enables the designer to retain the idea.

TIFF (Tagged Information File Format)

The standard (usually best) bitmap file format for printability.

Tint

Two meanings: in fine art, a hue plus white; in printing, a screened percentage of a color of ink.

Tools

Buttons to click that change the capabilities of the mouse.

Trapping

Building small overlaps into touching color shapes to cover for bad registration (not really necessary with a modern, well-maintained press).

Typography

The art and craft of setting type.

Ugly

The current fashion in illustration accurately presenting the frustrations of the younger generations.

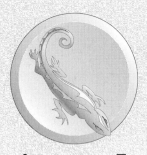

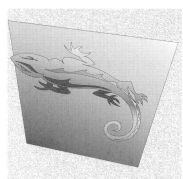

V

Vector Image

Graphics drawn with outlines in which the curves are rendered with countless short straight lines (vectors). FreeHand produces vector images.

W

White space

The empty, open, or blank areas of a design that are one of the most important factors to control in graphic design. These areas should be planned shapes to increase readability.

Winding

The direction of a path; clockwise or counterclockwise.

X

Xtras

FreeHand's name for its plug-ins.

Y

Z

228, 229–30, 234
variants, 191
Formal designs, 166
FRACTALIZE, 302
Frames, 262
FreeHand, 123, 137, 211, 325
color handling, 154, 155–59
setting up/customizing, 27–47
for Web graphics, 255, 261
Freehand tool, 53
Fugitive color, 147

G

Gamma, 256, 269
GIFs, 9, 266, 307
Web graphics as, 257, 258, 259–60
Gradient fills, 20, 73, 74–75
banding in, 224
for lines, 303
overlap and, 96
transparency and, 97
trapping, 242
for type, 132
in Web graphics, 259–60, 266–67
Graduated fill, 85, 87, 157
Graphic design, 163–70.
See also Graphics; Images;
PostScript illustration
complexity of, 173
on computer, 284
education for, 286–87
equipment for, 36, 268, 279
goals for, 170, 171
limitations on, 279
output considerations, 21, 77, 173, 224,
228
principles of, 170–74
professional, 117, 134, 192, 199, 256,
301
rules, 94, 122, 123, 126, 164, 201
for Web. *See* Web page design
Graphic design as job, xix, 105, 134,
170, 275–97, 322. *See also* Production
speed
budget, 100, 279, 281
client relations, 171, 291–92, 295–97
color, 159
costs, 207
designer's role, 171–72
education, 195, 199, 276
employer expectations, 293
printing problem avoidance, 77, 227–
28
services, 235, 278, 291
skills, 170, 173, 175
team, 174–76
work method, 36, 45, 275, 277–90
Graphic hose tool, 307
Graphic management software, 33
Graphic pen, 20
Graphic tablets, 20, 54–55, 62
Graphic user interface (GUI), 147
Graphics. *See also* Images
appropriateness of, 9–10, 189, 195–96
bitmap. *See* Bitmaps
editing, 249
embedded, 32, 232, 233, 248–49

exporting, 250–51
imported, 29–30, 32, 35, 242, 244, 247–
49
inline, 136
kind of, 240
nested, 230, 232, 234
PostScript. *See* PostScript illustration
printability of, 228
purpose of, 93, 169, 170, 185, 277, 278
reactions to, 165–67, 169, 198, 270, 275
resizing, 204, 232, 263
separating, 40
type/words as, 4, 126, 131–33, 189–90,
261
as type, 136
utility of, 6–7
Graphs, 6
Gravure, 221
Gray, 145, 150, 216
levels of, 223, 224
Greeking, 35–36
Grid color, 33
Grids, 98
Gripper, 227
GROUP, 53, 65
Grouping, 29, 52–53, 83–84
Groups, 15, 30, 85
Guide color, 33
Guidelines, 205

H

Hairlines, 20–21, 31, 238, 262
Halftone cells, 222
Halftones, 216–18. *See also* Photo-
graphs
HALFTONES panel, 39
Hallmarks, 163
Handles, 62
adjusting, 56
of bounding box, 36
point, 17–18
showing, 31
smaller, 29
text blocks, 127
transform, 29
Handwriting, 121, 122, 190
Headlines, 115, 117, 157
Helvetica, 119–20, 191
Hexachrome, 152
HIDE, 44
High-fidelity (hi-fi) color, 9, 152–53,
154
Highlights, 35, 93, 124, 157
HSB/HSV, 143, 147
Hue, 143
Hyphenation, 116, 124, 239
Hyphens, 113, 136

I

Idea creation, 276, 279–80, 282–88
Illustrator (program), 27, 30, 43, 83
Illustrators, 281

Image assembly, 226, 288, 290
Image manipulation, 3, 12
Image manipulation programs, 207,
262
Image maps, 265
ImageReady, 217, 255, 262, 263
Images.
See also Graphic design; Graphics
on screen, 34–35
sources, 282, 283
Imagesetters, 227
IMPORT page, 32–33
Importing, 29–30, 32, 232
graphics, 35, 242, 244, 247–49
Indents, 123, 124, 127, 128
InDesign, 4, 32, 39, 55, 248
Indexed color, 261, 263, 266
Info toolbar, 41
Informal designs, 166, 167
Initials in logos, 179
Ink
color, 142, 148, 150
cost, 320
custom, 8, 183
Pantone, 152
permanence of, 147
Ink holdout, 218, 316
Inkwork. *See* Lineart
Inline effect, 124
Inline graphics, 136
INSET PATH, 302
INSPECTOR panel, 22, 38, 43, 44
Intersect, 96, 302
Italic, 113, 114, 122, 272

J

Job ticket, 294
Jobs, real-world, xviii, 45, 324. *See
also* Graphic design as job
Join options, 70–71
Joining, 29, 30, 83, 84–85
JPEGs, 9, 209
Web graphics as, 257, 258, 260
Justification, 111, 135

K

Kerning, 86, 87, 115, 136
range, 115, 124
Keyboard shortcuts, 27, 46, 327–32
custom, 78, 137
memorizing, 40, 41, 43, 46
Keyline, 36, 40
Kiss fit, 241, 245
Knife tool, 61
Knockout, 239, 243

L

Layers, 15, 29, 83, 84, 165
in combining paths, 95
exporting, 76

Finally, here's the hill!

You made it, congratulations. I hope it was a fun journey. At the very least, you should have a good solid knowledge of why FreeHand is such an important program for professional digital publishers. I'll see you in the next book.

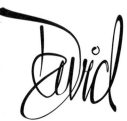